MY AFRICA

I do not sing that Africa.

There is no need for yet another negative reportage, which would leave a bitter taste and would serve no purpose.

There is a different side to this ancient land. It is the Africa that, since the beginning of time, has evoked in travellers a deep recognition, an inexplicable yearning to return. The place which still has what most of the world has lost. Space. Roots. Traditions. Stunning beauty. True wilderness. Rare animals. Extraordinary people. The land that will always attract those who still can dream.

Kuki Gallmann, *The Night of the Lions*, 1999

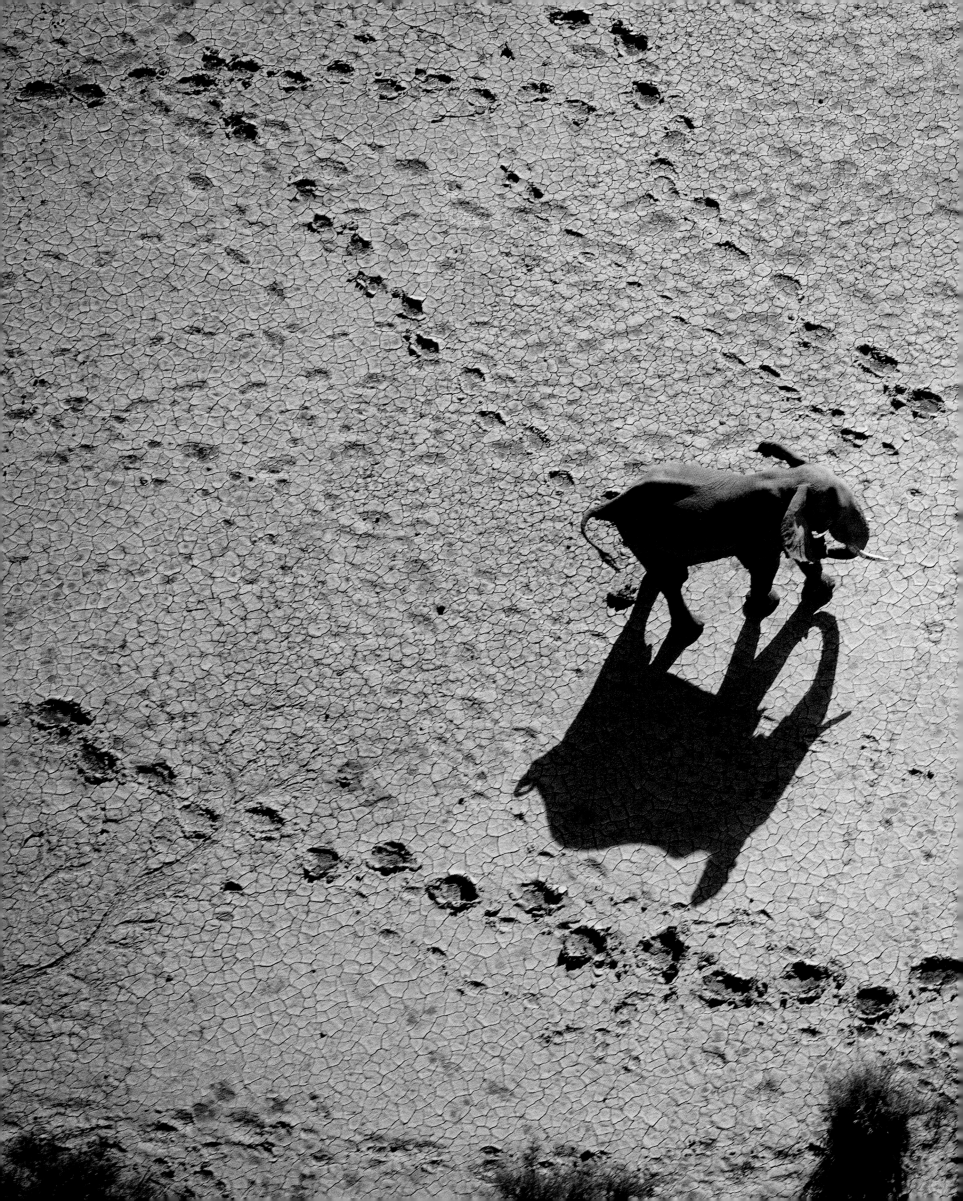

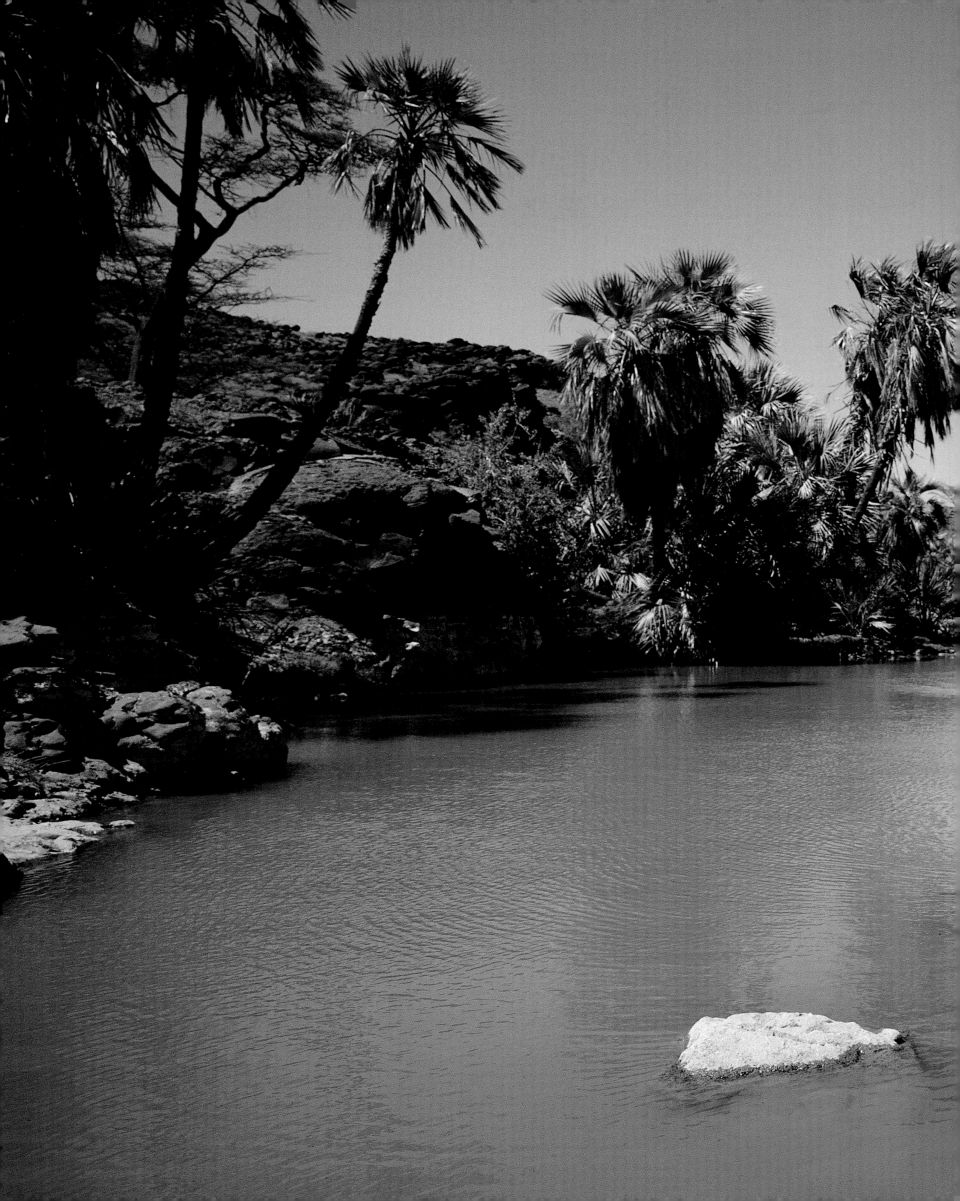

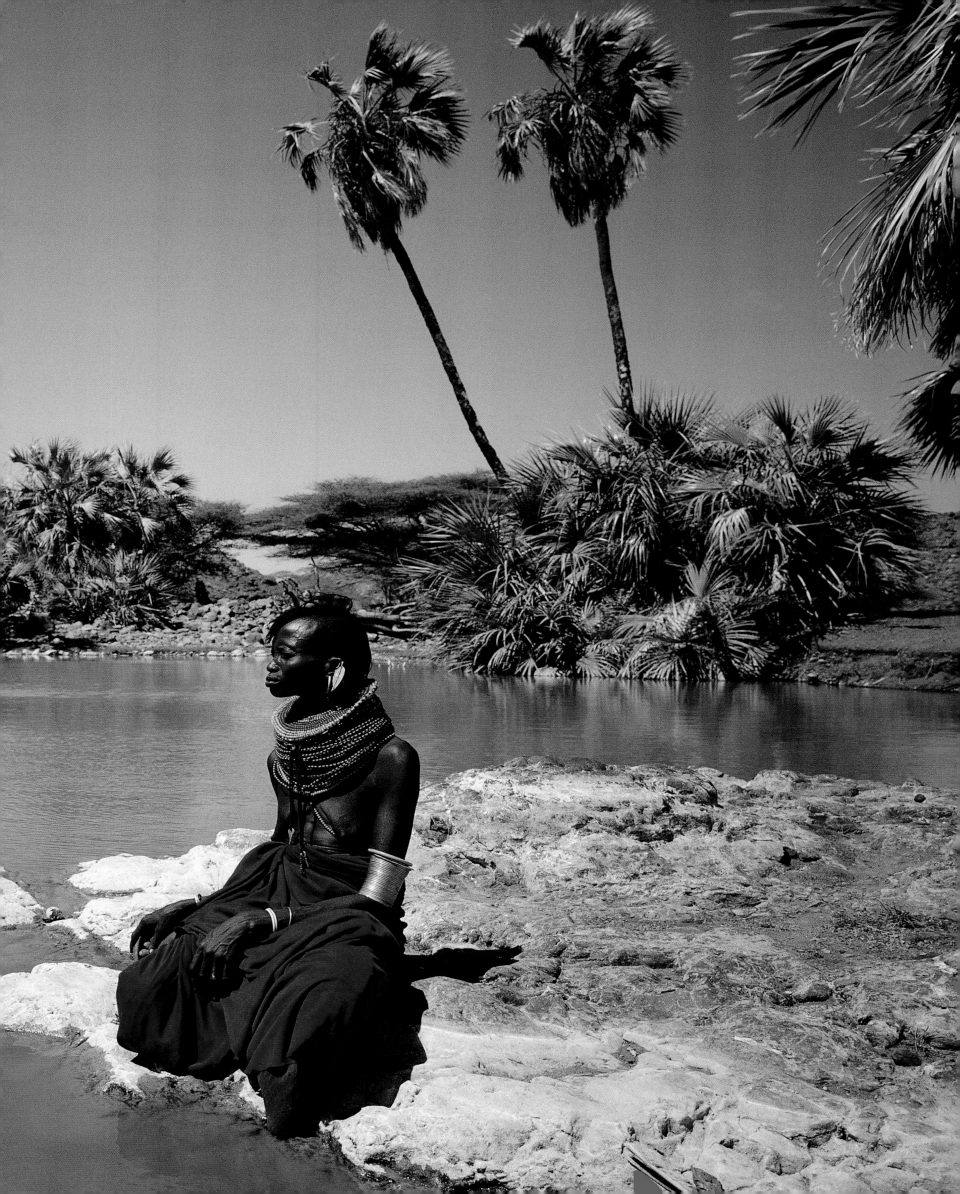

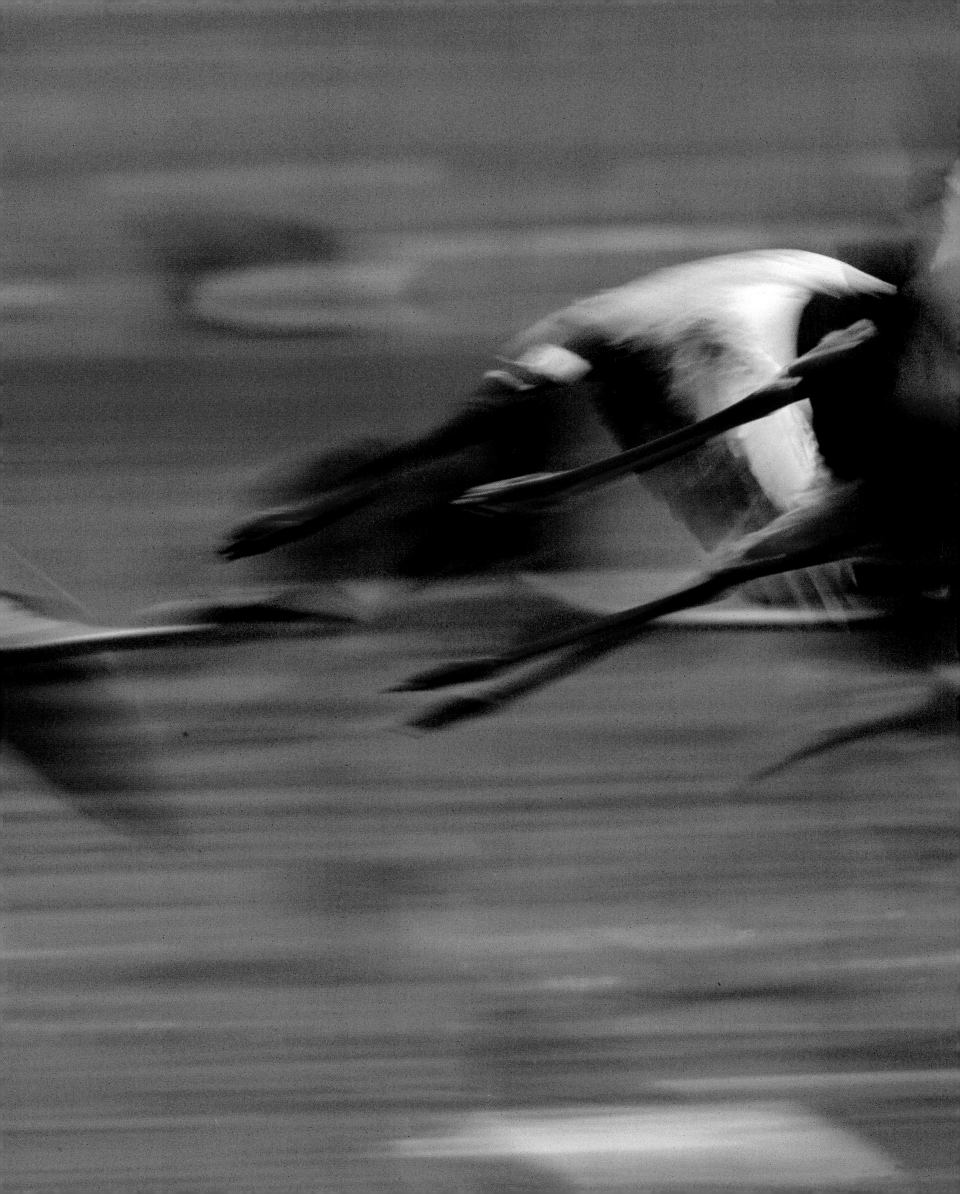

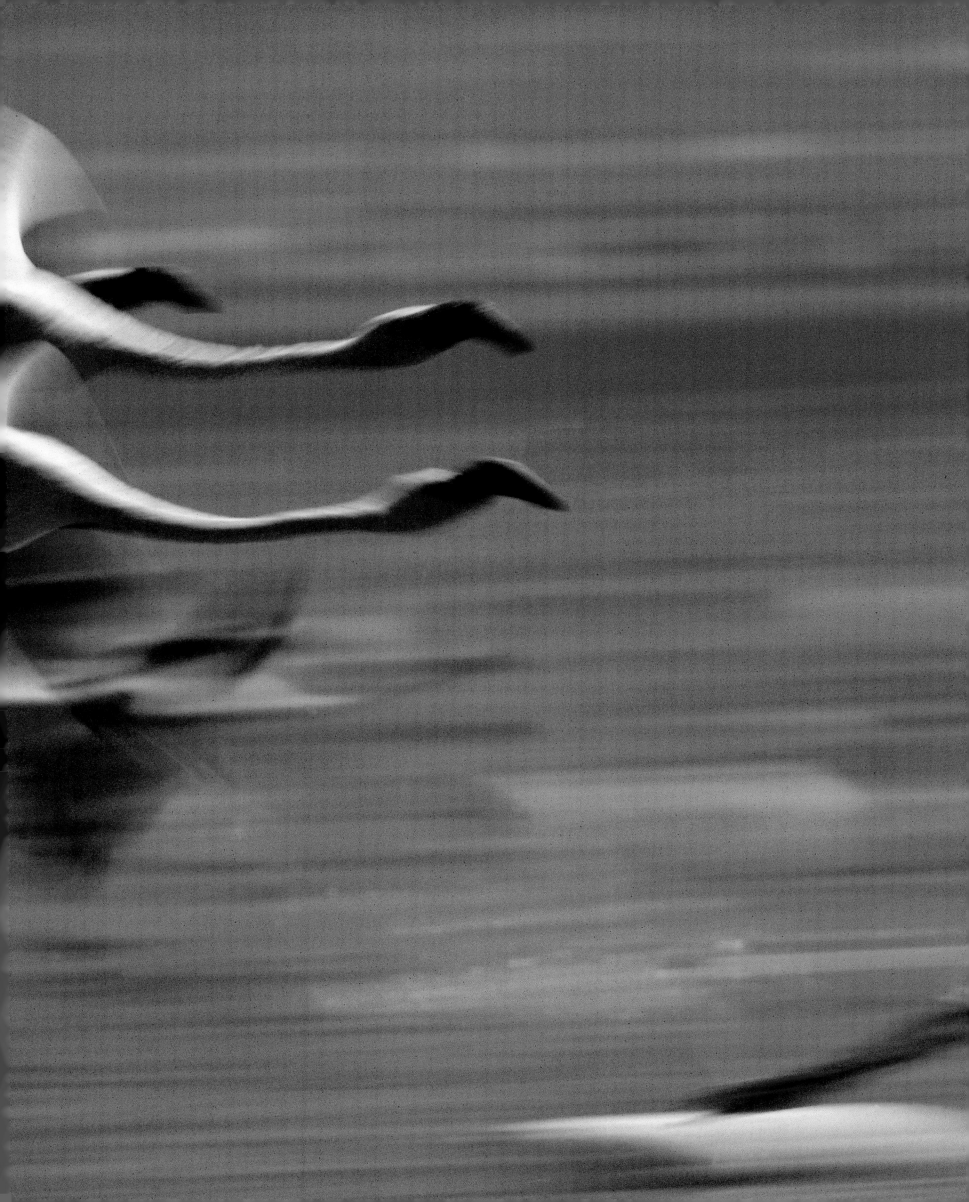

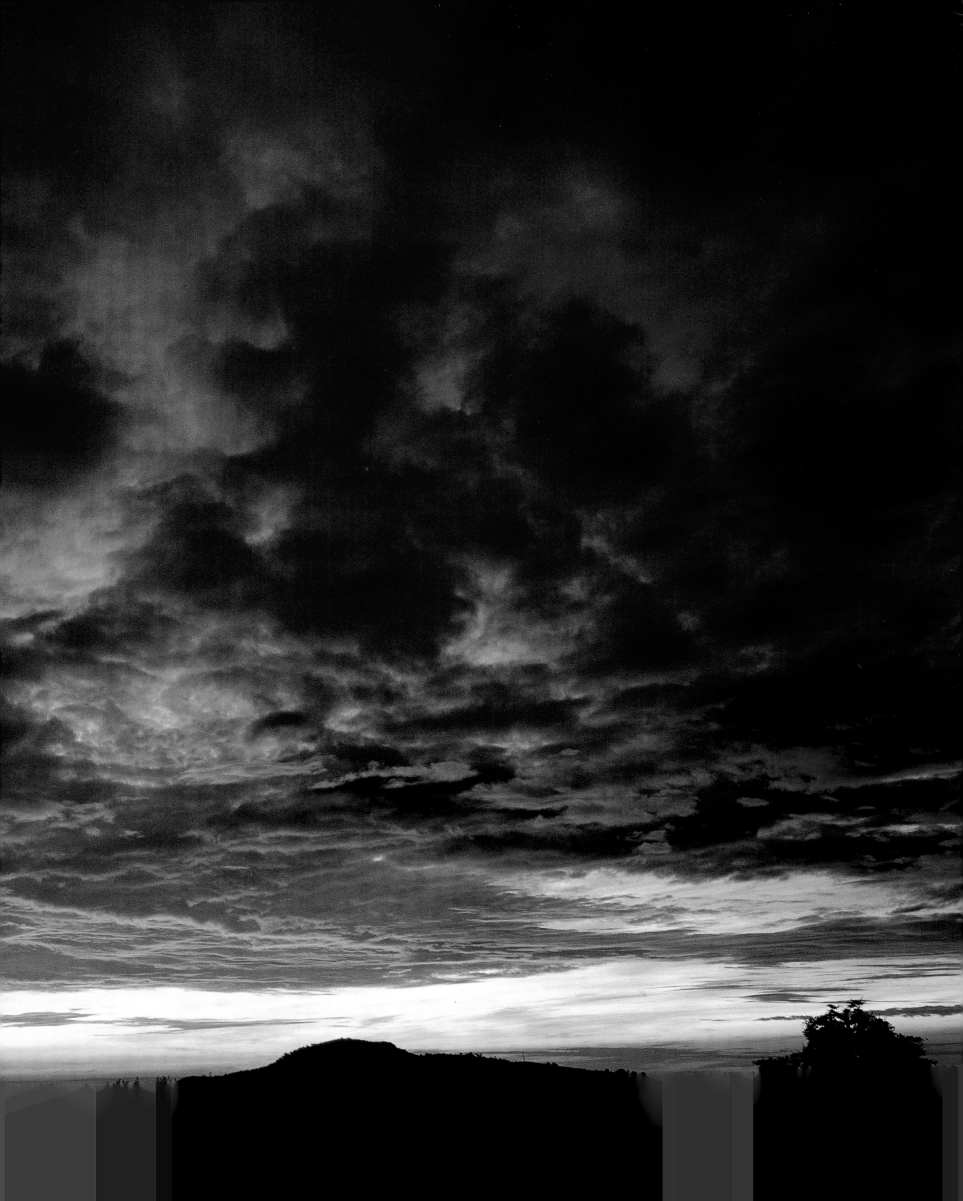

My A

CARLO MARI

FRICA

THE LANDSCAPE, PEOPLE
AND WILDLIFE OF EAST AFRICA

With texts by
Claus-Peter Lieckfeld

Translated from the German
by Michael Robinson

Frederking & Thaler

For my beloved sons, Andrea and Carlo Alberto

Acknowledgements

I first visited Kenya as a boy in 1970, with my father and my elder brother. The plan was to have a men's adventure holiday. I was so excited that I couldn't sleep days before we set off. I just couldn't wait to travel with adults and discover what would be a completely new world for me – and this all without my mother. It made me feel grown-up and important.

Over thirty years have passed since this first journey to Africa. My father has died in the meantime. He lost his battle with cancer some time ago now. Before he passed away he confided in me that, if he had to choose, he would rather lie down to die under a big tree in Africa than waste away in a hospital bed at home.

My mother suffers from the same incurable disease as he did, and she too is deeply in love with Africa. When she found out that she had only a short time to live, my first volume of photographs had just gone into preparation. My mother made it completely clear that she would not leave me before she had held this book in her hands. There have been five books now. My mother is completely incapacitated, and confined to her sick-bed, but her interest in my work has never waned. So she can scarcely wait to see my most recent book as well. At least I can bring the dream of Africa we share back to life for her in this way.

I have now been exploring this fascinating continent for years. I have always been able to count on the love and sympathy of many people. I should like to thank all of them here from the bottom of my heart.

But I would like to thank my parents most of all, for constantly providing me with new inspiration for my travels. C. M.

CONTENTS

Carlo Mari and his sons, Carlo Alberto (p. 15) and Andrea (p. 314)

Carlo Mari

MY AFRICA

You can probably tell by looking at me. Not that I think I'm anything special, but it's difficult to conceal feelings as strong as mine. I can hardly wait to get back to the unspoilt, utterly natural world of East Africa that I've come to know so well and have explored for so many years – to "my" Africa. As reflected in the pages of this volume, my travels have taken me from the north of Kenya to the south of Tanzania. I went on safari with my father for the first time when I was a boy of twelve. I can still hear the deafening tapestry of sound that met us in the Aberdare Mountains, a concert of chirping crickets and screeching birds and monkeys, with a background of muffled grunts from the elephants as they pushed their way through the undergrowth. I spent a whole night in hiding there, waiting to corner a leopard that was supposed to come drink in the little pool by the stilts our lodge was built on. The leopard didn't come that night, but it was still an exciting and unforgettable experience for me as a twelve-year-old. To this day coming face to face with a leopard remains for me the highlight of any safari.

This search for wild animals has taken me all over the Great Rift Valley and the East African forests and savannahs for the past thirty years. It is almost as though I'm driven by instinct, independently of my will. Perhaps I lived in Africa once before, in a different, long-forgotten life. Maybe I was a leopard, or perhaps there's a trace in my genes of ancestors who were moving around here in this place where human life probably began, tens of thousands of years ago. Many prehistoric finds support the theory that the cradle of humanity lies in East Africa.

I think it must be true, because so many people – including a number of photographers – feel the same way: "My" Africa. How many books include this in their title? "My" Africa is the Africa of all those people who carry it in their hearts and, like me, feel homesick when they aren't there. We all share this mysterious, inexplicable wanderlust that causes us to examine and record our African experiences with a particularly critical eye, so that sometime we can at least attempt to explain this phenomenon.

If you are lucky enough to encounter some of East Africa's various nomadic peoples, you will think you're dreaming, or travelling back in time to our very origins. Until recently I had had only sporadic contact with the tribes living south of Lake Turkana, formerly Lake Rudolf, and with some Maasai families who are scattered across the Rift Valley. These brief encounters showed me how much unites us. I feel completely at home there in their country, and these people don't regard me as a nosy intruder, but welcome me as a brother.

Yet it is still the leopard that makes me want to keep embarking upon extended safaris, making my way through the dense forests, crossing savannahs, rivers and lakes, and climbing mountains. This has meant that I have been lucky enough to see landscapes in which people have managed to preserve the heritage of our hu-

man history in all its natural beauty. I have seen animals of all kinds and I have moved with them, looking for new pastures, watering holes, nuances of colour. I have slept under the African sky, incomparably rich in stars, and I have often woken in the morning in the purple light of dawn, with fiery orange clouds above me, set alight by a sun that is just rising above the horizon, soon to be high in the equatorial sky. Then in the evening I have fallen asleep by a blazing fire, while the sinking sun suddenly throws a crimson-red blanket over the slumbering earth …

I open my eyes and return to the present: maybe I have been dreaming, or perhaps that old feeling has just taken hold again. Indeed, it is time to revisit my Africa.

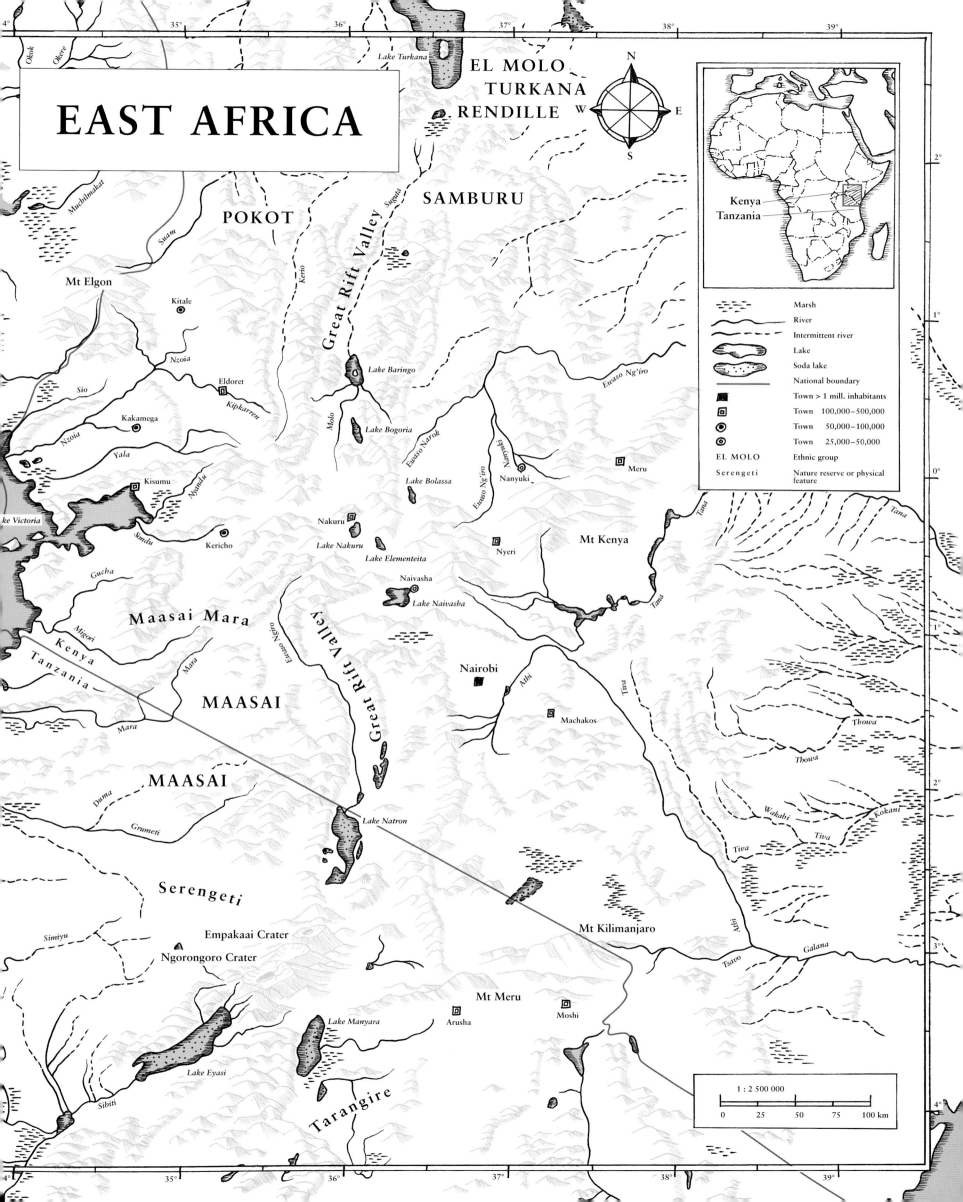

Claus-Peter Lieckfeld

PICTURES OF PEOPLE, PICTURES OF ANIMALS, PICTURES OF SOULS

"Oh dear, Africa …", my friend Klaus K. groans. "… From a journalist's point of view we seem to be stuck with the same handful of headlines for Africa stories: drought, famine, civil war, corruption – and, of course, for the past few years AIDS."

When Klaus says something like this, I can't just shrug my shoulders and ignore it. Klaus has been an Africa correspondent for twenty-nine years, chronicling a debilitated world that the West somehow thinks of as a southern appendage of Europe – that is, if it thinks of Africa at all.

"So, for you Africa is always five negatives …?", I ask. "Then just have a look at these photographs!"

Klaus bends over a selection of photographs taken by Carlo Mari in the savannahs of Kenya and Tanzania. These are the pictures of a man who has gone in search of the Africa of his dreams – and has found it. Klaus leafs through the pictures, nods in acknowledgement a few times and makes a few autobiographical comments: "…I was there before the Pokot massacred the Samburu." Finally he tears himself away from the

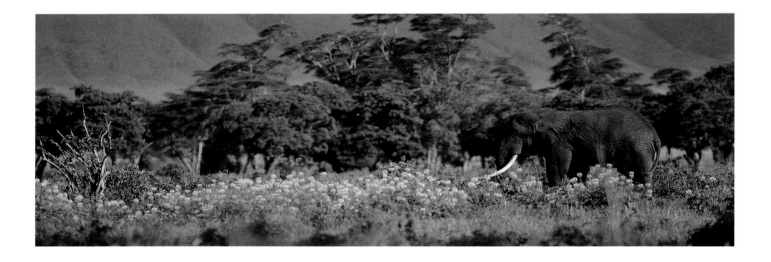

short journey that Carlo Mari's Africa pictures have taken him on in his thoughts and says: "No … these photographs aren't deceptive. Africa is beautiful enough to make you weep for joy – still. But it's enough to make you cry your heart out as well."

Beautiful enough to make you weep for joy. Anyone with any sensitivity lucky enough to have spent some time in this magnificent, ancient land would have to agree – the savannahs of Kenya, Tanzania and even further south provide food for the limbic region of the brain, where the really deep emotions lurk.

Some writers about Africa indulge in some fascinating speculation: if it was here that the first people walked upright, isn't it conceivable that these ancestral landscape images have sunk in deeply somewhere? That these are larger-than-life images of an immense, nourishing expanse of terrain that is both vast and good? That they are so deeply embedded as to be fixed genetically, and can still be sensed – by tourists on safari and lovers of Africa's wide-open spaces, for example – as a kind of aesthetic grounding even six million years after the first pre-human inhabitants walked the savannah? Is it therefore the early human being in us grunting in agreement when we stammer our "oohs" and "aahs" at the sweeping vastness of the Serengeti? Or when we see acacia trees silhouetted against the floating, snow-capped peak of Kilimanjaro? Or herds of gnu setting off on their great migration – a powerful metaphor for thirst, the thirst for life?

My friend Klaus K., the Africa veteran, suggests turning our attention to questions that can be answered *beyond doubt*. What, for example, are the African savannahs? Why are they so wonderful and in what way are they so vulnerable? According to the Heidelberg geographer Horst Eichler savannahs are "tropical grasslands, warm all the year round, dry in winter … (usually) scattered woodland and clumps of trees, with the occasional larger wooded area, the so-called tree savannahs". Geographers subdivide the greater savannah landscape even further, according to how dry it is: on the fringes of the deserts, with the Sahara in the north and the Namib in the south, the African continent is home to the so-called thornbush savannahs; at the other end of the scale are the equatorial wet savannahs. Semi-arid areas, where the desert is inexorably reclaiming ground from the savannah, must be content with a mere 300 millimetres of annual rainfall (mm/a). Wet savannahs, on the other hand, enjoy 1400 mm/a of precipitation. This is where the savannah gives way to the steamy, water-soaked jungle.

In addition to the all-important factors concerning rainfall – its distribution, severity and regularity – there are others that are equally important: above all the quality of the soil, whether it is poor or rich in nutrients, and the type of terrain, be it mountainous, hilly or flat. In a landscape that might otherwise threaten to become monotonous, plateaus and so-called *inselbergs* provide geographical relief, rising above their surroundings to enjoy climatic conditions of their very own. Some of the rivers and streams support their own ecosystems, with vegetation that is utterly untypical of the savannah.

From the point of view of the great herbivores, wet savannah does not always mean "good" savannah, just as little moisture is not necessarily "bad". In the dry savannahs, particularly delicate, nutrient-rich grasses, herbs and foliage flourish after a rare rainfall or bush fire, whereas in the wet savannahs, the soil is

often leached and thus poor in nutrients. There is enough greenery, but it is not sufficiently filling. All these factors and conditions are textbook knowledge from geography and geobotany. Though they can be discussed, their validity can scarcely be questioned.

Things are not as clear-cut when it comes to the highly controversial subject of human beings grazing animals, on which a wide range of opinions have been and indeed continue to be espoused. The debate has been making the headlines for about fifty years now: "Cattle in the Garden of Eden!" ... "Nomads ruin the national parks!"

But let's start with something non-controversial. There's no doubt that the savannahs would look very different if huge herds of wild ungulates were not allowed to graze on them. They would be covered with bushes for as far as the eye can see. In areas with more rainfall there would be woods crowned with dense canopies. Yet it is equally true that the gnu is as much a part of the African savannahs as the buffalo was of the North American plains.

The very age of the African savannahs – the Serengeti has existed for at least one million years – proves that even enormous herds never graze their food sources to the point of destruction. The savannah becomes unproductive before it is worn away by too many hooves. The herds move on in good time, and sooner or later the rain ensures that a green, healing skin grows over the worn patches.

So far, so good, the nature-lover nods in agreement: as long as Mother Nature budgets prudently, the extended family will have enough to eat – from the tiny savannah moth to the largest bull elephant. Yet it was the nomads' excessively large herds of cattle that have threatened to break the food chain once and for all. At any rate, this was long thought to be an incontrovertible fact. Almost all the savannah national parks have been declared off-limits to pastoral peoples; the nomads have lost their best grazing land and watering holes.

The result has been the widespread eradication of age-old nomadic cultures, which in turn has led to famine, impoverishment and infirmity for thousands of former herdsmen now living in urban slums. And, as if the cultural and physical annihilation of tribes, clans and whole ethnic groups weren't enough, the great clearances in the savannahs – done in the name of nature conservation – would seem to have been completely unnecessary. At least that is what is suggested by the results of a complex, long-term study conducted by Katherine M. Homewood et al. entitled "Long-term changes in Serengeti-Mara", which shocked the nature conservationists in 2001. The authors of the study concluded that changes in vegetation caused by grazing have affected much smaller areas over the decades than the transformation of savannah into agricultural land. Moreover the population density and growth of the Maasai people have not led to a diminished number of wild animals in the Serengeti-Maasai-Mara region.

This survey essentially confirms a moving, 270-page indictment by the Oxford zoologist and author George Monbiot entitled *No Man's Land: An Investigative Journey through Kenya and Tanzania* (1994). In it Monbiot asserts that it is not so much competition with domestic animals in the parks that is endangering the wild animals; what is ruinous is the high concentrations *outside* the reserves. What happens is that the large herds of wild animals regularly pass through unprotected areas when they are on the move. Here their grazing rivals, domestic animals, reach concentration levels that have – inevitably – become intolerable because of the exclusion policy. Footpaths are blocked and the very thing that parks had intended to prevent is happening outside: overgrazing, overuse and, finally, erosion. Conservation is devouring its own.

A counter-world to that of the oppressed, if not eradicated, nomadic peoples is to be found in Tanzania's Ngorongoro Conservation Area. On the south-eastern tip of the famous Serengeti National Park, 40,000 Maasai are allowed to drive their cattle in among the top currency earners – the elephants, lions, zebras, gnus and antelopes – without any apparent damage being done to the ecosystem and without obstructing the views or emotional horizons of tourists. Nevertheless: "There have to be at least small use-free zones in this cramped world, protected boundaries within which biodiversity can be preserved, completely undisturbed, for future generations", says Christoph Schenck, director of the Frankfurt Zoological Society (FZS), which maintains one of its traditional key work areas in Central East Africa. He adds: "Besides, we cannot assume that the

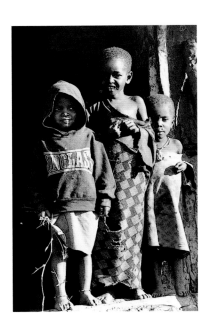

nomads of our day will act as sensitively and in such an environmentally friendly way as their forebears. It would be somewhat naïve to view the present generation of Maasai as born nature conservationists."

Regardless of whether in the future a controlled number of cattle will be admitted to parks for grazing purposes or not, the real problem lies elsewhere. The principal enemy of gnu, elephant, zebra, buffalo, rhinoceros, lion and cheetah is the transformation of large areas of savannah into farmland, a practice that is particularly widespread in Kenya. The large herds of wild animals, for which there are no park boundaries, are restricted in their migration routes. In their quest for water, which is by its very nature a race against death, they are increasingly being diverted to their detriment.

"Just a moment. What are we talking about? I mean, what is your main concern – man or beast?", asks my friend Klaus, who has seen all Africa's big game, but has never lost sight of man.

"I don't think we should separate the two … do you?"

"No. But I think readers should be given an idea of what it means to force a people like the Samburu to settle, people for whom leading a nomadic pastoral existence has been in their blood for millennia."

Who are the Samburu? Klaus explains that ethnologists consider the Samburu to constitute their own ethnic group, separate from the Maasai. The tourist industry is less discriminating, however: the Samburu are "sold" to tourists in Kenya under the tried-and-tested Maasai "trademark", to conjure up notions of the "noble savage", of the "real" Africa. "Sleep alone!" is the Samburu's final salute to their venerable old men, who have the privilege of being laid to eternal rest on an animal hide. This hide used to be a blanket. The men were born on hides, and they wore charcoal-dyed, black leather garments in anticipation of their ritual circumcision. Cowhide was their second skin. To take this away from a Samburu is tantamount to flaying him.

The Samburu do not just live *on* their animals – cattle mainly, but also goats. All nomadic pastoral peoples do that. They live *from*, *with* and *in* their animals. In this sense *saroi*, the Samburu's elixir, is certainly more than a tried-and-tested emergency treatment and nourishment in a parched environment. It is made of bull's blood and milk, combining two elixirs of life in one. It is therefore no wonder that it can work miracles.

Bull's fat, applied to the body of a barren woman, is believed to help her become fertile again, so long as the occasion is marked by a celebratory feast with an ox as the centrepiece; another ox is due after the birth as well. As a final farewell to their youth, future heads of families have to wrestle a bull to the ground together and suffocate it, so that its blood does not flow until the ceremony officially begins.

When two Maasai meet in the savannah, they will greet each other with the words: "I hope your cows are well!"

This greeting says more than "good day"; it means "good life", and "God be with you". According to the Maasai's creation myth the god Enkai acted like a good shepherd of his flock, for when he separated heaven and earth, he left the cow for the Maasai.

Cow and earth fused to form a sacred mystery – and sacred things should not be disturbed. The Maasai's distaste for agriculture therefore has deeply religious foundations. Ploughing a furrow is a piece of desecration and, strictly speaking, even digging wells is deemed a sacrilegious act. Things are different among the arch-enemies of the Maasai and the Turkana, the belligerent Pokot. They were arable farmers over the centuries, then lived as nomads for a time through force of circumstance, but now, for several generations, they have gone back to their roots – in both senses of the word.

As late as 1850, the Maasai inhabited a strip of land 1100 kilometres long from north to south and 300 kilometres wide – extending from Lake Turkana (formerly Lake Rudolf) in northern Kenya to what today is Manyara National Park in northern Tanzania. But their heyday was not to last for long. In 1889 a devastating cattle epidemic wiped out roughly 95 per cent of all the nomadic and wild herds in and around the present-day Serengeti National Park; the figures were hardly less dramatic in other savannah landscapes. A smallpox epidemic was raging at the same time, to which thousands of Maasai fell victim.

As the tribes were gradually recovering in the early 20th century, the settlers' advance began – illegally, semi-legally and ostensibly legally. Whatever the case, it was remorseless and unstoppable. In 1926 the British

colonial rulers set up Maasai reserves in what is modern-day Kenya, which at least prevented the herdsmen from having their land taken from them. Africa's native populations fell victim to the same "broken treaties" as the Native Americans, with little heed of their rights being paid by the white settlers.

Ultimately it was two well-meaning movements that brought the nomadic culture to its knees. First, the herdsmen started to be excluded from the game and nature reserves in the 1950s; this became all the more inexorable as national park tourism became the chief source of foreign currency in Kenya and Tanzania. Even at the time, objections were raised: hadn't the Maasai cattle co-existed harmoniously with the wild herds for long periods of time? But something else played a crucial role: the paying tourist wanted and continues to want to see pure wilderness. A cow is no substitute for a koodoo.

The second blow was the socialist-inspired "Ujama" (community) policy practised by the Tanzanian president Julius Nyerere from 1967 – as proclaimed in the famous "Arusha Declaration". Essentially Nyerere, who was a statesman of integrity, wanted to turn tribes, some of which were hostile to each other, into a state populace, and for him this quite naturally entailed settling nomads, for whom there were no national boundaries. Roaming tribes were to become settled arable farmers. In the end they were left with only one choice: dig the land or dig your own grave. The benefit proclaimed over and above the human disaster was: national unity, modern agriculture or, quite simply, progress.

Few voices were raised in protest; when it wanted to set up "progressive" agri-farms and food corporations on former grazing land, it was easy for the Tanzanian central government to exploit existing prejudices, namely, that settled peoples – the world over, incidentally – consider a nomadic existence to be inferior and regressive.

But anyone who was still unwilling to be forced to his knees – or into a ploughed furrow – was caught up in a vicious circle: milk yields diminished rapidly on poor pasture and with no rights to watering holes. The Maasai and Samburu built up their cattle stocks; more and more cattle, sheep and goats, penned in on a ruinously small area, gradually destroyed the grass pastures. At the end of a battle that was lost from the outset, the Kenyan Maasai (the Tanzanian Maasai fared better) had no choice but to move into the slums of the medium-sized and large towns, only to be confronted there with hunger and poverty, which led to petty crime and prostitution. Some did manage to take off into the 21st century and brought off a soft landing. There are even a few prosperous and wealthy Maasai in Nairobi and elsewhere.

Some of them also managed to escape into the niche existence of the postcard Maasai. They turn up on the main tourist routes selling jewellery and "Maasai masks", for example, which relate to their traditional culture in roughly the same way as sombreros do to turbans. This "airport art", souvenirs such as the handy miniature spears and sleeping stools that fit so well into one's luggage, is usually made by the Rendille, who are skilled craftsmen.

"Why be so cynical?", Klaus admonishes me. "Of course the tourists are offered trinkets … But all this staged folklore works very well as a distraction. Ninety per cent of the tourists are satisfied with it,

which prevents the masses from penetrating the few areas where the Maasai have retreated and really can be Maasai."

I nod and feel a bit caught out. But as a tourist to Africa I would rather not be caught out, falling into every clichéd trap.

"So what really has survived of the nomadic culture if you leave out the airport art and Kodachrome dances?"

Klaus thinks for a while, and then goes on to explain: "I think the Maasai and Samburu are defined in three ways: by the Maa language, which is not yet threatened with immediate extinction. Then by the all-defining centre of their lives, the herd – it's well known that things are crumbling away there, and a culture can't survive without its heart. Thirdly we shouldn't forget the age-set system; it's more important than any family ties or clan membership."

Maasai youths of the same age who go through the circumcision ritual together remain a close-knit group for life, like in a kind of brotherhood. They become mature warriors (*murran*) together, first junior warriors, then senior warriors, then finally junior elders and senior elders, and only then junior members of the eldest group, and possibly the highly esteemed senior eldest group. Members of the brotherhood are committed to mutual assistance. If a *murran* loses his animals, there are almost no circumstances under which a fellow *murran* can refuse to help him form a new herd.

Young men qualify as *murran* by undergoing numerous trials of courage and stamina. Formerly, before the days of the national parks, for example, by hunting lions – less for the meat than to protect their herds – and by undergoing an endurance test. But the greatest bonding occurs during the long, isolated, meagre bachelor life in a remote *manyatta*, where the new generation learns traditions, songs, dances and fighting skills.

The term "fighting skills" brings us to a few aspects of tribal life that do not particularly appeal to us seekers of harmony in today's savannahs. Belligerent attacks, cattle theft, bloody competition for the greenest pastures were and are by no means simply the bad legacy of colonial breakdown. Wresting something away from a neighbouring group, stealing their cattle or – if you had been on the receiving end – avenging such attacks, was seen as sound proof of your own adequacy and improved your standing within the community.

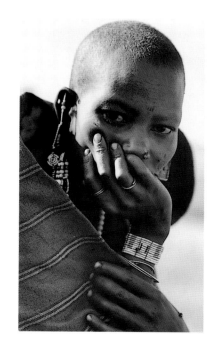

In the case of the Pokot, who enforce a strict policy of preserving the peace within the community, warriors are simply considered inadequate if they haven't killed at least one enemy. The notion of the "killer" is thus an ideal among the Pokot. At the same time he is the legitimate, authoritative protector of pregnant women, providing a link between birth and death, a frequently recurring theme among tribal societies.

As long as the few instances of ritually prescribed killing of individual savannah neighbours was done laboriously by hand – with spear, arrow, knife or axe – it may have been terrible, but it was never catastrophic.

Yet it became that with the introduction of modern firearms. Kenya's ex-president Daniel Arup Moi and his lackeys had them distributed to the Pokot so that they could slaughter their traditional rivals, the Samburu and the Turkana, whose cattle could then fill Nairobi's cold-stores – a nice little present for the electorate.

The people of Kenya, who in 2002, after twenty-four years of the ruthless Moi dictatorship, looked with horror into his torture-chambers and prisons, must still face daily state and state-tolerated terror in the savannahs. One wonders whether the survivors will suffer the same fate as those European nomads, the gypsies? Their tragic fate as victims in German concentration camps scarcely impinged on public awareness for years. To settled people, its seems that it is somehow the nomads' own fault.

Cain, the tiller of the earth, killed God's favourite, Abel, the keeper of sheep. Abel is the good man, but Cain is superior, for he survived. And that counts for more than a bit of fratricide.

Things like that stick in my throat: "Haven't you noticed", I ask Klaus, "that you can't talk about the nomads of the great savannahs for long without getting round to expulsion, killing or even genocide? Or at least without bringing up the perennial conflict between pastoral farming and the national parks?"

Klaus nodded in agreement: "At least if you're going to be honest you come round to these subjects … inevitably, but …" (… can there still be a but? I ask myself) "… you have to understand that the national parks are the top foreign currency earners in Kenya and Tanzania. Protecting those huge areas is an enormous achievement, even if you allow for the injustice done to the nomads, so don't dismiss it out of hand."

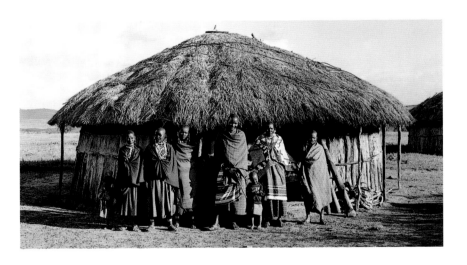

Let's take one corner of Africa's savannah landscape, *one* vast area, and let it stand for the whole, well aware that the problem areas are different in every park and reserve. Nothing suggests itself more readily than the Serengeti National Park and the Maasai Mara Reserve.

There is one obvious reason why – as the person who saved it from destruction, Professor Bernhard Grzimek, states in the title of his 1959 book – "the Serengeti should not be allowed to die": its breathtaking beauty – and, one could go on to say, its unique character, its status as part of the human heritage, its wealth of mag-

nificent creatures, its breathtaking size. Here the world's largest migration of mammals takes place; the gnu, Serengeti's emblematic animal, migrates several hundred kilometres from the dry south to the wetter northern tip, in the Maasai Mara Reserve on the Kenyan side. Today there are six times more than the 150,000 Grzimek senior and junior counted, or rather estimated, in the 1950s. The Frankfurt Zoological Society can take a great deal of the credit for this success. As the intellectual and practical successor of its founder, Bernhard Grzimek, it ensured that the peripheries of the reserves were protected, providing inoculations for the herds of domestic animals (domestic *and* wild herds are susceptible to cattle plague) and initiated development projects for those living near the parks.

Tanzania's minister of natural resources and tourism, Zakhia Maghij, praises the newly conceived work in the Wildlife Management Areas (WMA) as a "pioneering new phase in Tanzanian wildlife management". Some controlled hunting is actually permitted on the park borders – a measure intended to foil poachers.

"Poaching. That's such a handy, European word – one term that simultaneously stands for case, charge and judgement", says Klaus.

"Meaning …?"

"I mean, starving people scrape out trenches as traps or set snares … people who see mountains of flesh available in their neighbourhood, while their children are crying with hunger beside them …"

At the time of writing, there are still about 40,000 animals poached annually in the Serengeti (meaning "endless expanse" in the Maasai language); gamekeepers confiscate about 15,000 snares a year. Wandering herds of gnu can easily stand to lose a few members, but buffaloes and giraffes have already become very rare in some areas.

The Swiss biologist Markus Borner is hoping to see changes occur as a result of the planned award of land ownership rights to people living immediately adjacent to the park. Borner co-ordinates work in and around the park for "Frankfurt" – this is what Tanzania's state nature and resources conservationists call their most important benefactor. In the early stages, he and other white experts were met with some scepticism in the settlements near the park, for the "nature conservationists" – at least as perceived by the herd owners – were the people who had taken their grazing land away from them. And now they were suddenly trying to make out they were on their side. Borner: "Now people are applying to the ministry for their own, locally administered conservation areas around the Serengeti. The FZS is currently involved in staking out these border areas and helping village communities draw up zoning plans."

Some 90,000 tourists a year flood the Serengeti National Park, whose 14,763 square metres make up one sixty-fourth of Tanzania's total area. An estimated six million hooves pound the earth there, including those of 200,000 zebras and 300,000 Thomson's gazelles. The world nature conservation community sees the Serengeti as one of its very few success stories. And so do the scientists: there is no other geographical area as large as this in the world where animal populations have been so meticulously counted and keenly observed. Some five hundred bird species attract ornithologists and birdwatchers from all over the world like hummingbirds to nectar; they are prepared to ignore even the unbeatable "big five" – elephant, lion, Cape buffalo, leopard and rhinoceros – in favour of ibis and marabou, drongo and various species of eagle.

This could in fact be a more or less happy ending to our observations: Carlo Mari's Africa fits in well with the vision of Africa of the much-loved Frankfurt TV zoologist who won a whole generation over to the Serengeti. The gnus' backs still ripple, zebras gallop, elephants wave their trunks, giraffes splay their legs at watering holes, crocodiles lurk, cheetahs sprint, vultures hover, lions yawn. Paradise has not gone to the dogs.

But it could be on its way there, or at least that route could be approved. Kenya is obviously toying very seriously with the idea of diverting the Mara River into the northern tip of the Serengeti/Maasai Mara ecosystem. If this is done, it will no longer deliver the water it collects from an area of 10,000 square kilometres into Lake Victoria; instead it will flow through outlandishly expensive tunnels and diversion systems into the great dry regions south of Nairobi, where it is to irrigate fields, drive turbines and finally end up in Lake Natron.

Here is some of the minor collateral damage that would be done if this madness were to become a reality: the famous Tanzanian Lake Natron, whose northern tip touches the Kenyan border, would suddenly be flooded with fresh water; this unique ecosystem, famous worldwide for its clouds of pink flamingos, would be watered down.

The Serengeti gnu would not survive the loss of its final destination on its life-saving thirst marches. The Mara is its last refuge, especially in dry years. If things really get serious and there is a long dry spell, a FZS-financed study predicts that the large gnu herds would shrink to a fifth of their present size – and without any chance of recovery. The imminent drought in Africa, a consequence of global warming, would prevent the large herds from recovering naturally. Without a healthy gnu population, the savannah's efficient lawnmowers, the ecosystem would collapse irrevocably. We should start putting the most famous war-cry of recent nature conservation history into practice again: "the Serengeti should not be allowed to die".

"What do you feel when you look at these photographs?"

"Homesick", says Klaus. And, after putting Carlo Mari's images down, he adds: "I want to beat the big drum for Africa again!"

Homesick, says Klaus. I can't get that word out of my head, especially because in the case of equatorial Africa, wanderlust would seem to be more appropriate. Everyone who has seen the firmament here talks differently about the sky – they believe this world has a meaning of its own; they do not want to give up heaven on earth. A heaven with eternal life – not without death – but with rebirth from dust, grass and water.

As a modern-day nomad, you decide to revisit a good hotel, a pleasant beach, a lively city. Then you forget about it. You do not forget the savannah. You leave it without turning your back on it. It stays with you. There must be something in the idea that the savannah has left an indelible mark on our subconscious, from our earliest days of walking the earth.

Anyone who has ever witnessed the majestic dignity of an old elephant, anyone who has heard the thunder of a galloping herd of gnu or has simply felt the breeze rushing through the grass of the savannahs becomes a prisoner of this freedom.

Magnificent things – however threatened they may be – win hearts over with their magnificence. And the people who defend Africa tooth and nail live on this hope. And so do artists like Carlo Mari, who provide us with unforgettable pictures: pictures of people, pictures of animals, pictures of souls.

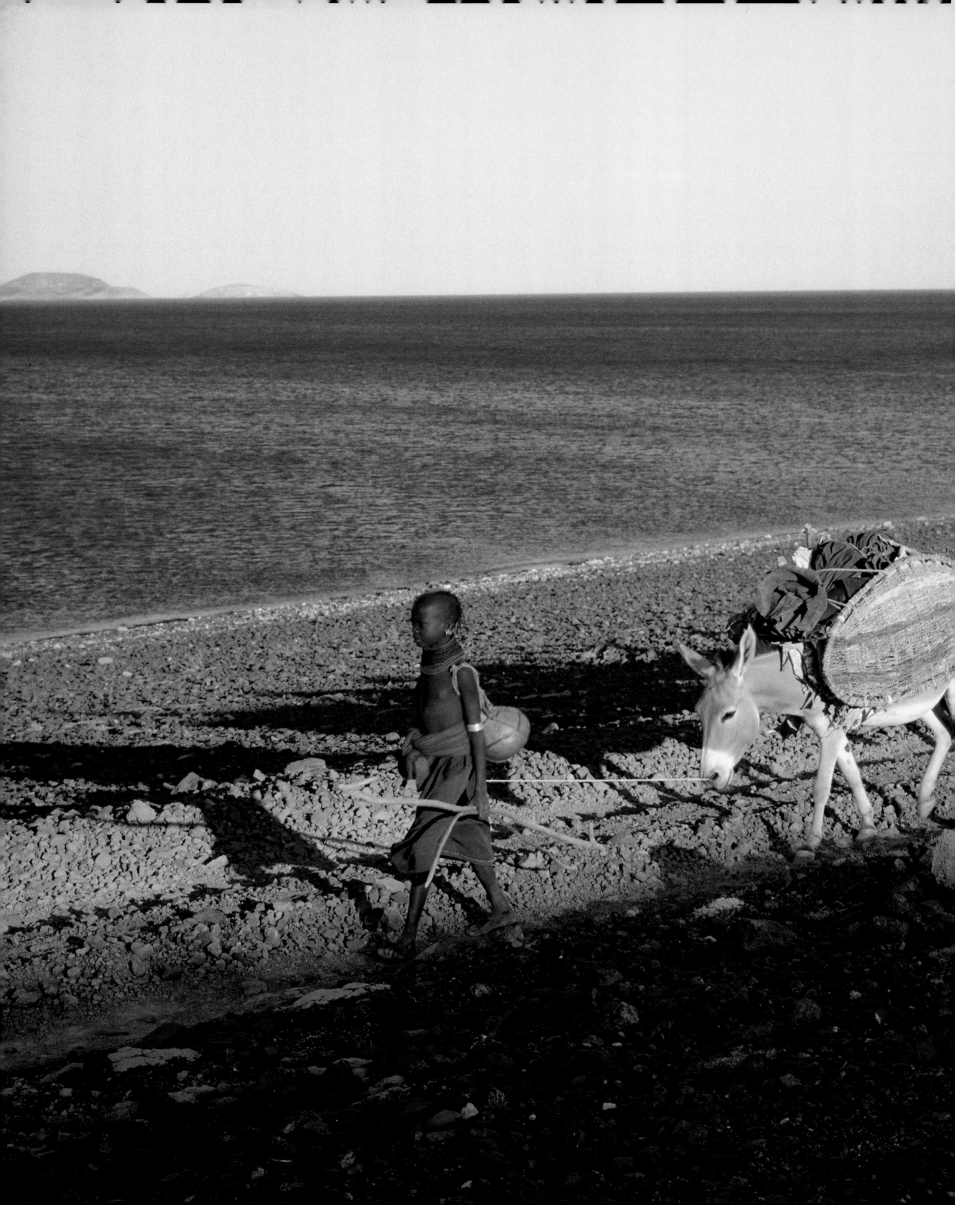

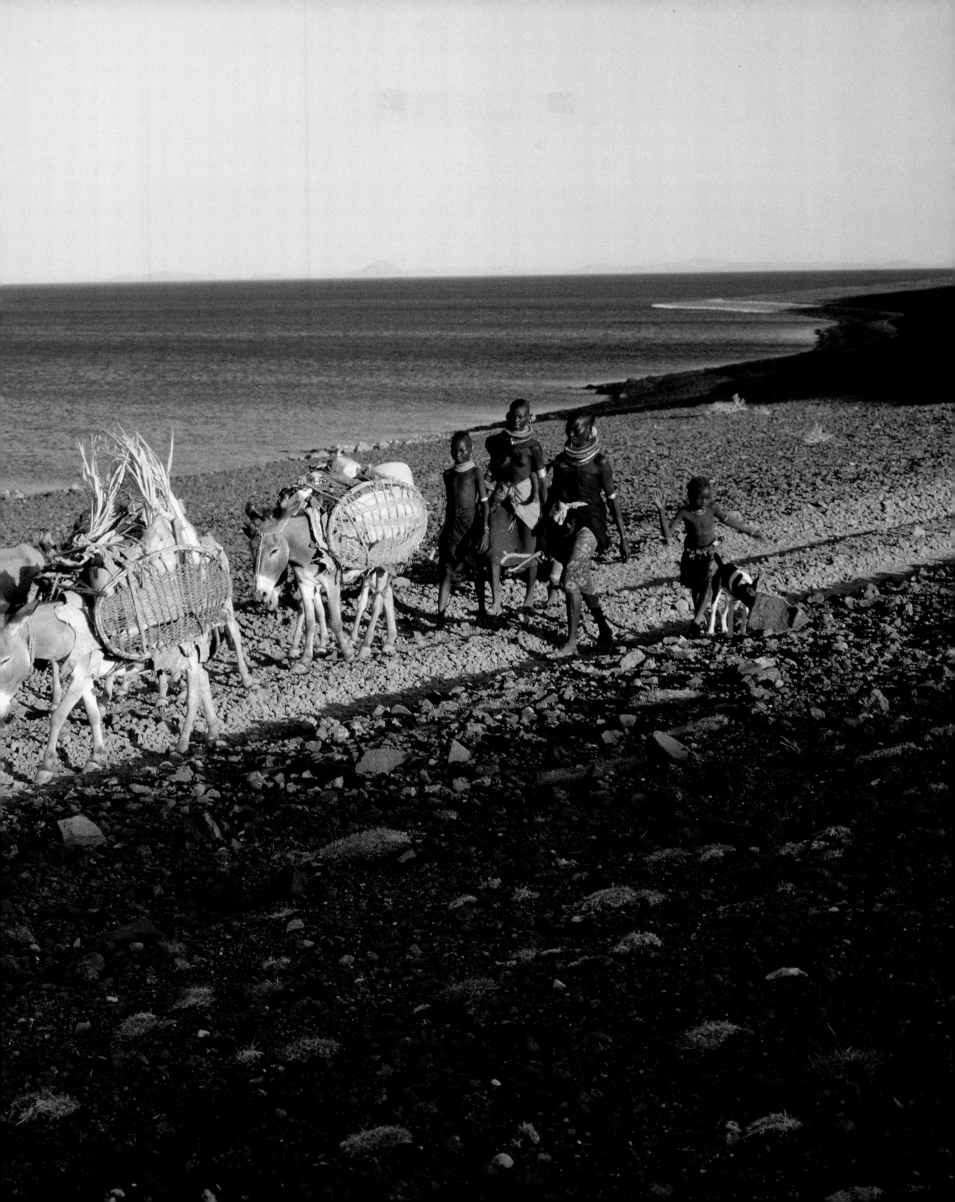

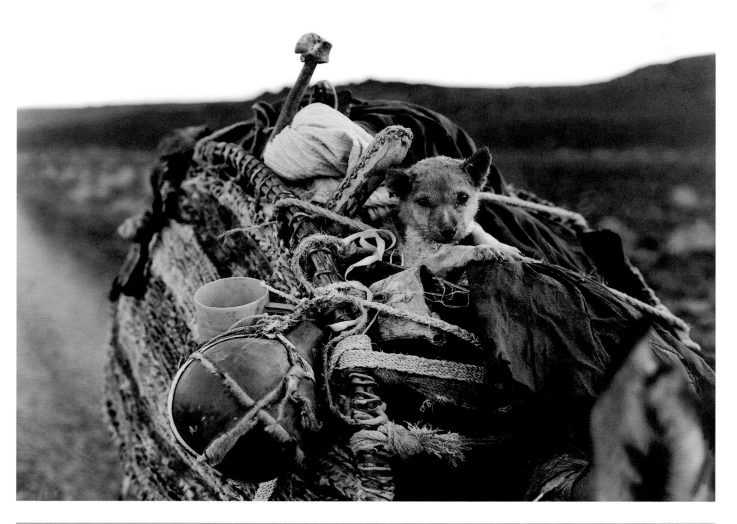
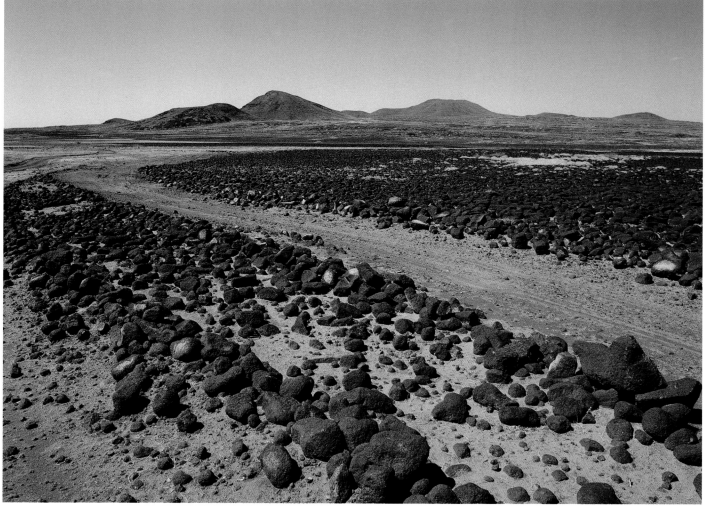

EL MOLO

Like other ethnic groups in the East African savannahs, the El Molo have Cushitic ancestors who left the Ethiopian-Somalian area a few centuries ago. Shortly after they had settled on the eastern shore of the 180-km-long Lake Turkana, they fell victim to belligerent neighbours. The few survivors fled to small islands in the lake. The name "Island of No Return" is a reminder of the suffering and struggle for survival of this smallest of Kenya's ethnic groups; the island is opposite the present El Molo settlement area on the south-eastern shore.

The El Molo inhabit a hot, inhospitable terrain with only 50–60 mm of precipitation a year, if it rains at all. Drinking water is the greatest problem for this lakeside people, as the fluoride content in the water is seven times higher than the figure recommended by the World Health Organization (WHO). The lake water, to which there is no alternative, makes bones brittle. Half of this small community suffers from tooth disease, bone changes, deformities and fractures. European aid organizations are working to provide safe drinking water and to initiate planting projects.

Fish is the principal food; plant fare consists almost exclusively of berries and the fruit of the doom-palm. This fan-palm species is essential for the El Molo: they make garments from its fibre, and also nets and traps for catching fish; the women – they are the El Molo's house-builders – cover the round huts with their leaves. The frame is made of a large number of sticks bent to form a domed roof. Doom-palm trunks are tied together to make rafts on which these excellent and daring fishermen go off armed with harpoons to hunt crocodile and hippopotamus. Meat makes a welcome change from the daily monotony of Nile perch and tilapia. If the fish is not eaten fresh after the catch it is dried in the sun on raised racks.

The men, especially the older men, relax after the rigours of the day by playing *kalaha*, a game in which the only way to score points is by rapid and precise mental arithmetic. The wooden headrests, which occur all over East, Central and South Africa, are by no means as uncomfortable as they look; they enable one to rest in a relaxed way as the cervical vertebrae are well supported and people don't have to worry about harming their hair-dos, which are often very elaborate.

However hard everyday life may be, the El Molo have always faced it with dignity, that is, by wearing beautiful jewellery. Most of their many necklaces are made of glass beads (acquired from early traders from Venice, Bohemia and India); the bangles, formerly often made of copper wire, are plastic nowadays. As the El Molo have assimilated many characteristics of the Samburu into their own culture, they are becoming increasingly less distinct as an ethnic group.

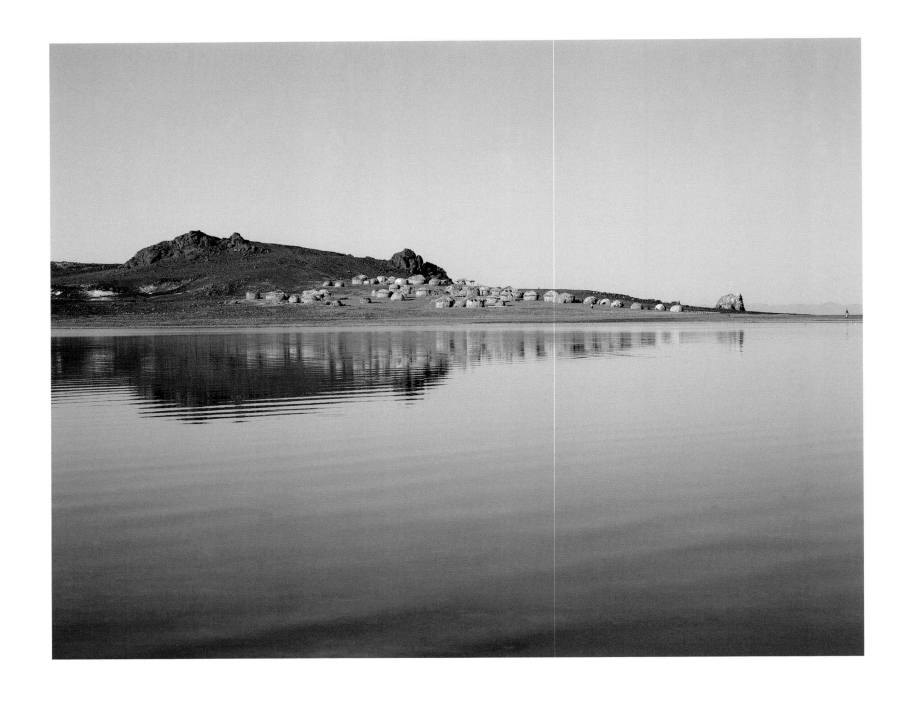

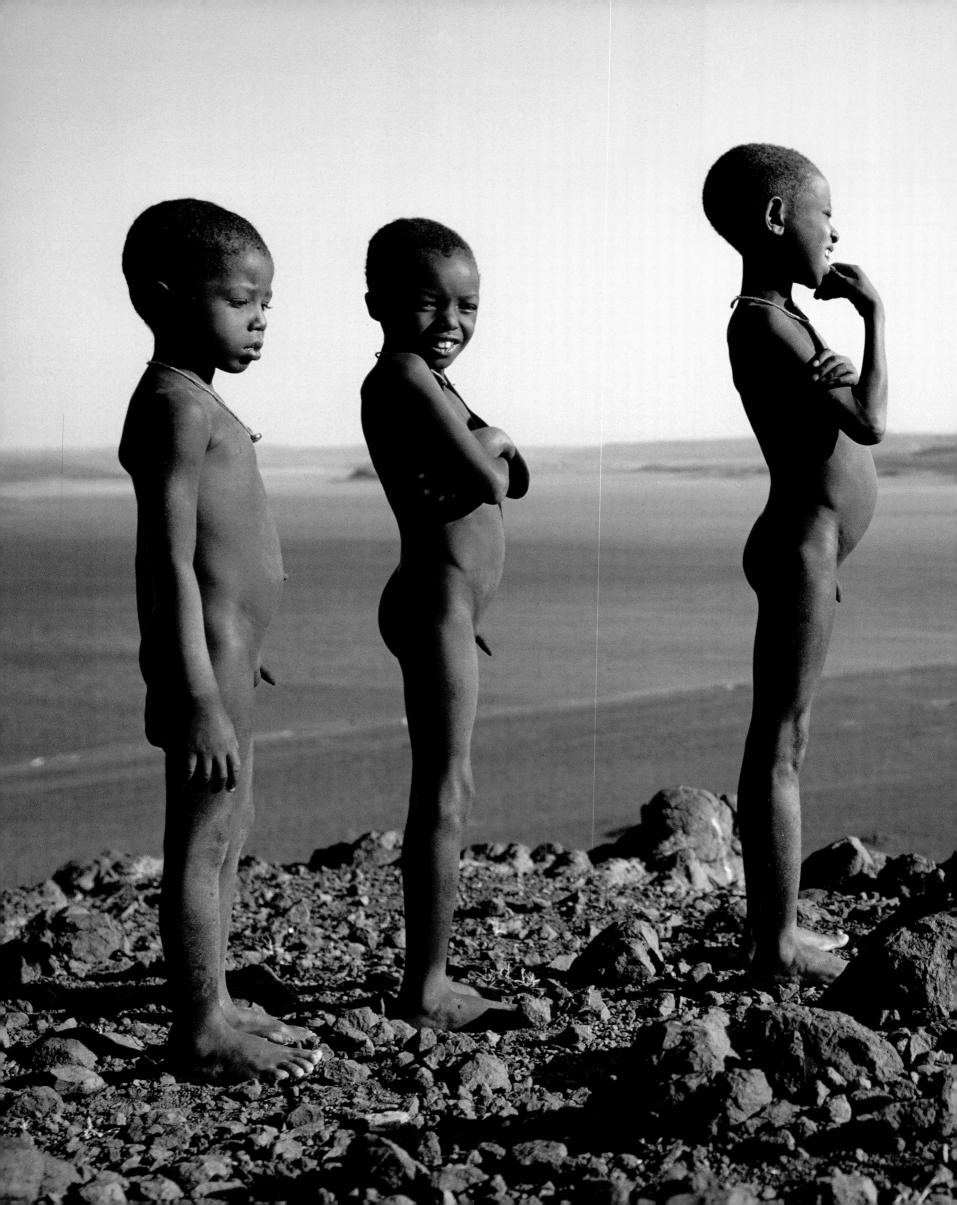

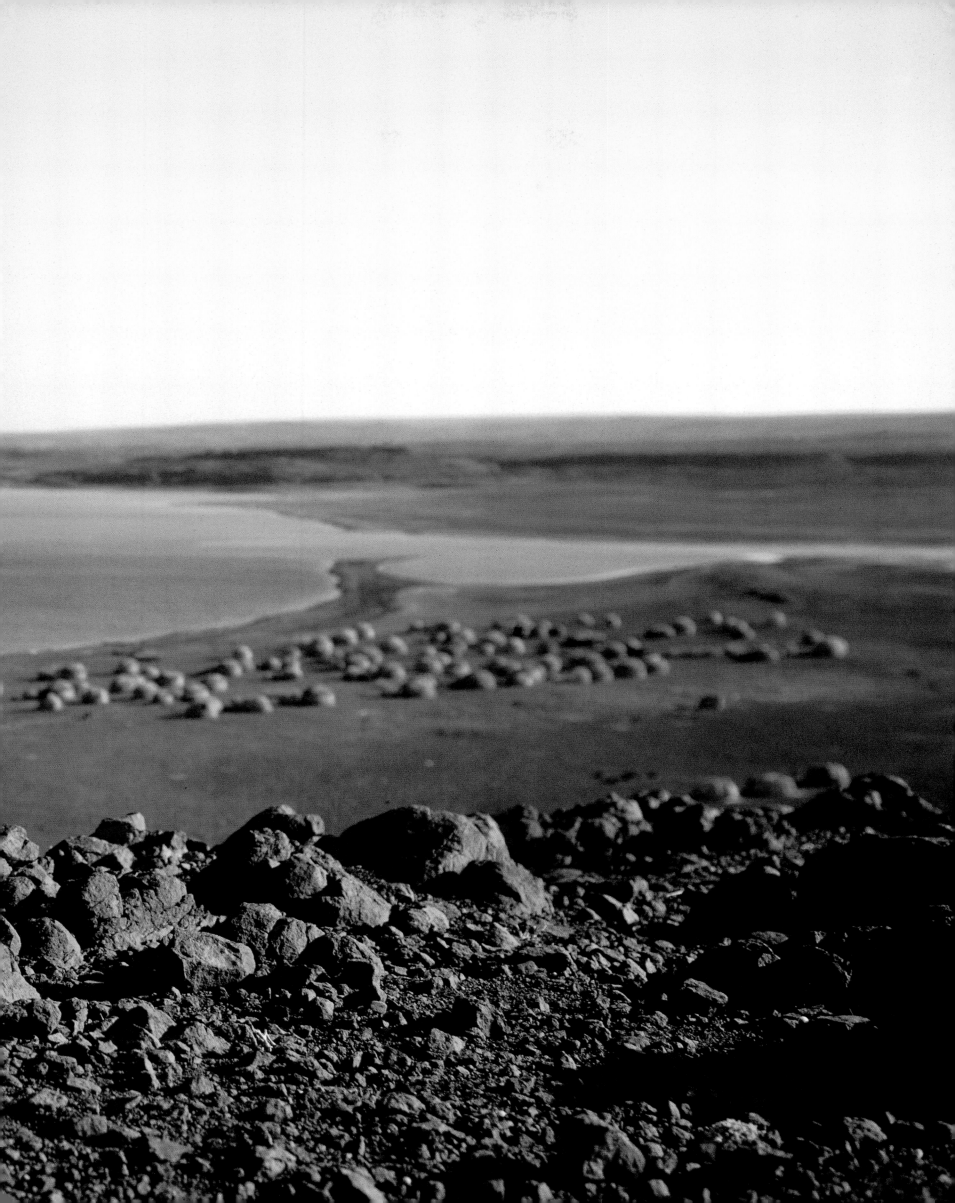

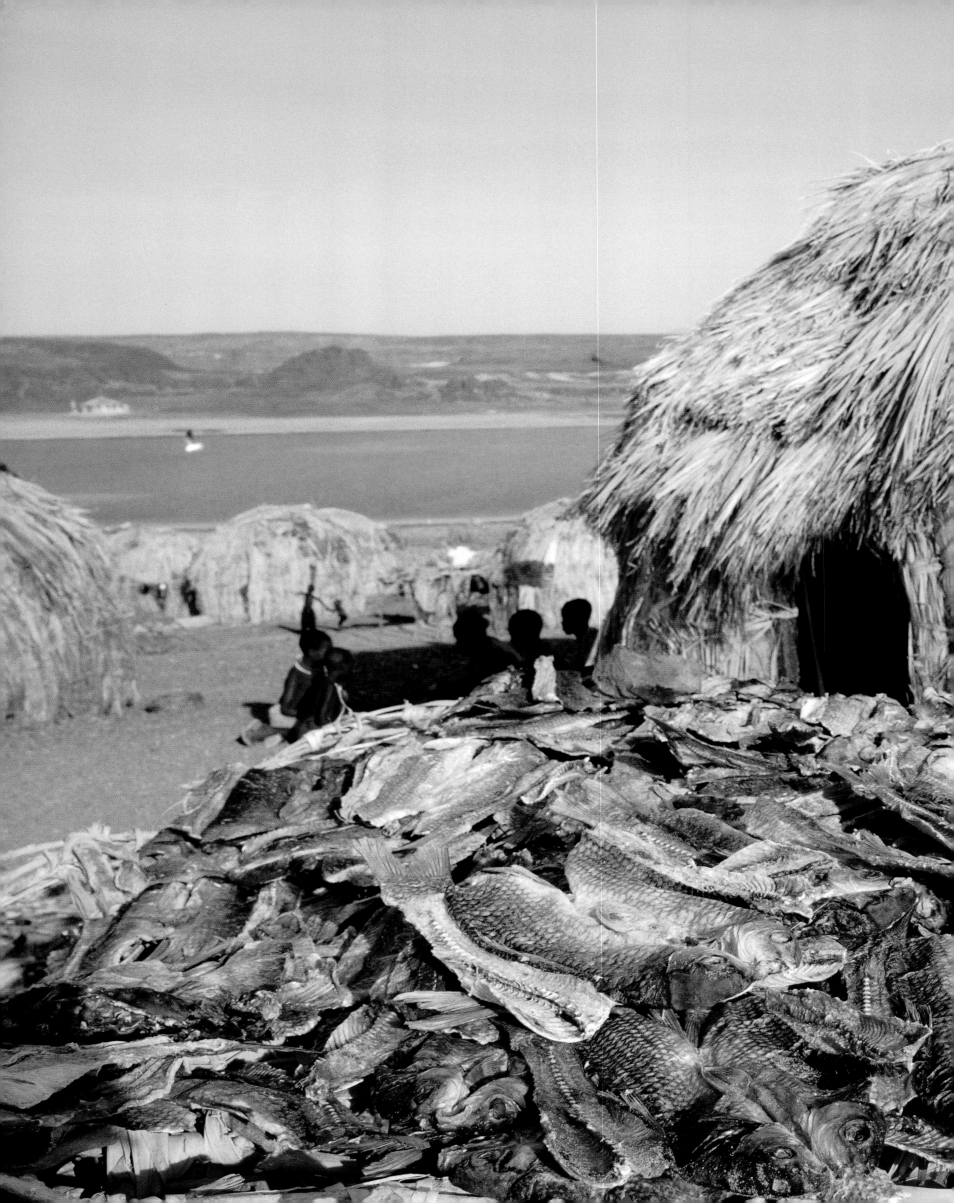

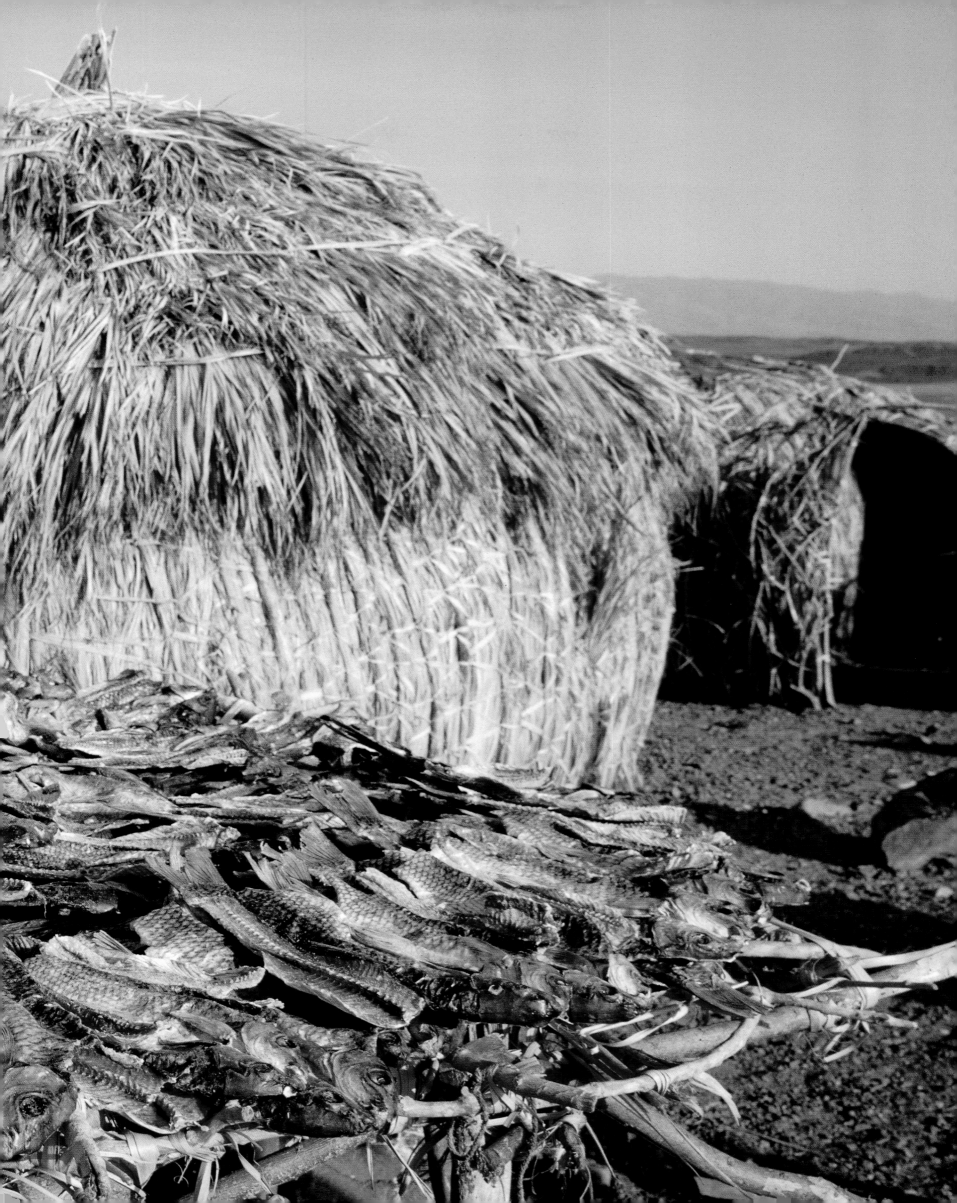

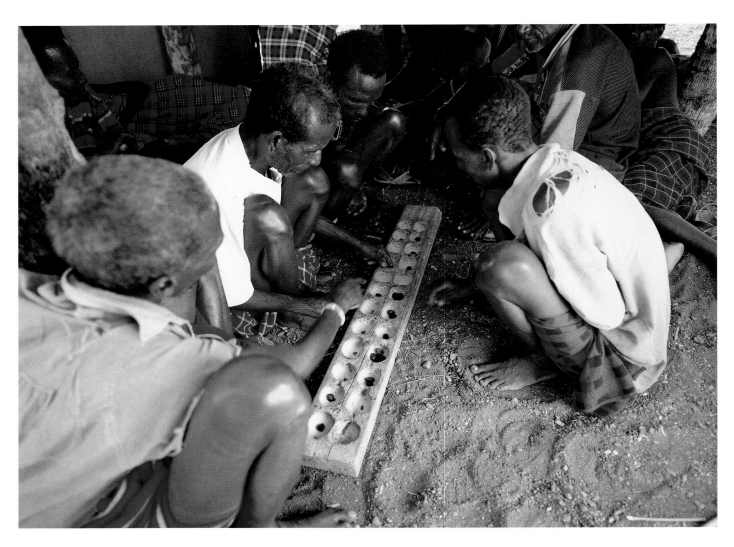

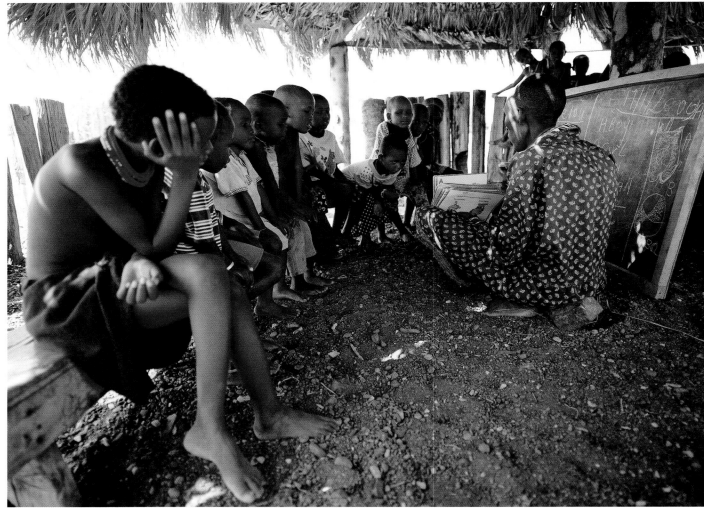

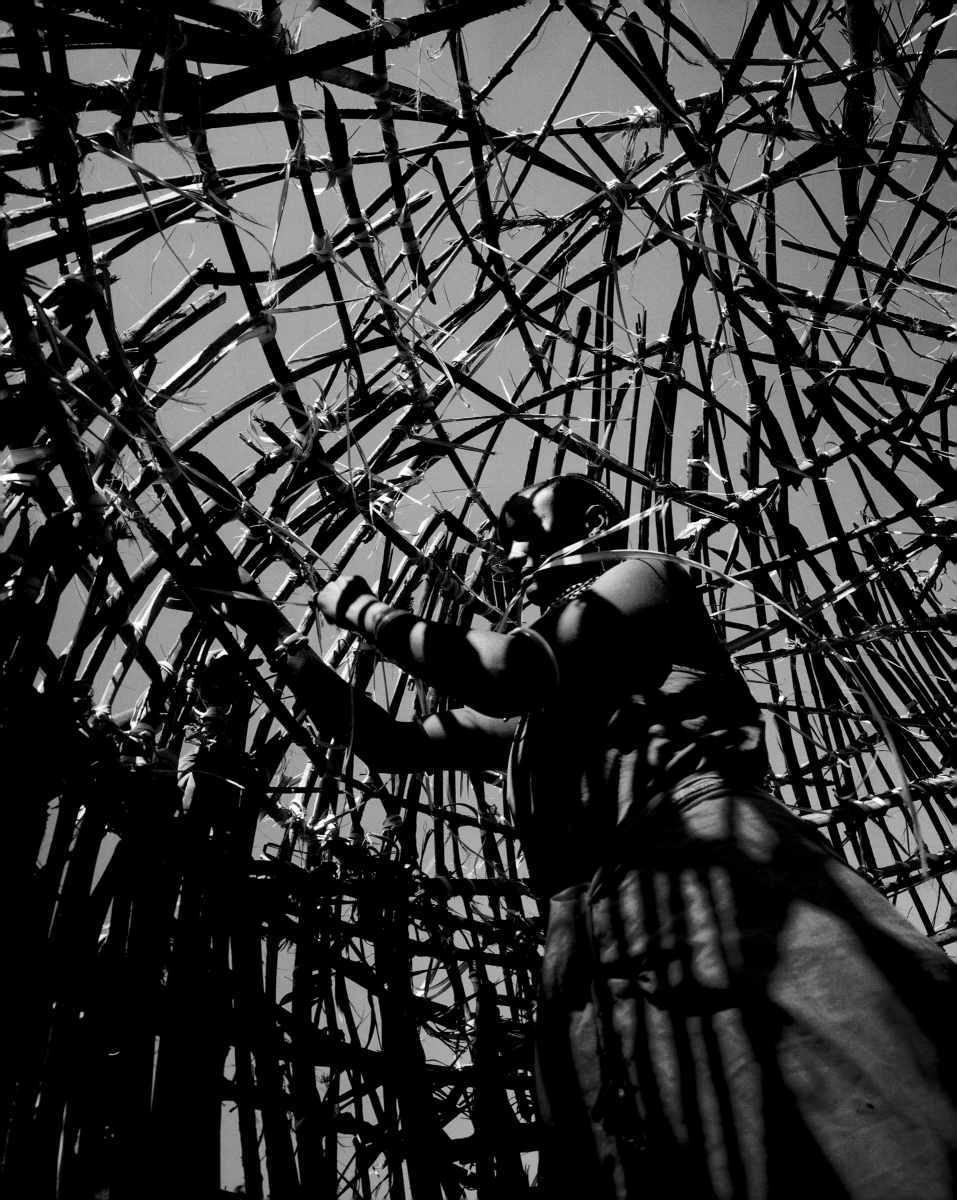

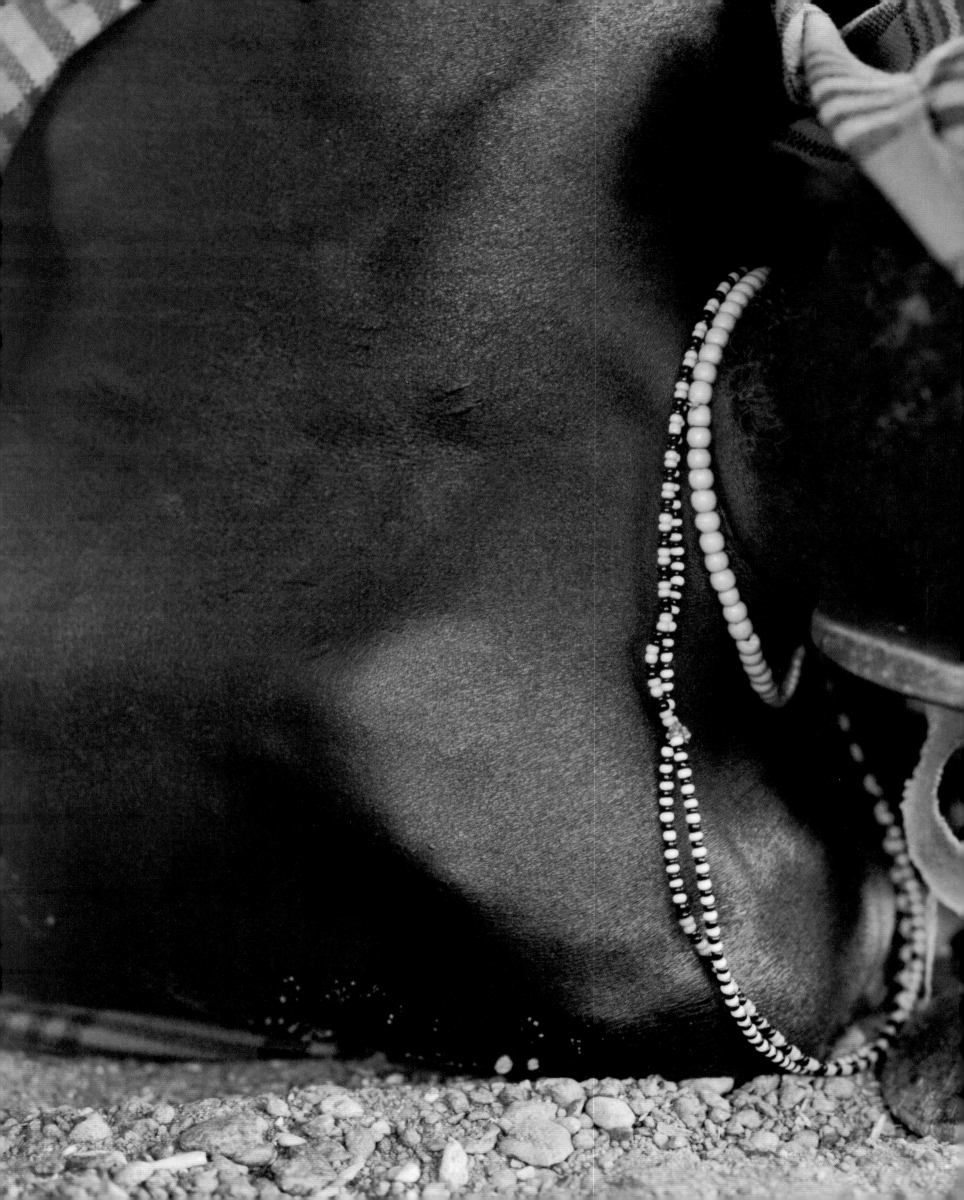

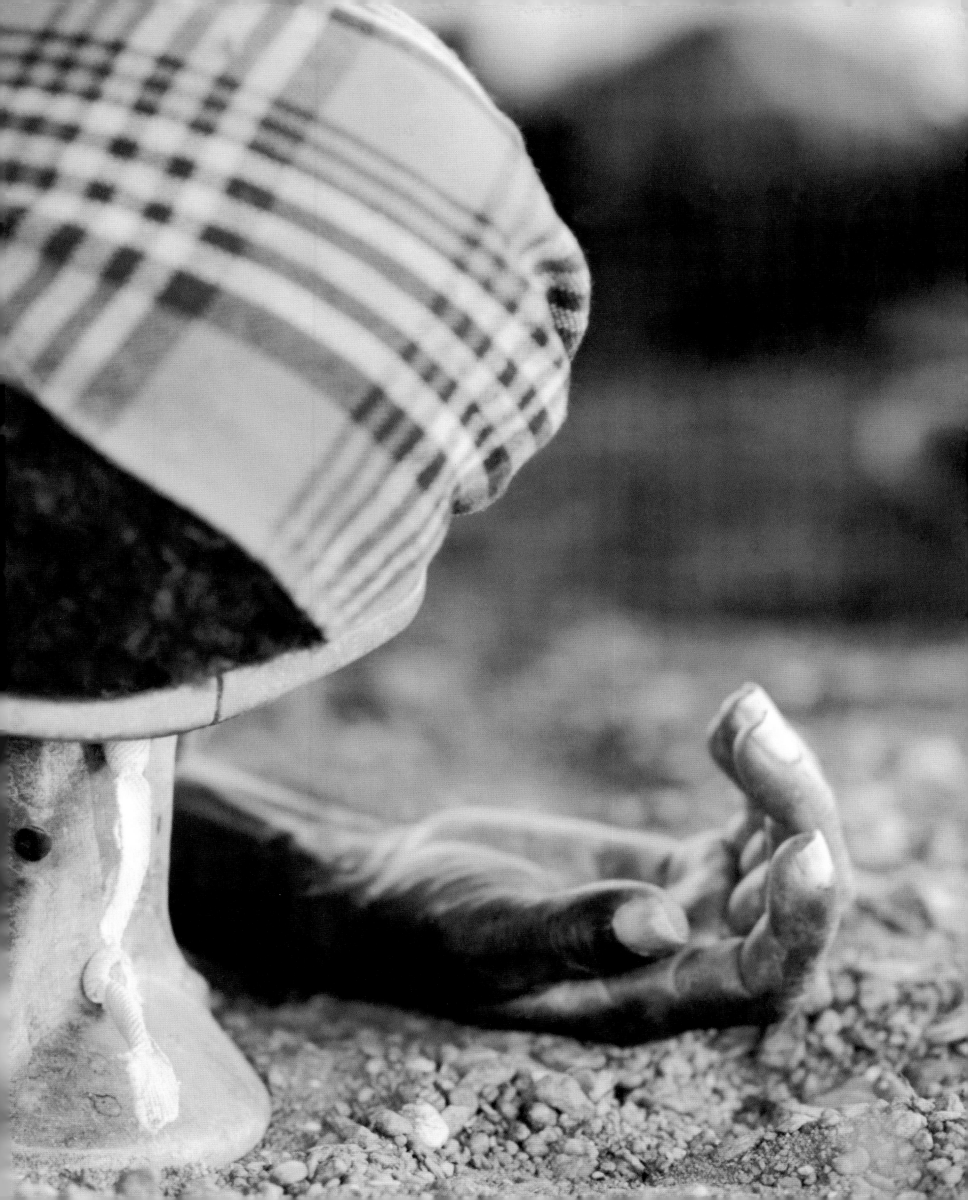

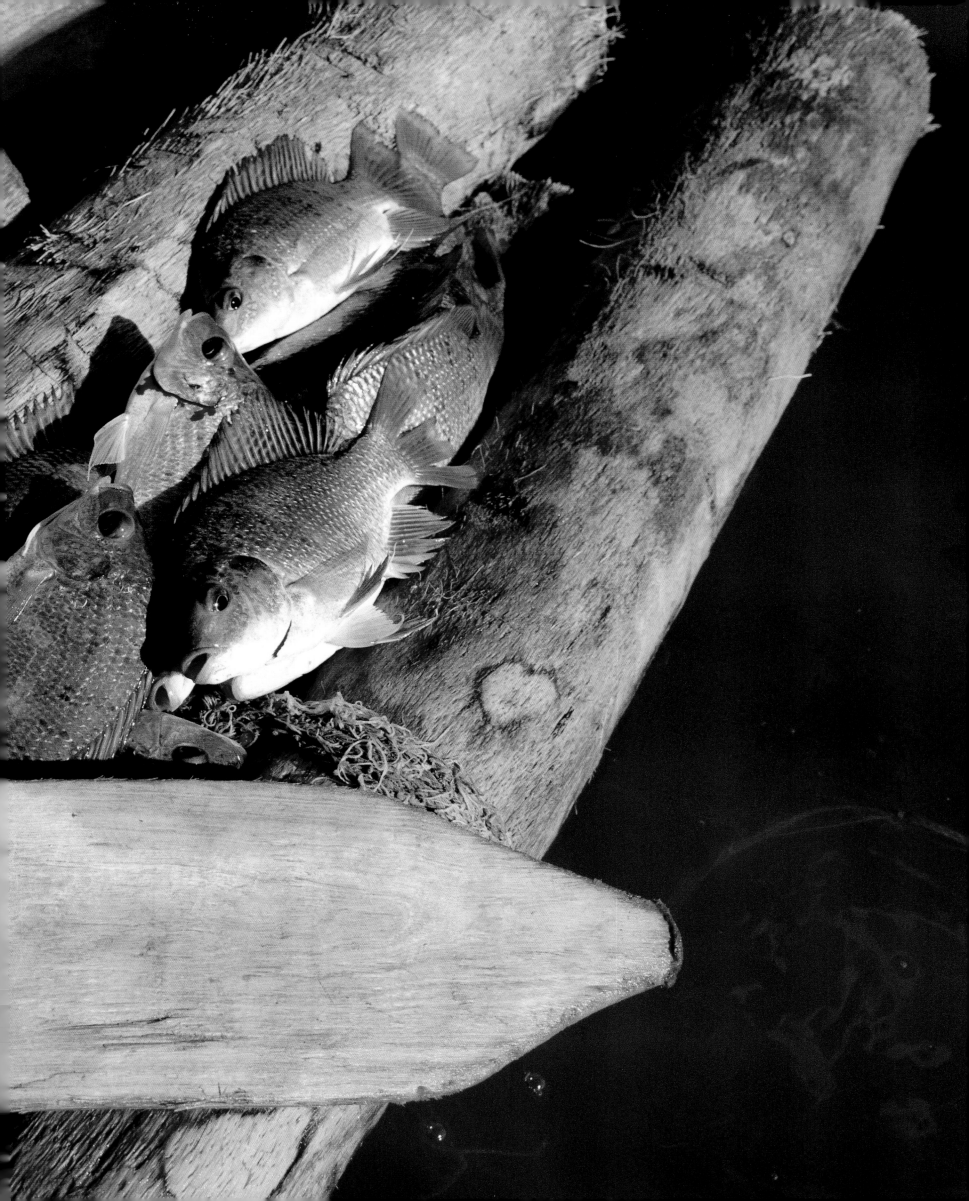

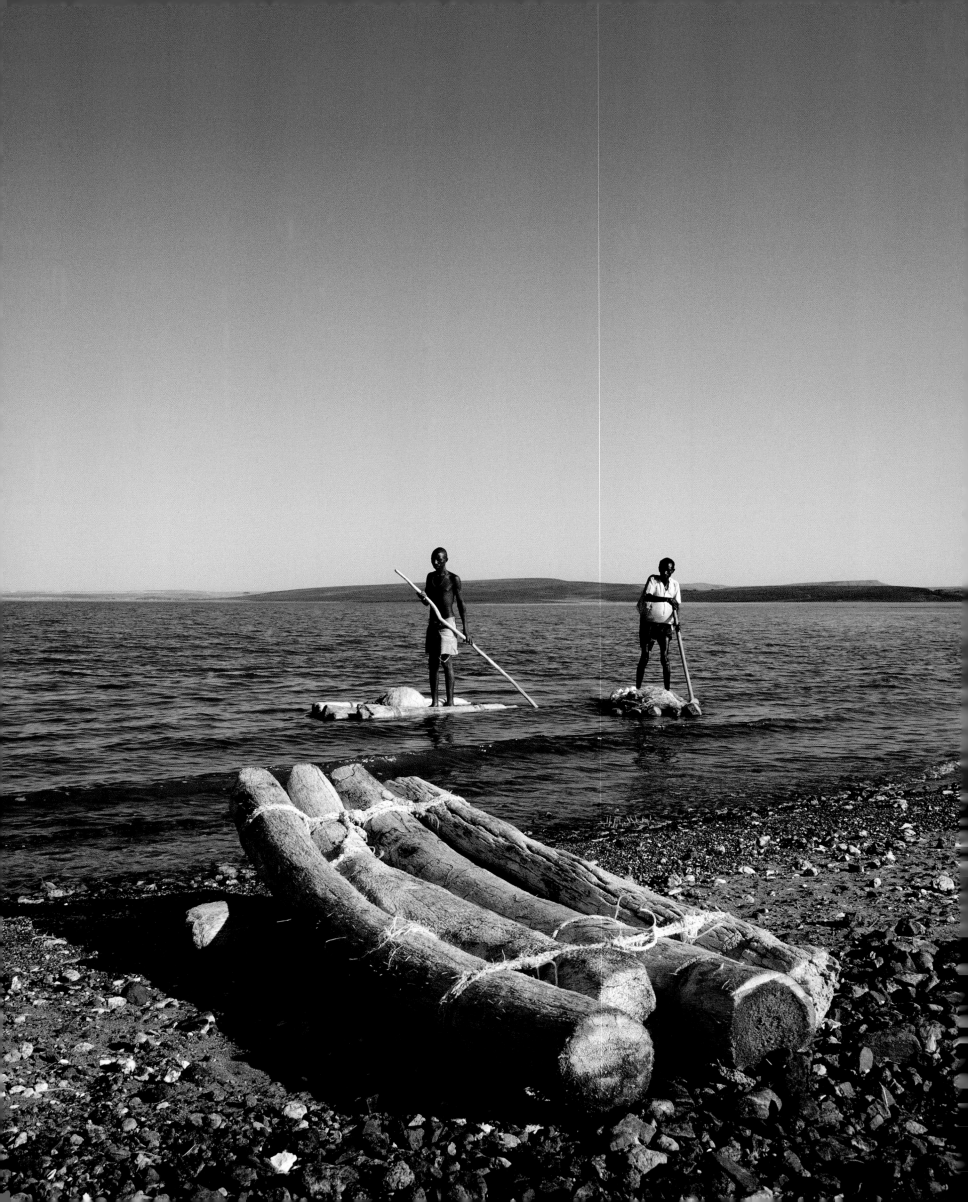

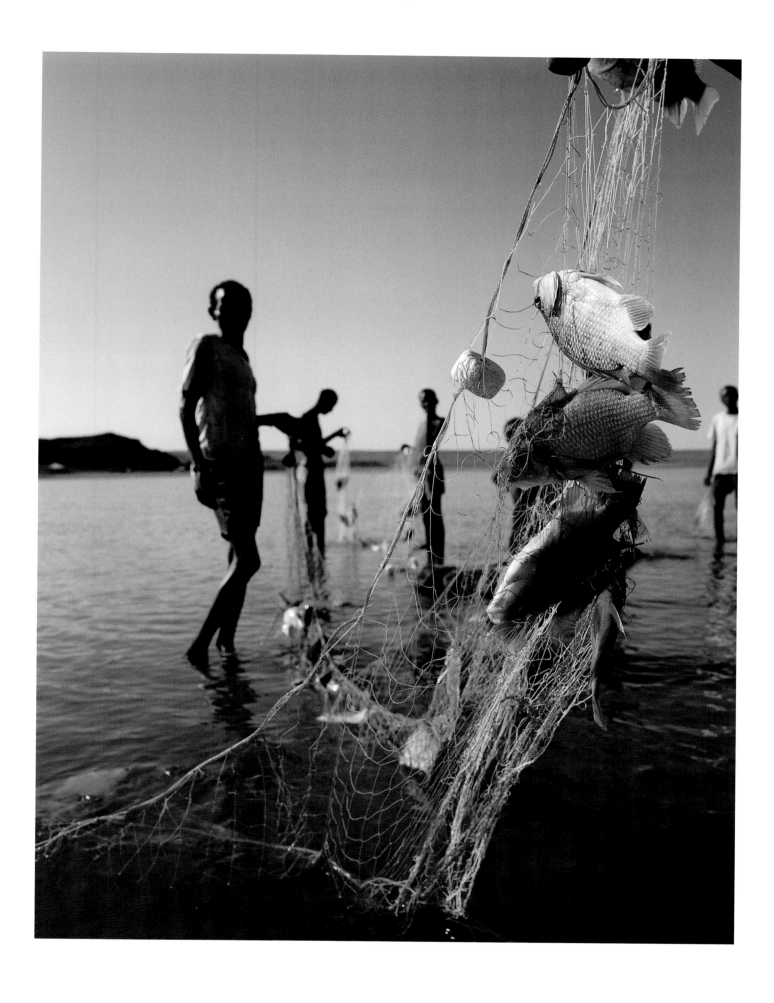

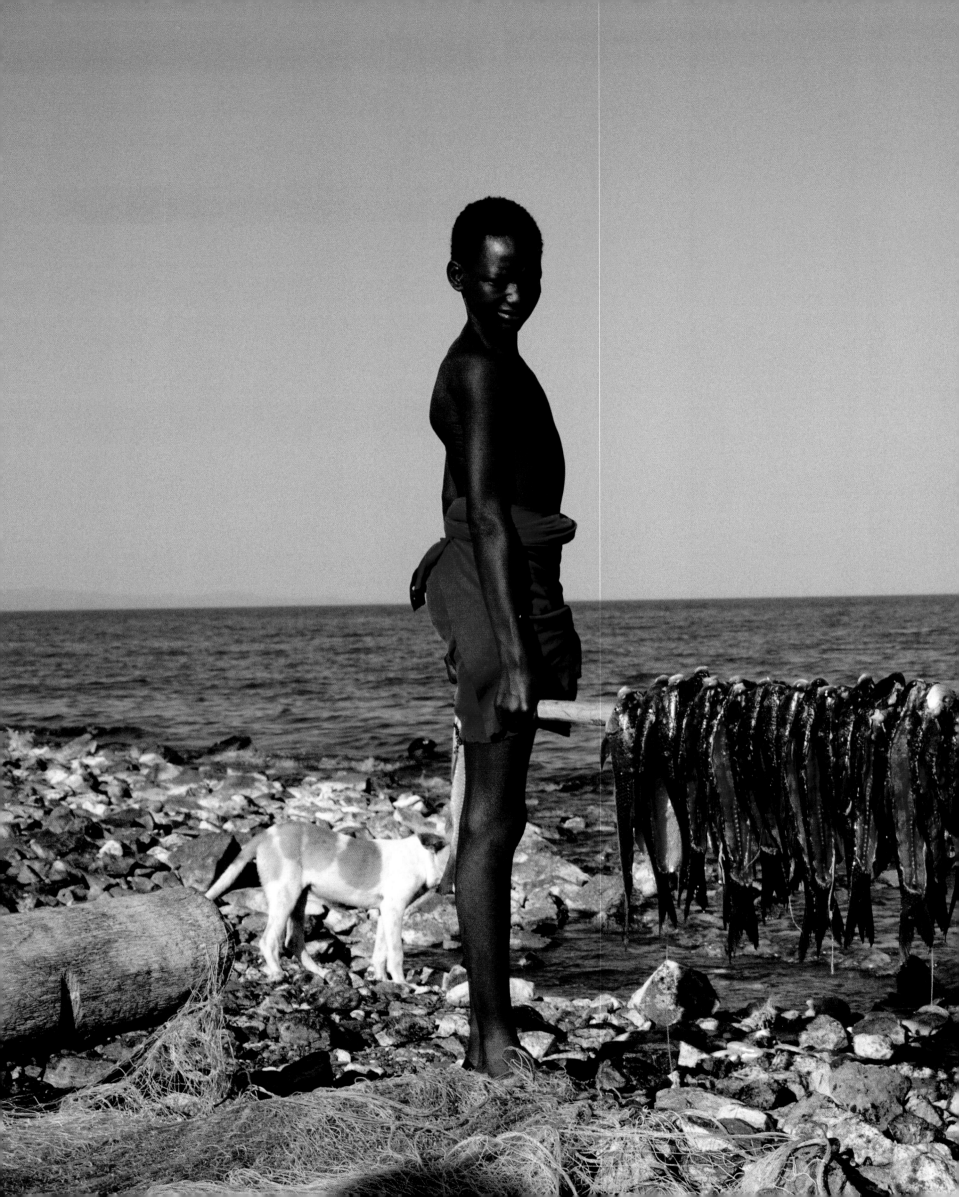

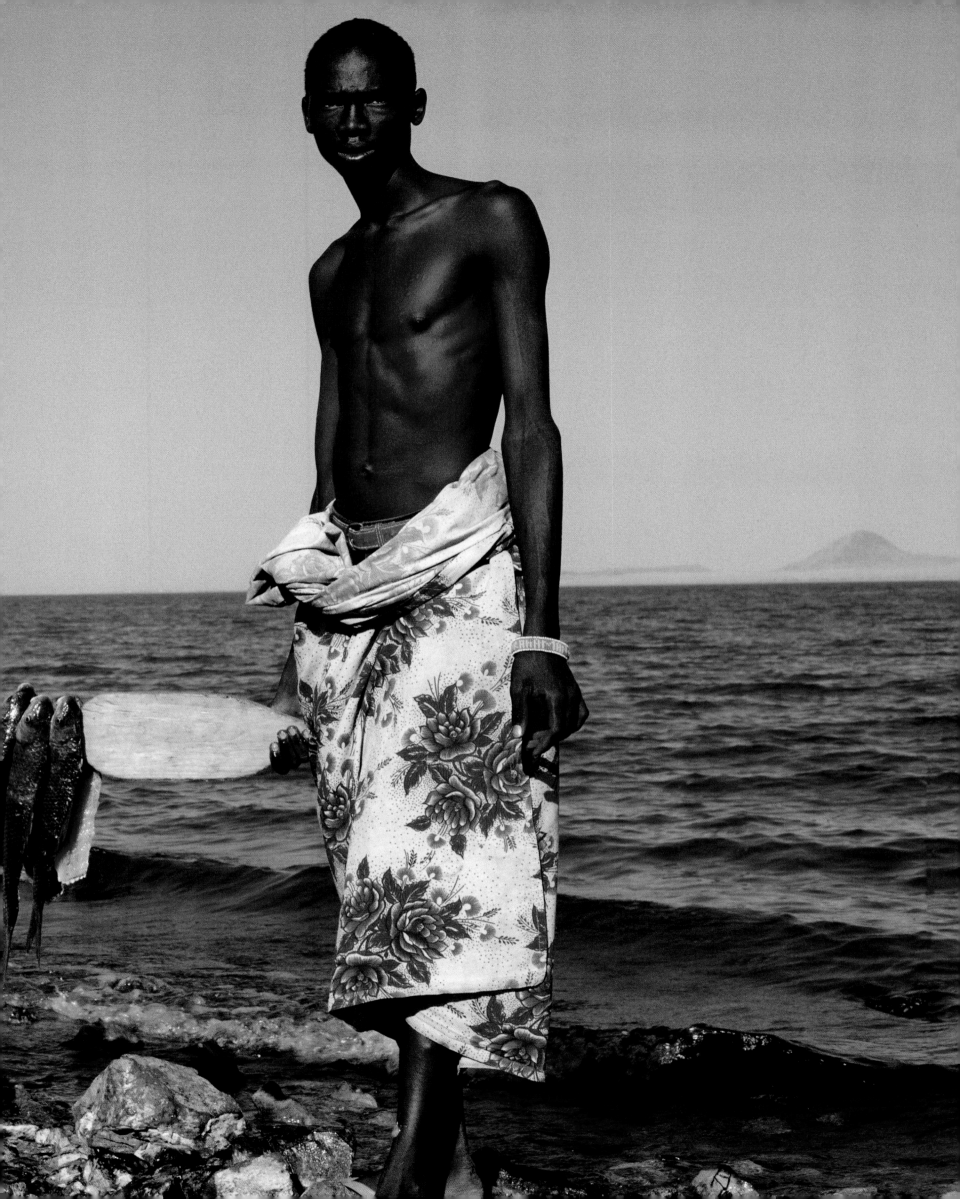

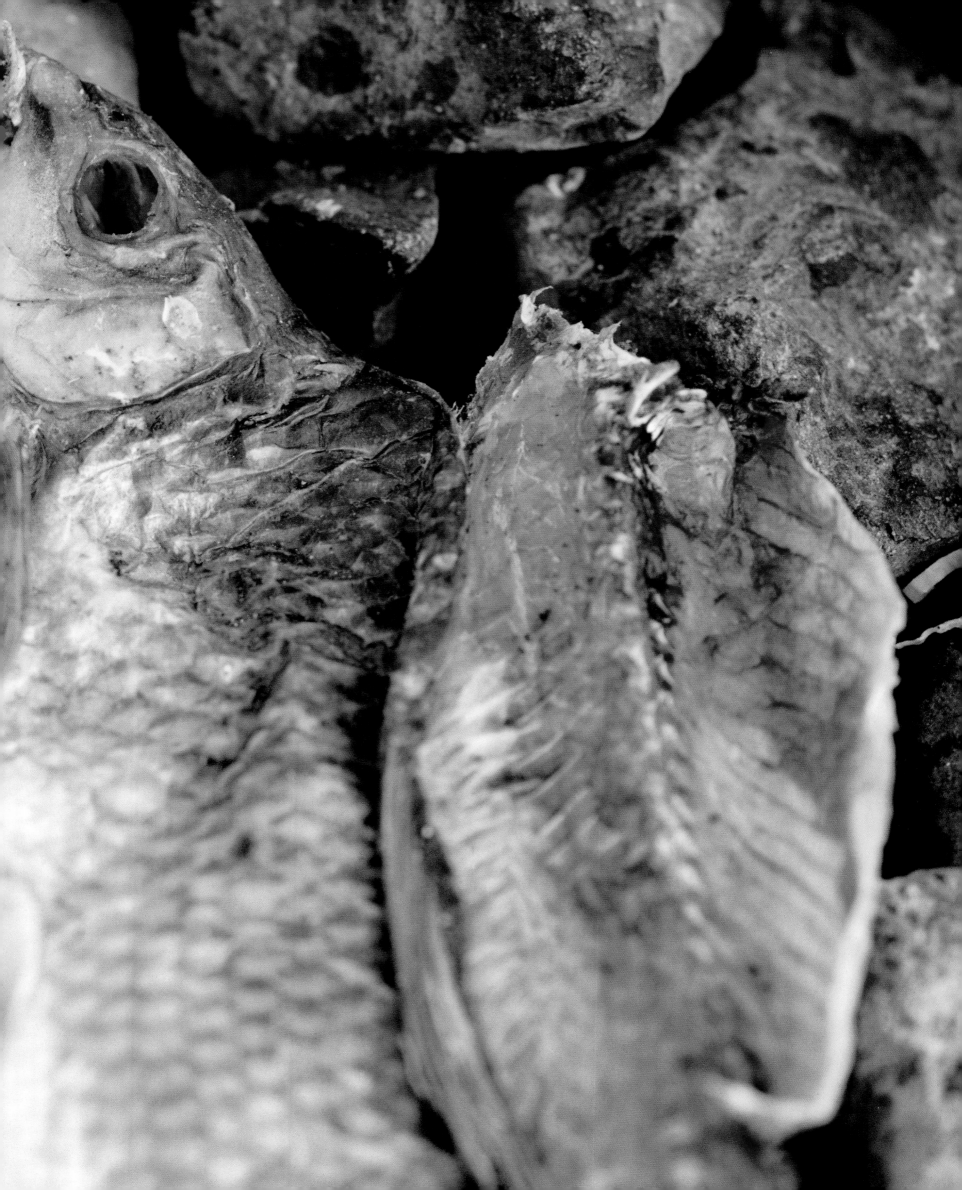

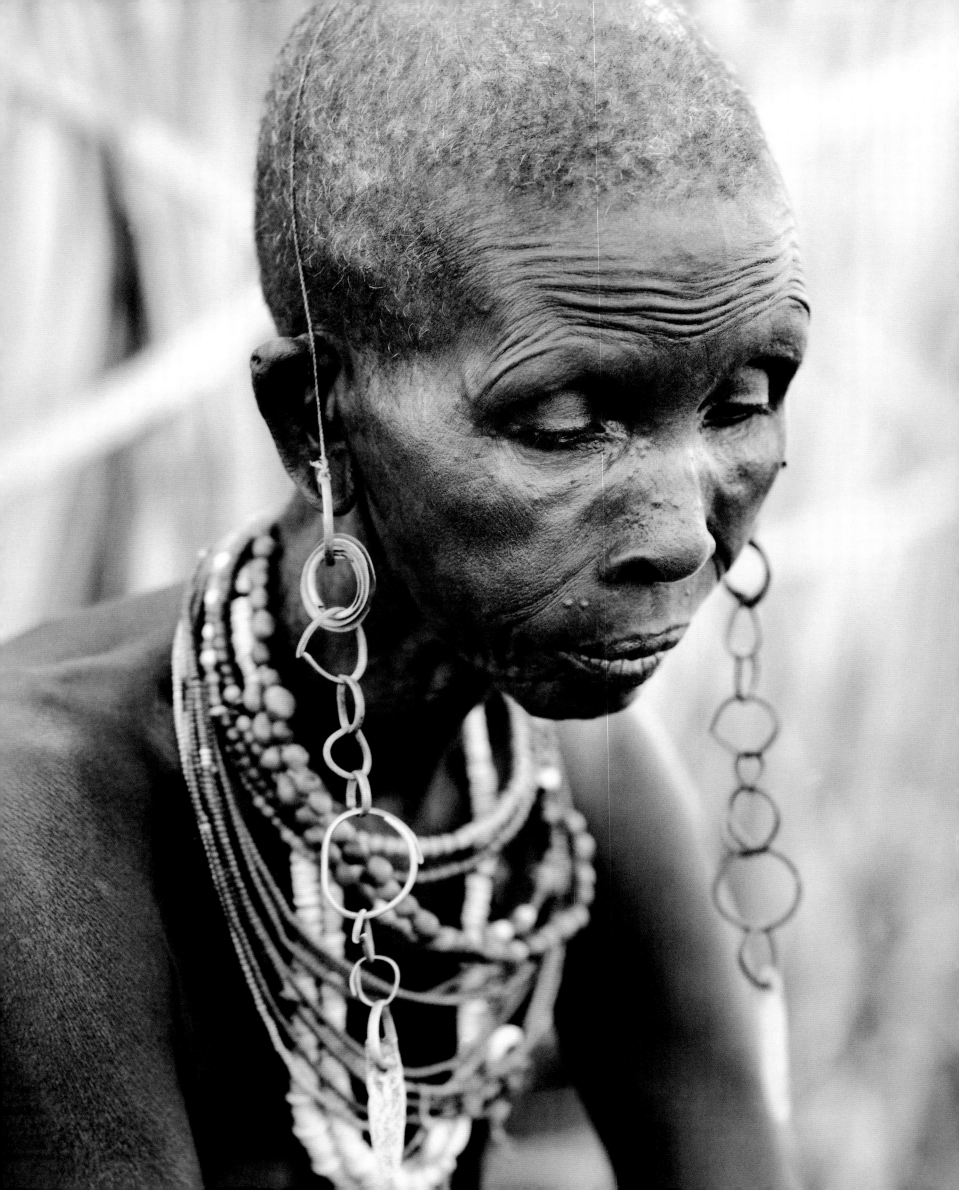

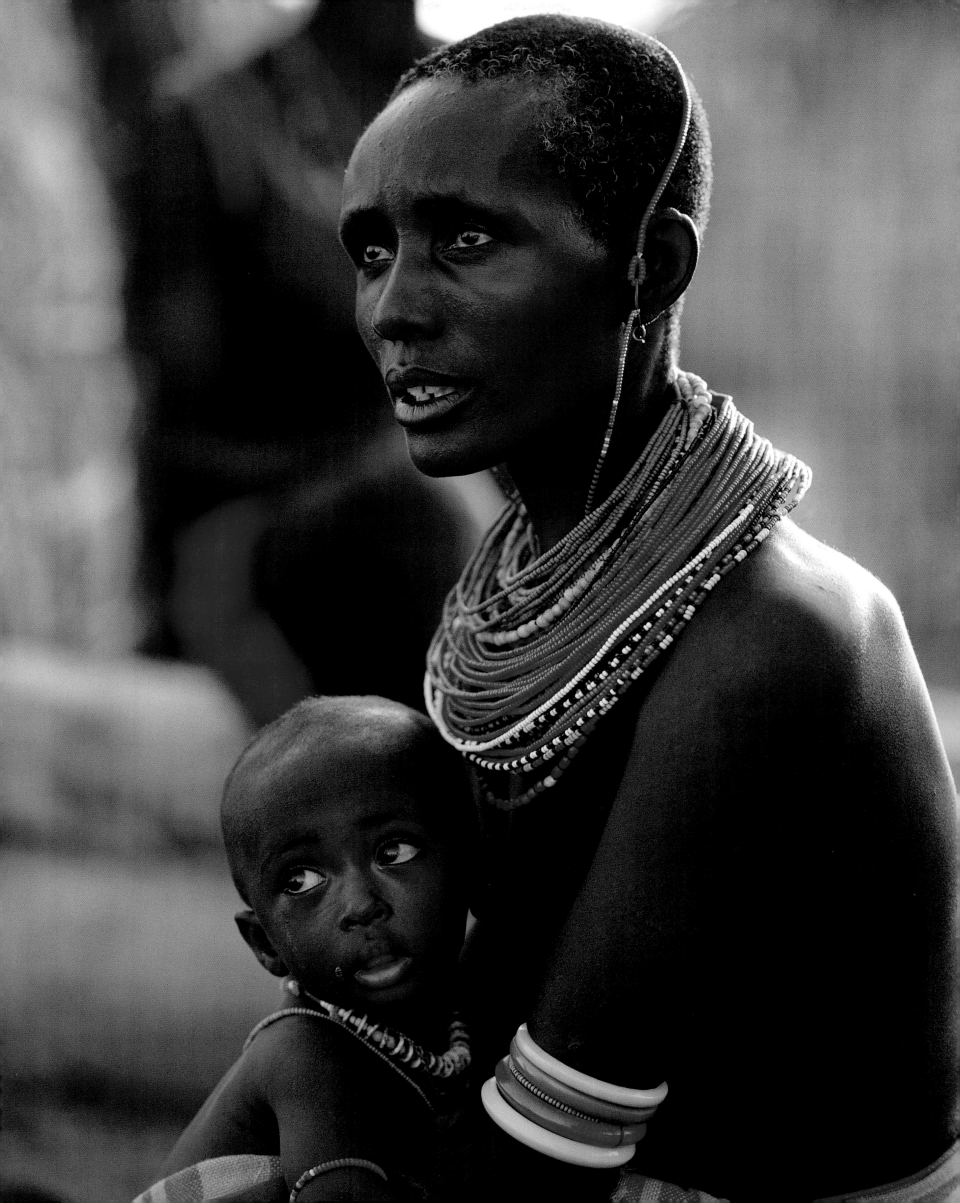

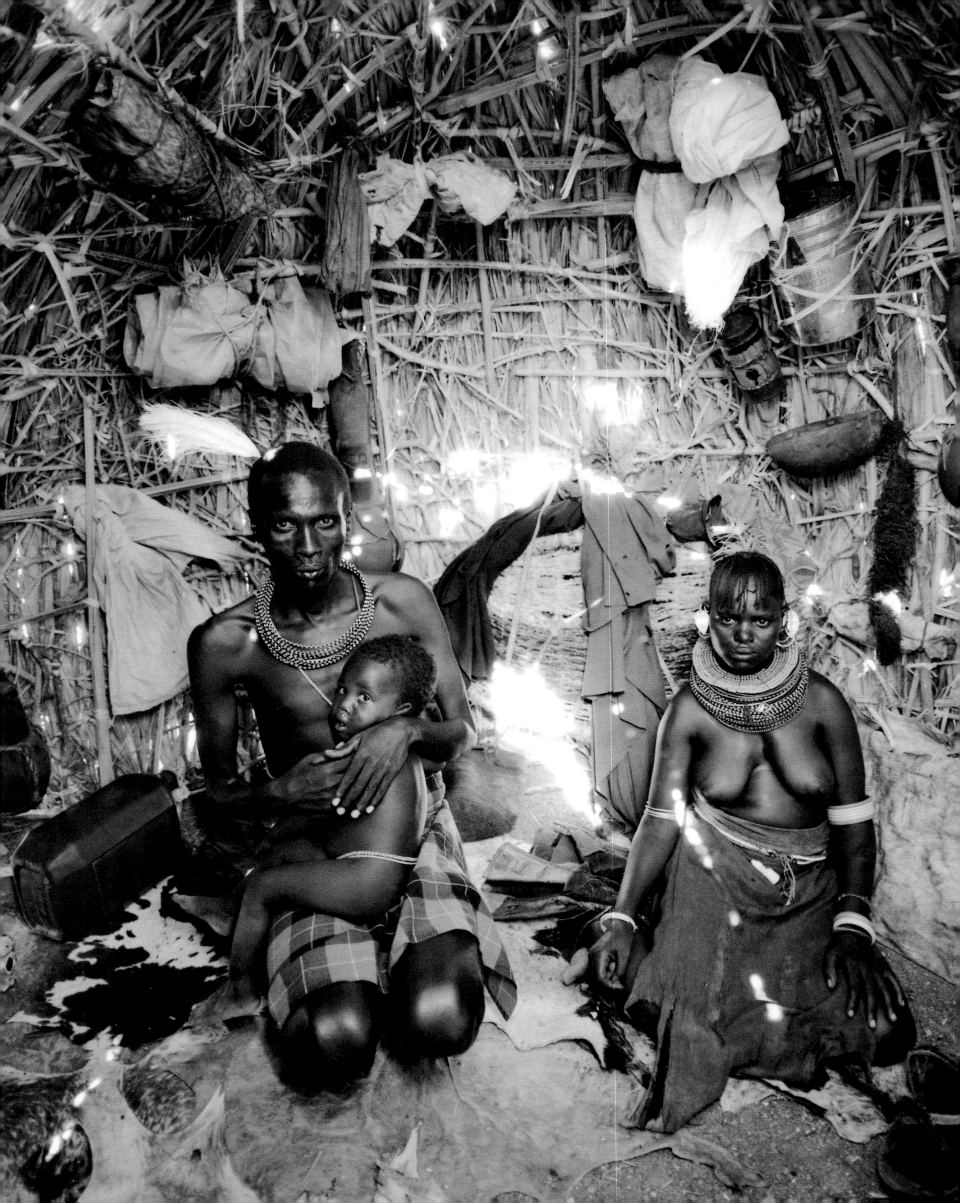

TURKANA

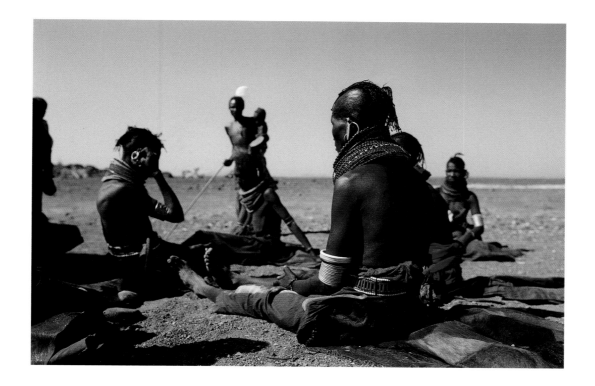

In the 17th century, members of the Jie tribe left their territory in present-day Uganda and moved eastwards. The new name tells of their spiritual affinity with the holy Mount Aturkan. In only thirty years' time the warlike Turkana successfully drove out all rival nomads and took over large tracts of land.

Not all the Turkana live in the same way. The so-called Lake Turkana have always had a mixed economy: livestock, fishing, agriculture. Others, who were exclusively nomadic herdsmen for generations, were forced by drought and theft into existing as fishermen.

Age sets (men who form a lifelong bond with other men of roughly the same age) play an important part in the structure of Turkana society, but they are not as crucial as they are for the Maasai, Samburu and Rendille. Clan membership is at least equally important.

Nomads arrive in one place only to set off for another; for this reason they carry only essentials with them. Their limited possessions, for example clothing, are stored in the huts on racks made of poles, to save space. The fenced farmsteads conceal enclosures in which cattle and small domestic animals are reasonably safe from predators and thieves.

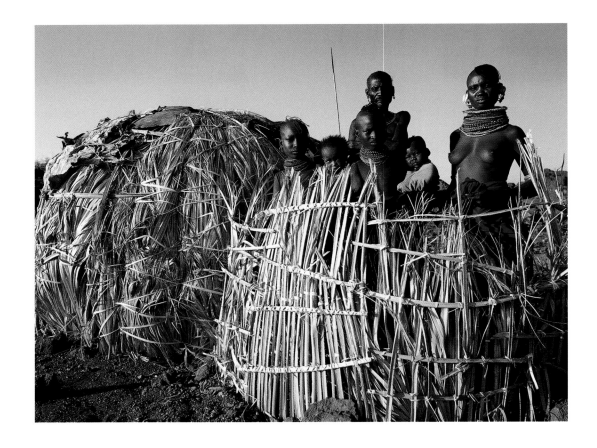

The Turkana's warfare skills are legendary – this was why the British colonial rulers liked to recruit these "born soldiers" into their own armies. Today the Turkana use their spears exclusively for hunting, if at all.

The ritual spears used for ceremonies – for example, when wooing a bride – can be identified by their rounded tips. An interesting custom, which has also survived in Europe, is the abduction of the bride on the wedding-day.

Every feast includes a competition between the dancers to determine who can jump the highest and who is the most graceful. These leaping dances are still customary among all East African nomads.

Traditional clothing and jewellery give those in the know a glimpse of status and rank, indeed of a whole life story. Unmarried girls are readily identified by their leather skirts, decorated with ostrich egg shells and beads. Lip plugs in copper or woven brass wire are reserved for married women and initiated men. And the typical clay caps are also something for the men, intended to make an impression with painted signs of status and ostrich feather decoration.

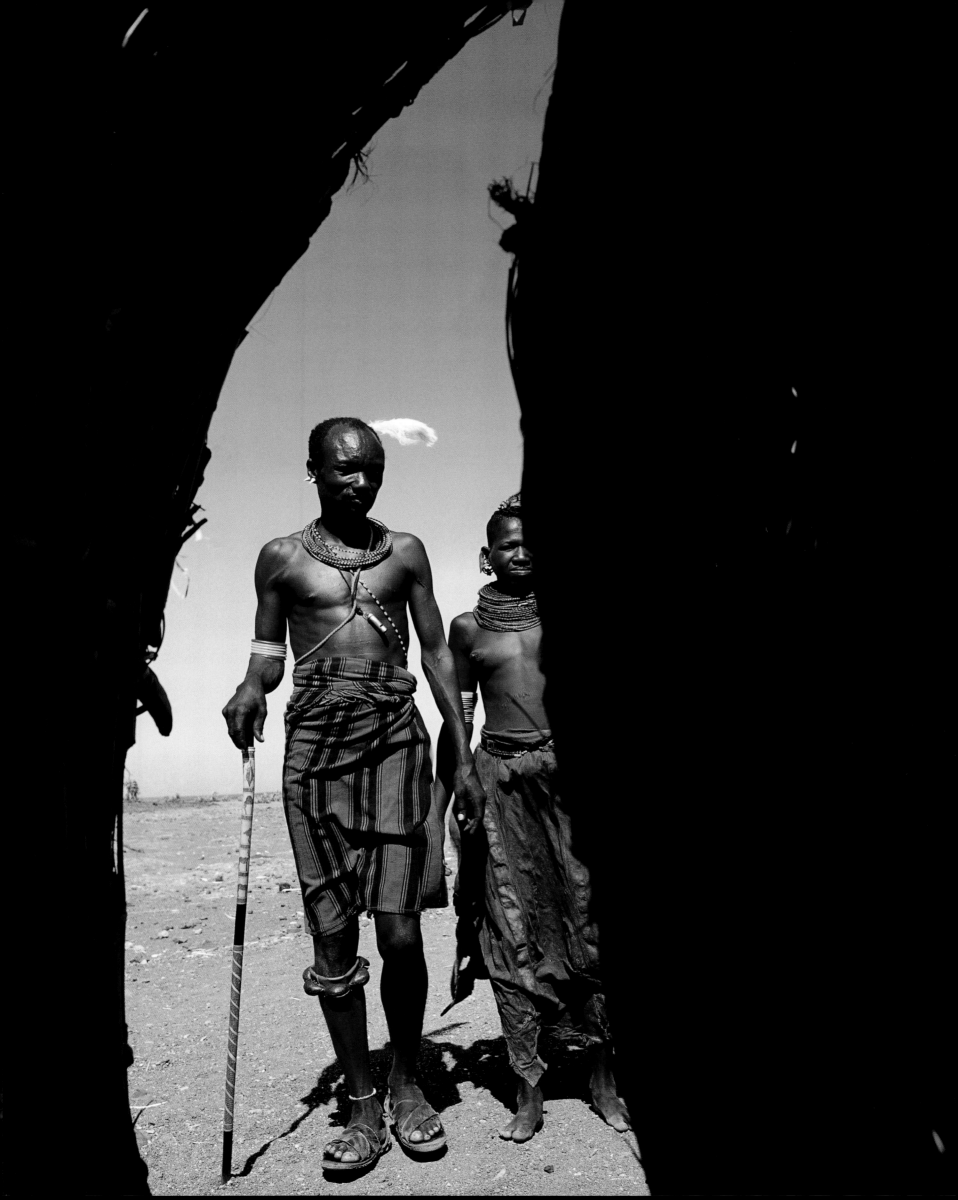

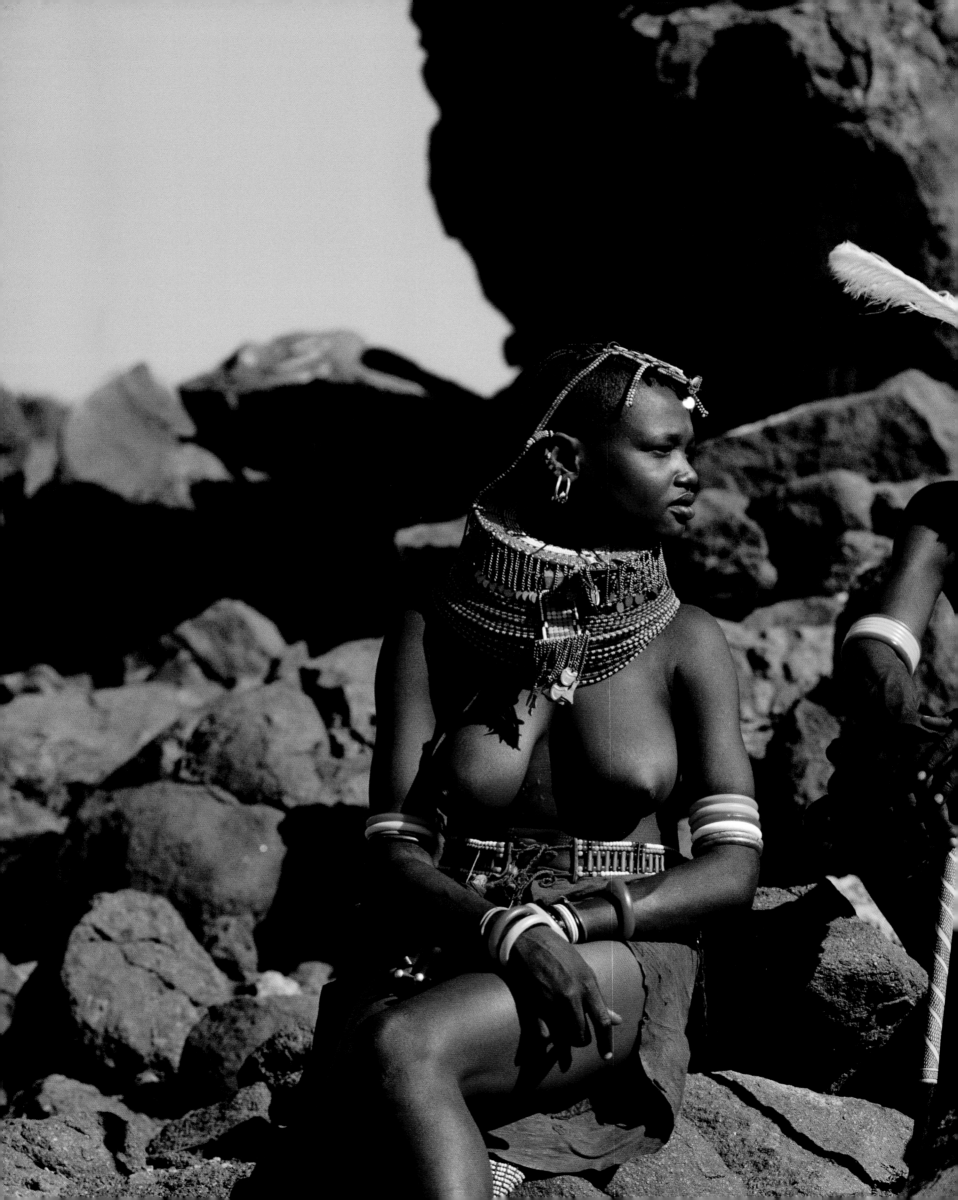

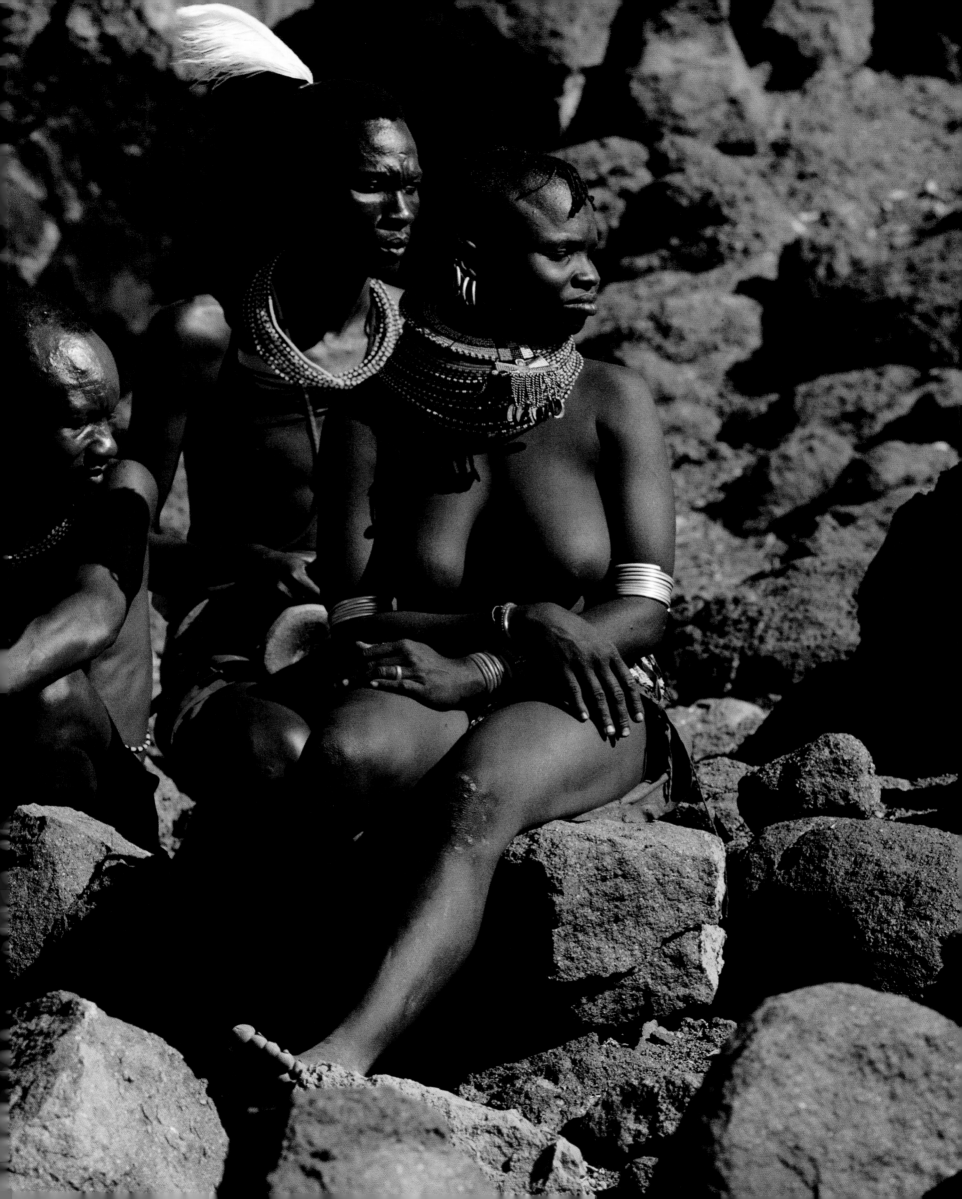

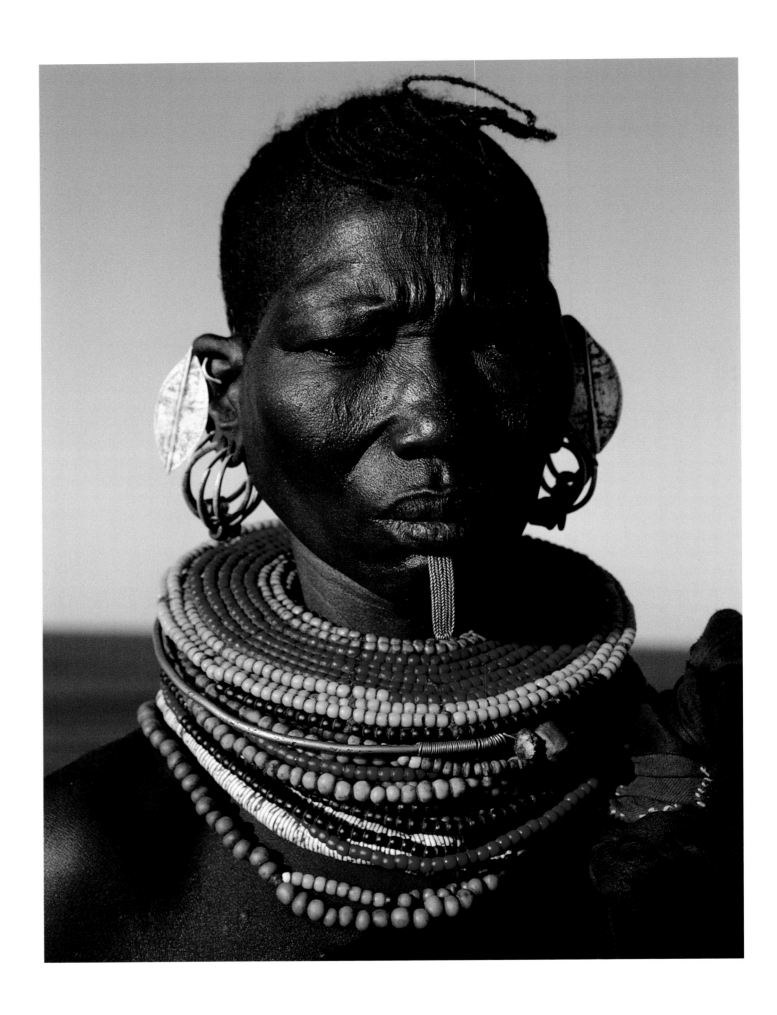

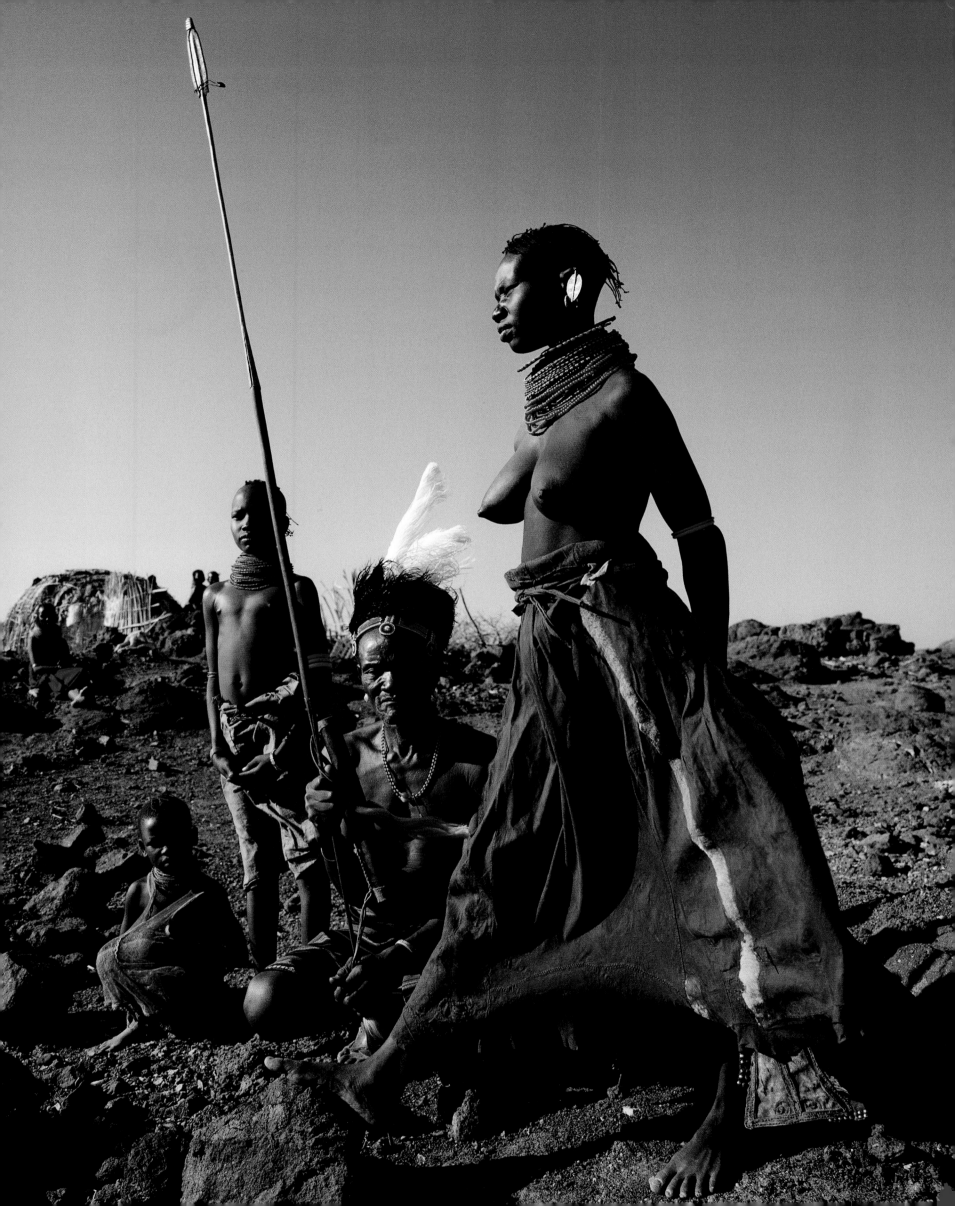

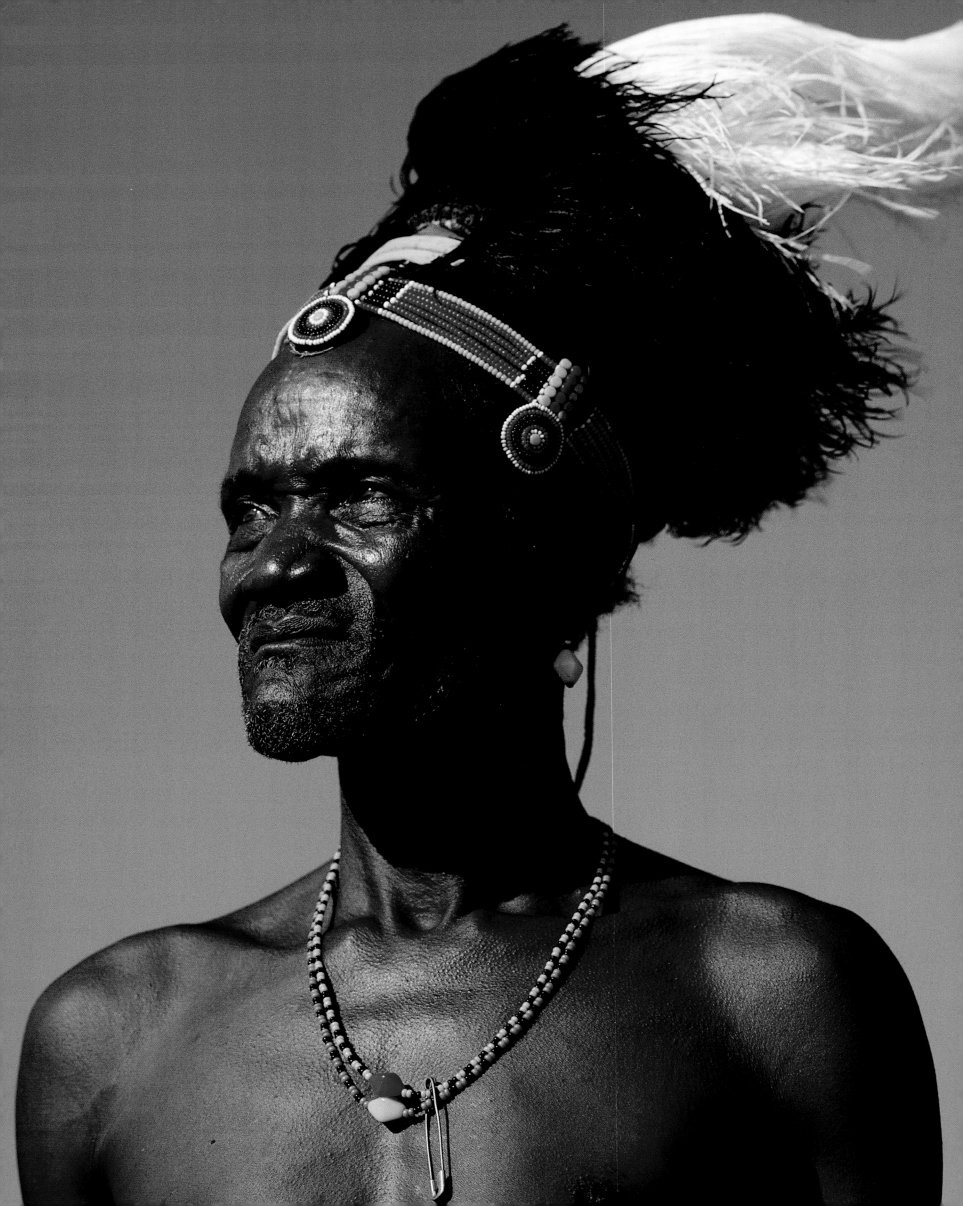

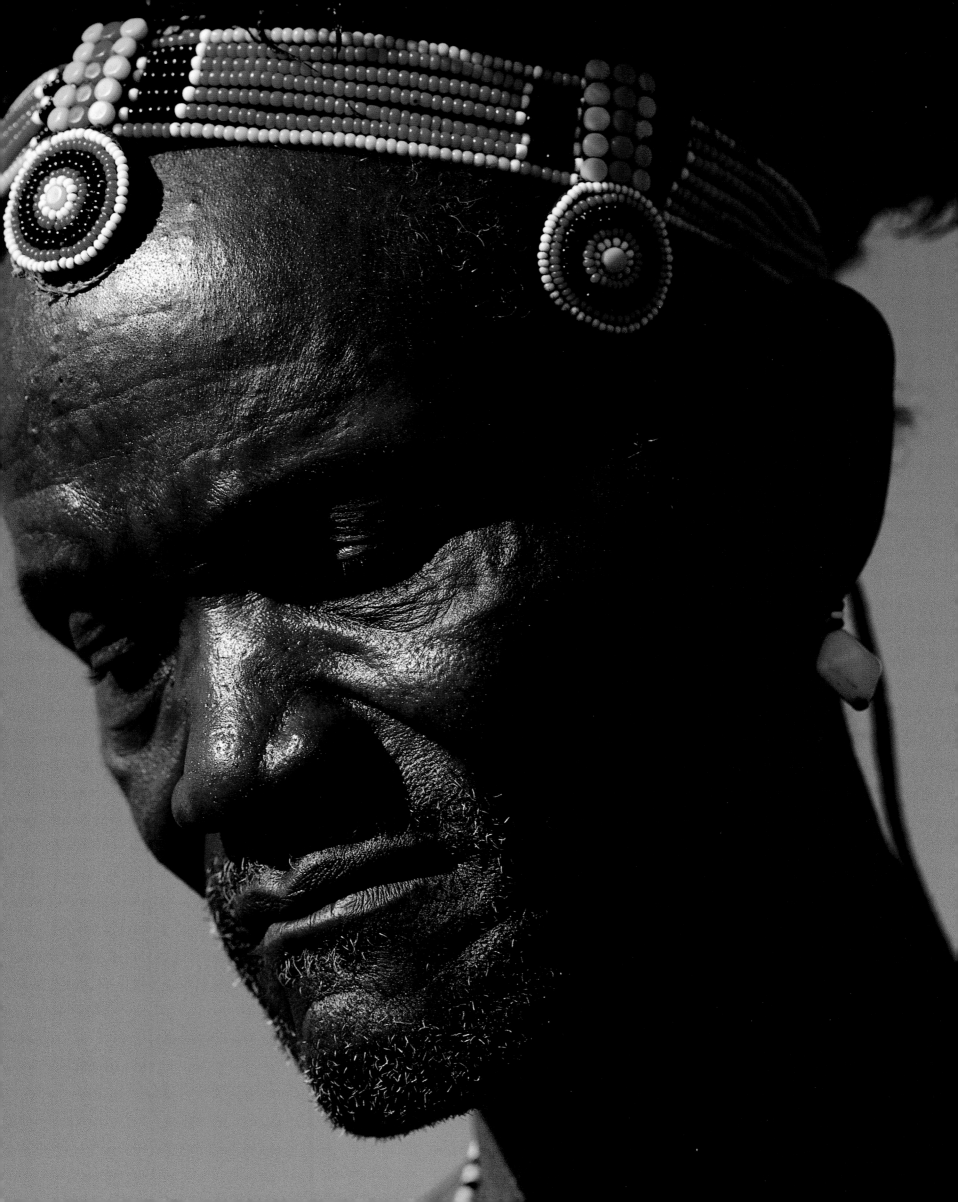

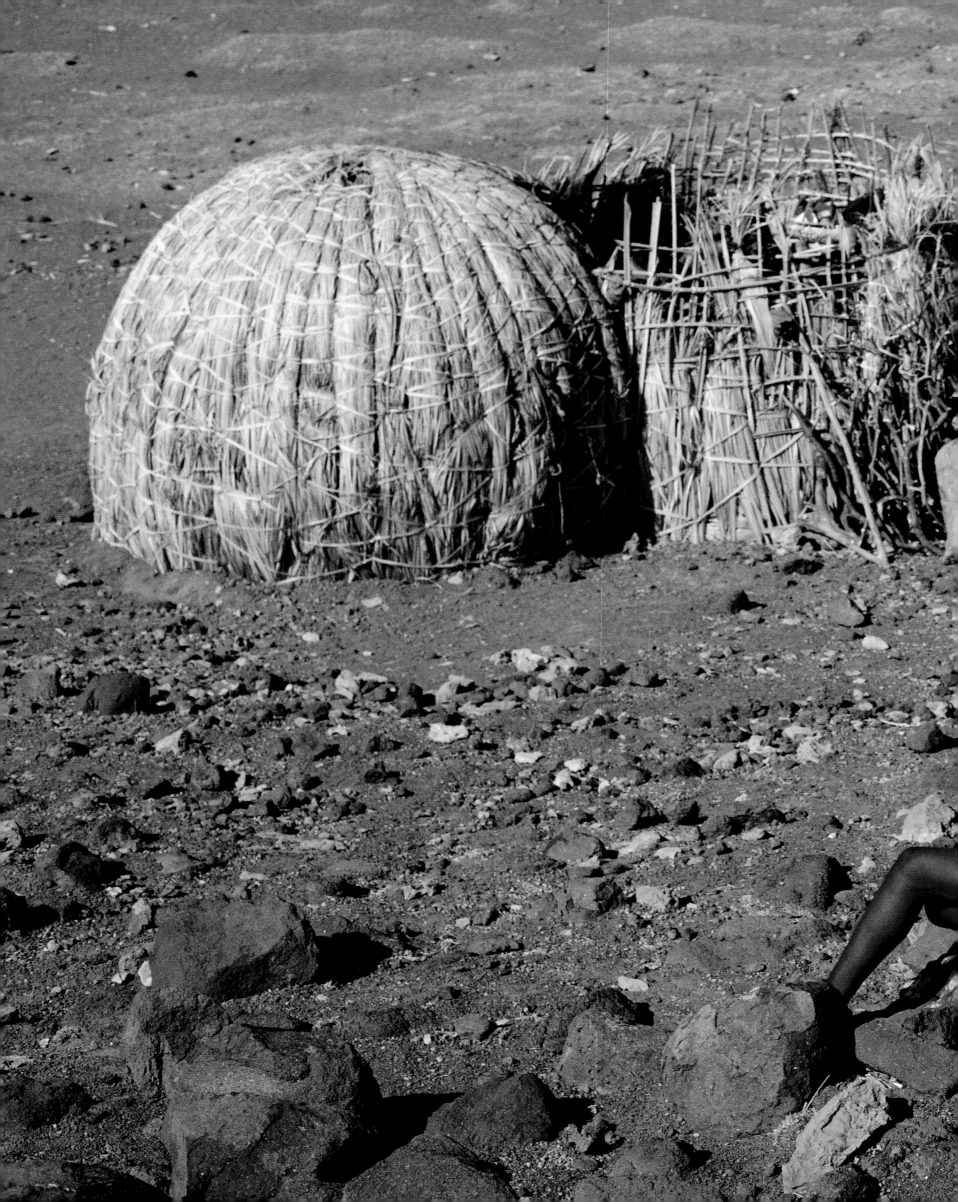

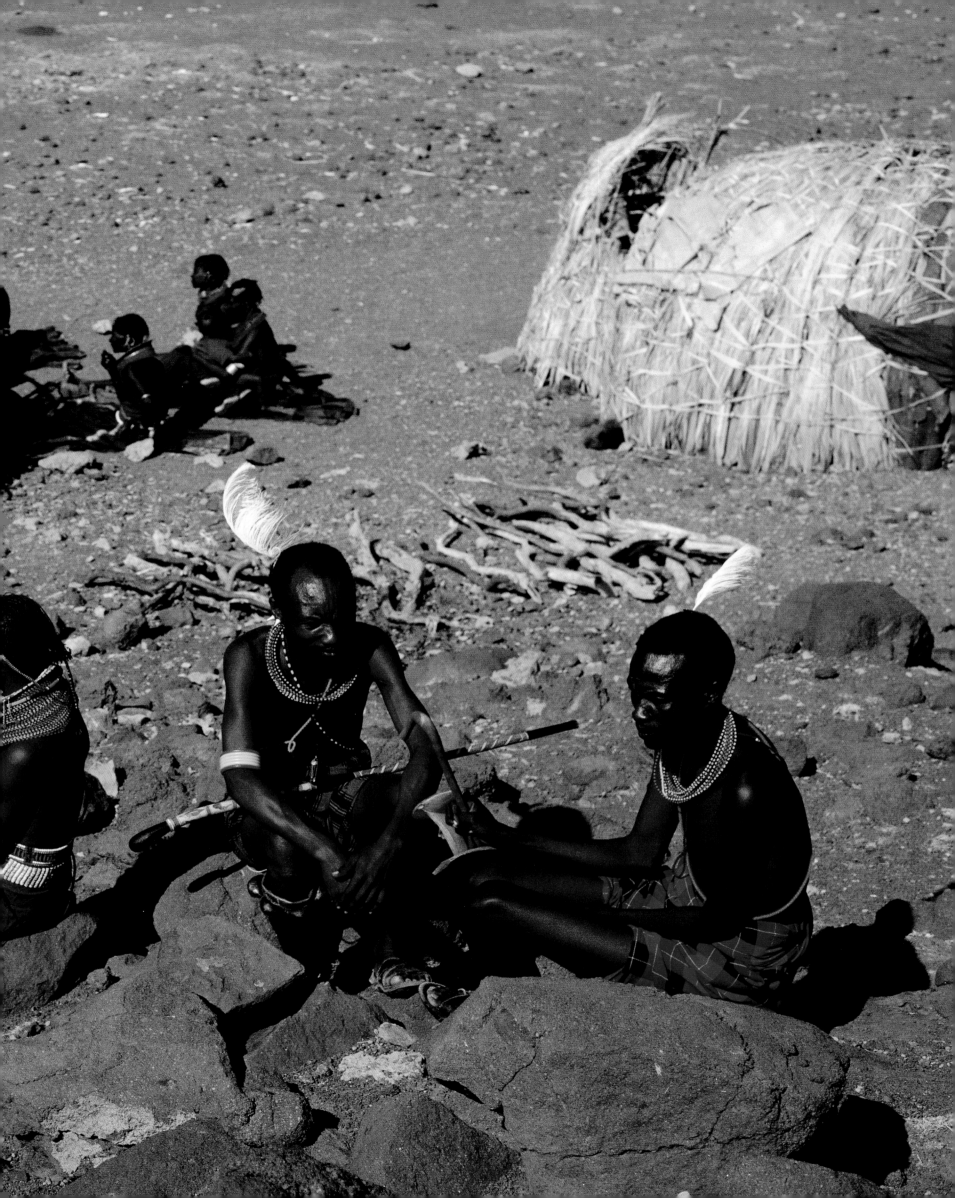

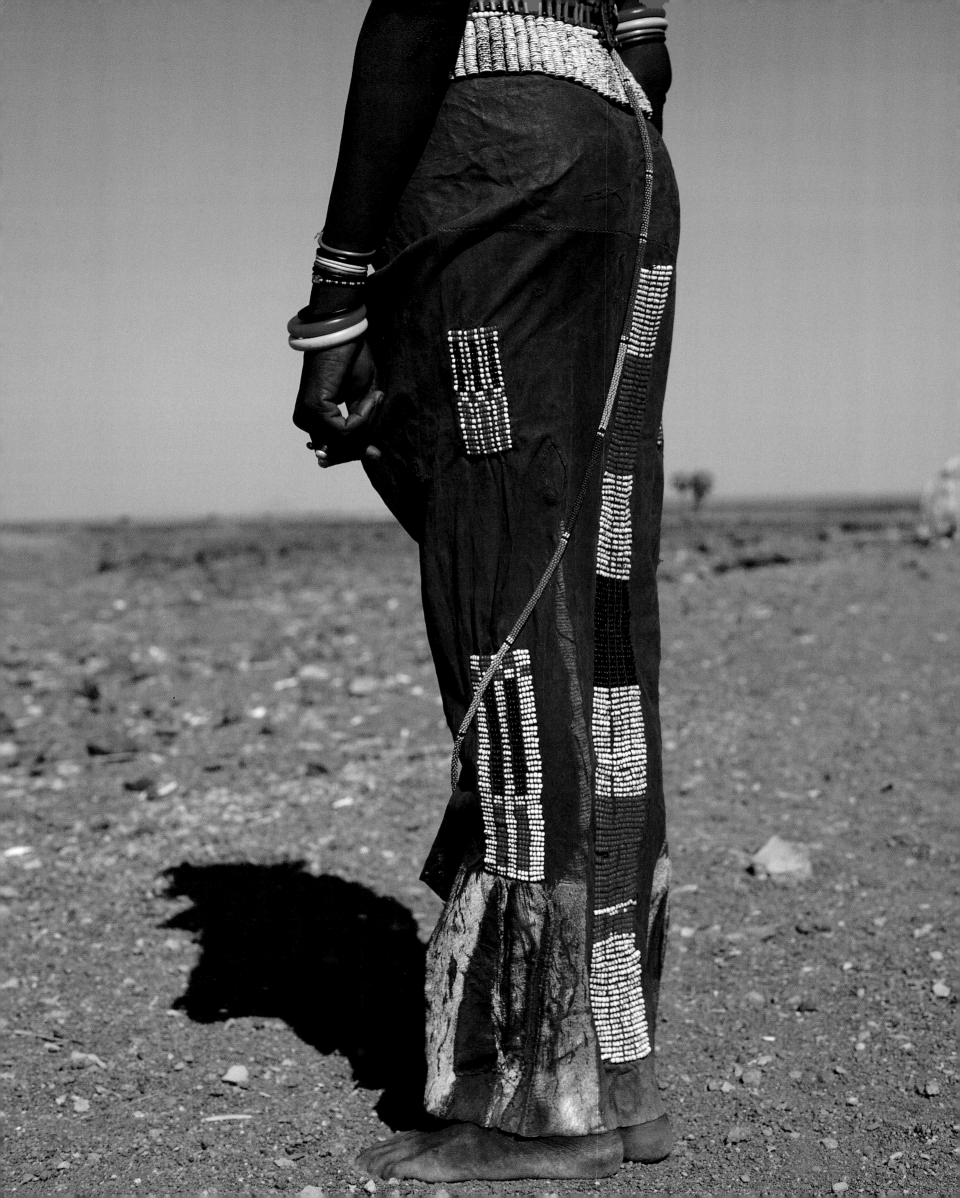

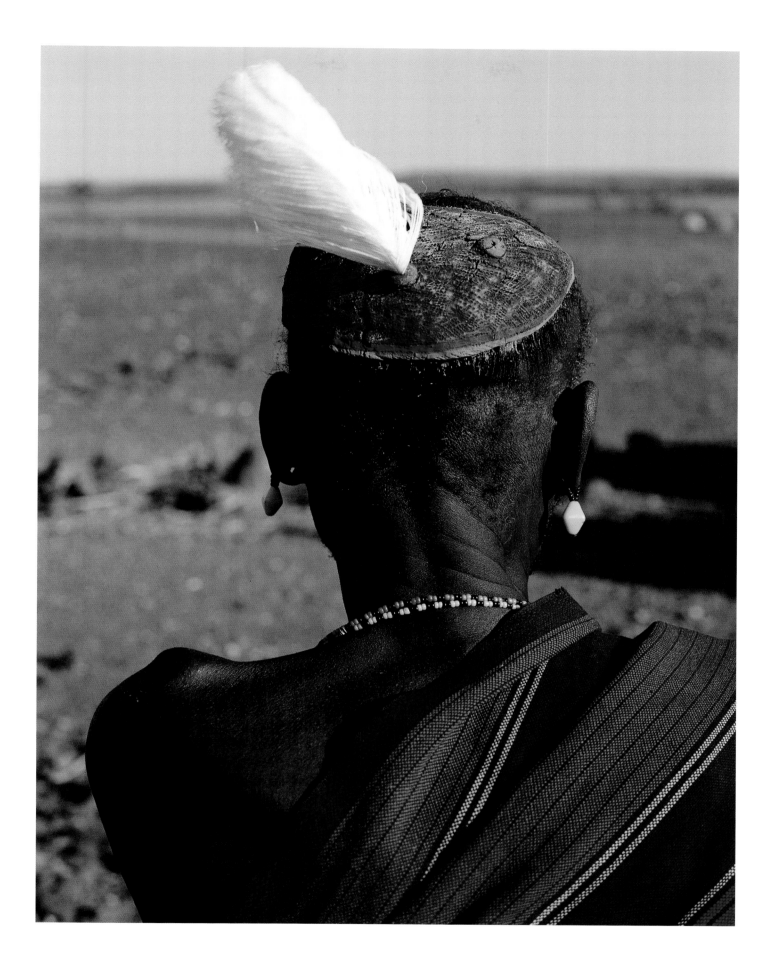

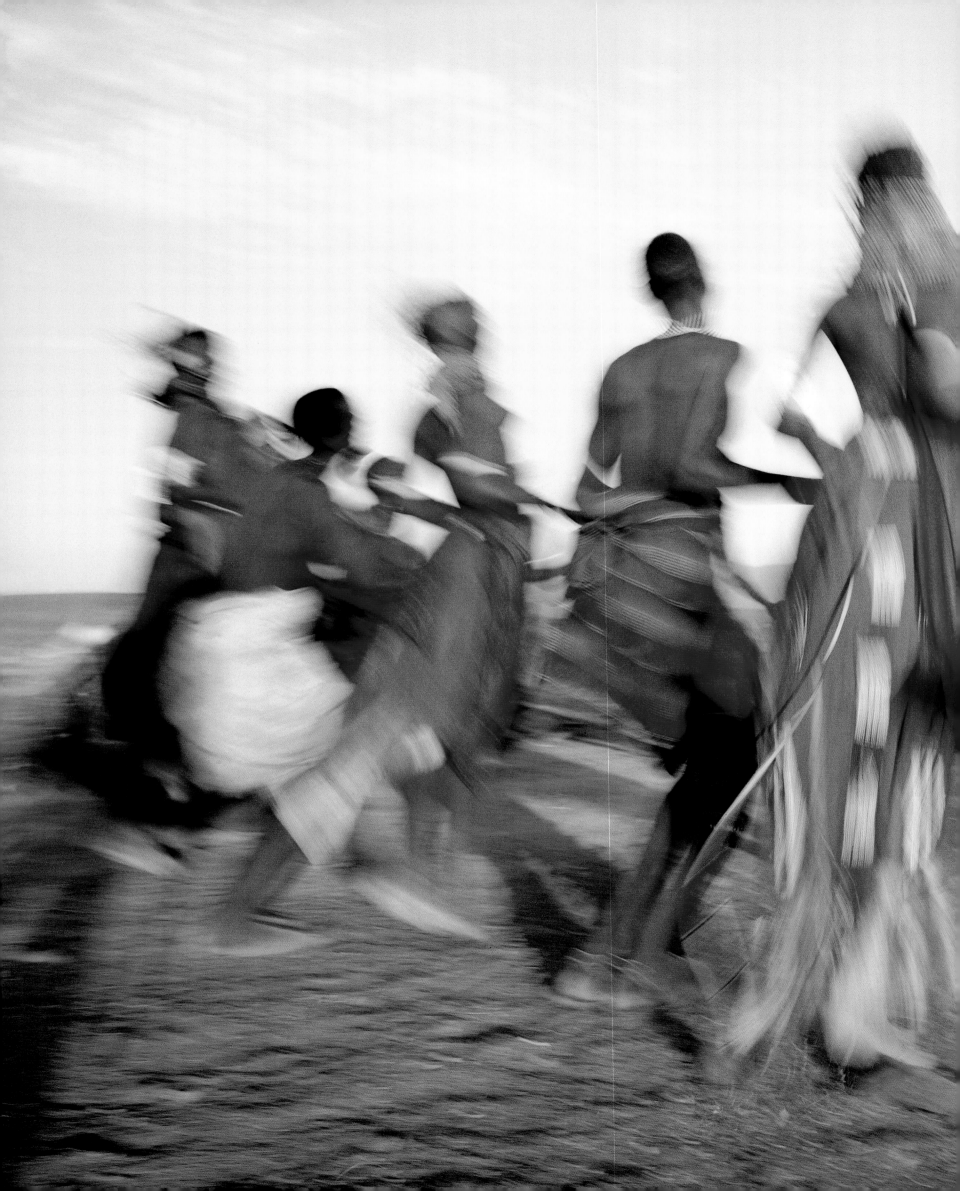

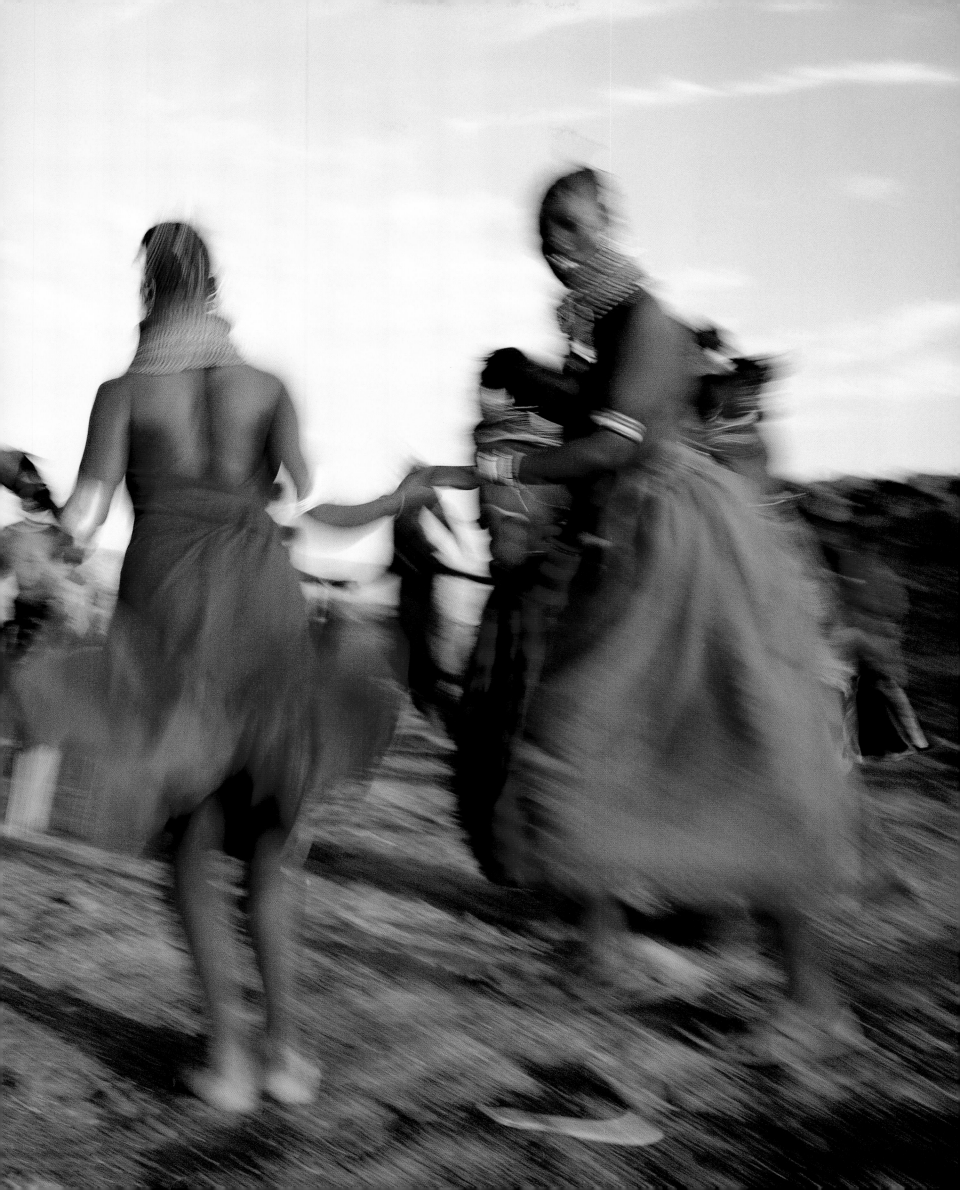

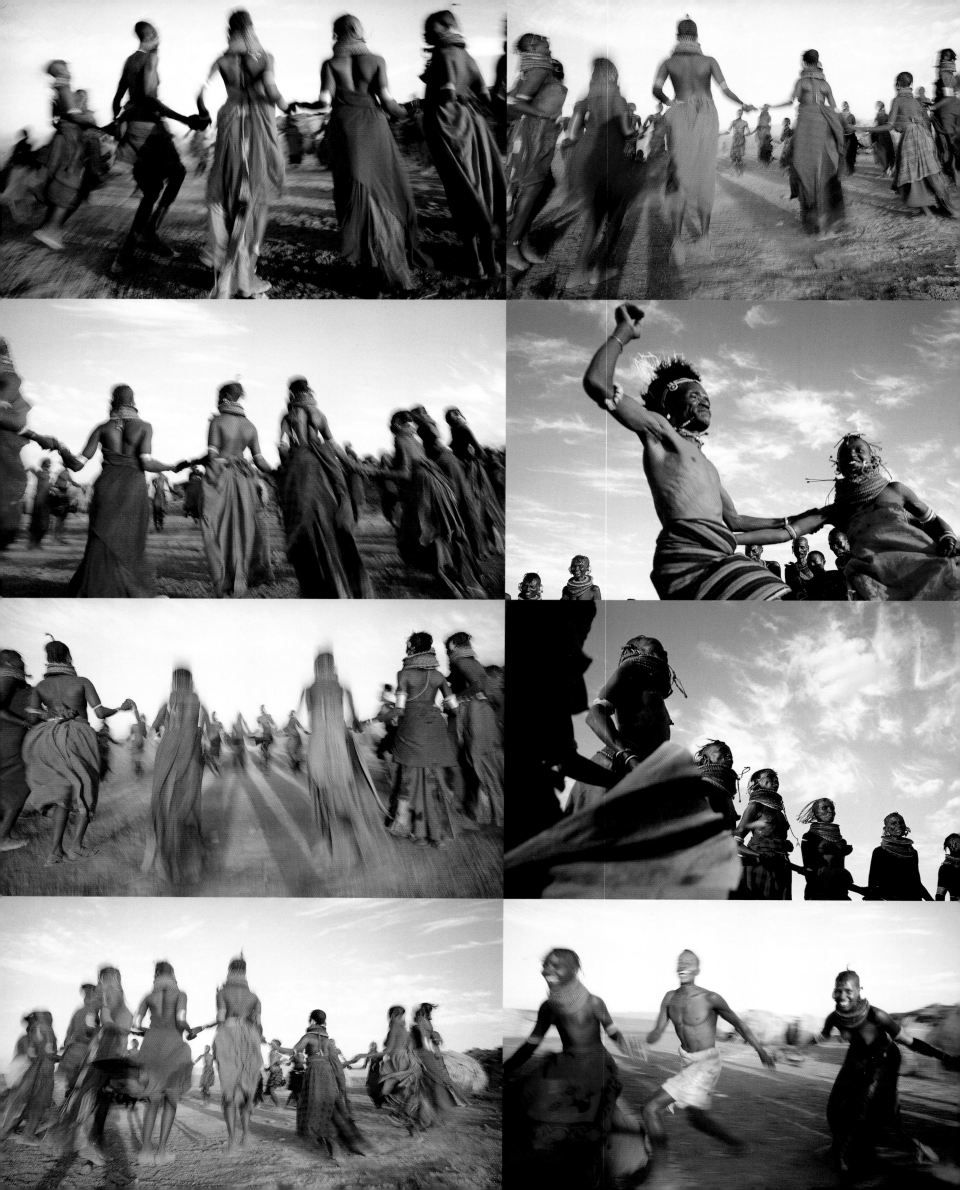

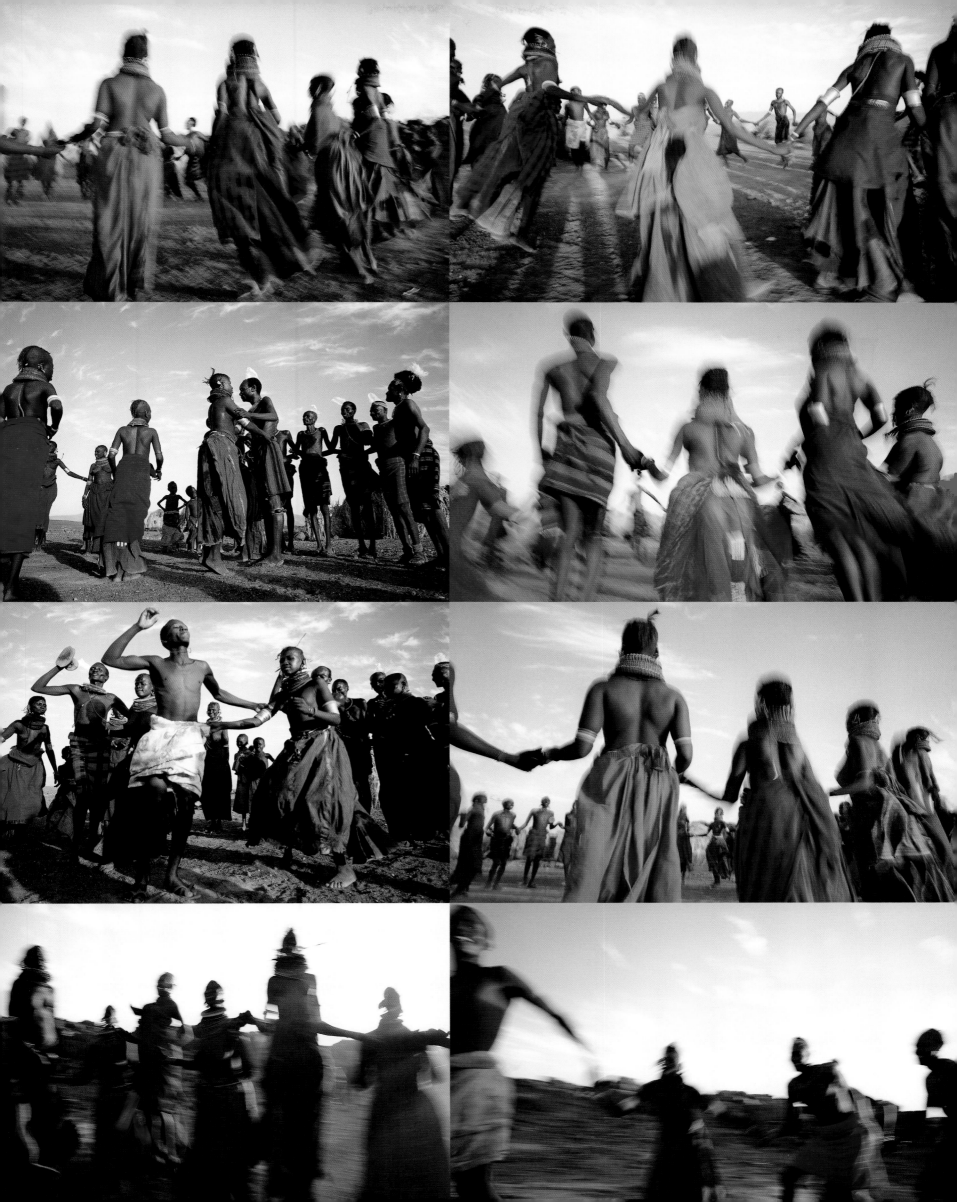

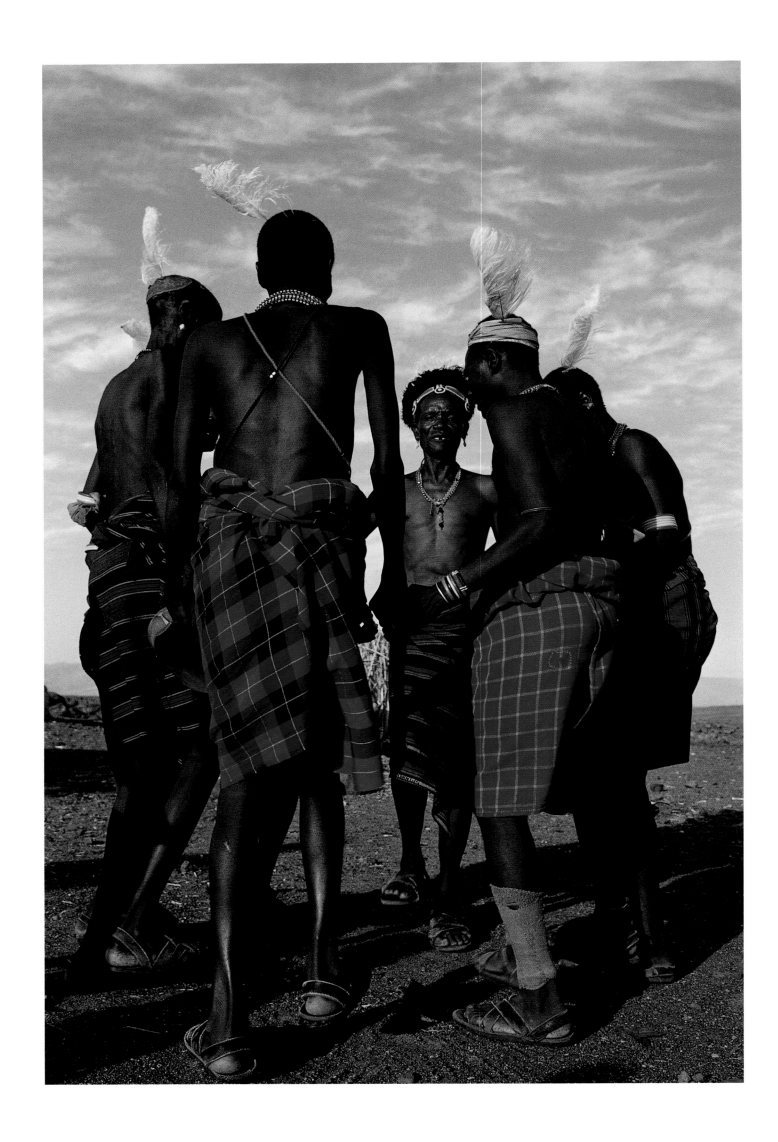

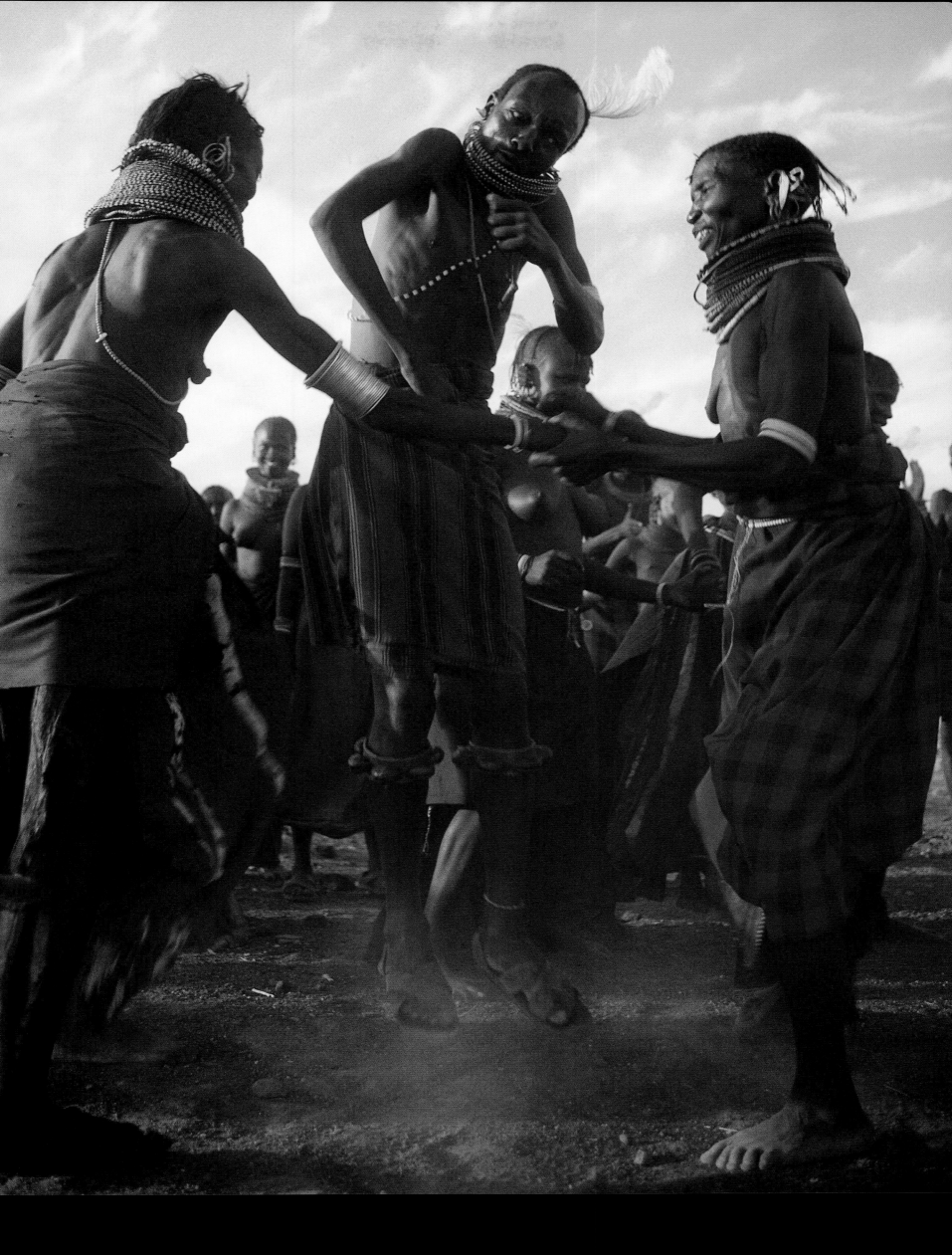

POKOT

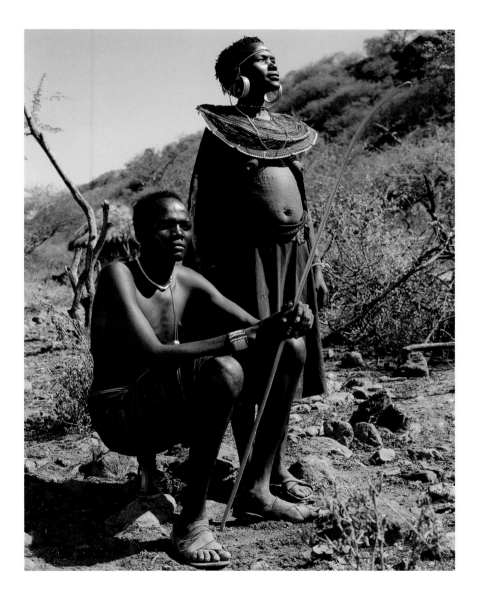

Internal peace and aggression towards outsiders – these are the two poles between which the west-Kenyan Pokot live. An extremely complex network of relationships maintains internal peace even at times when resources are scarce.

There are a number of things that encourage communal peace: wide-ranging marriage patterns, dowries that benefit the clan members as well as the bride's parents and a complex system of mutual commitment backed up by gifts and community help schemes.

And if all these intricately spun bonds of friendship cannot deliver what people imagine they promise, the Pokot believe that the outside world will be damaged as well: bad things will occur, like drought or the outbreak of an epidemic.

Many generations ago, when large numbers of Pokot left the mountainous region of eastern Uganda, the arable farmers became nomadic herdsmen, people of the semi-arid savannah. Their social structure changed at the same time. They adopted the age-set system practised by their neighbours. And they launched a long series of raids in the Maasai territory, brutal ambushes for which they became notorious.

Soon the Turkana, with whom they had mingled formerly, became their bitterest enemies, which they continue to be. The heavy concentration of weapons in East Africa – a regrettable legacy of two world wars and the Cold War – have made the ancient feuds all the more murderous.

When the weapons are still, so are the warriors. The wooden headrests, also providing relief for backs, legs and arms, are merely the most striking practical items in a culture that has to travel light.

Pokot men – just like nouveau riche Europeans and Americans – like to demonstrate their affluence by the quality of the things they hang round their wives' necks. Power equals purchasing power. When there were no glass beads coming into the country and jewellery was still skilfully made from antelope bones and ostrich-egg shells, the women wore comparatively modest neck jewellery.

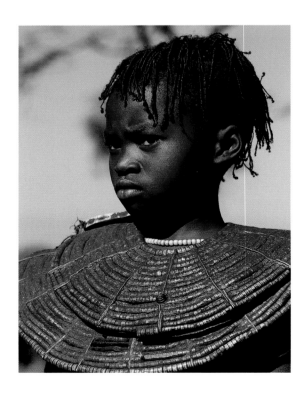

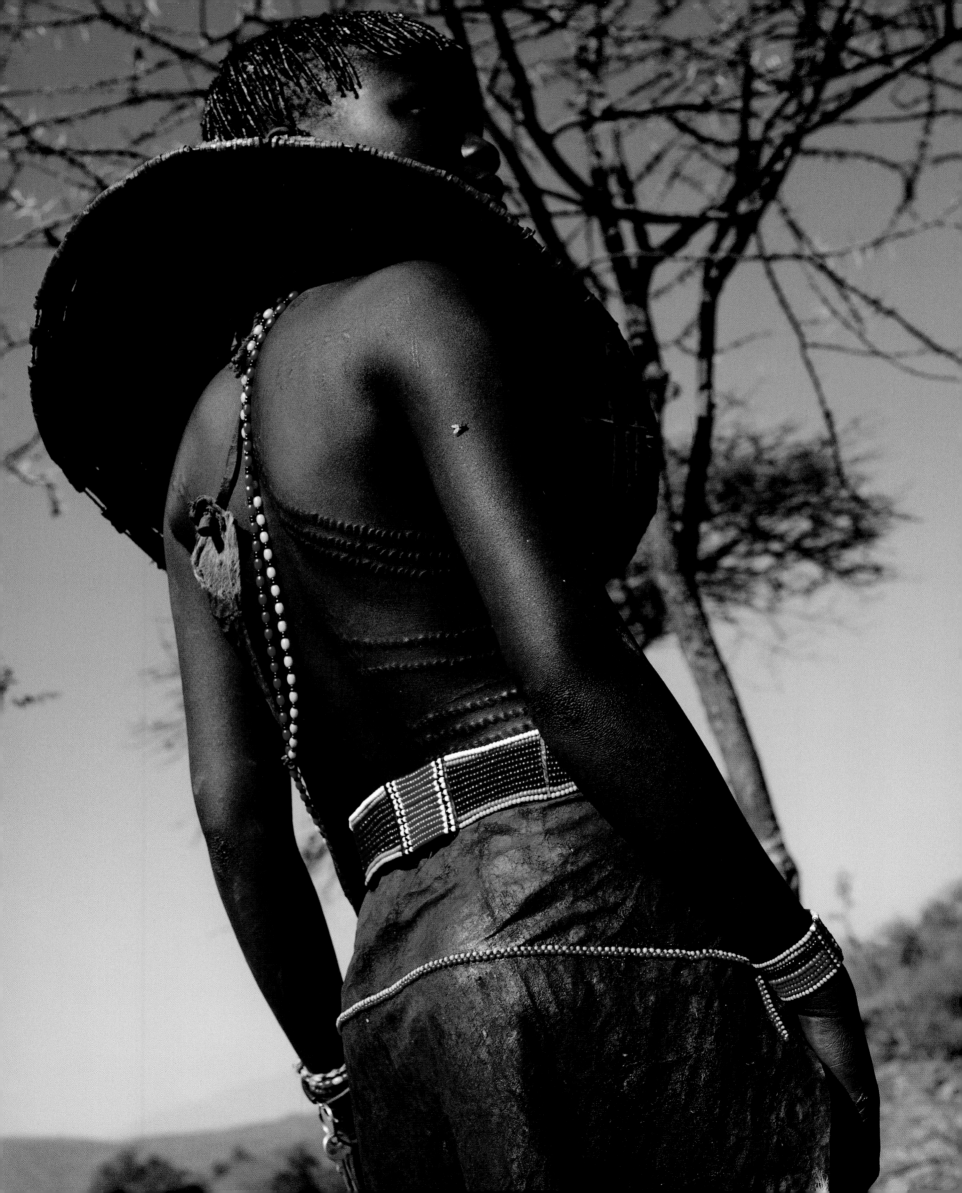

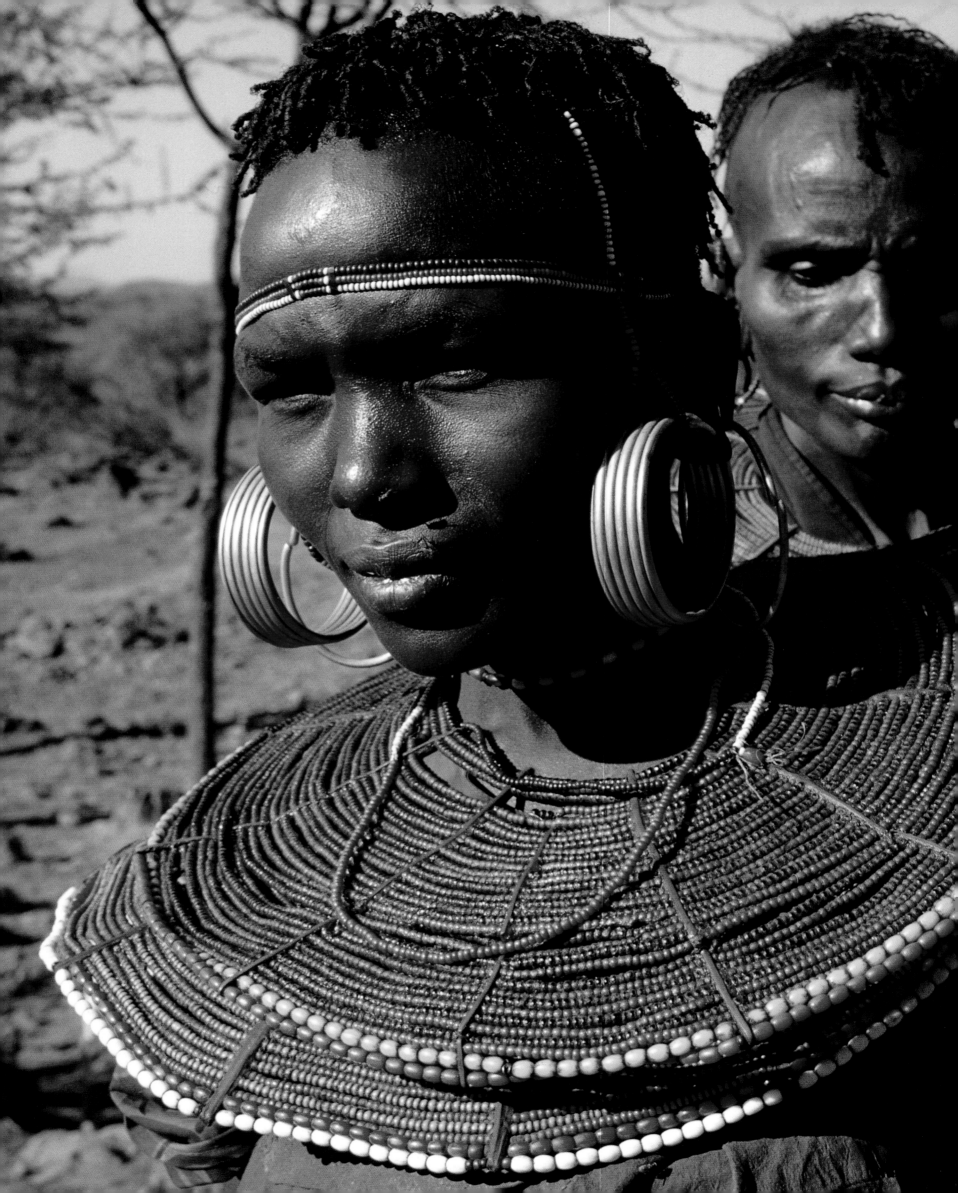

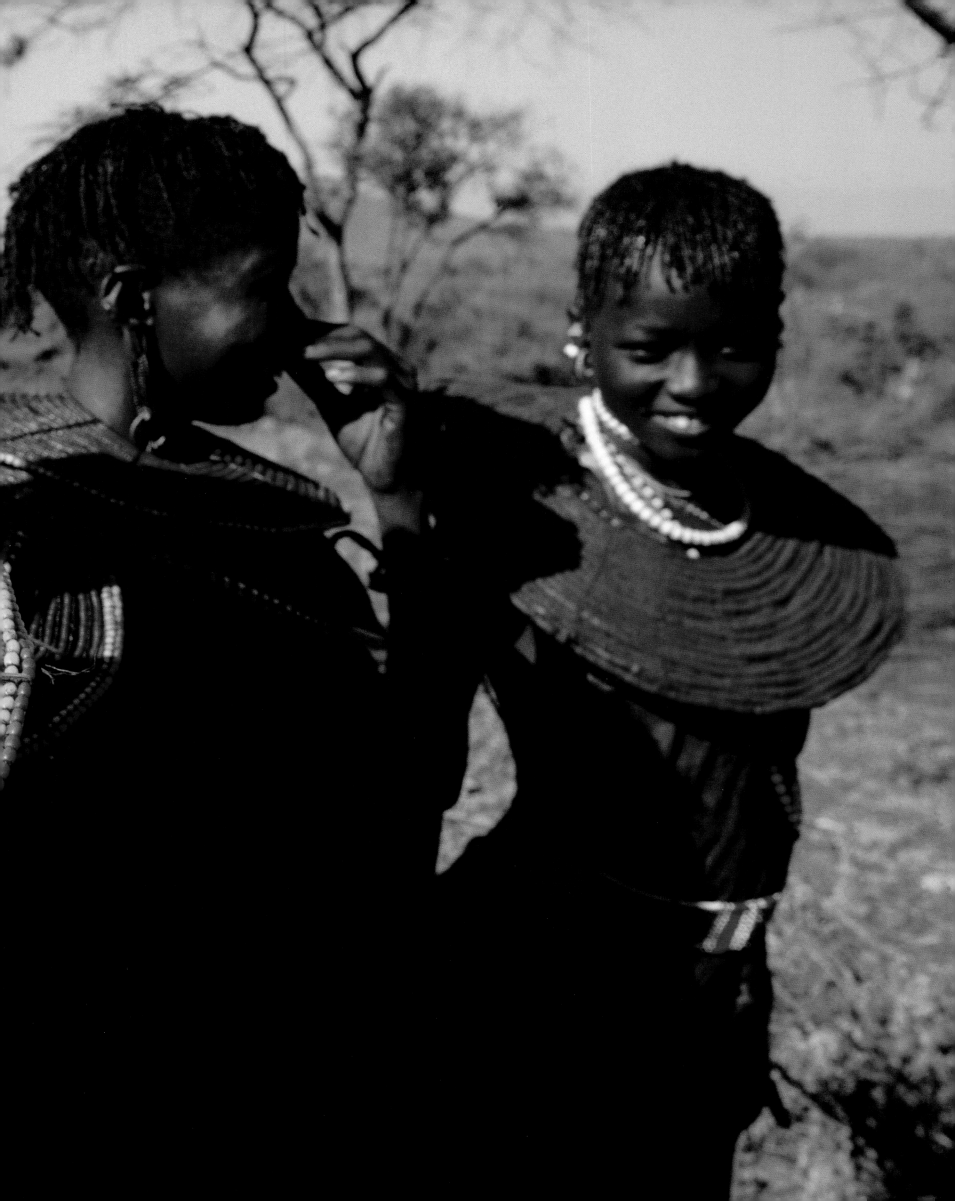

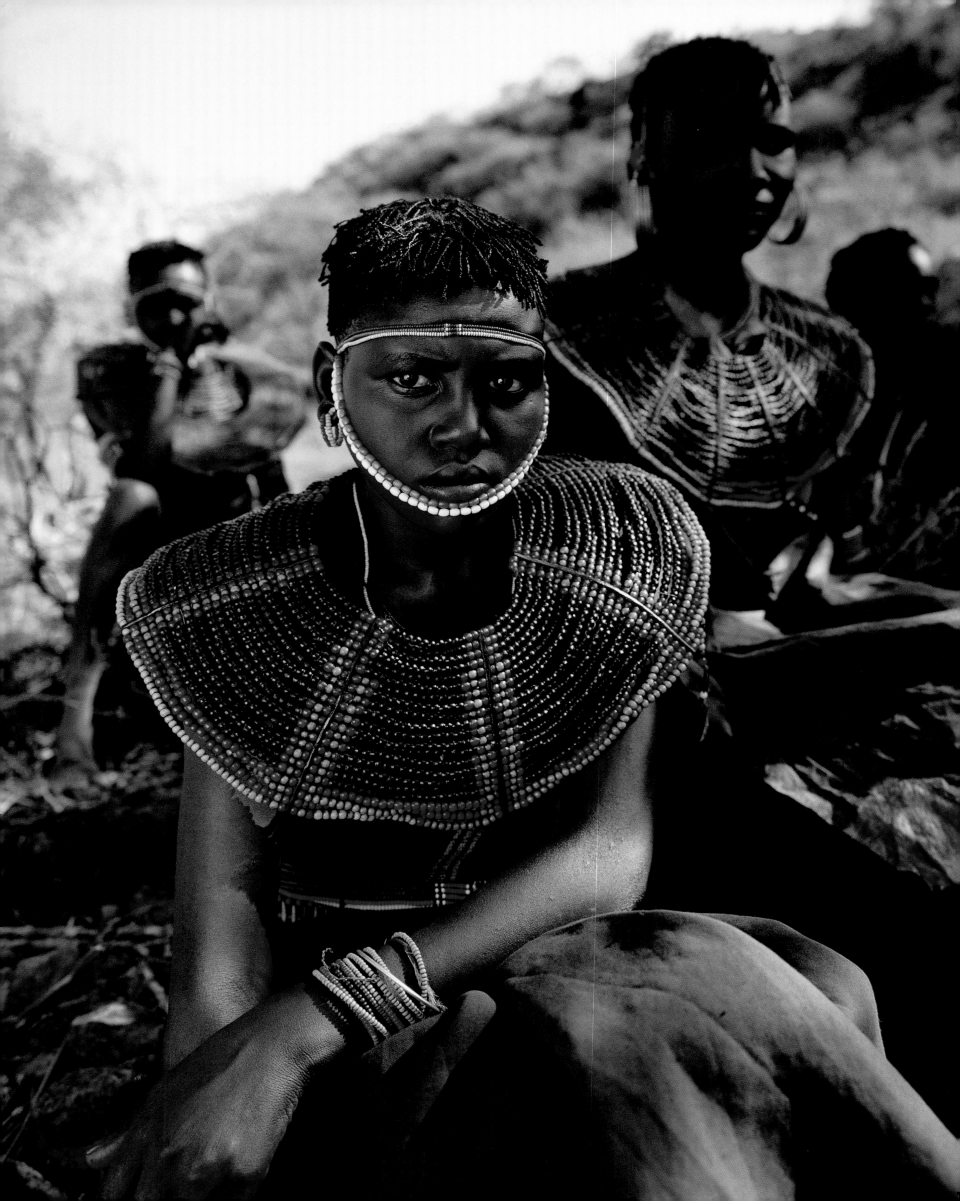

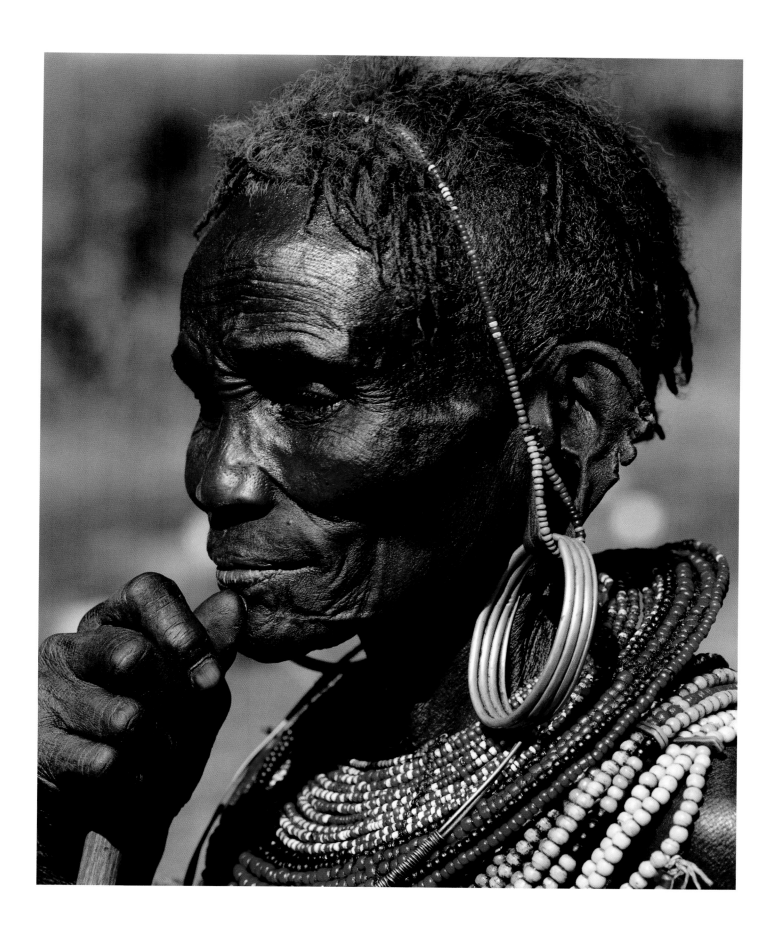

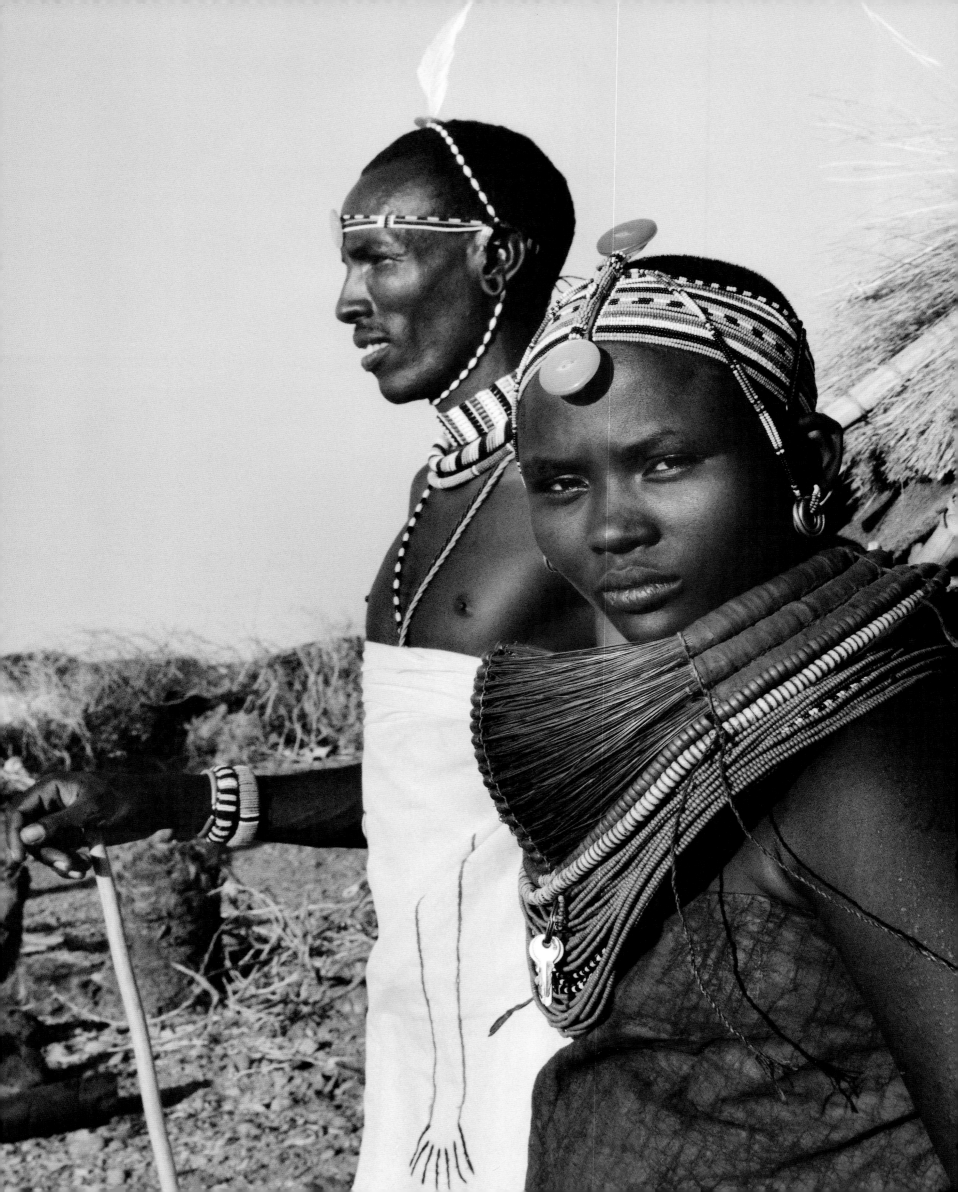

RENDILLE

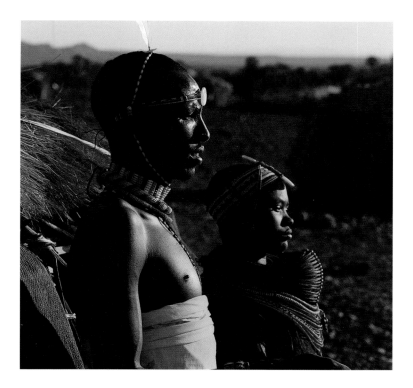

The constant search for new pastures also forced the Rendille to leave their homeland in present-day Somalia. Some settled south-east of Lake Turkana, others moved further south, entering Samburu territory, where they stayed and a relationship as friendly neighbours developed. The Rendille had brought camels, which posed no real threat to the Samburu cattle in terms of either watering holes or grazing land.

The newcomers assimilated so much of their new neighbours' and allies' culture into their own that the two groups can scarcely be distinguished from one another today; unless you listen: the Rendille have retained their language, which is very similar to modern Somali.

Age grades are also the ordering principle behind a Rendille man's life; as with the Samburu and Maasai, the *moran* (warrior) period starts after circumcision. Like their Samburu neighbours, the Rendille women adorn their necks with plant fibre and a vertical string of beads above many bead necklaces. The vertical string of beads is handed down from a mother to her daughter when she is married, symbolizing the chain of life: she who is born in turn becomes a bearer of new life. The jewellery also expresses hope for fertility and prosperity in its own way: healthy children, strong herds.

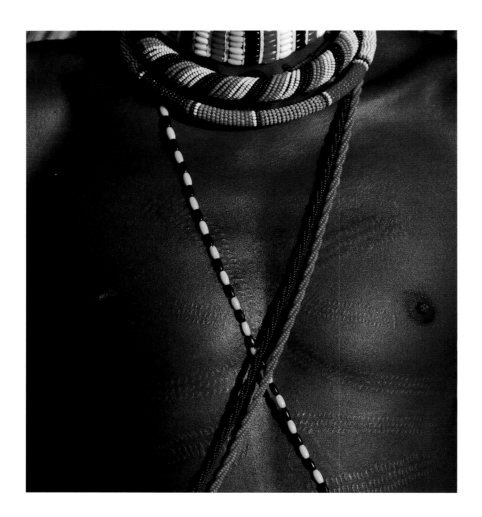

Today many materials used for jewellery are available in shops; this also applies to the cowry shells the Rendille use to decorate leather shoulder-bands, for example. In precolonial days these shells circulated as currency in many parts of Africa.

The Rendille made themselves famous among ethnologists and population experts by the way they protected themselves against over-population: some of the methods they used were draconian, intended to ensure that the population figures continued to match the food available; emigration, monogamy, child-killing (for as long as another baby was being breast-fed) – all this was obviously less terrible than the threat that a time could come when there would not be enough camels' blood and milk for all.

An essential element in this control system was embodied by the *sepaade*; these were women who were allowed to marry only after all their brothers had done so. By the time the youngest brother and latecomer was going through his long period as a warrior his poor eldest sister was no longer in her childbearing years.

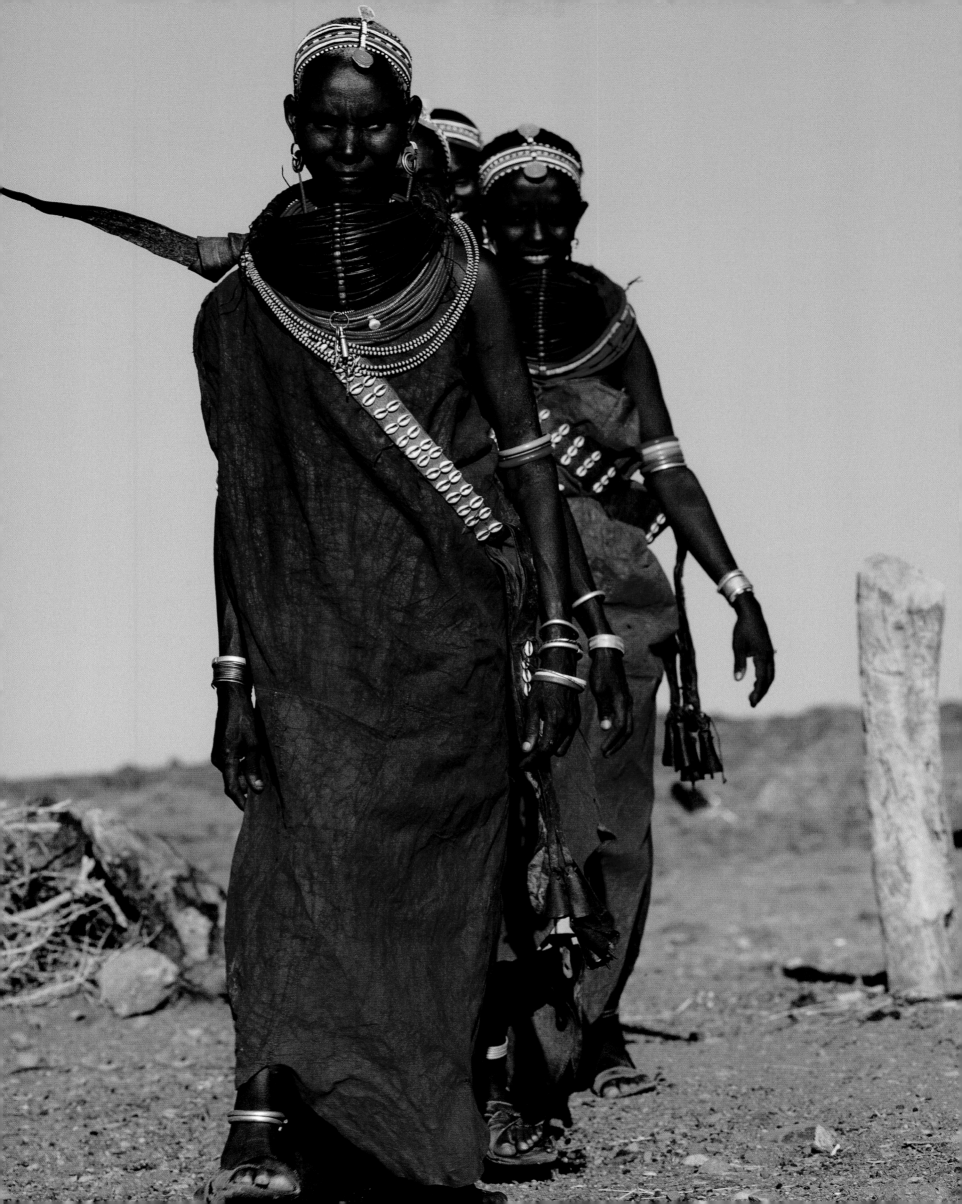

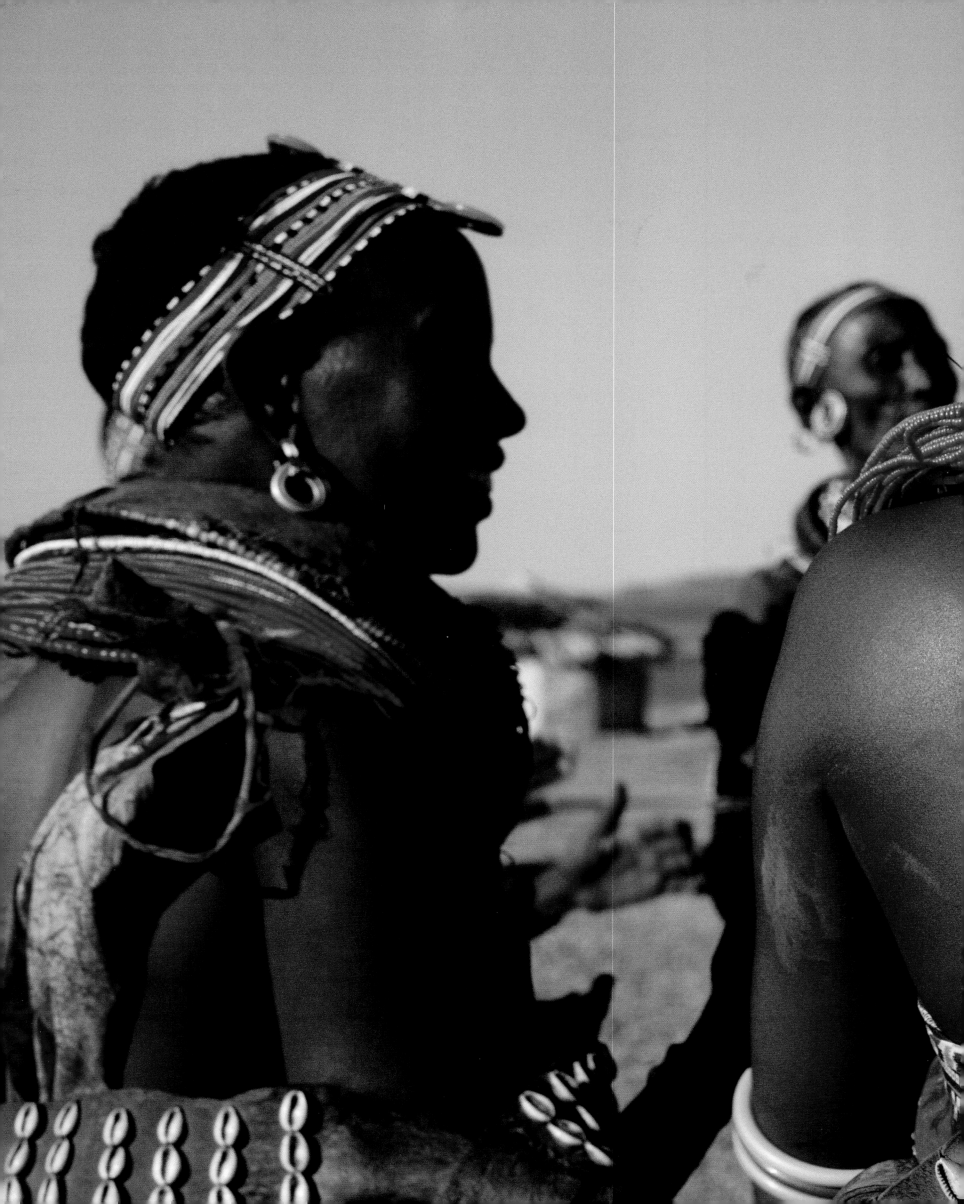

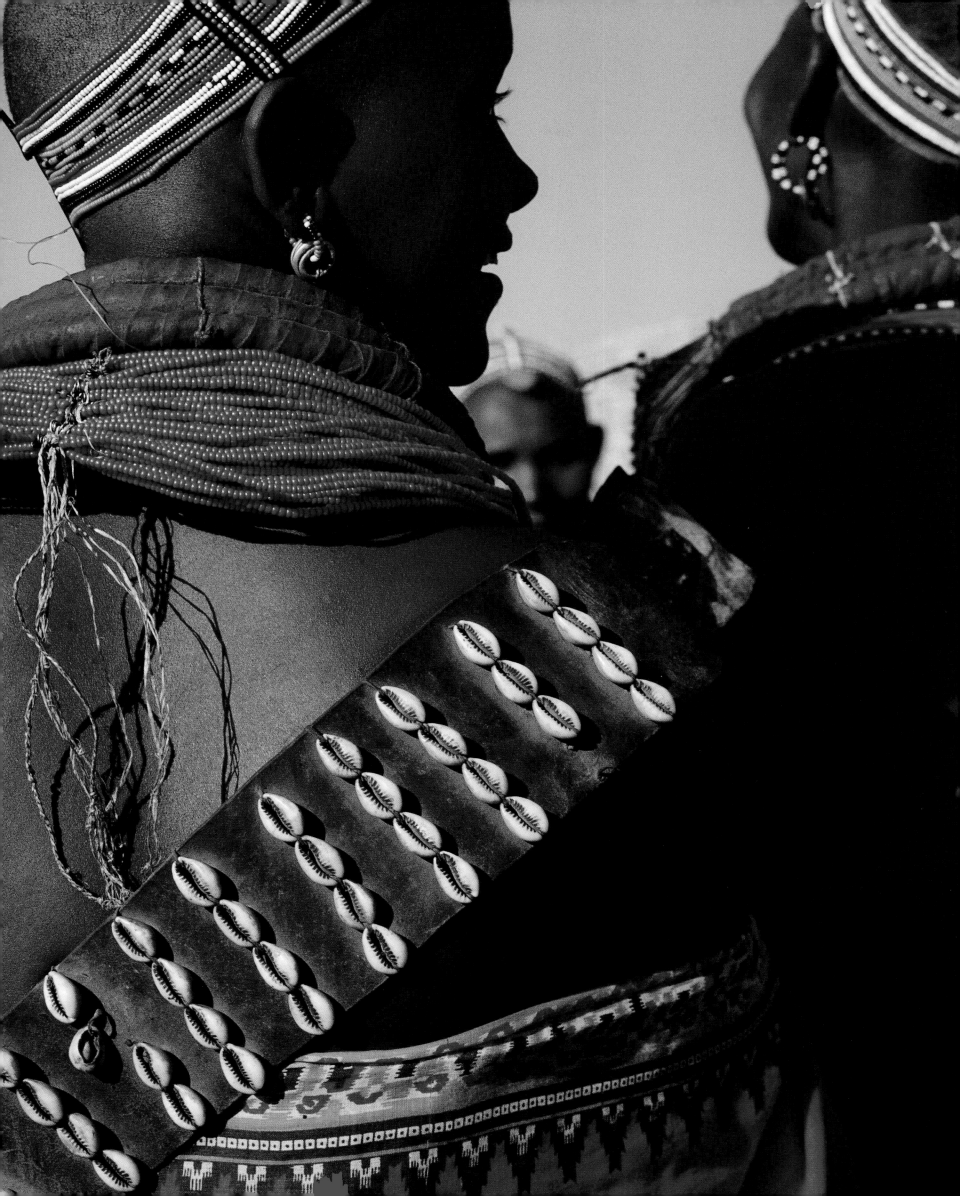

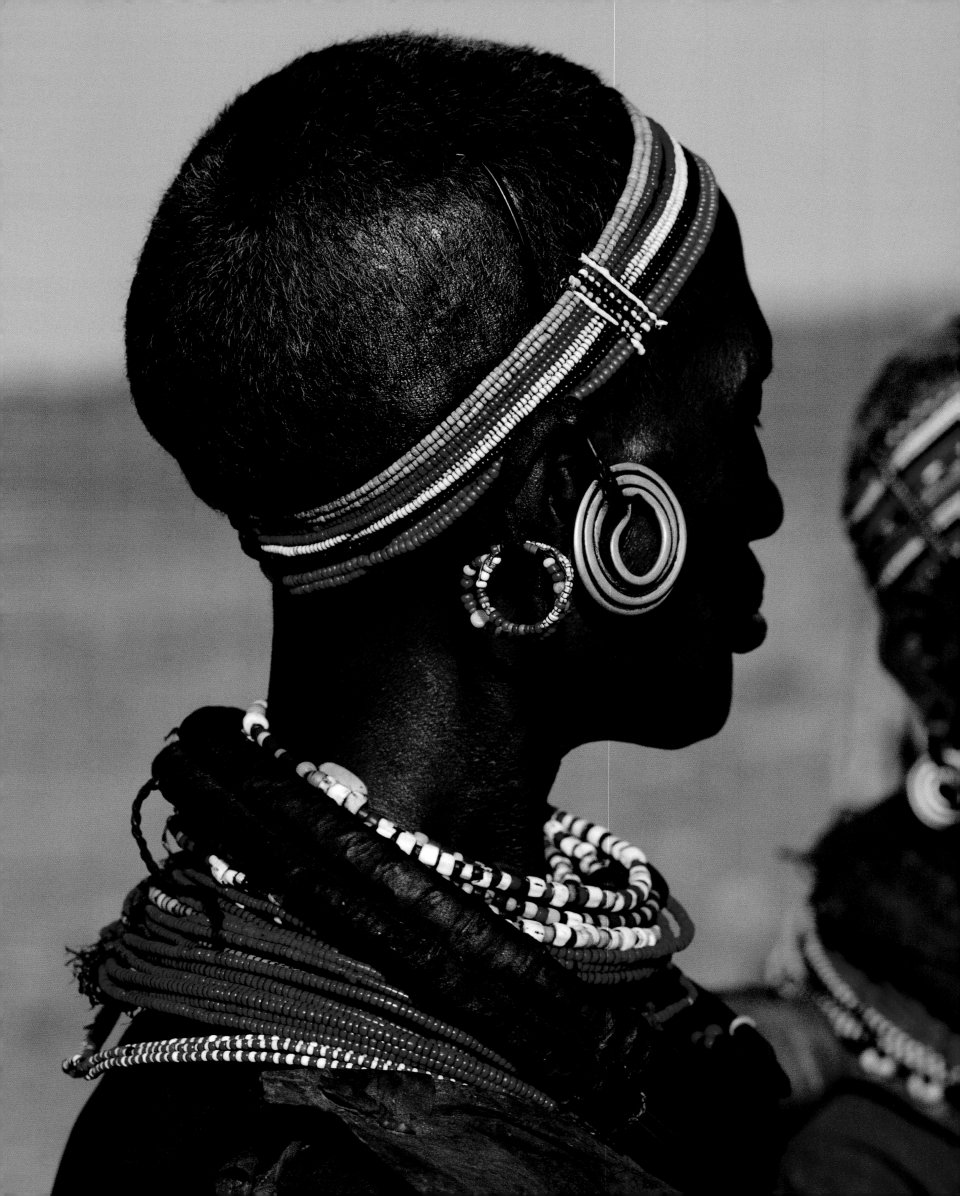

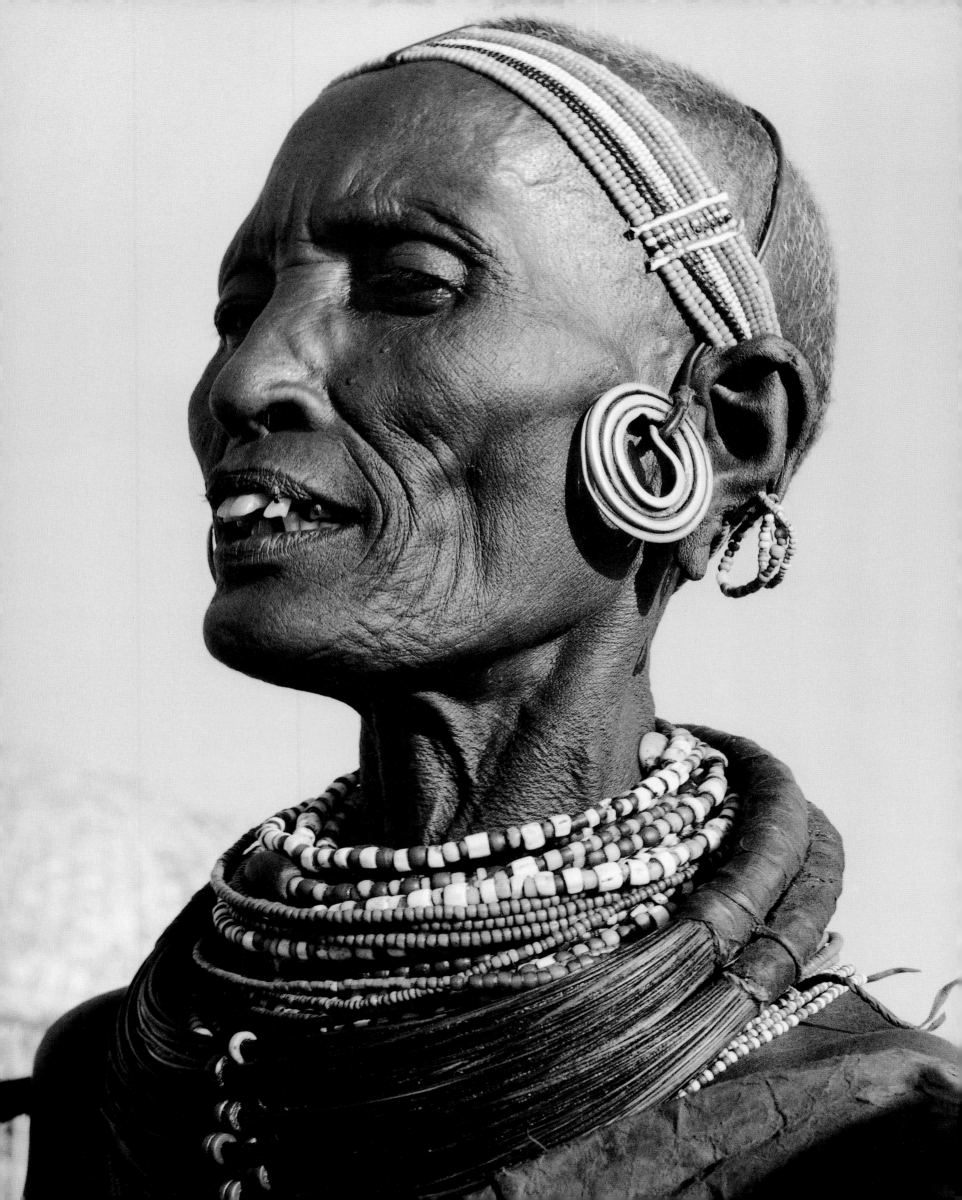

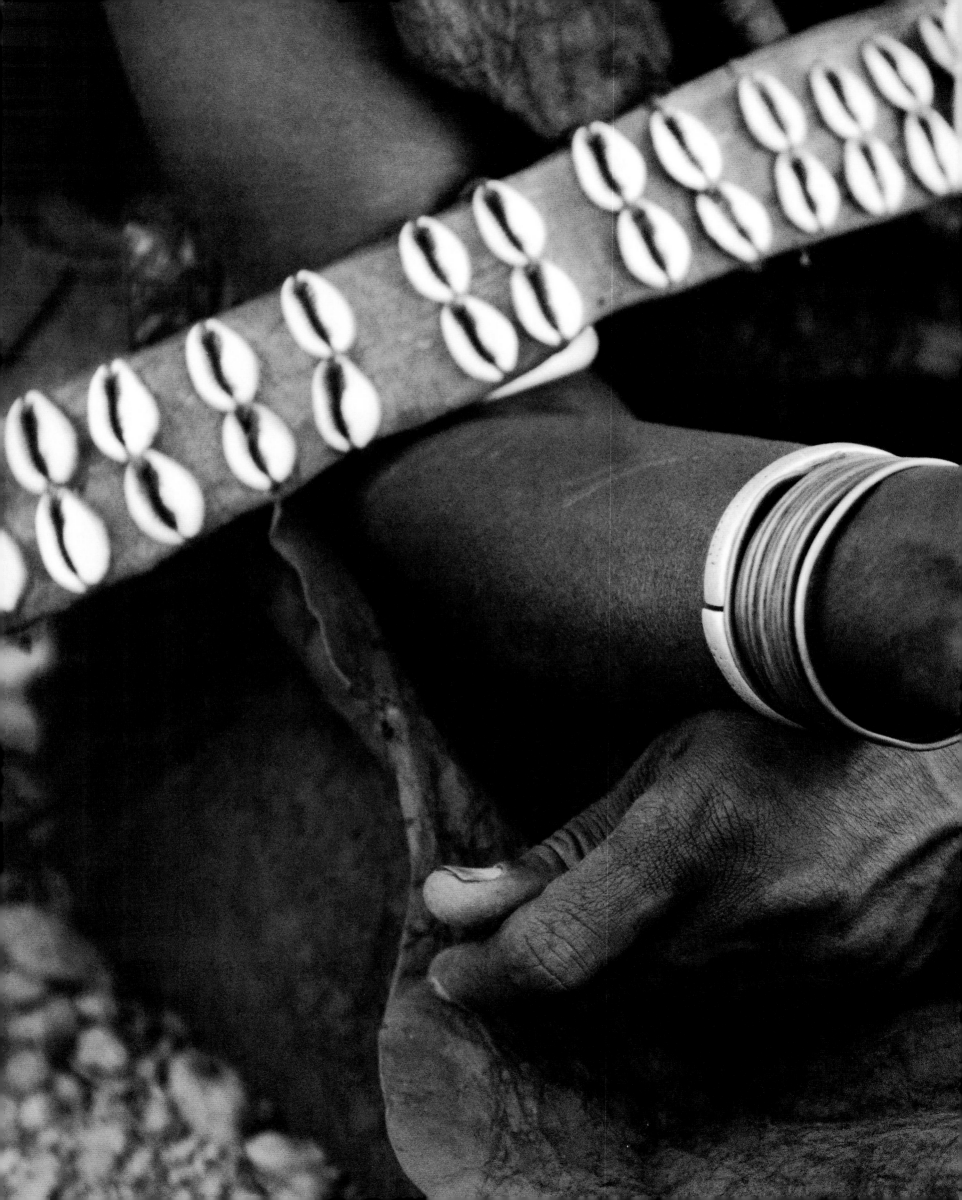

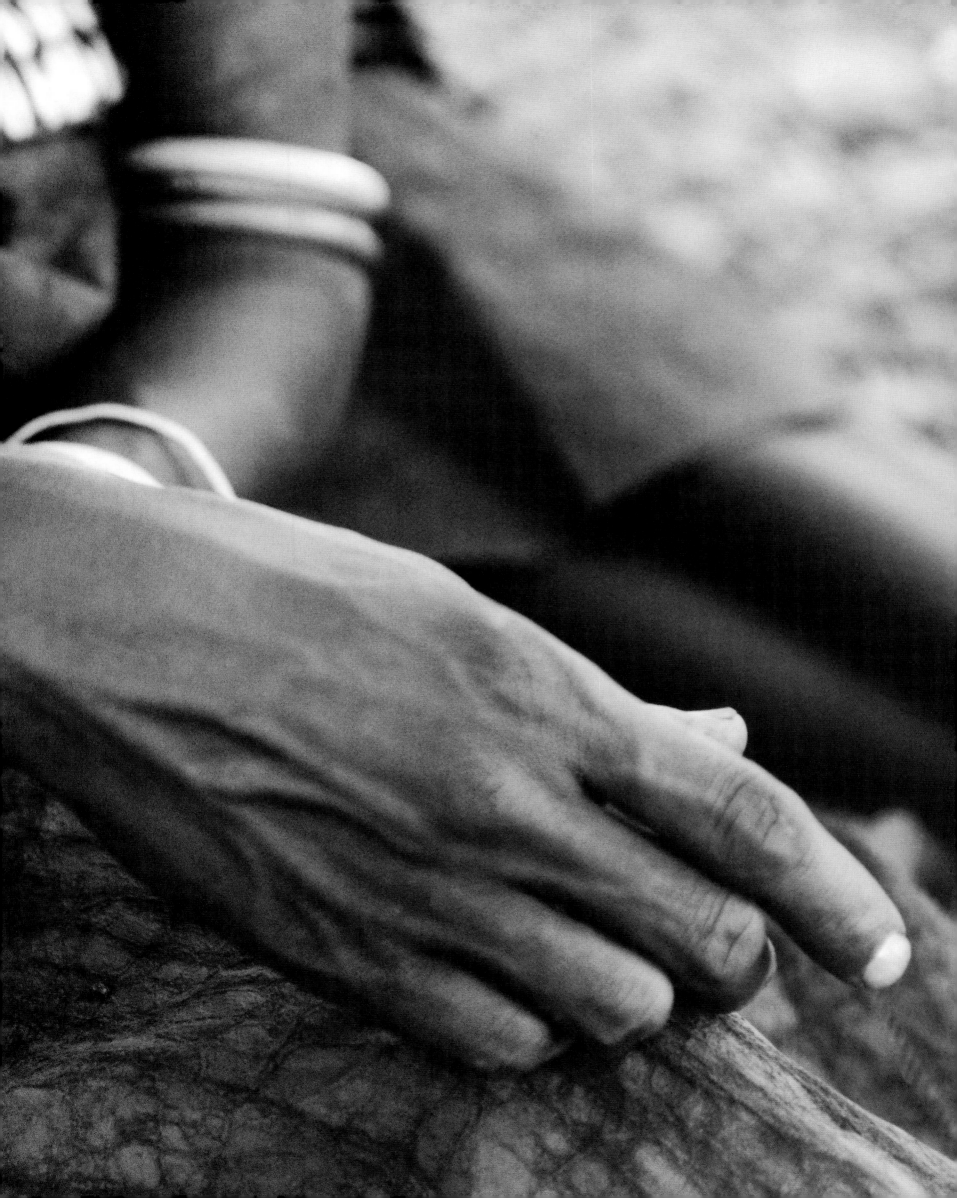

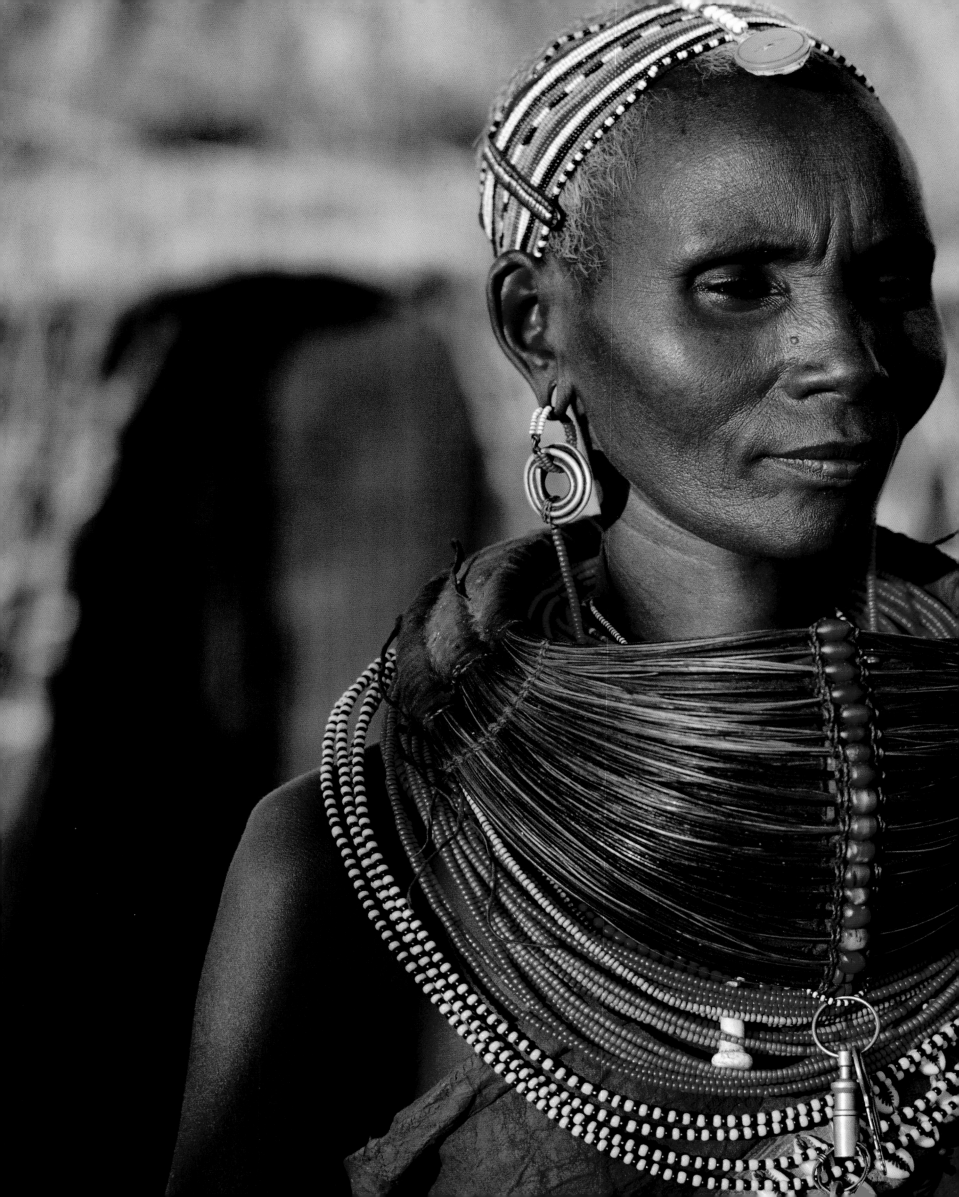

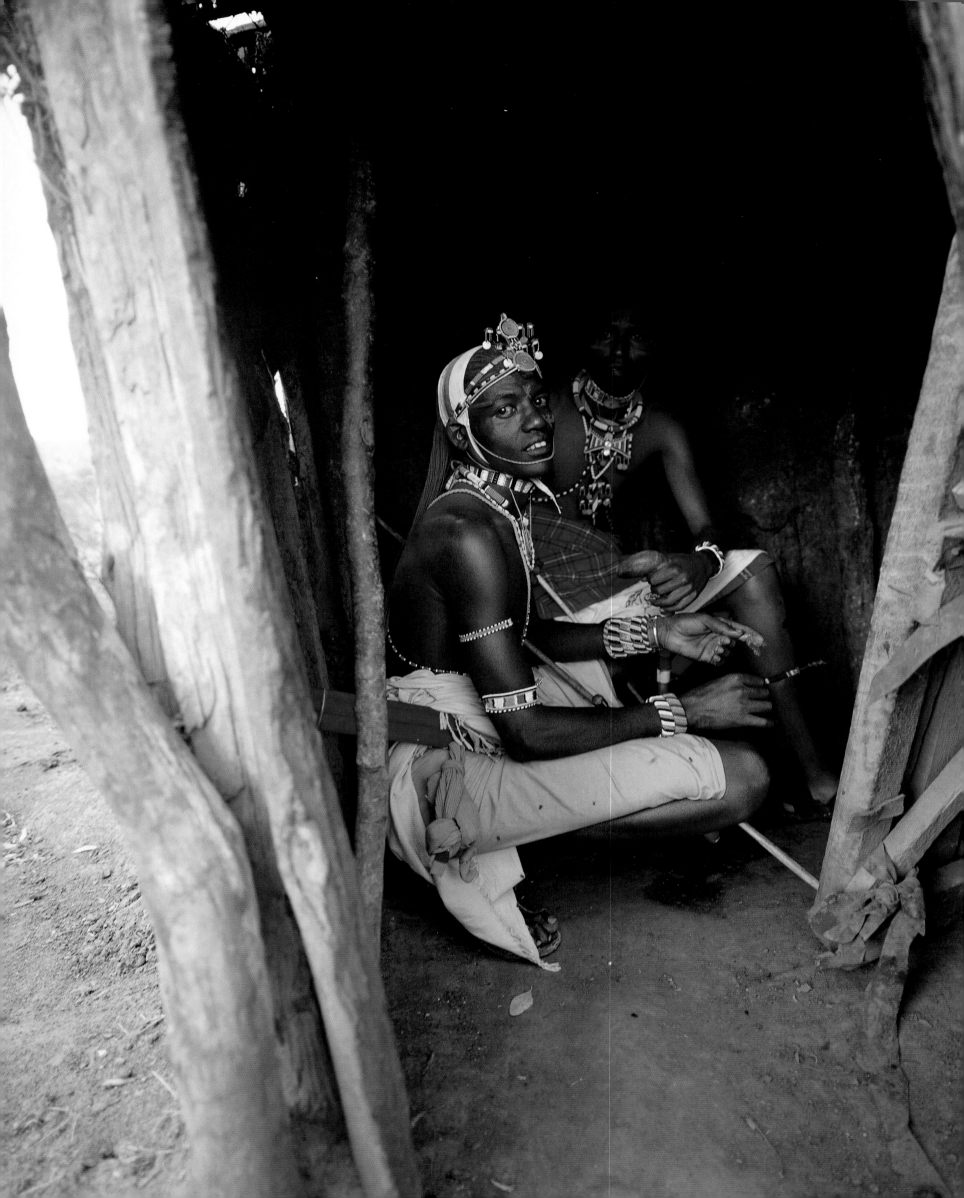

SAMBURU

The Samburu are presumably close relatives of the Maasai, but ethnologists are not prepared to pin themselves down. They may just be Maasai with a few unusual features. It is not clear when the Samburu broke off from the Maasai mainstream, remaining in northern Kenya while other groups moved south with their cattle, deep into Tanzania. Is this enough for them to merit a place of their own on the ethnological map of Africa?

The name *Samburu* is a bit puzzling as well. Probably the most attractive explanation is that the name is said to signify "butterfly", an allusion to the Samburu's gentle, refined manners. Indeed they are seen as less belligerent than the "real" Maasai. But, as to language, lifestyle, social structure and appearance, they are almost identical to the latter. Most Kenya tourists don't realize that many of the Maasai they snap are actually Samburu.

But, to those in the know, there are some crucial differences: young Samburu men who live with their age set, the *moran* (warriors), for several years in a separate *manyatta* (group of huts), spend an inordinate amount of time on body care. After each long bath they repaint their faces and bodies with artistic decorations and style their long, much-plaited hair with red ochre and fat. They compete for the attention of the young girls who come to visit them in their *manyatta*; a certain amount of sexual permissiveness is permitted, but pregnancy is taboo.

If an attractive warrior is wearing thick ivory rings in his widened earlobes he is definitely Samburu and not "just" Maasai.

Some items of jewellery, such as bangles in copper and another metal, are produced in the smithy. The craft is passed down from father to son. The apprentice takes several years to learn how to make jewellery, blades, arrow- and spearheads.

The smithies are located outside the village. The practical reason is fire protection, but there is a loftier, mystical one, too: fear of mysterious powers that the smiths are allied with – a belief occurring in many cultures the world over.

The semi-nomadic lifestyle of the Samburu is seriously threatened, especially since the horrors of the 1990s: after four years without rain and many raids by the Pokot, their herds shrank from 100,000 to only 10,000 head. Is the butterfly losing its wings?

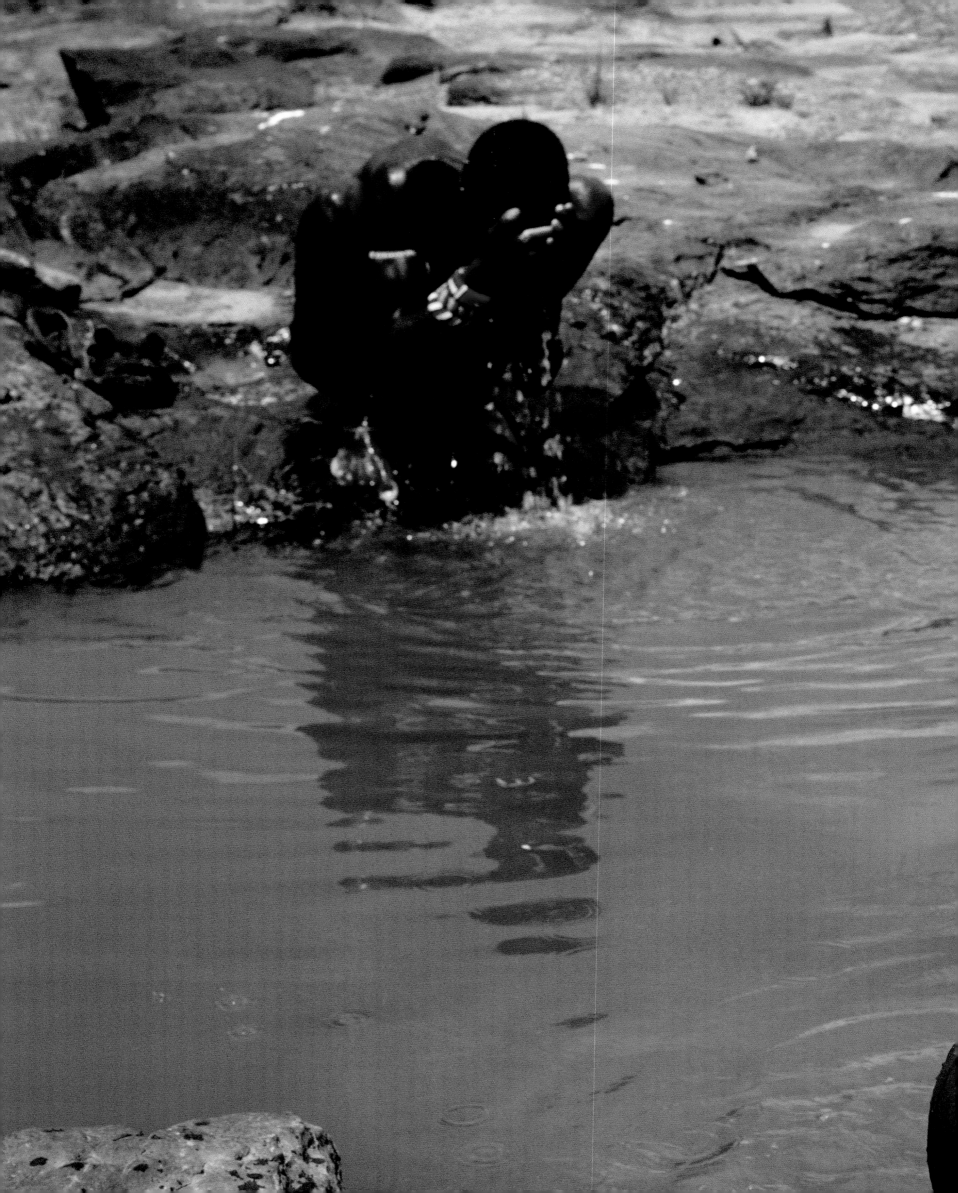

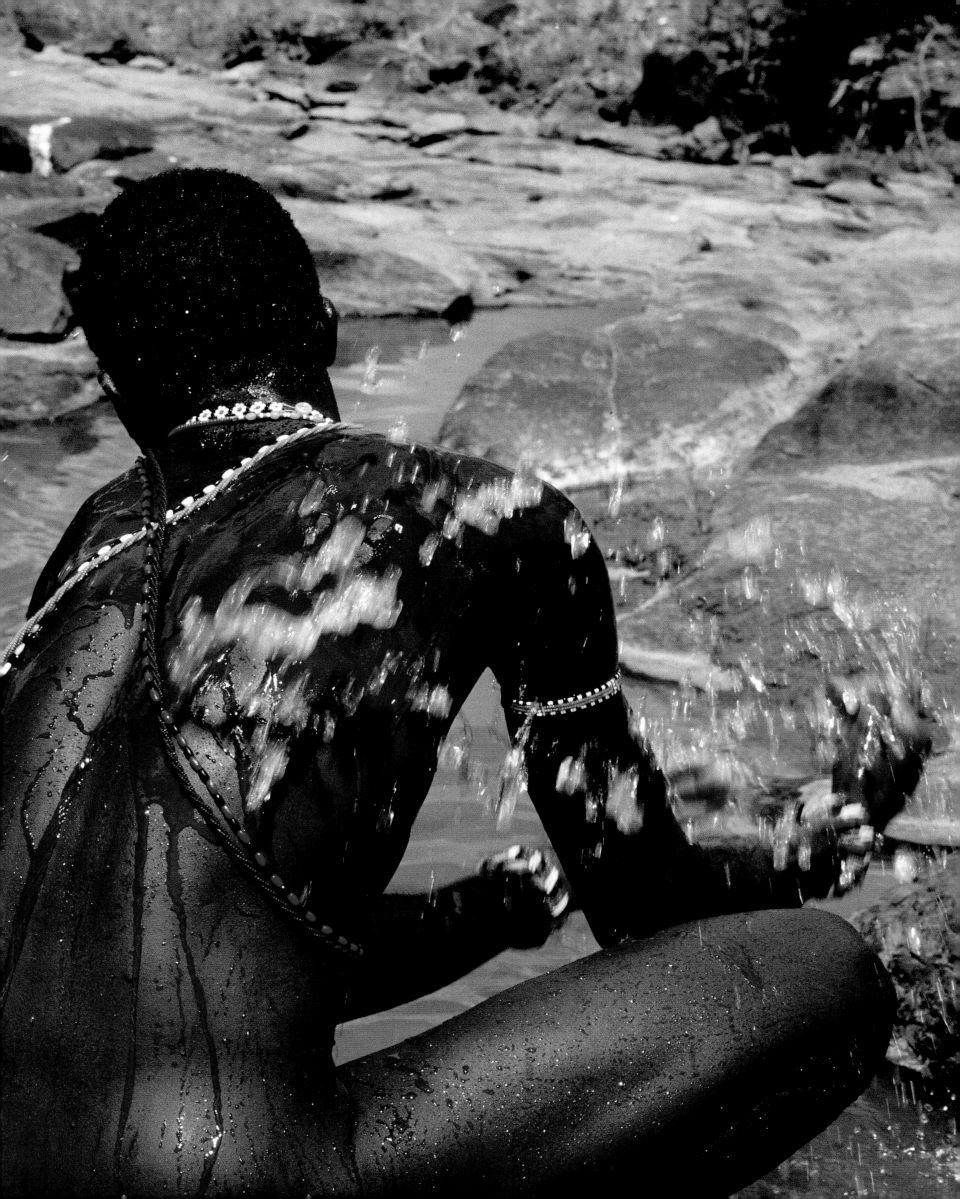

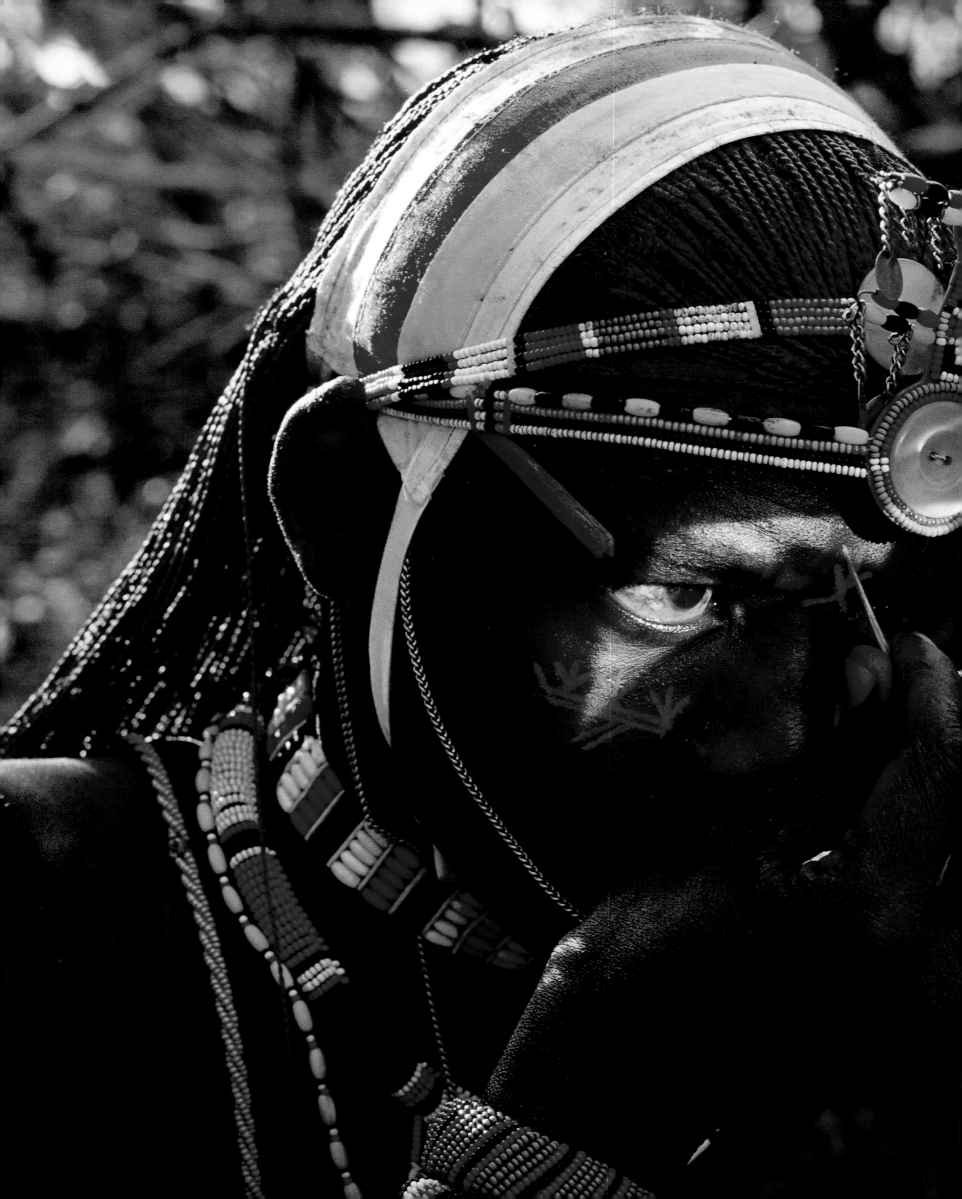

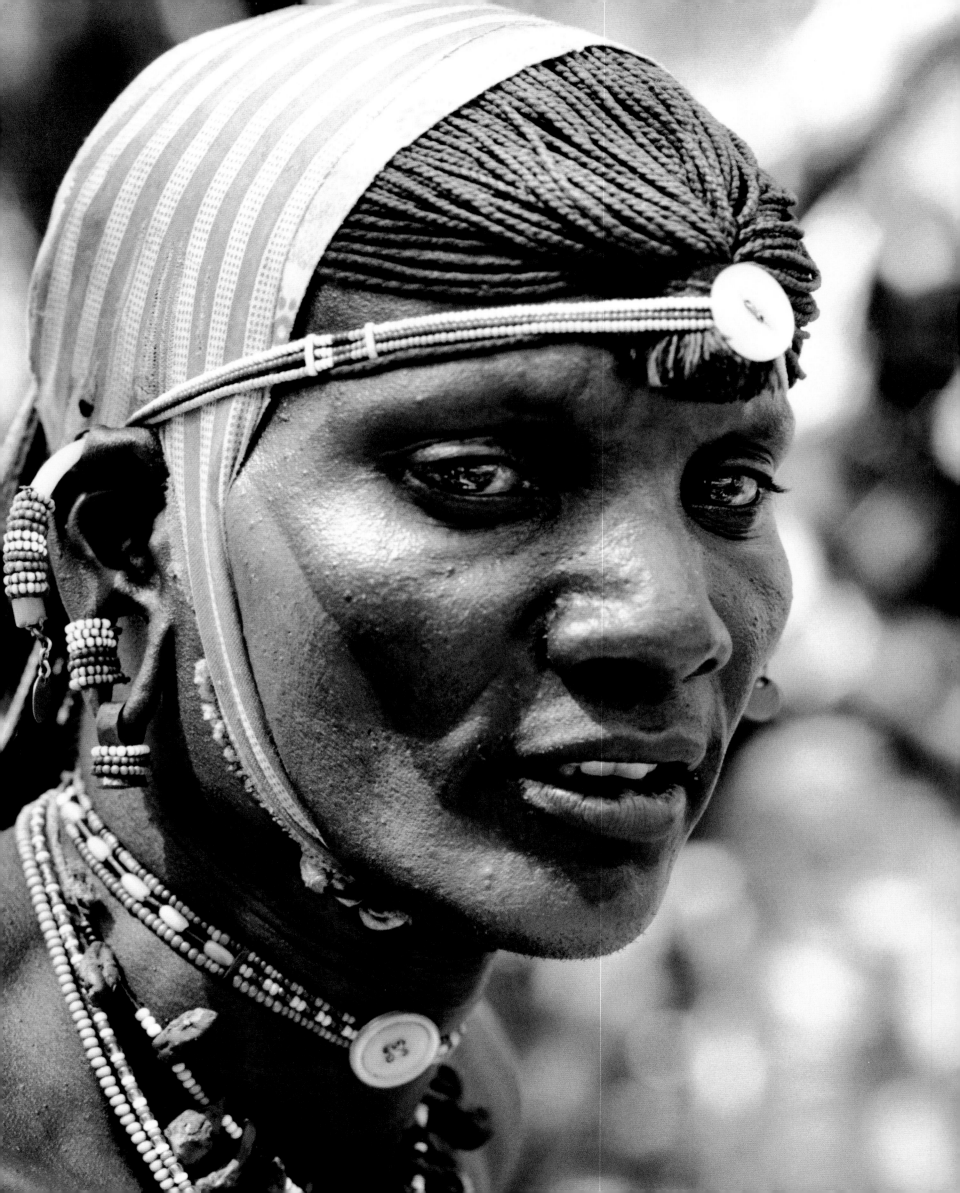

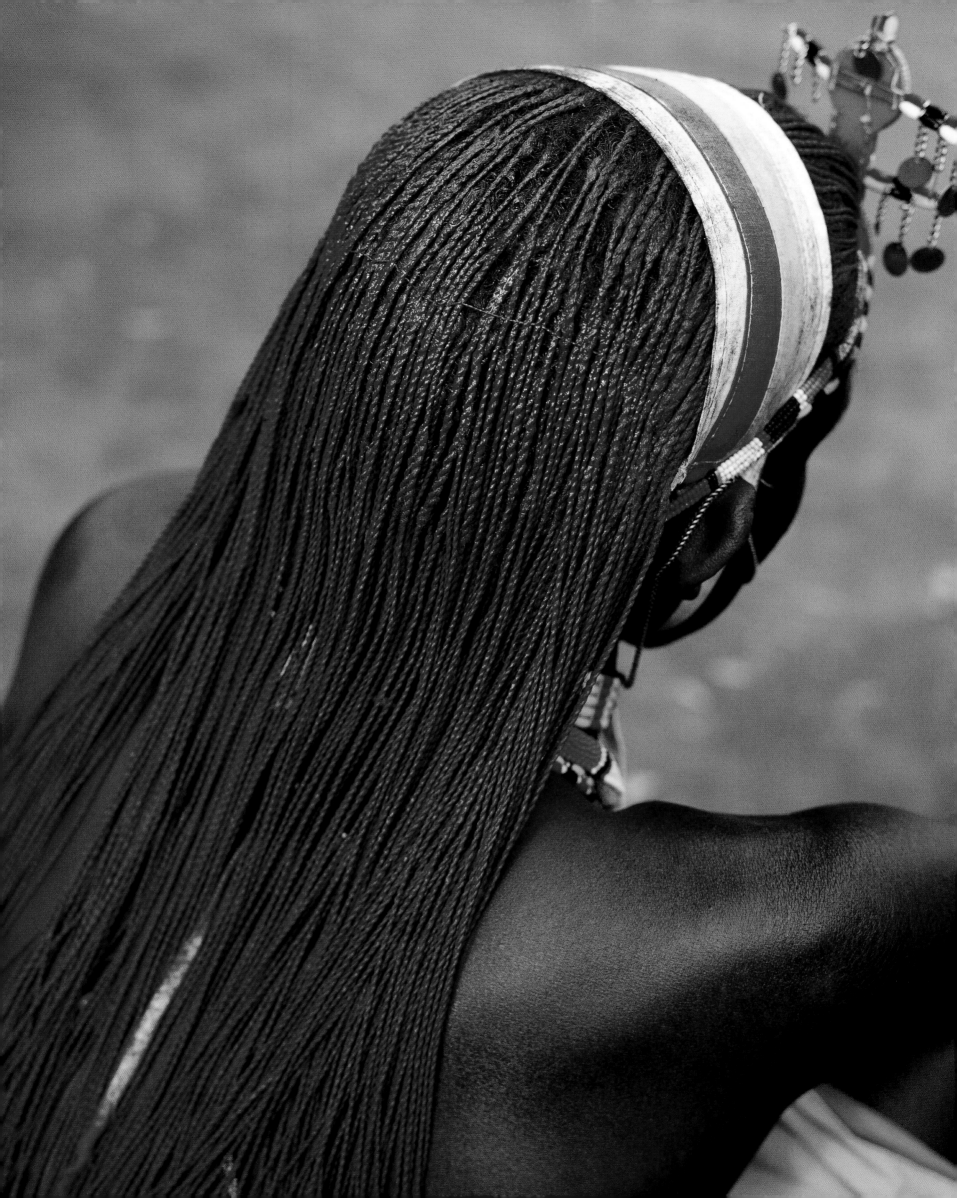

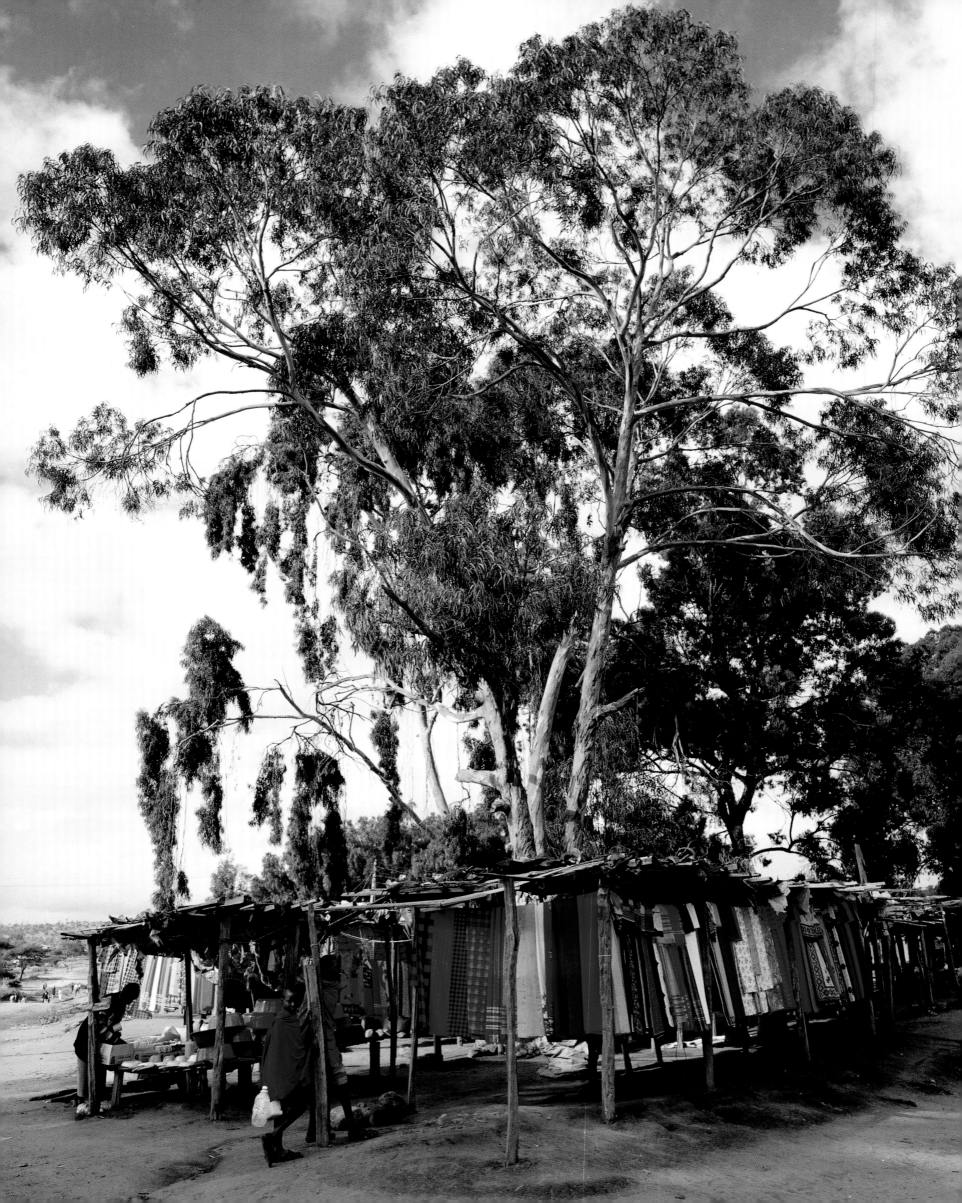

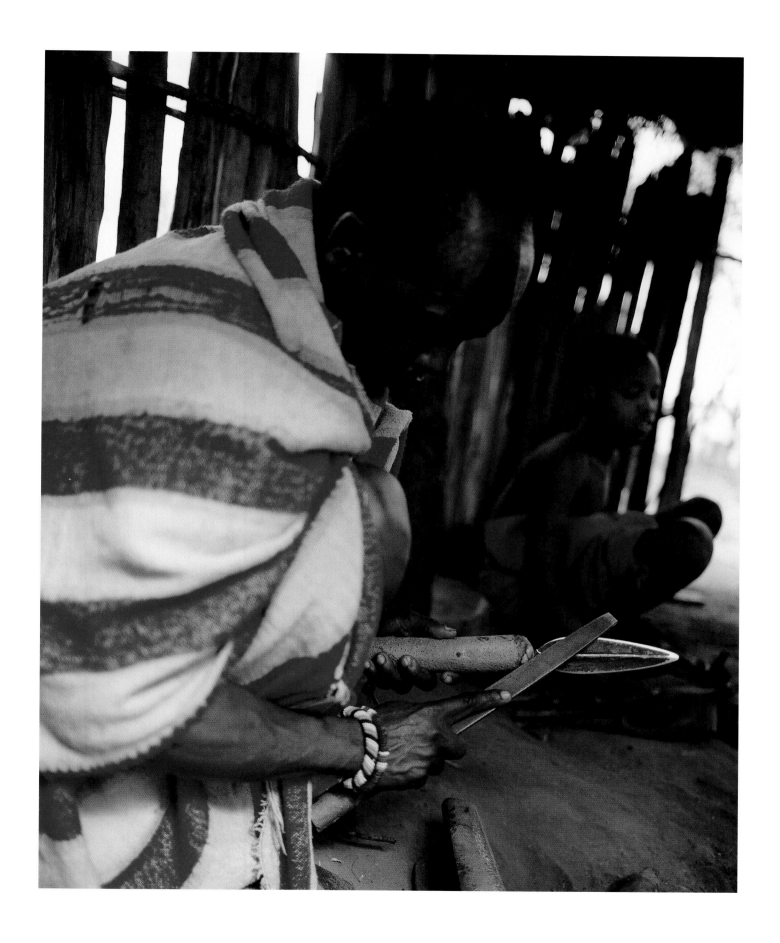

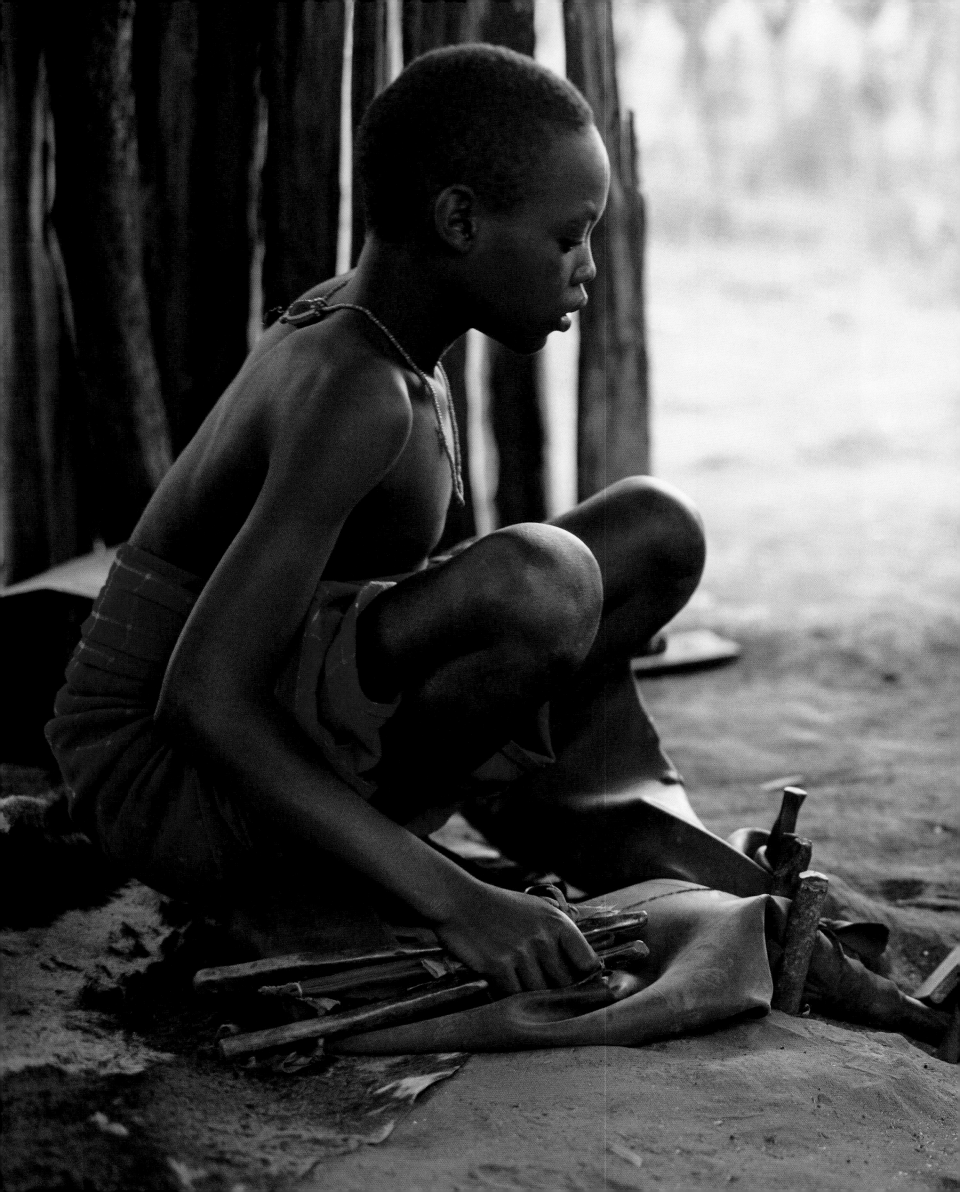

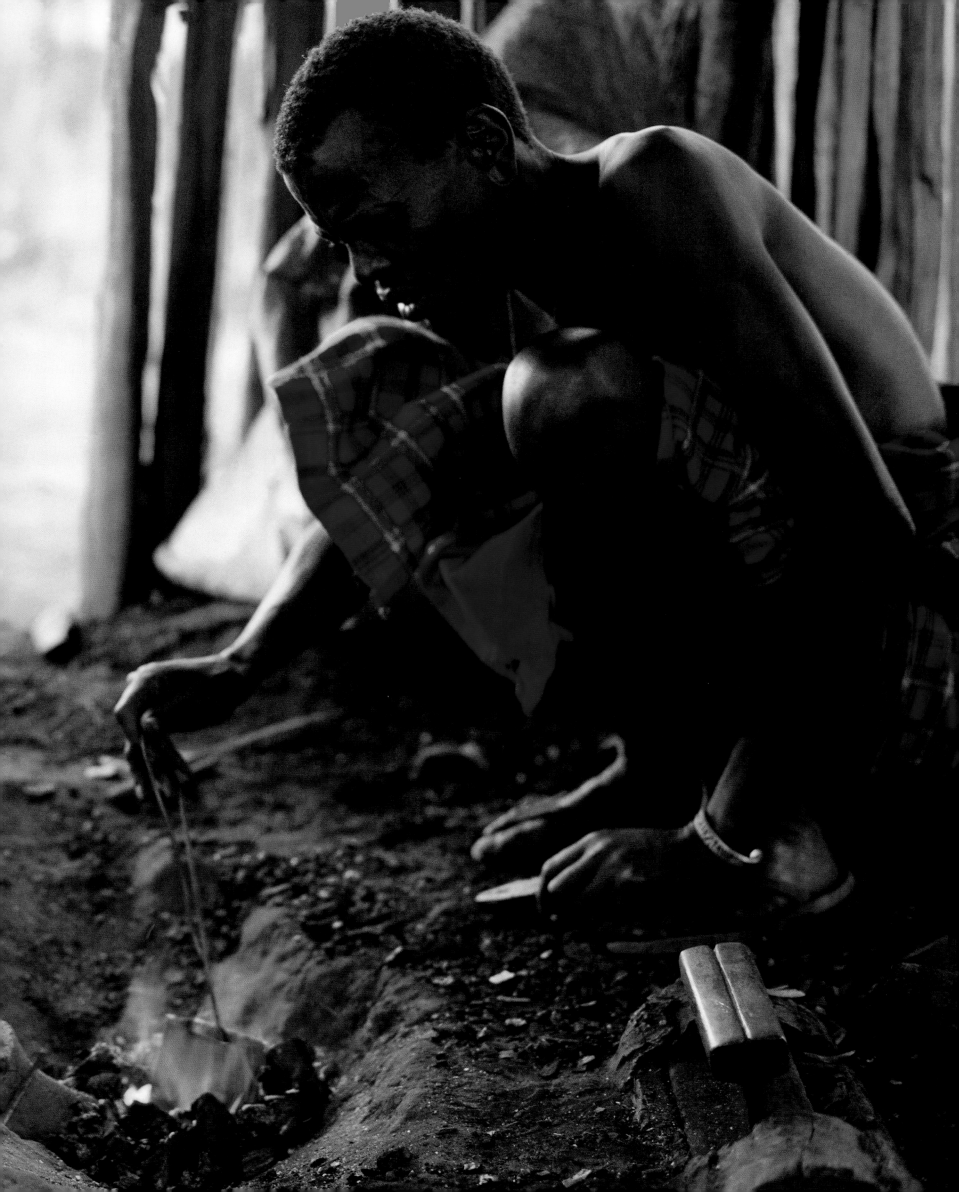

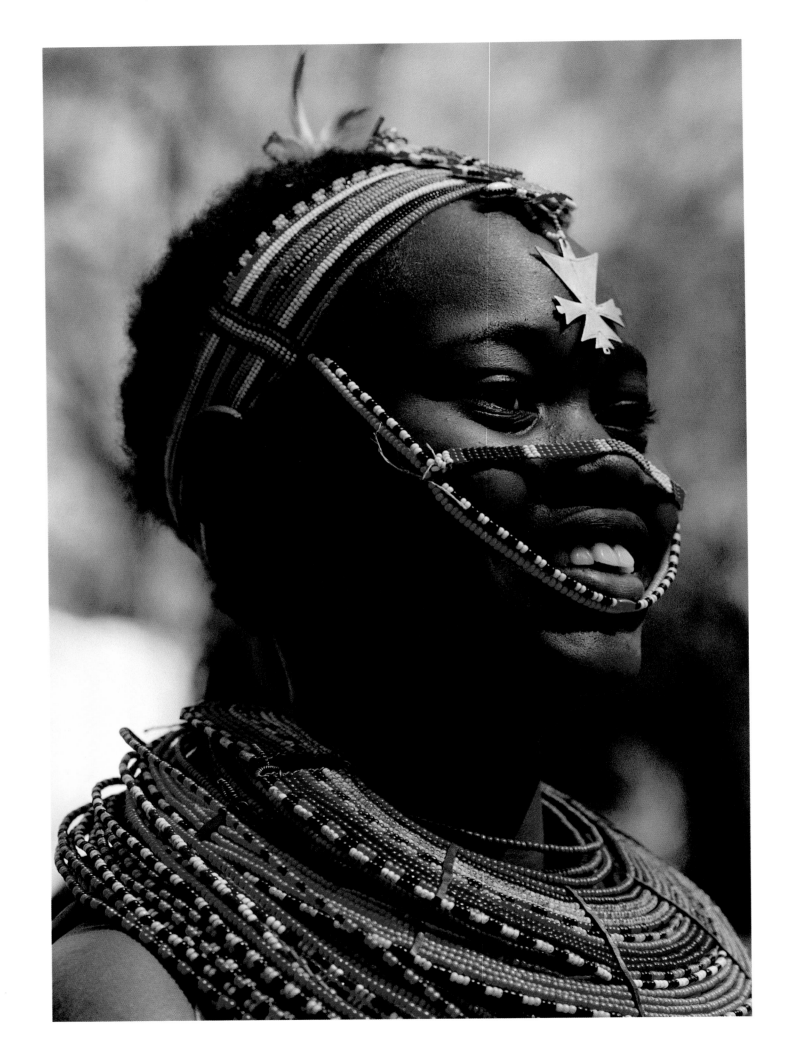

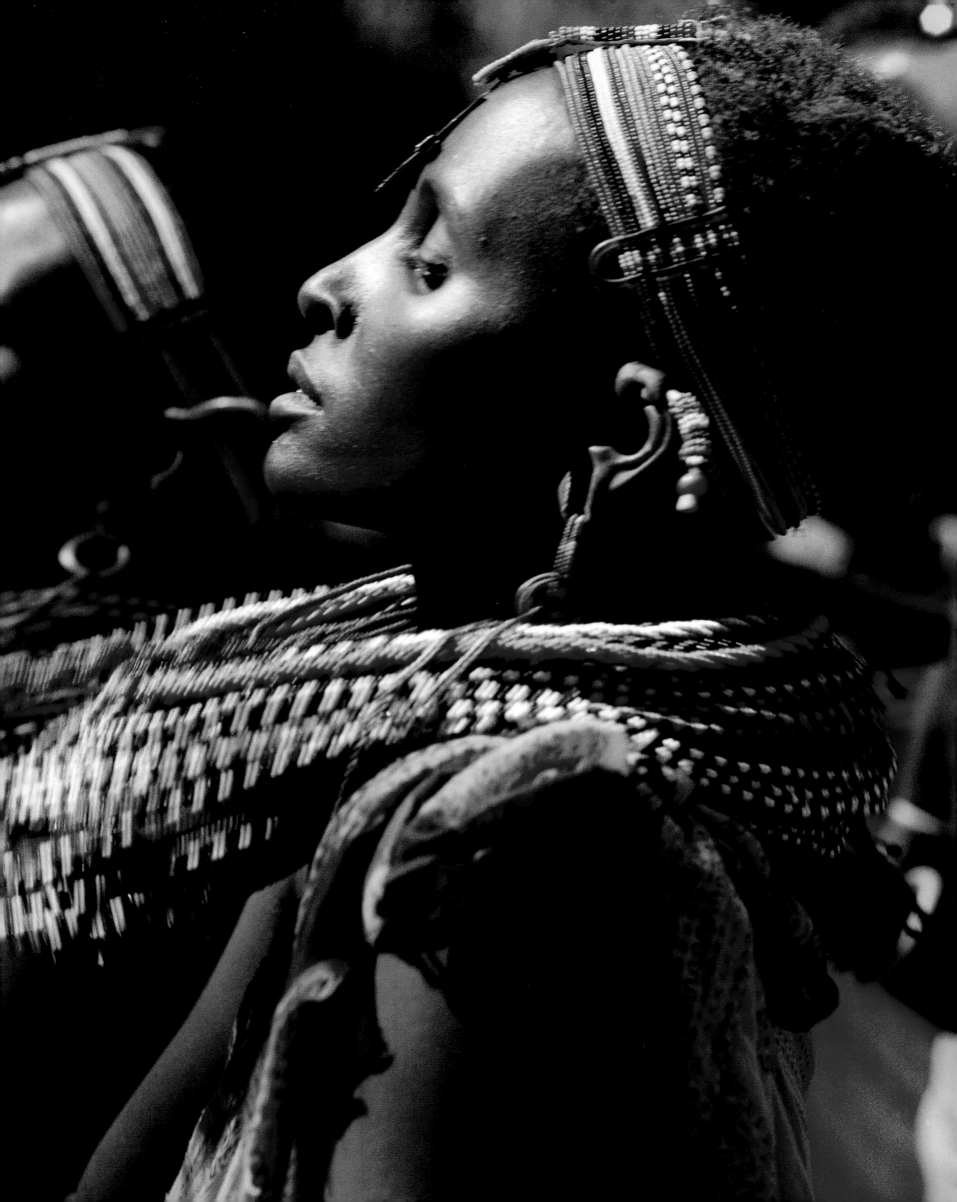

THE SODA LAKES

For nature-lovers, the soda lakes simply mean flamingo lakes. This creature's miraculous, pink existence is based on the shortest food chain imaginable. At some point or another, we lay-biologists grasped what a food chain is. For example, grass-gnu-crocodile or ice algae-krill-whale: a sequence of eating and being eaten. In any case, it almost always begins with something green and ends with a carnivore.

When the chain has a lot of links, it sometimes ends up with just *one* specialized, illustrious "end-user". An osprey, for example, pouncing on a heavy pike represents the end of a series of links that starts with plankton and extends through entomostraca, dragon-fly larva, white fish and trout, right into the osprey's talons. Countless primary producers (in the present example, green algae) feed only one osprey per lake. Many middlemen reduce the final yield.

In the case of very short food chains, things are distinctly different. The most famous example of a highly productive food chain with only two links in it is provided by the soda lakes in the African savannah.

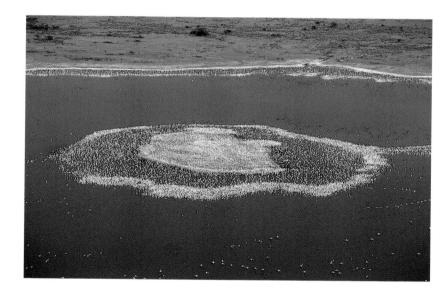

Only a few plants can survive in the highly alkaline soda water; but the ones that do have no competition and thus flourish. In the soda lakes the blue algae called *Spirulina platensis* have won the "who-can-take-the-most-soda?" competition.

Dense swirls of algae sometimes transform the water into a soup, which only the lesser flamingos can do anything with. And because they have no competitors trying to feed on this nourishing green gruel, the famous swathes of pink accumulate to form the end of this two-link food chain.

The beaks of these shallow-water specialists work like presses: the tongue pulsates rhythmically to push the water out of the slimy mass of algae, and the green mash disappears down the bird's throat. 450 grams of dry weight per square metre of lake surface are roughly what a lesser flamingo would call a good pasture.

Up to one-and-a-half million of these extraordinary birds have been counted on Lake Nakuru. And there are still many thousands of active pairs on the much smaller Lake Bogonia.

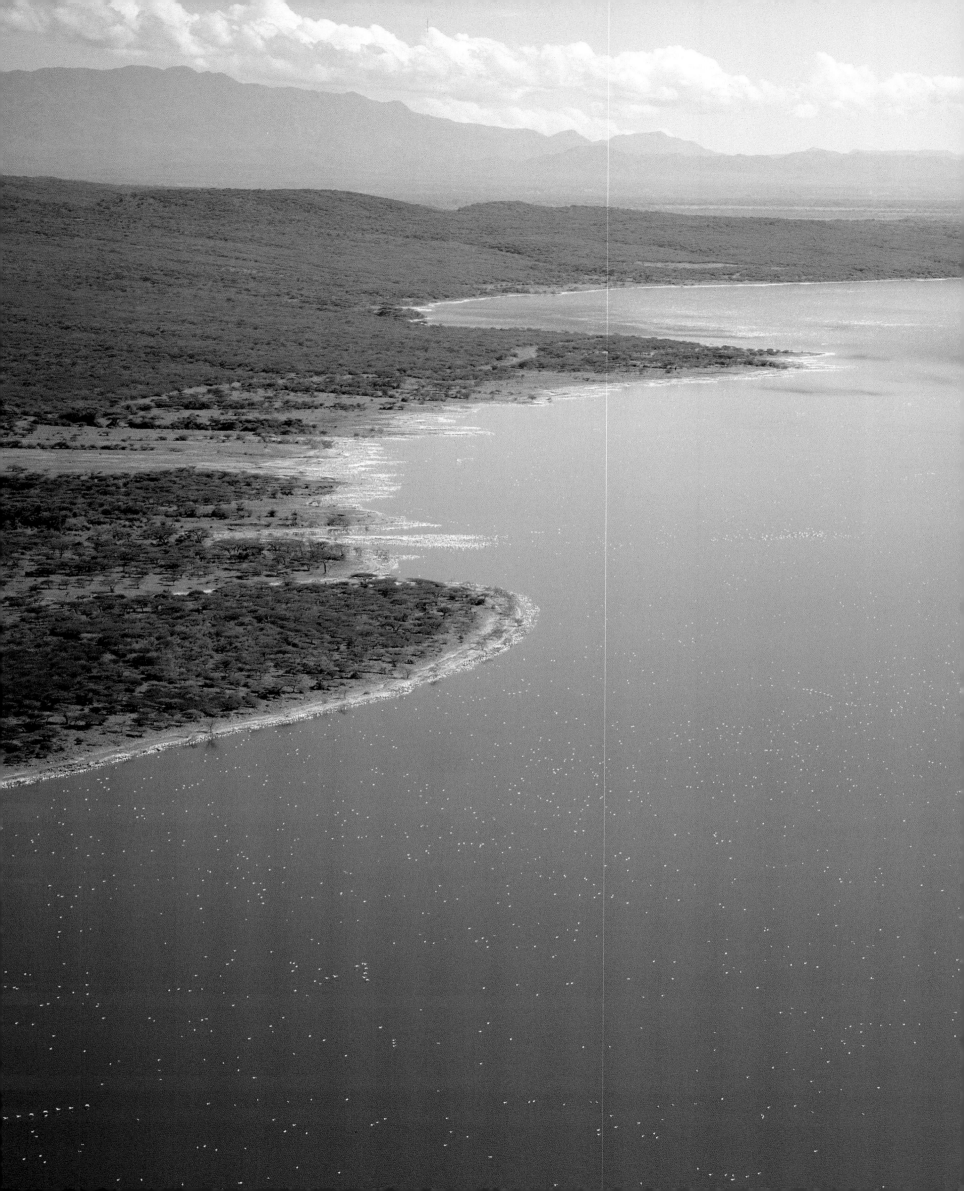

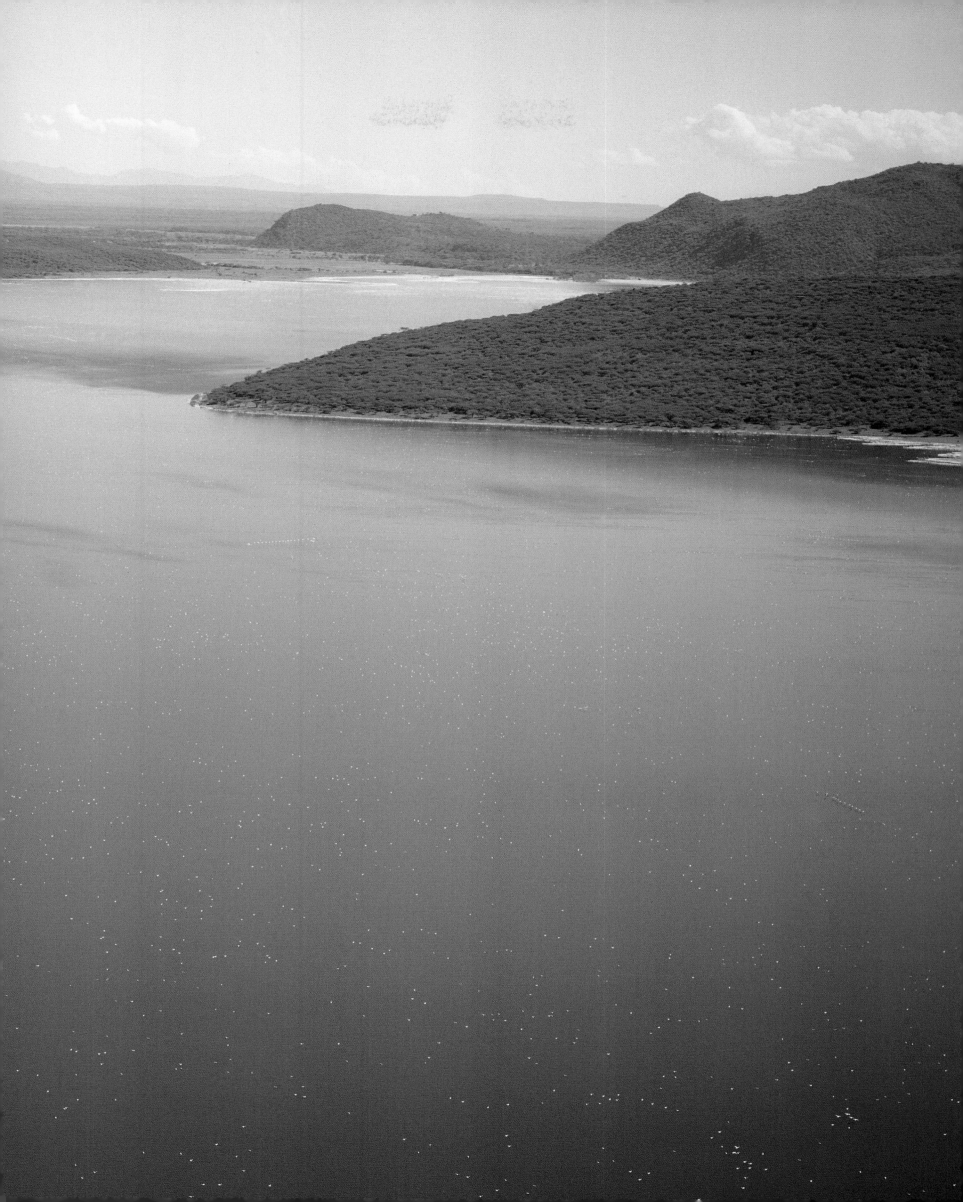

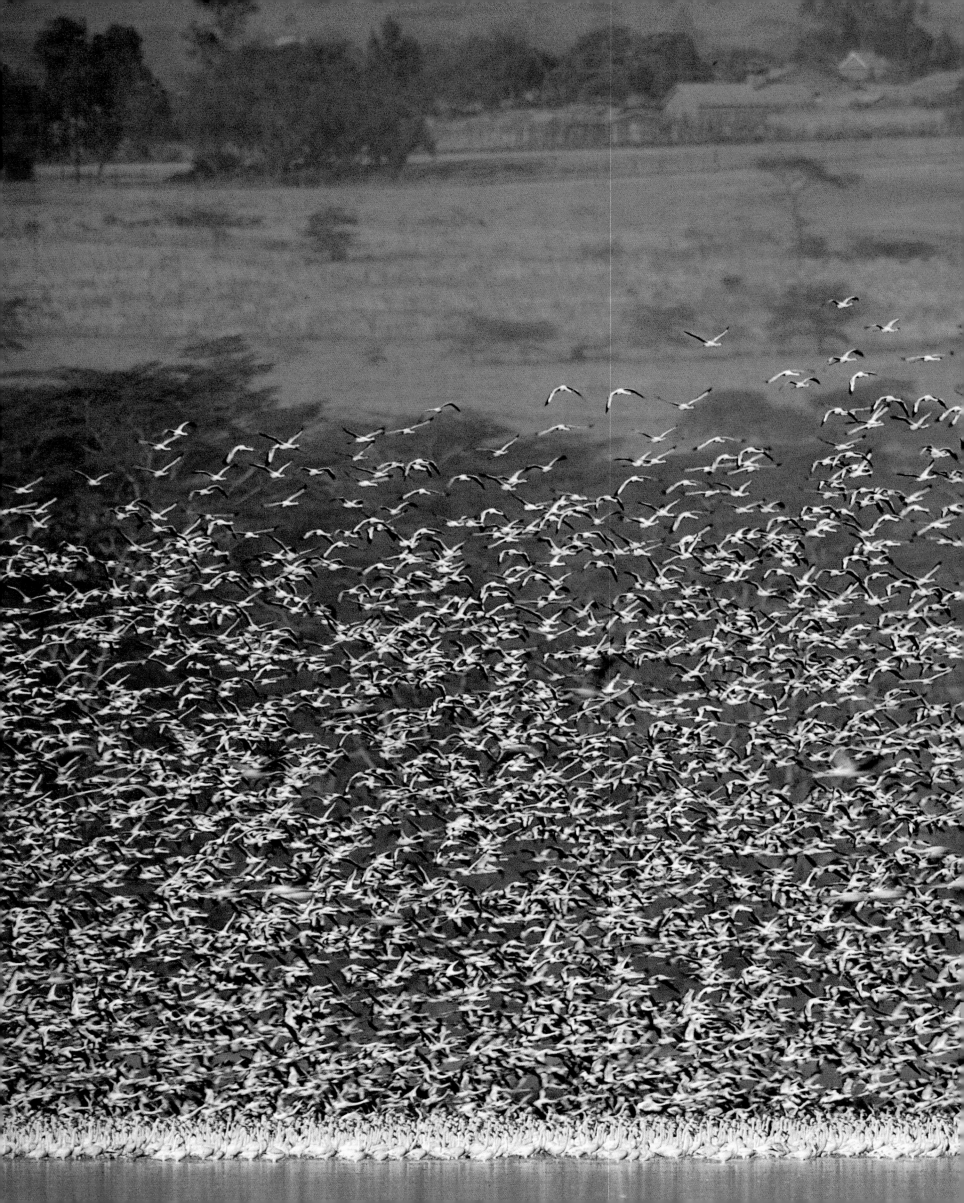

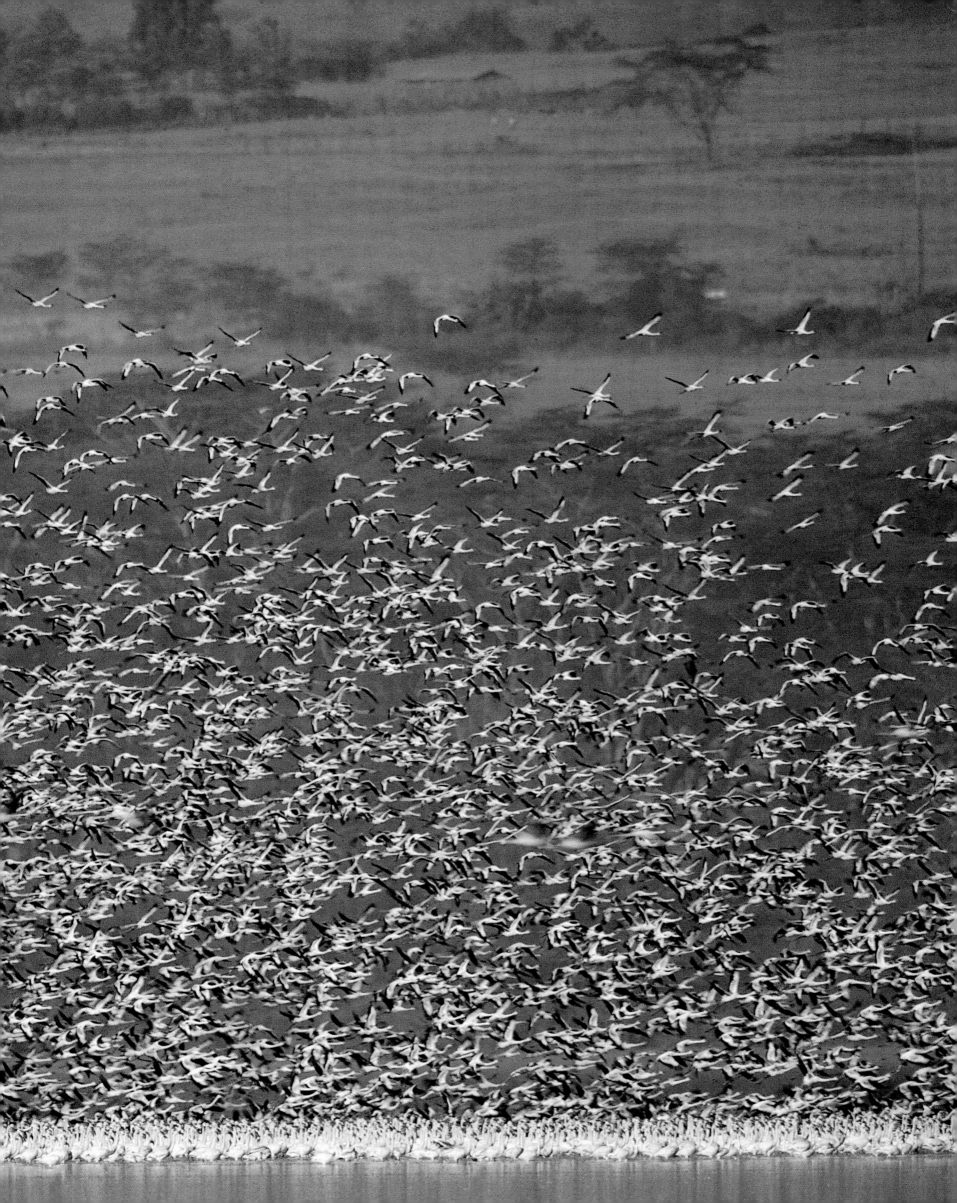

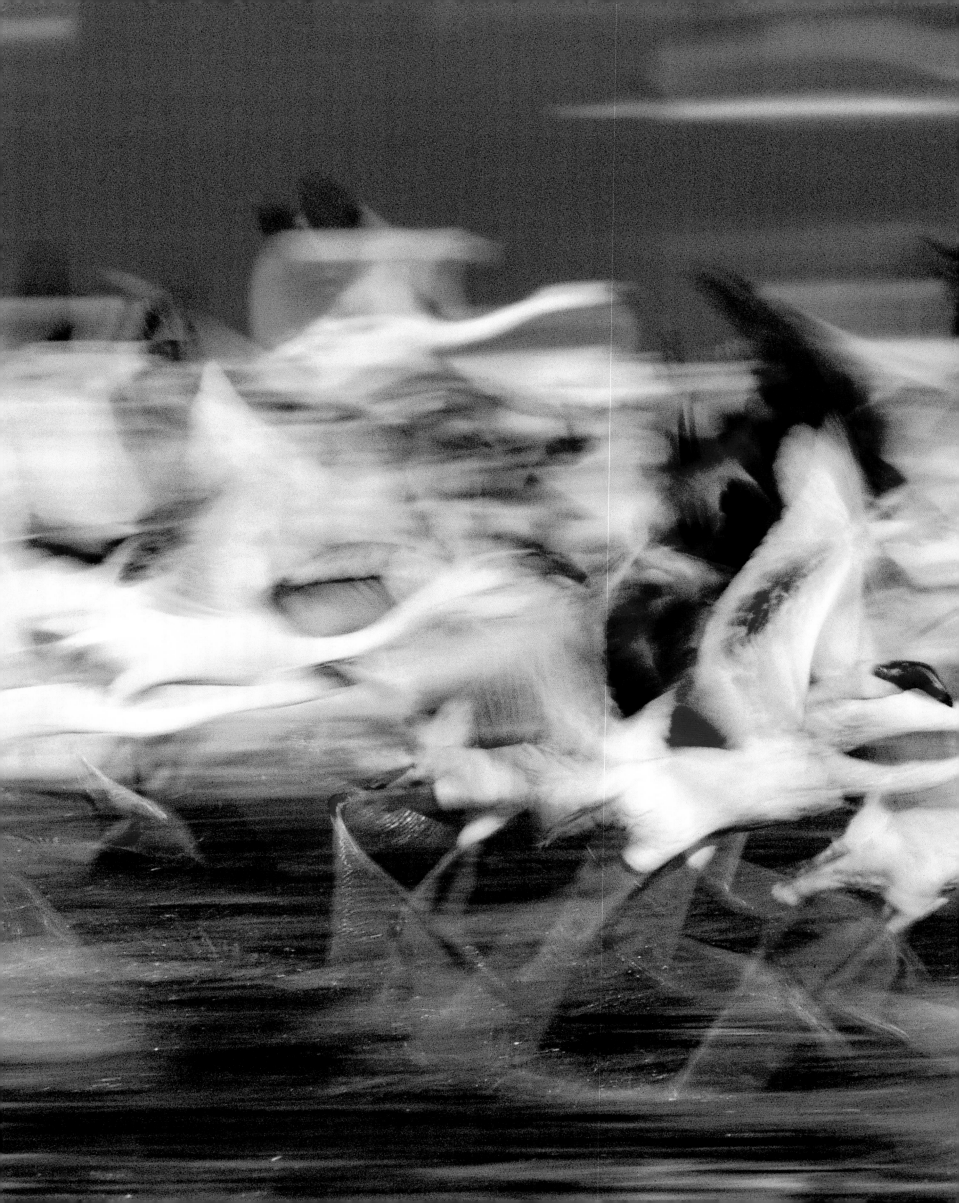

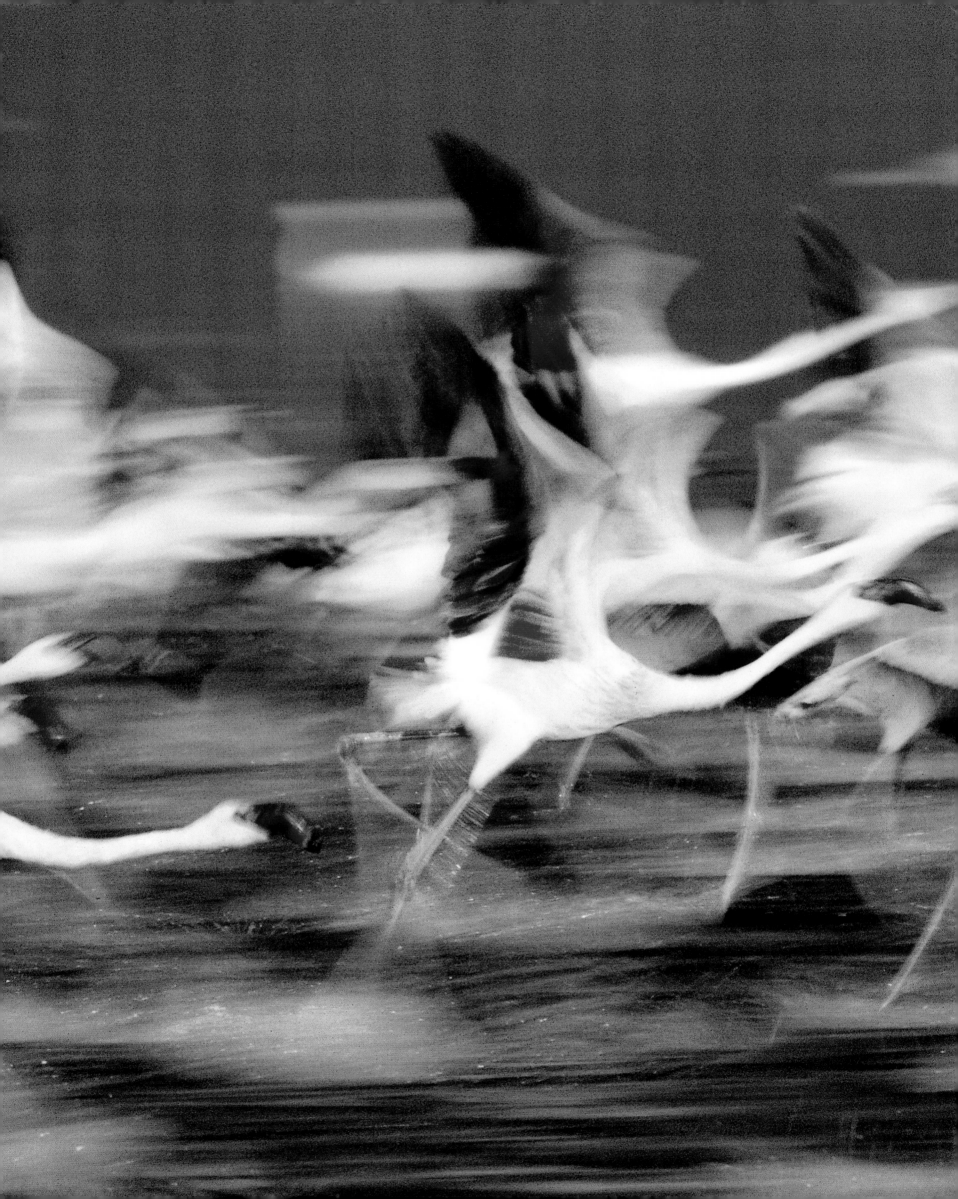

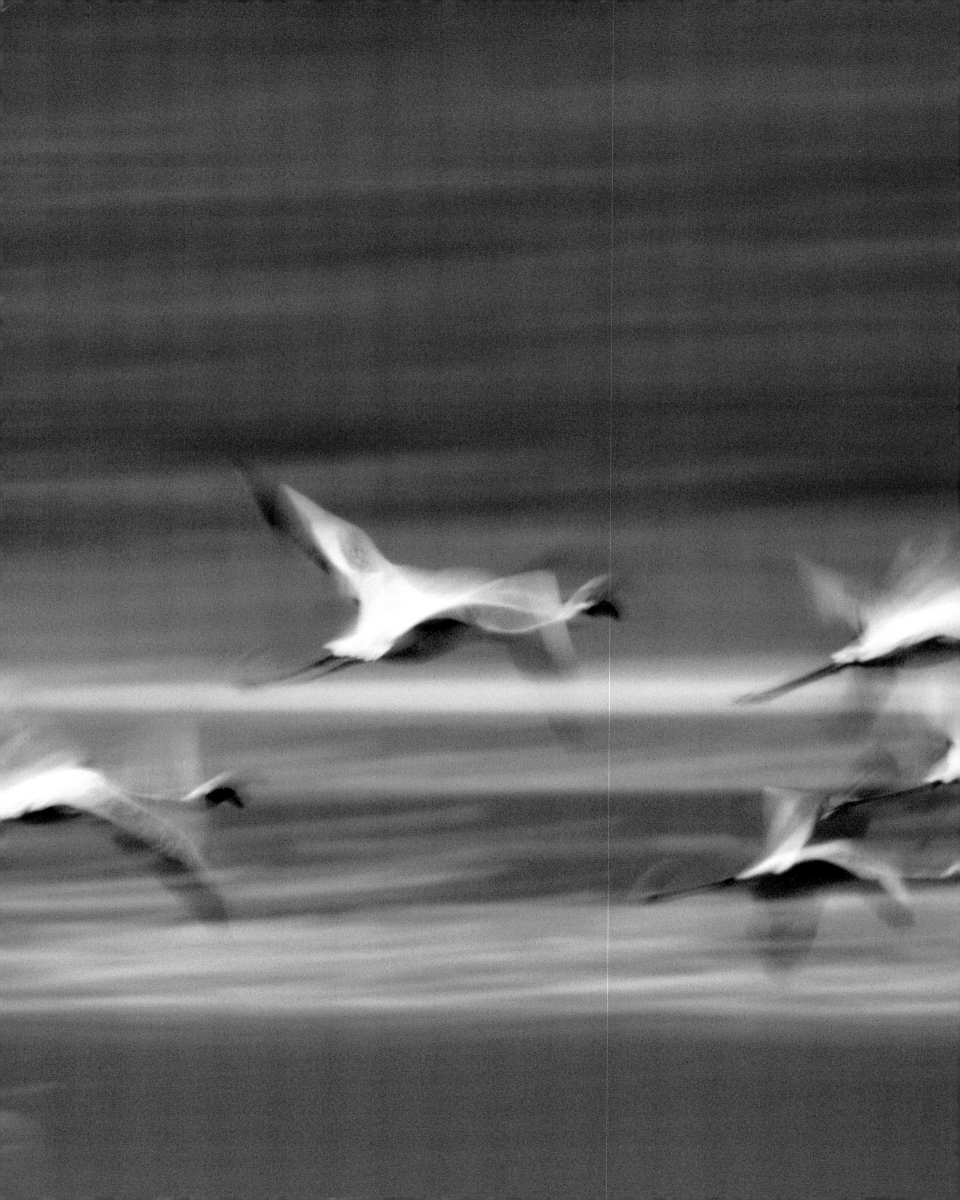

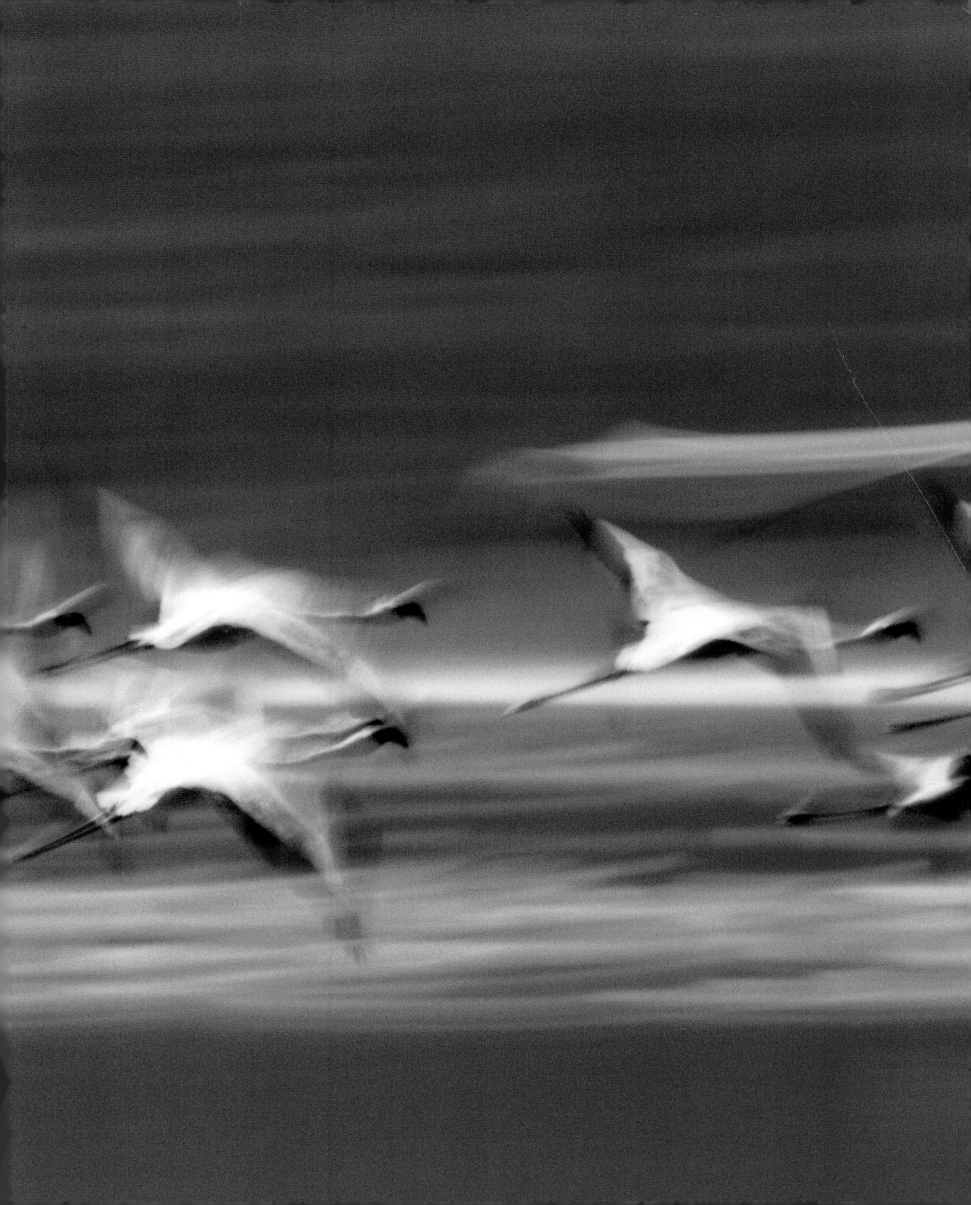

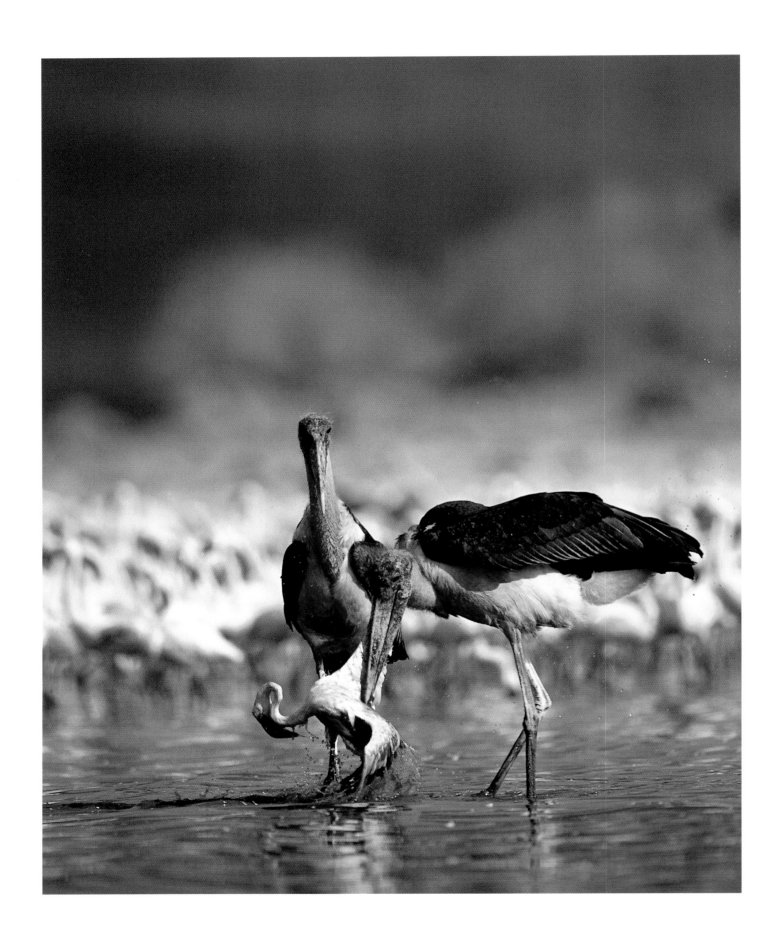

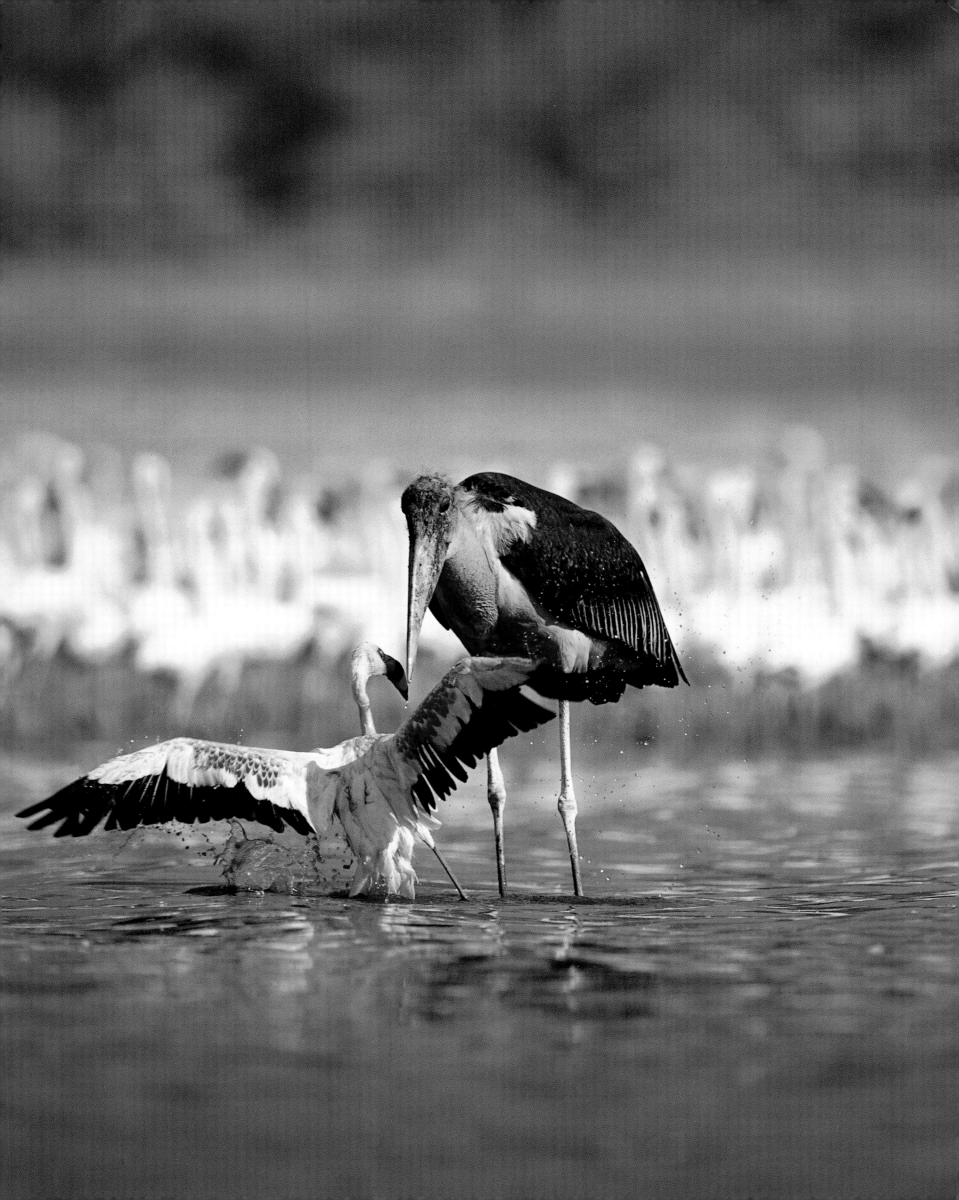

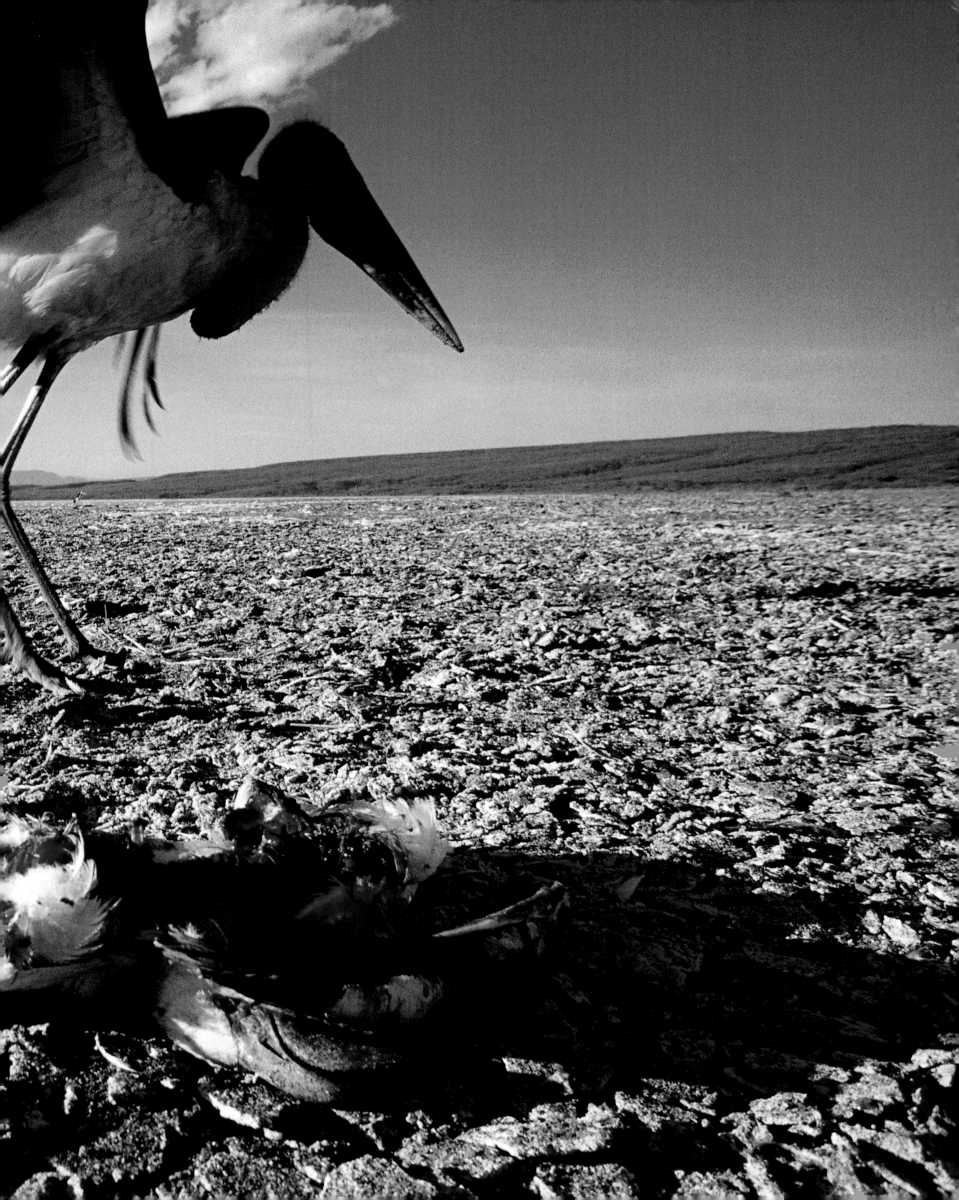

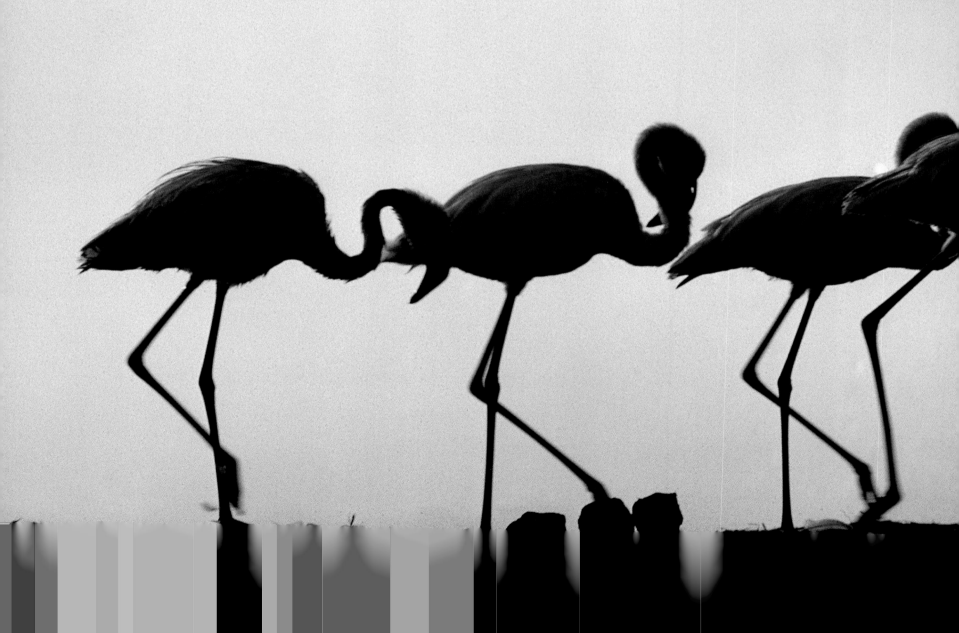

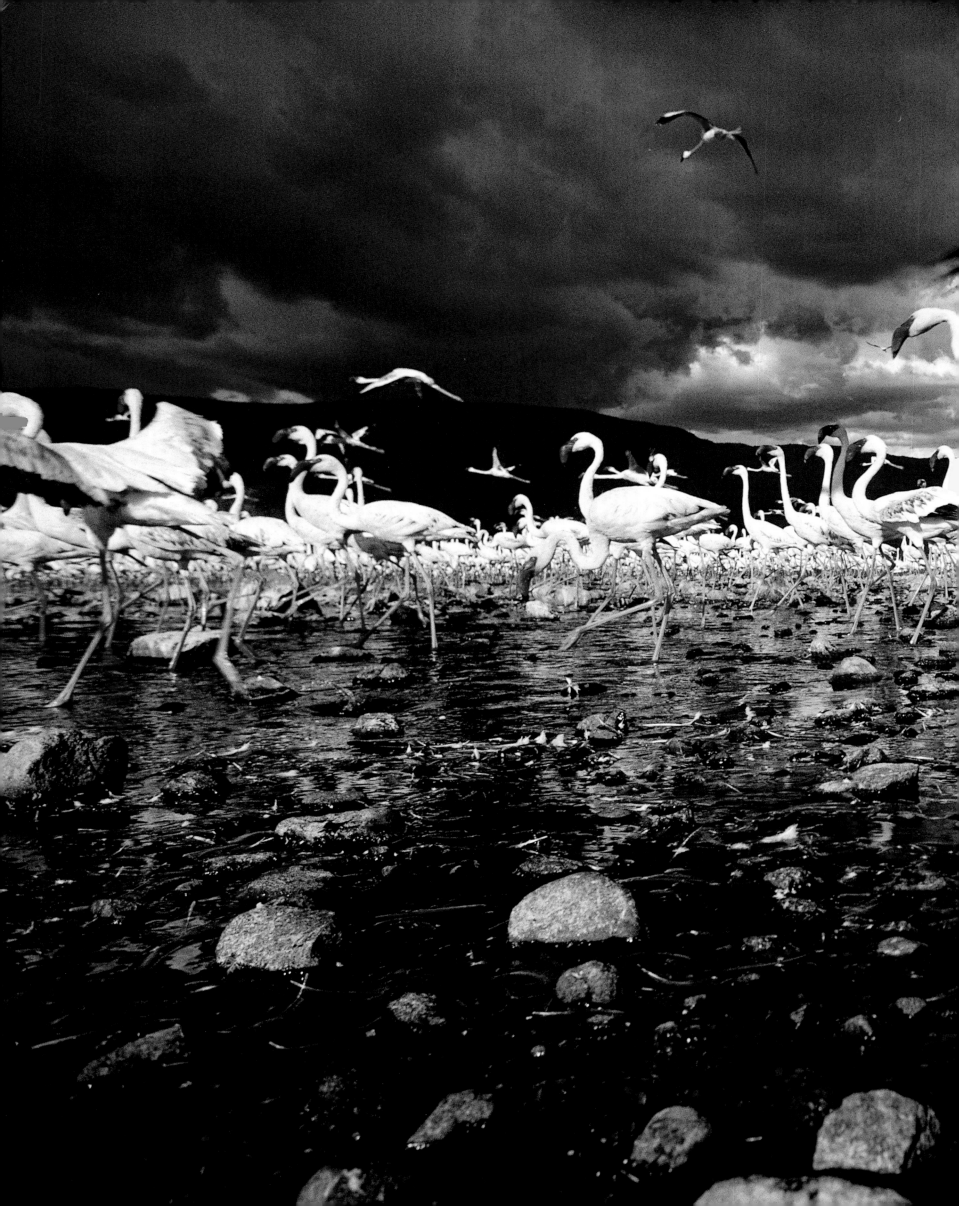

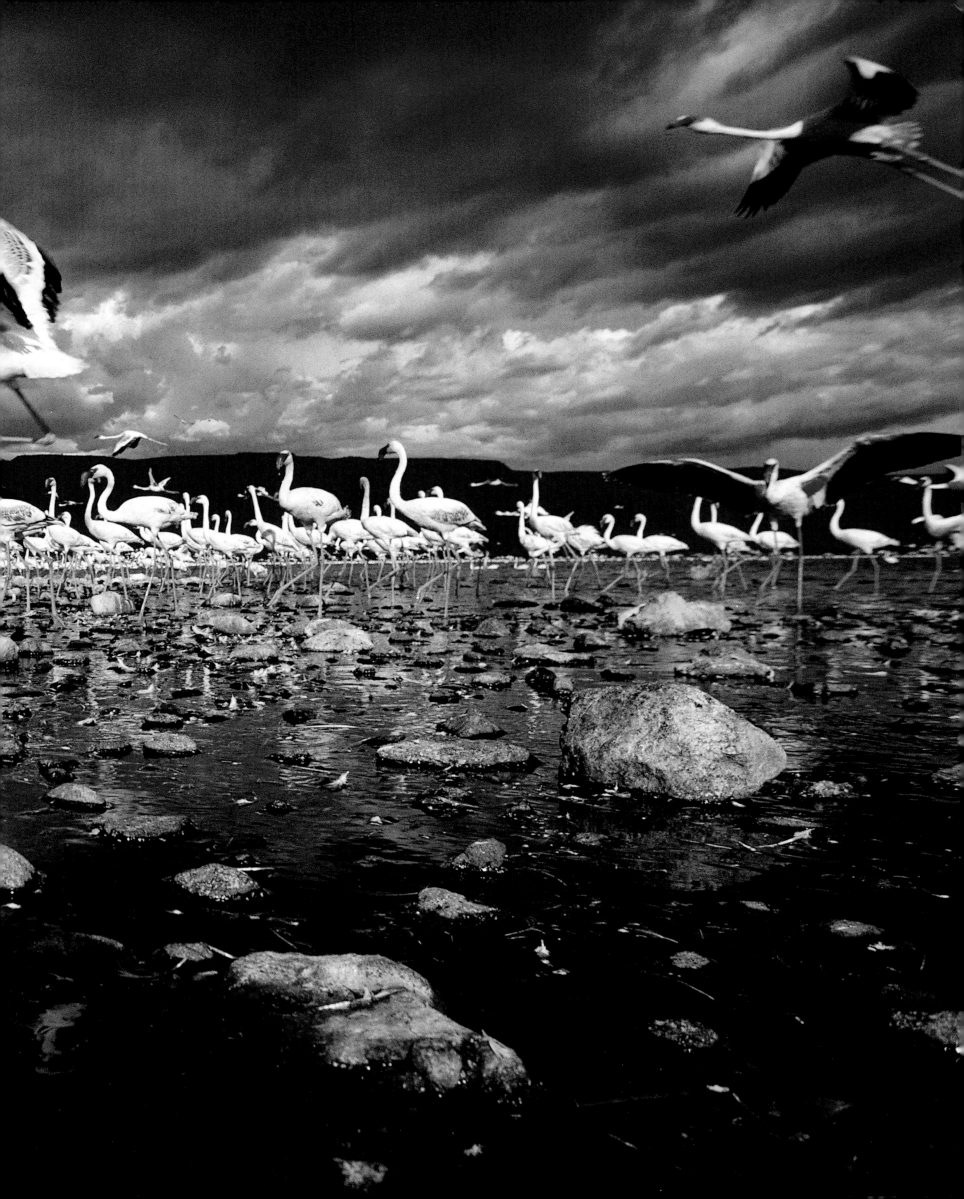

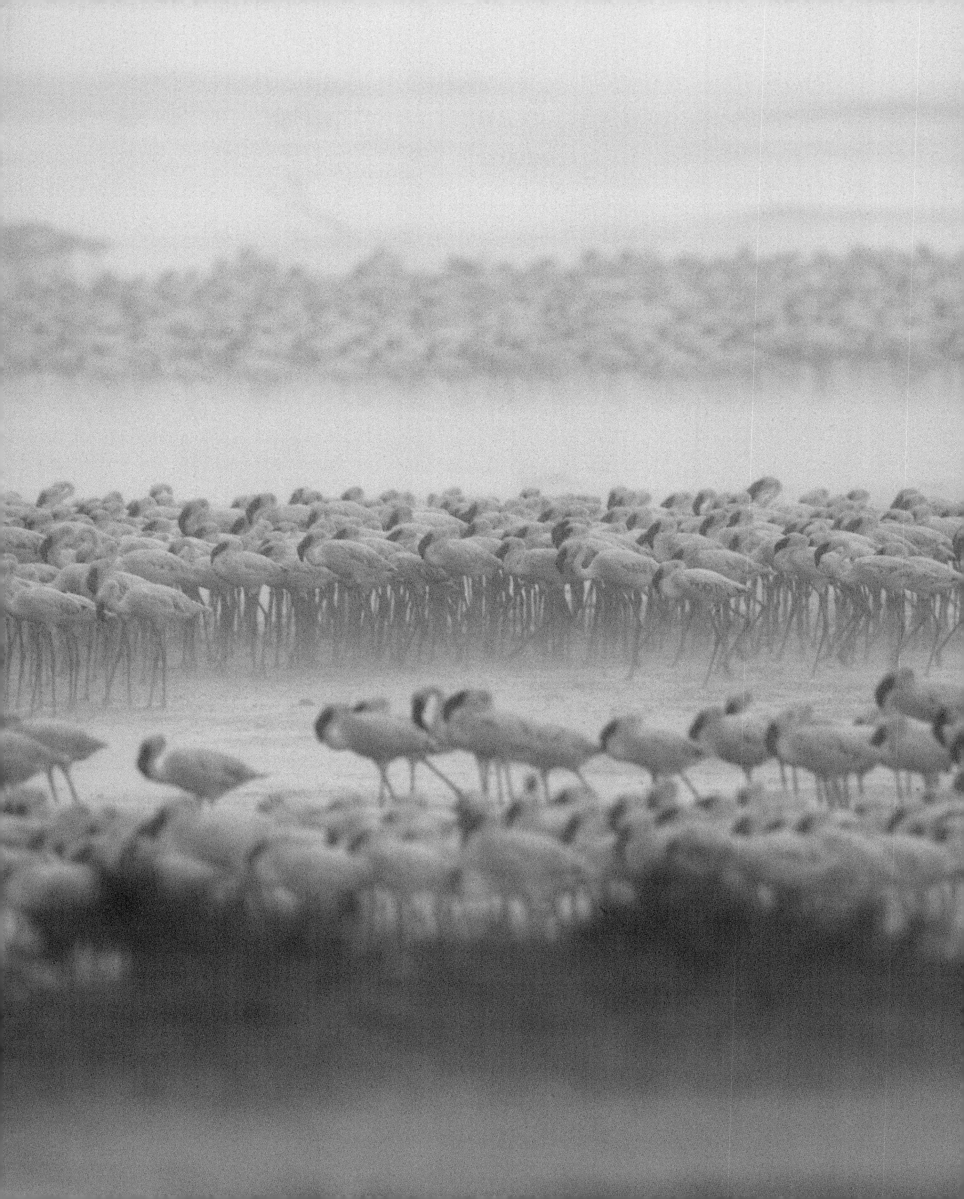

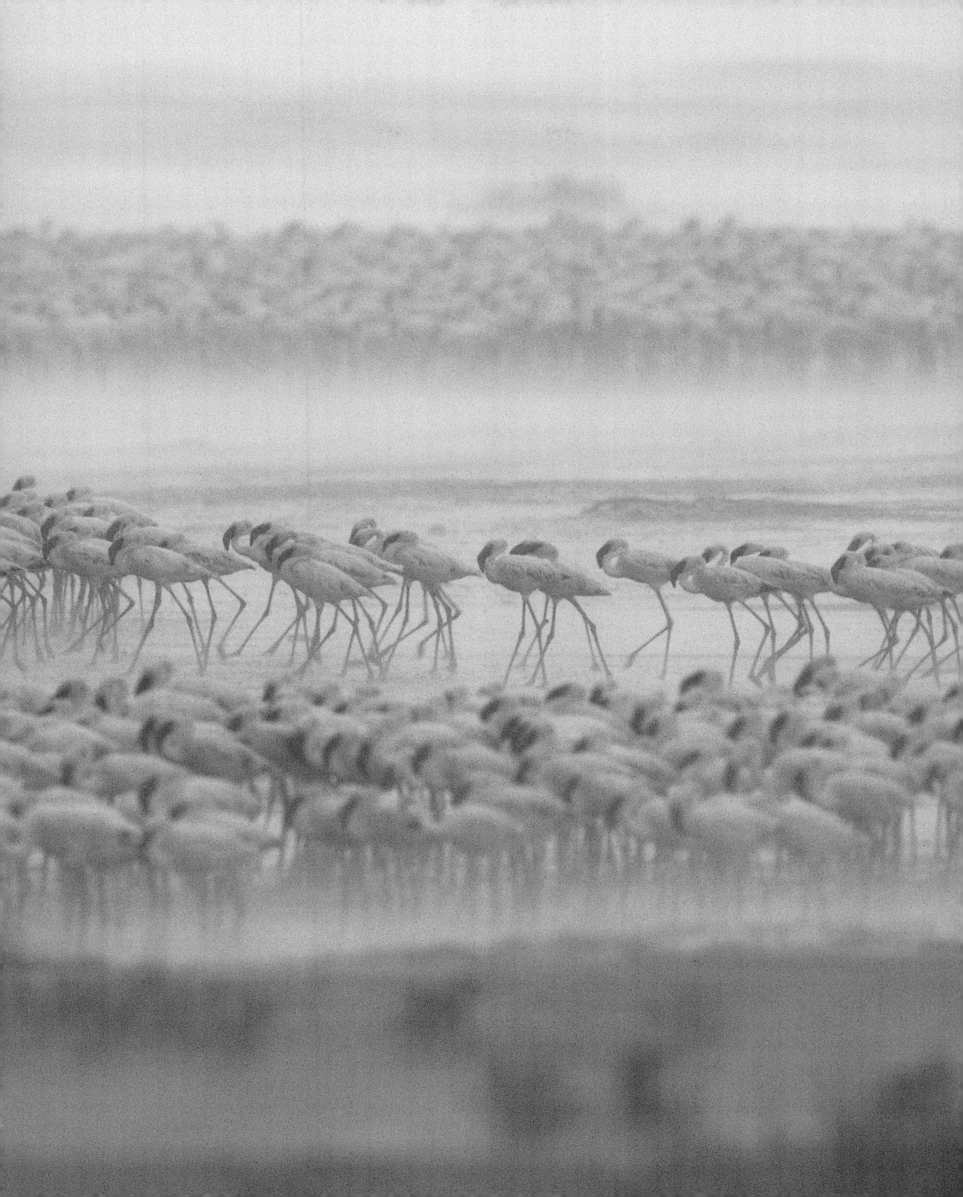

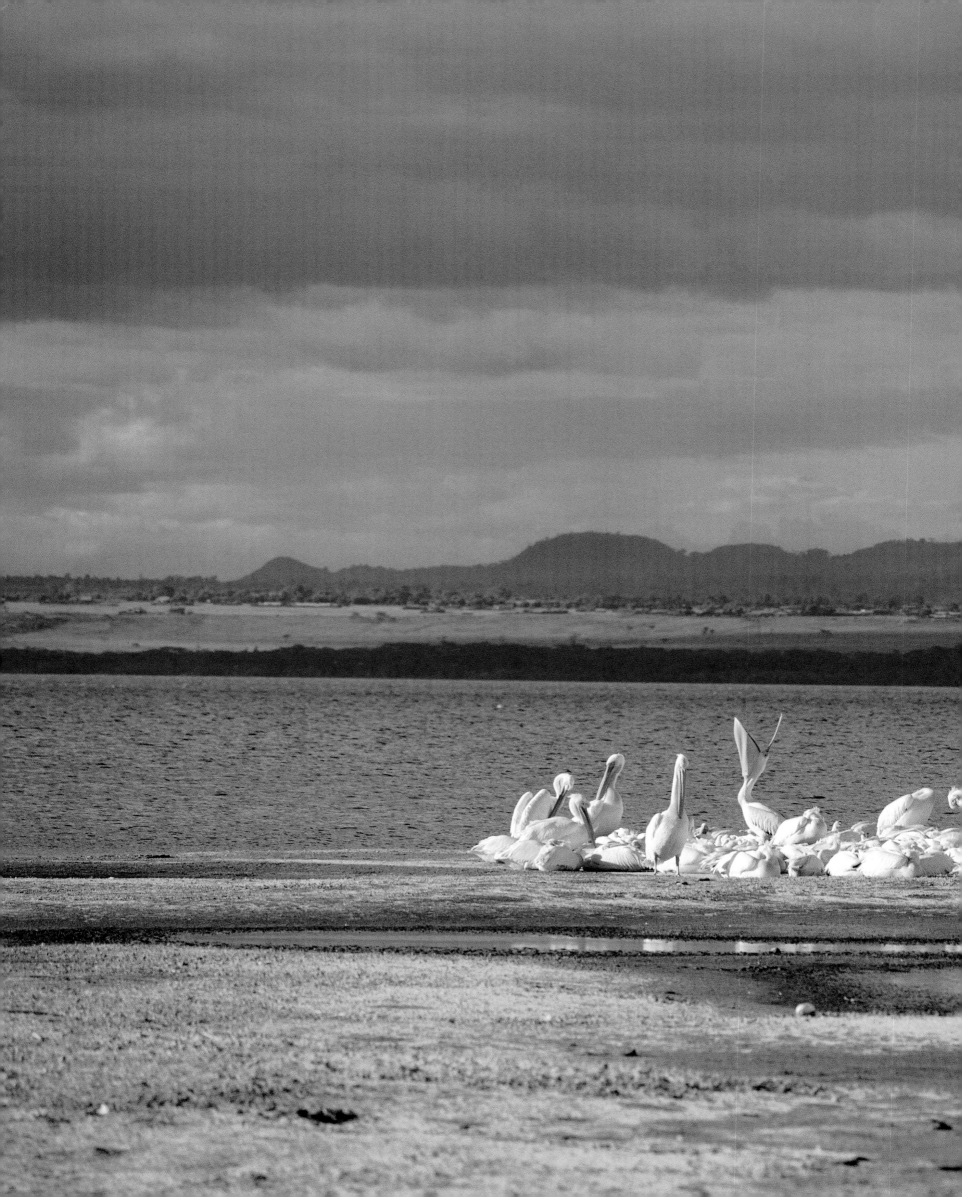

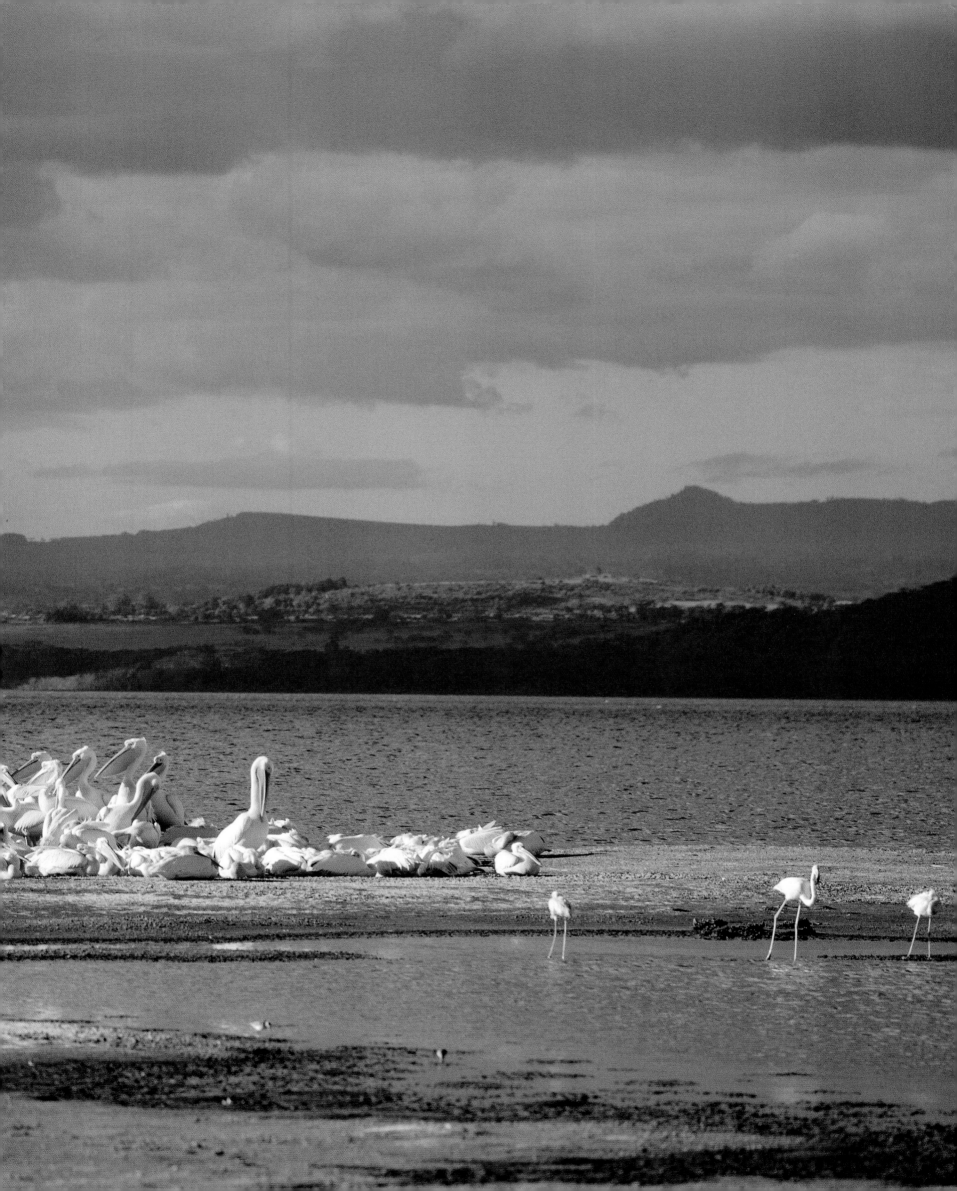

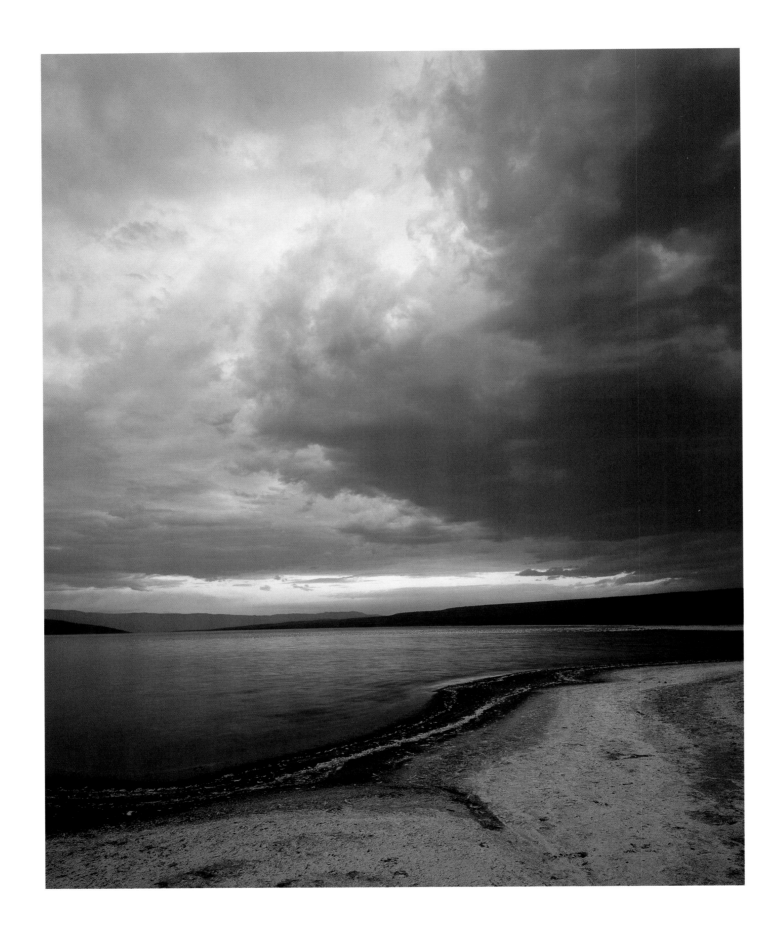

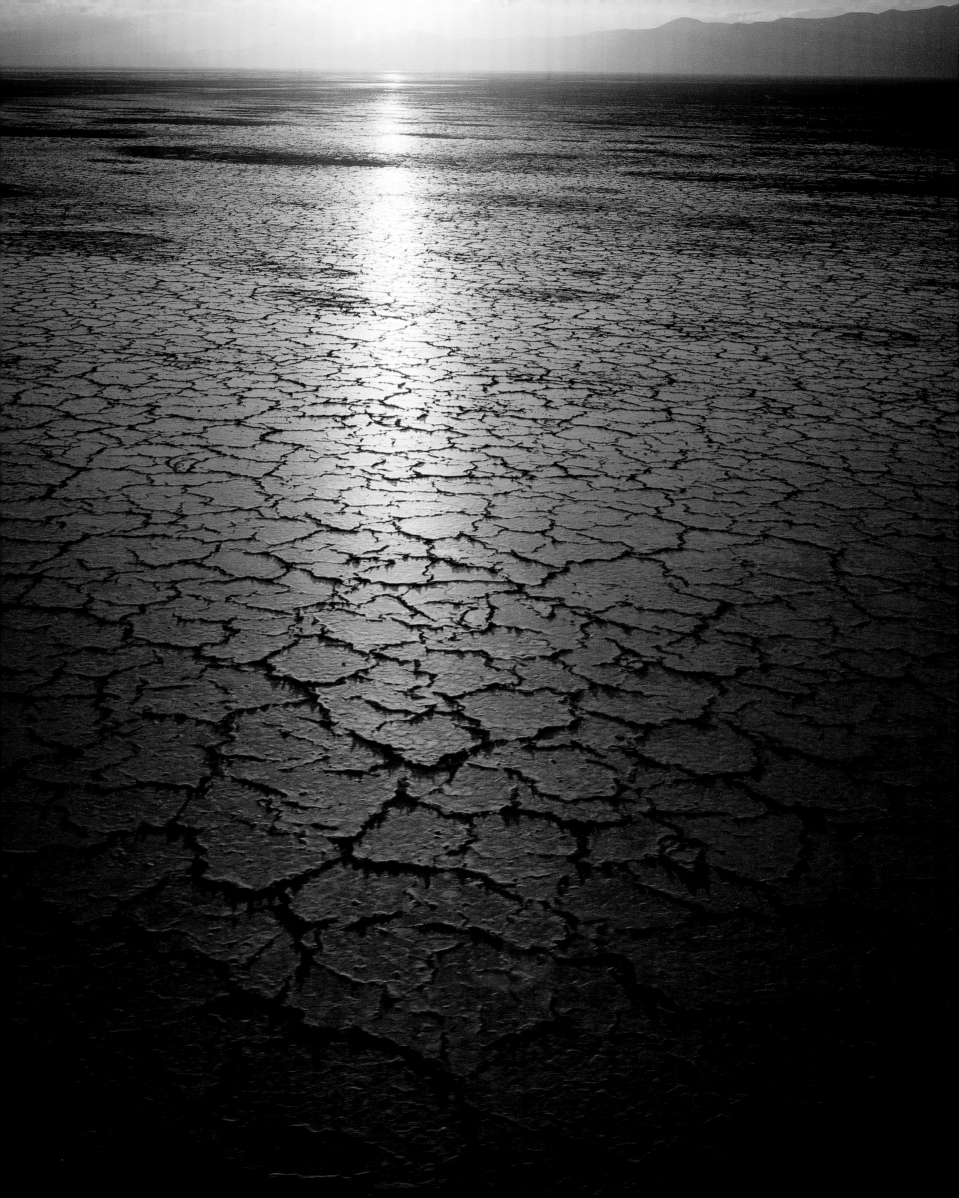

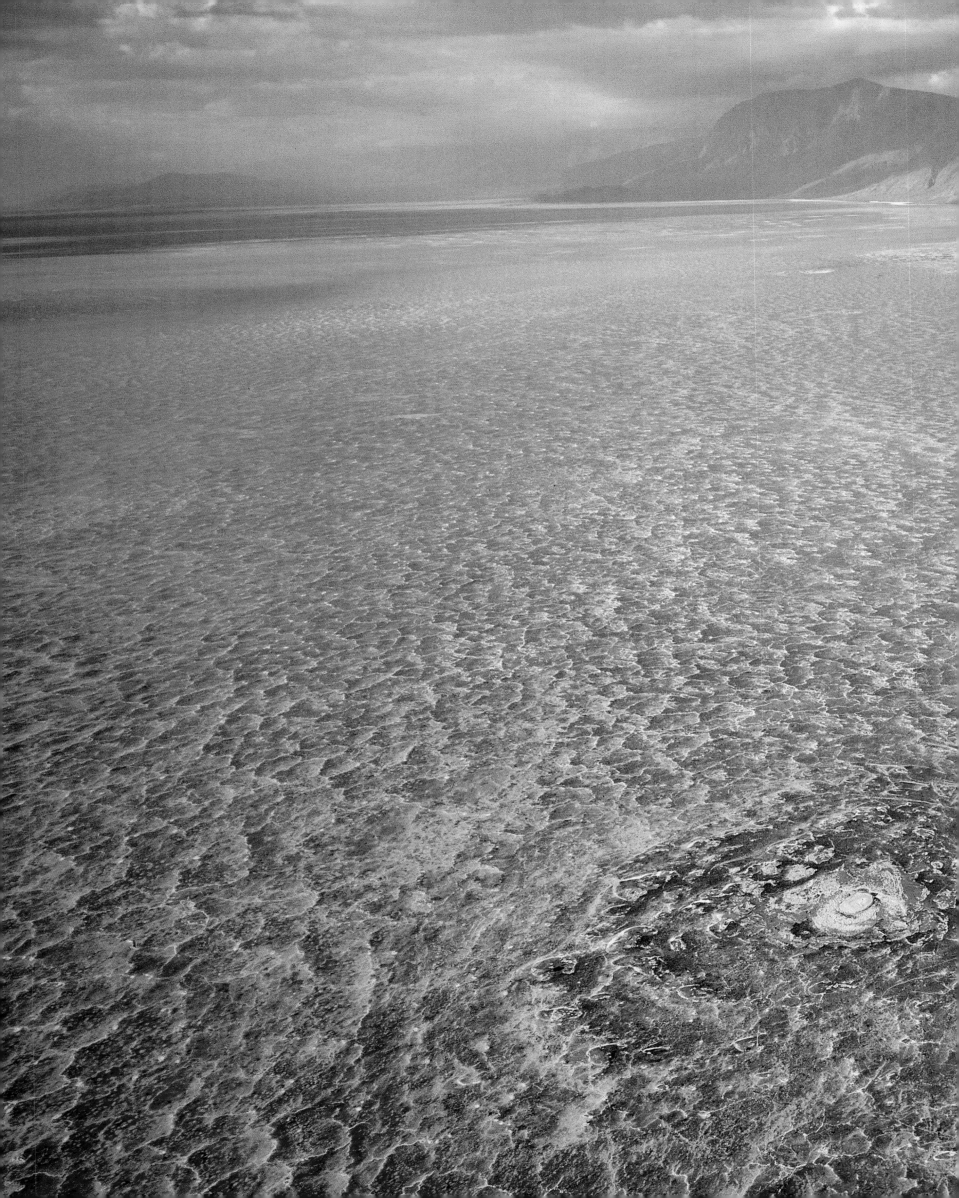

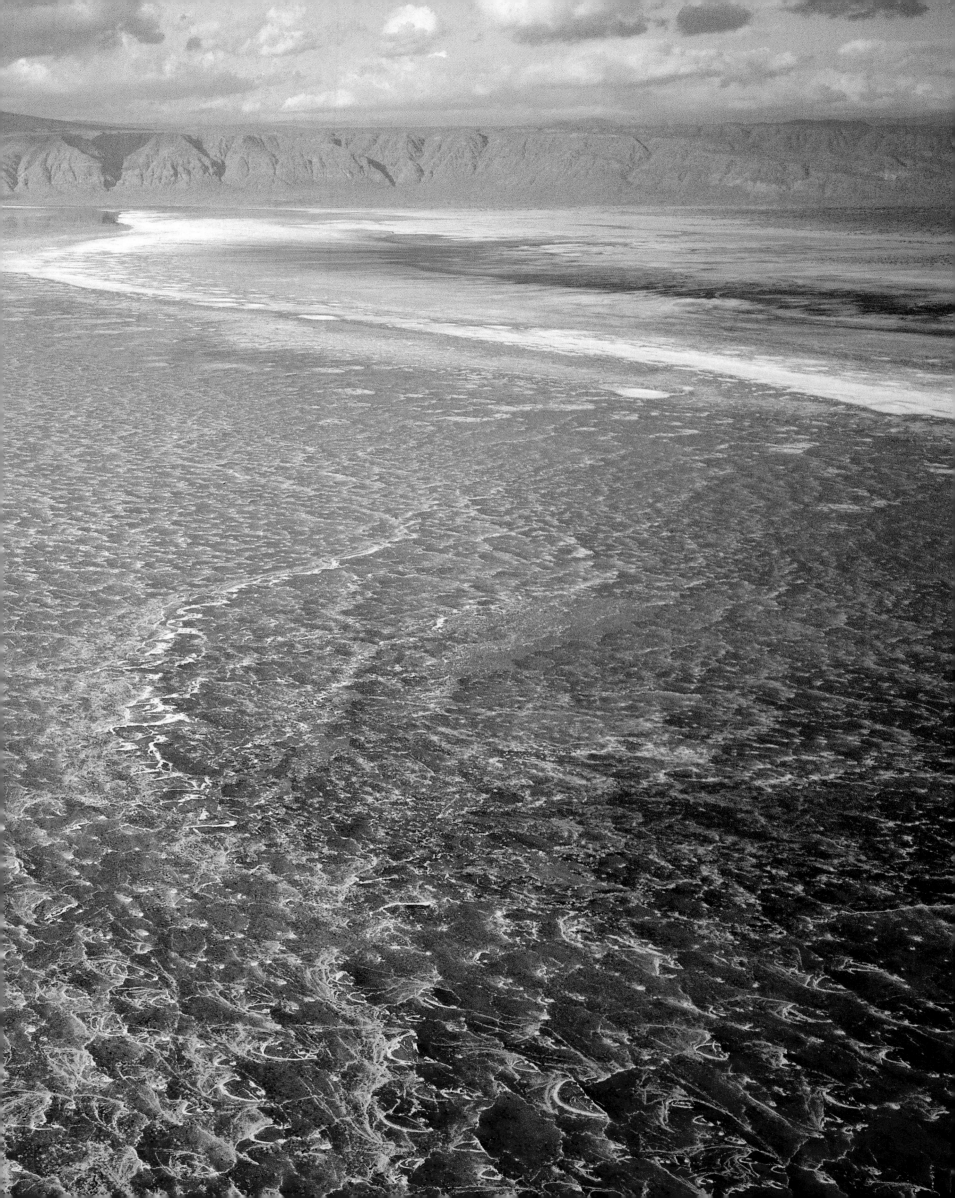

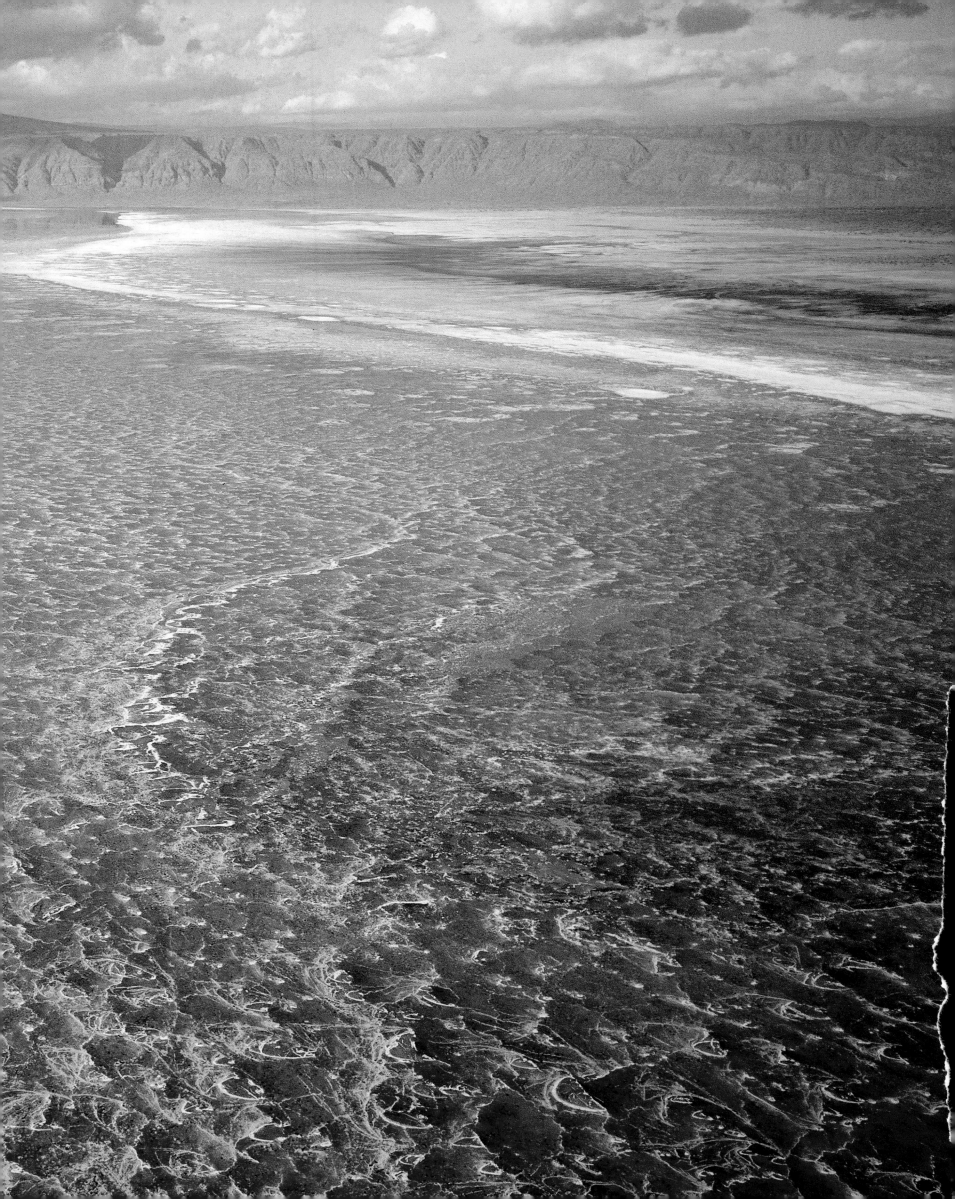

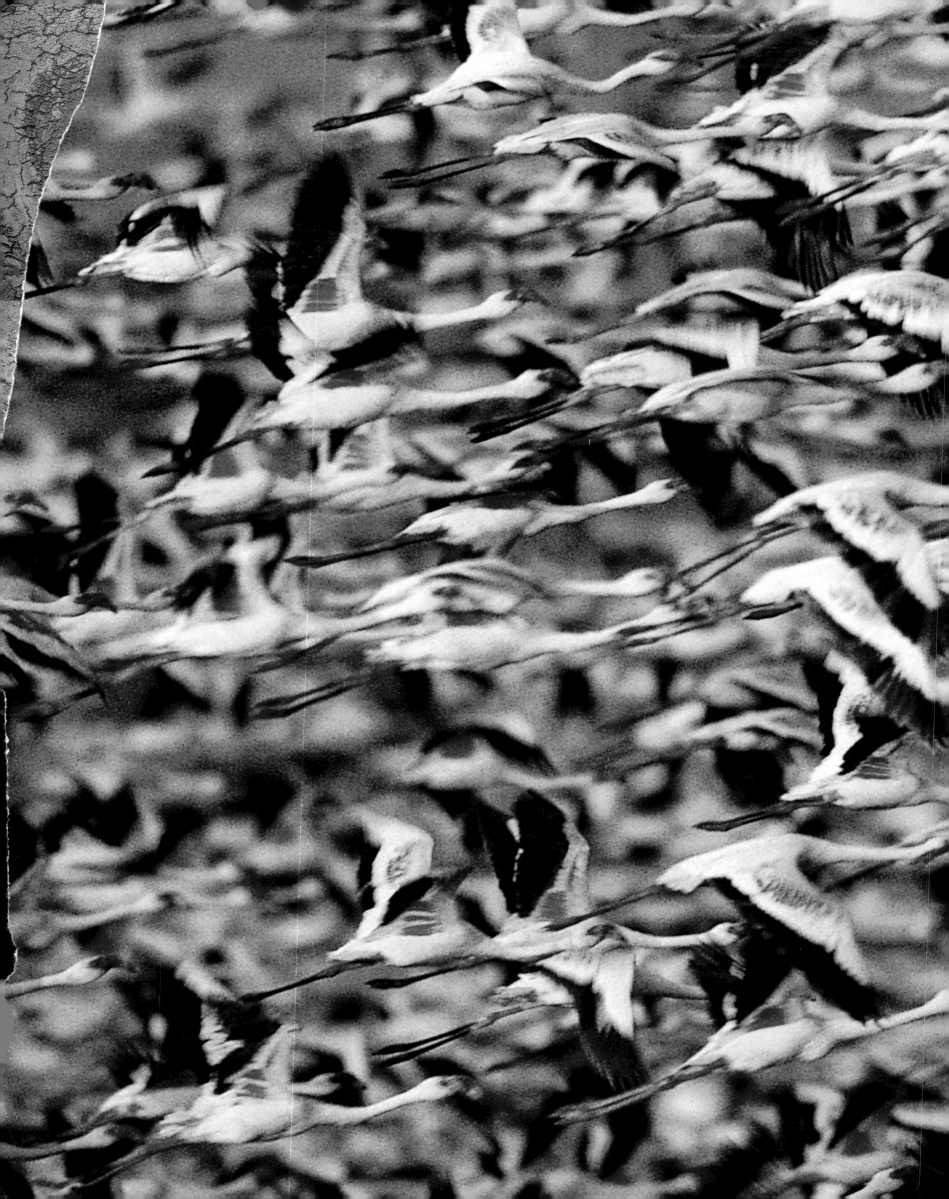

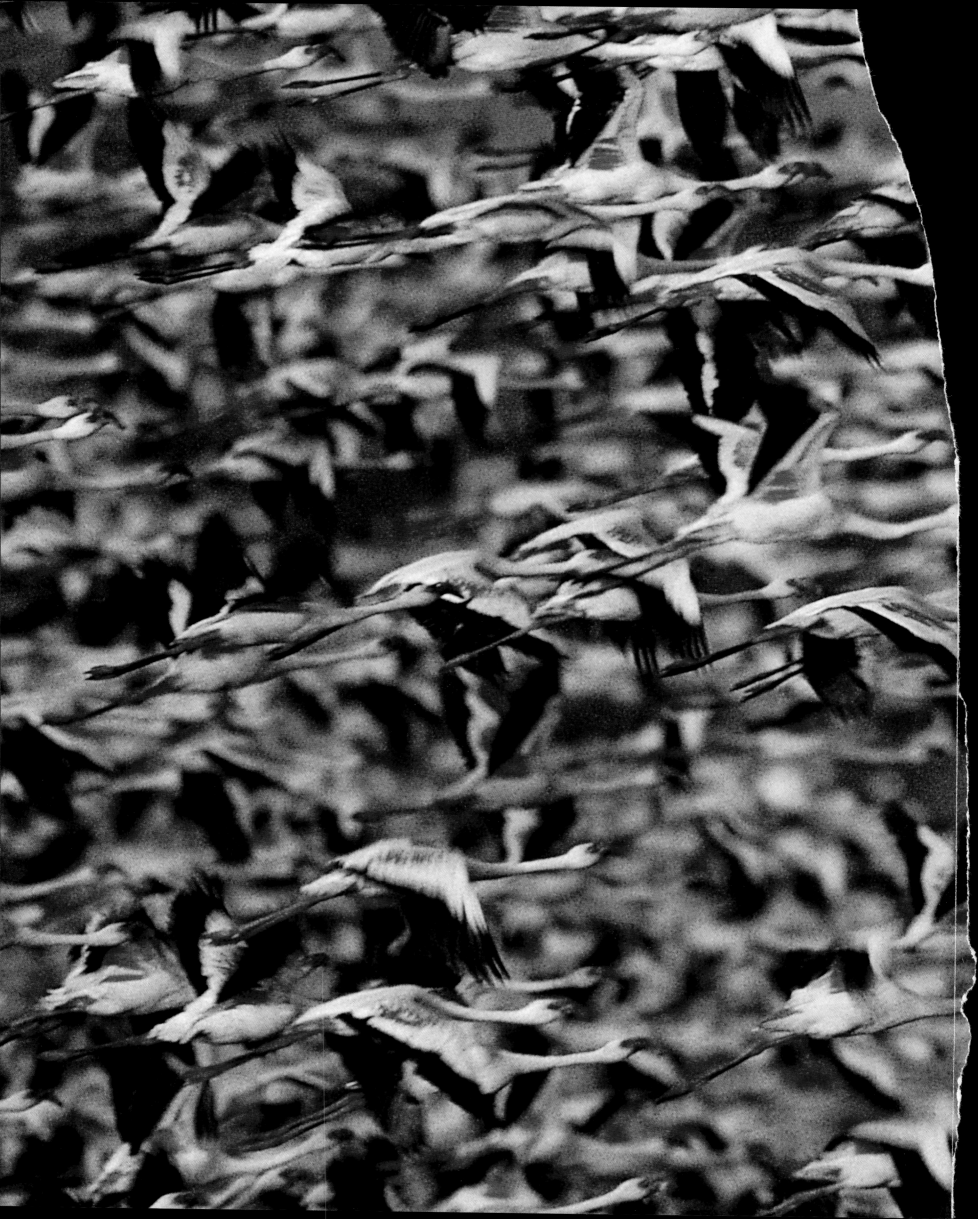

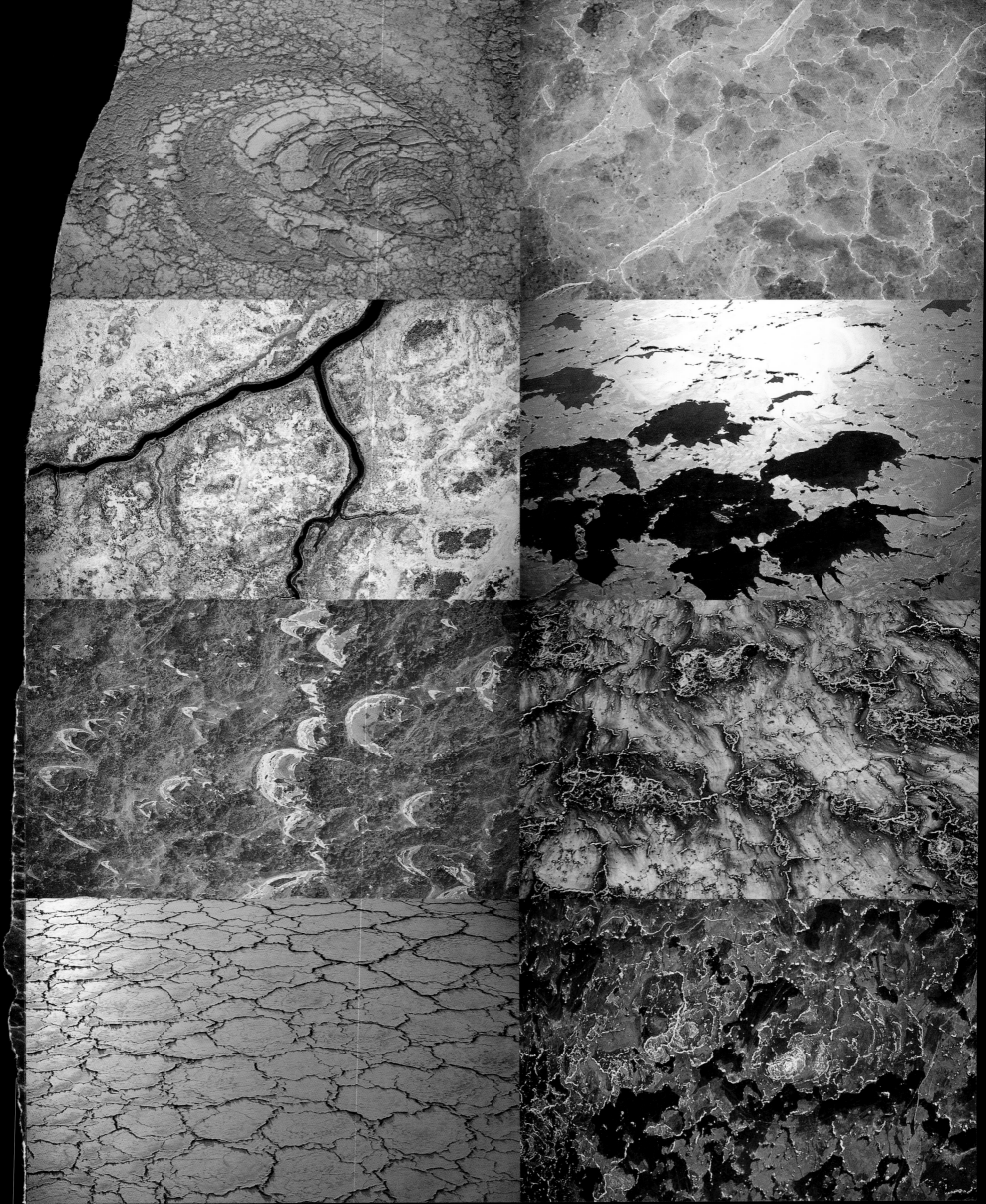

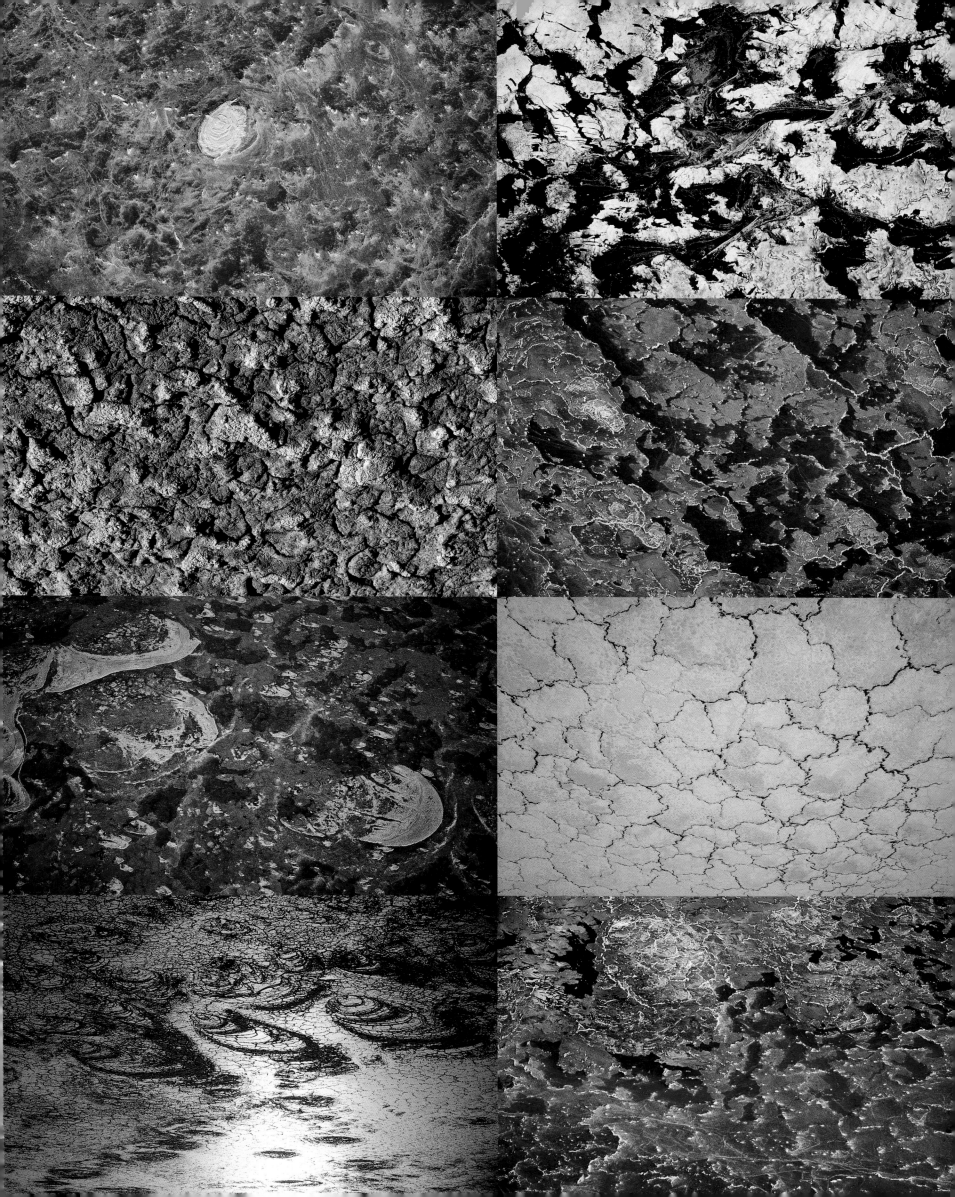

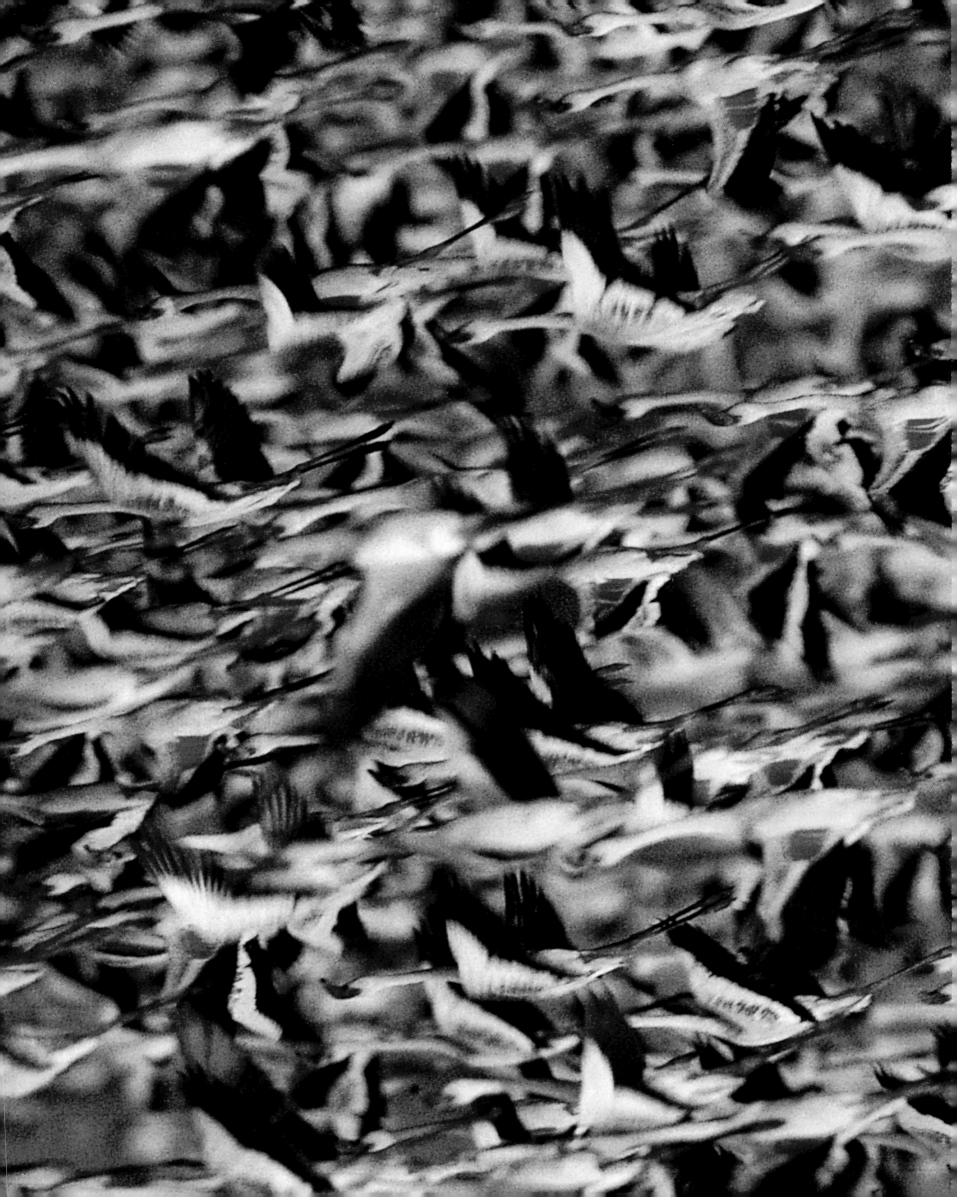

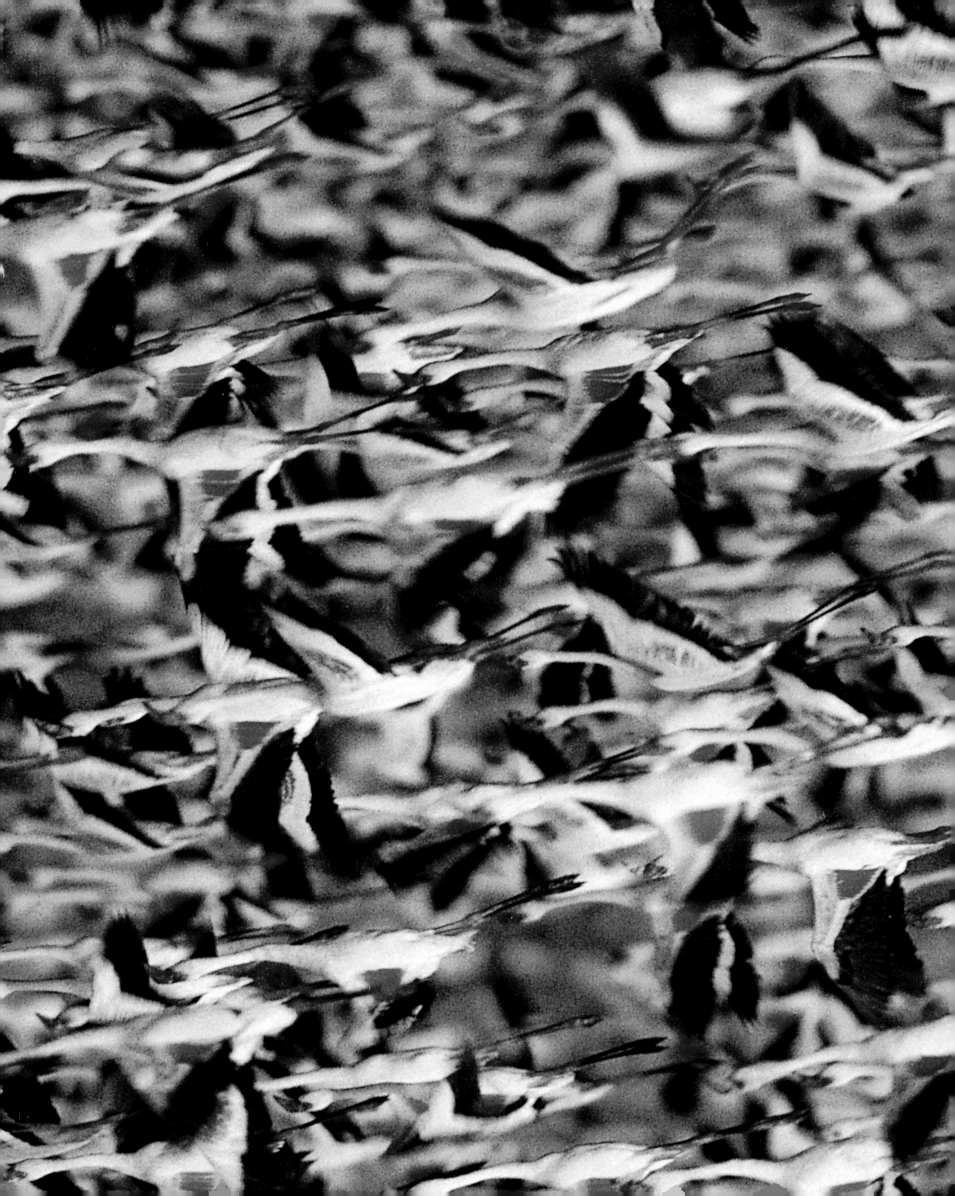

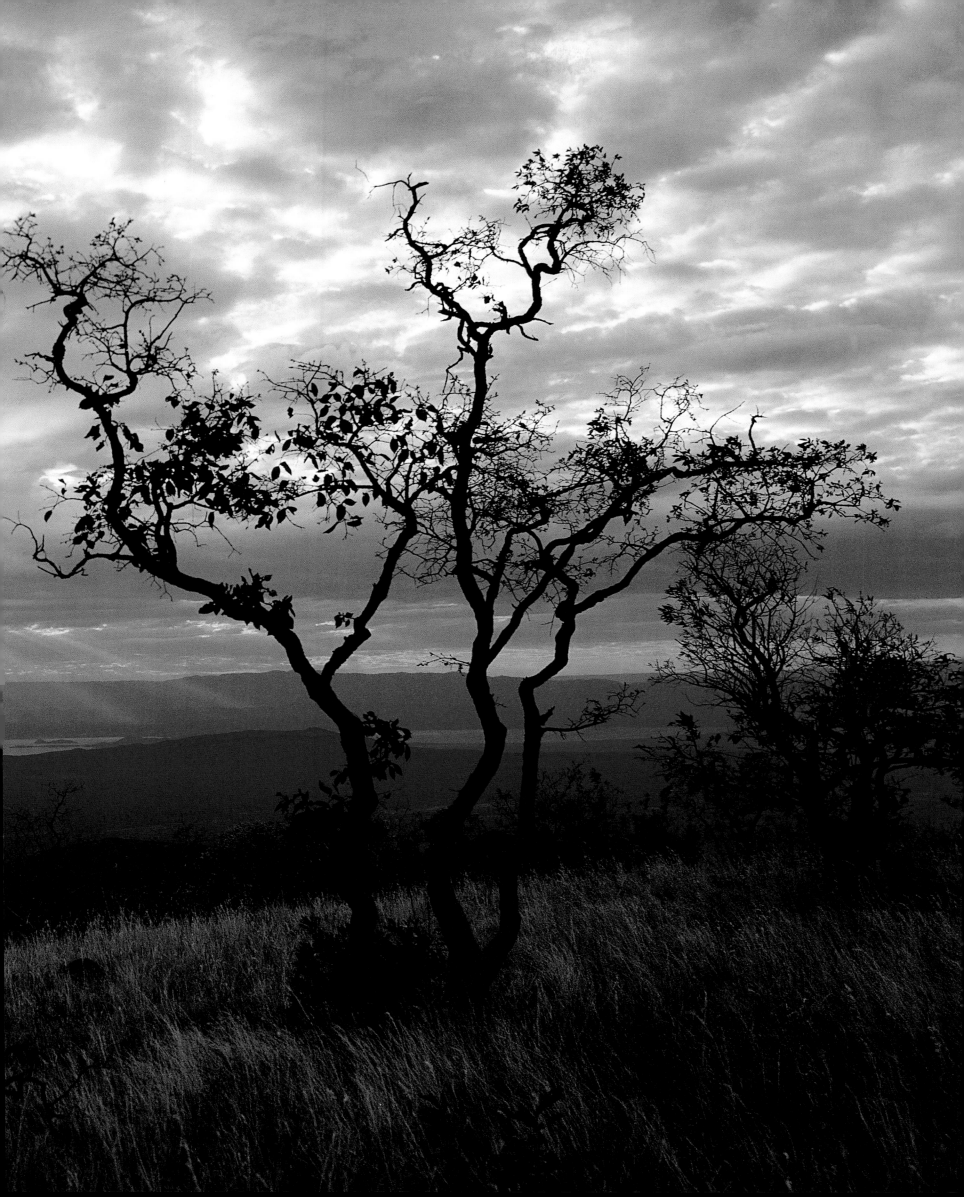

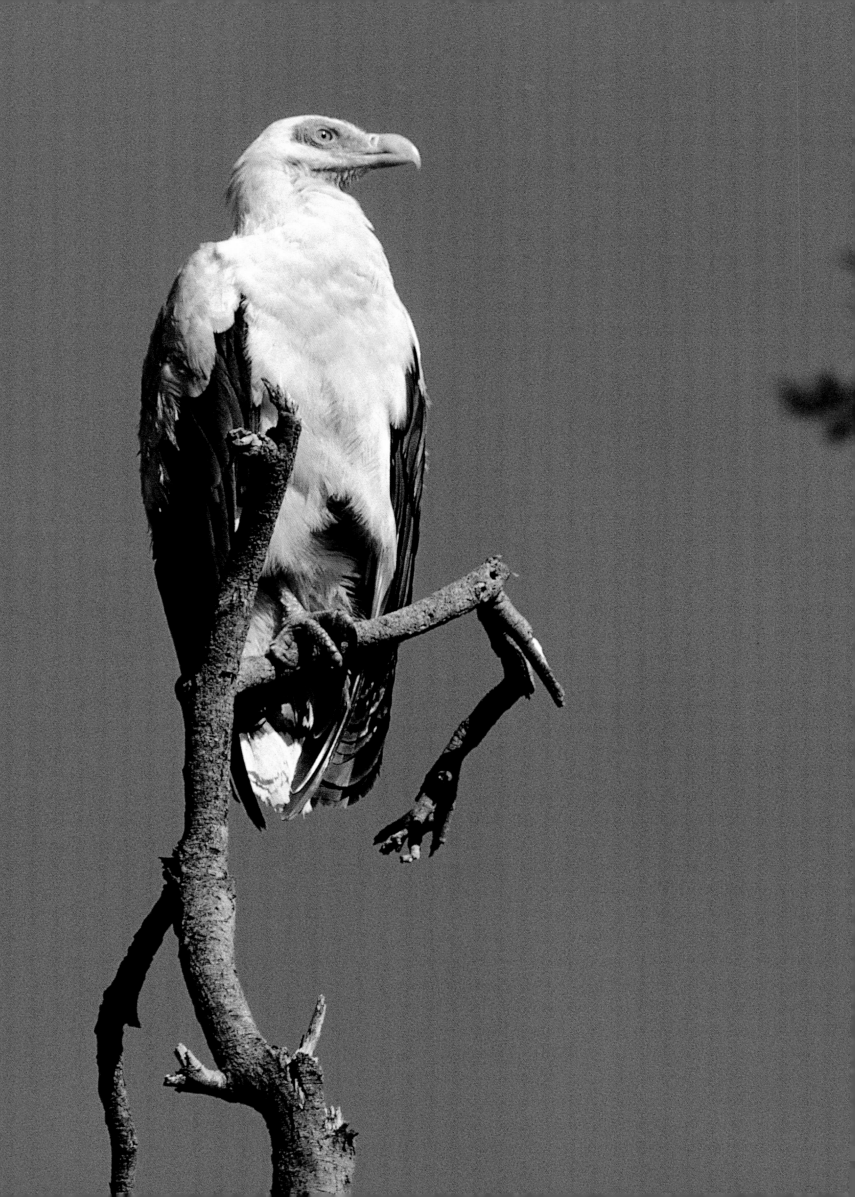

CONTINENT OF BIRDS

There are said to be some 10,000 bird species worldwide. This is a controversial figure, particularly because the scientific criteria defining a species as independent or just a subspecies are constantly changing.

The African savannah – ideal for birdwatching because of its wide-open spaces – is a Mecca for ornithologists and birdwatchers: exquisite birds, both in terms of quality and quantity. Here the most heavenly of skies arches over the binocular enthusiasts who have travelled so far – that strange subspecies of nature-lovers for whom the magnificent acrobatics of a bateleur eagle in flight means far more than the sight of giraffes on the move, or mighty bull elephants.

Anyone who is familiar with the image of "our" stork – a bird that is also known to spend part of its time in Africa – won't be able to take their eyes off its relative the wood ibis, an inland African migratory bird that preys on fish, amphibians and water insects in shallow water. This red-faced bird stirs up the mud on the bed with its sturdy beak; if the mud is too dry or hard, *Mycteria ibis* continues on its travels, in search of more water.

Kori bustards stalk into the picture in an even more spectacular fashion, especially when the courting males wear their neck plumage like feather boas and raise their tail plumage ecstatically – like gigolos' fans. The great bustard, just still able to fly at about 18 kilos, is more of a tenacious pedestrian by nature. The grass savannahs offer this bird of the open spaces a lavish buffet of insects and small vertebrates.

Birdwatchers who travel the world to see as many species of bird in their natural habitat as possible are always pleased to collect a few superlatives on the side; for example: after the heaviest bird capable of flight comes the littlest hornbill as an encore. The red-billed toko has found a radical way of protecting itself against nest robbers. It walls its female up in a hollow tree for the thirty-day hatching period and feeds her through a small slit. This may seem misogynistic, but it is a tried-and-tested method. Where the survival of the species is concerned, success is all that counts.

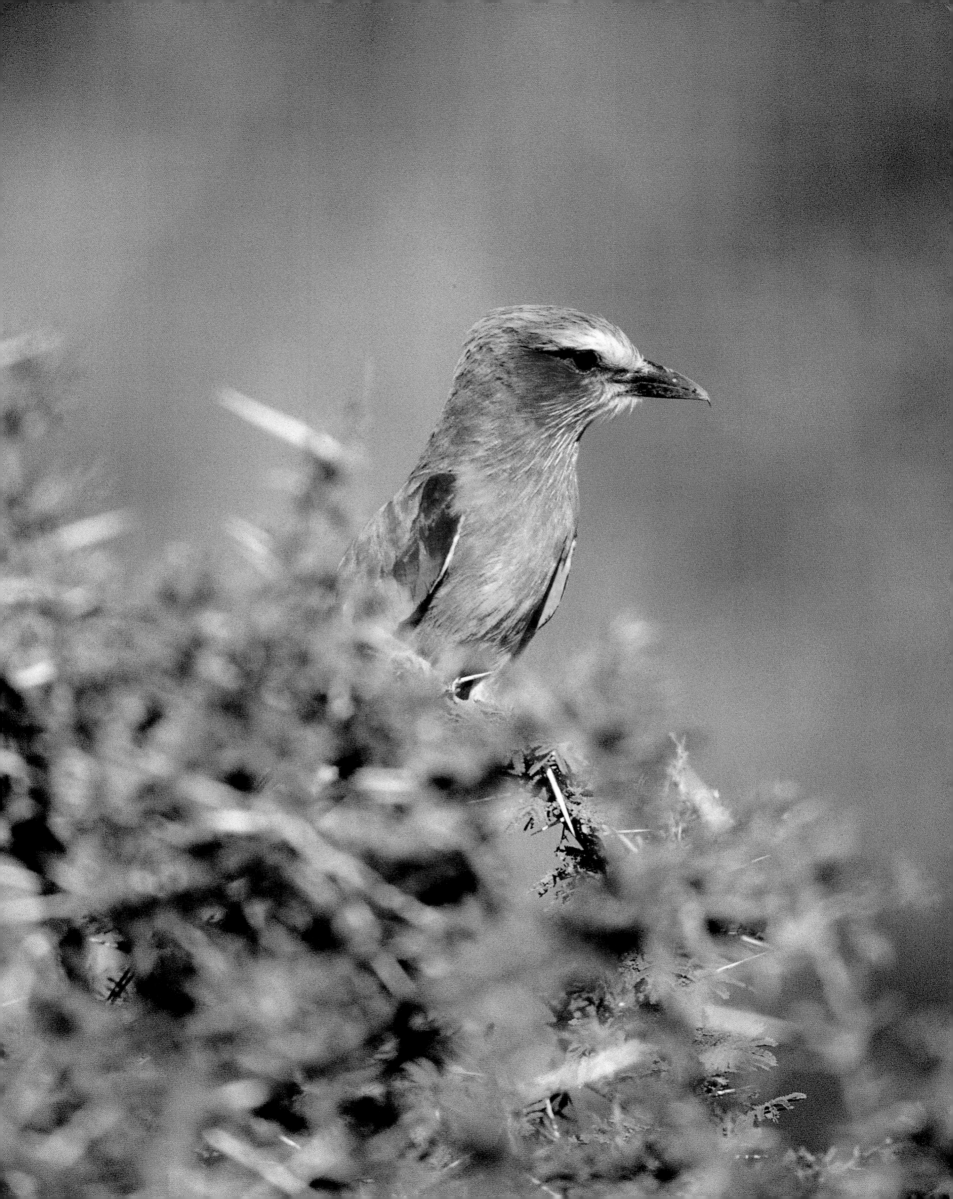

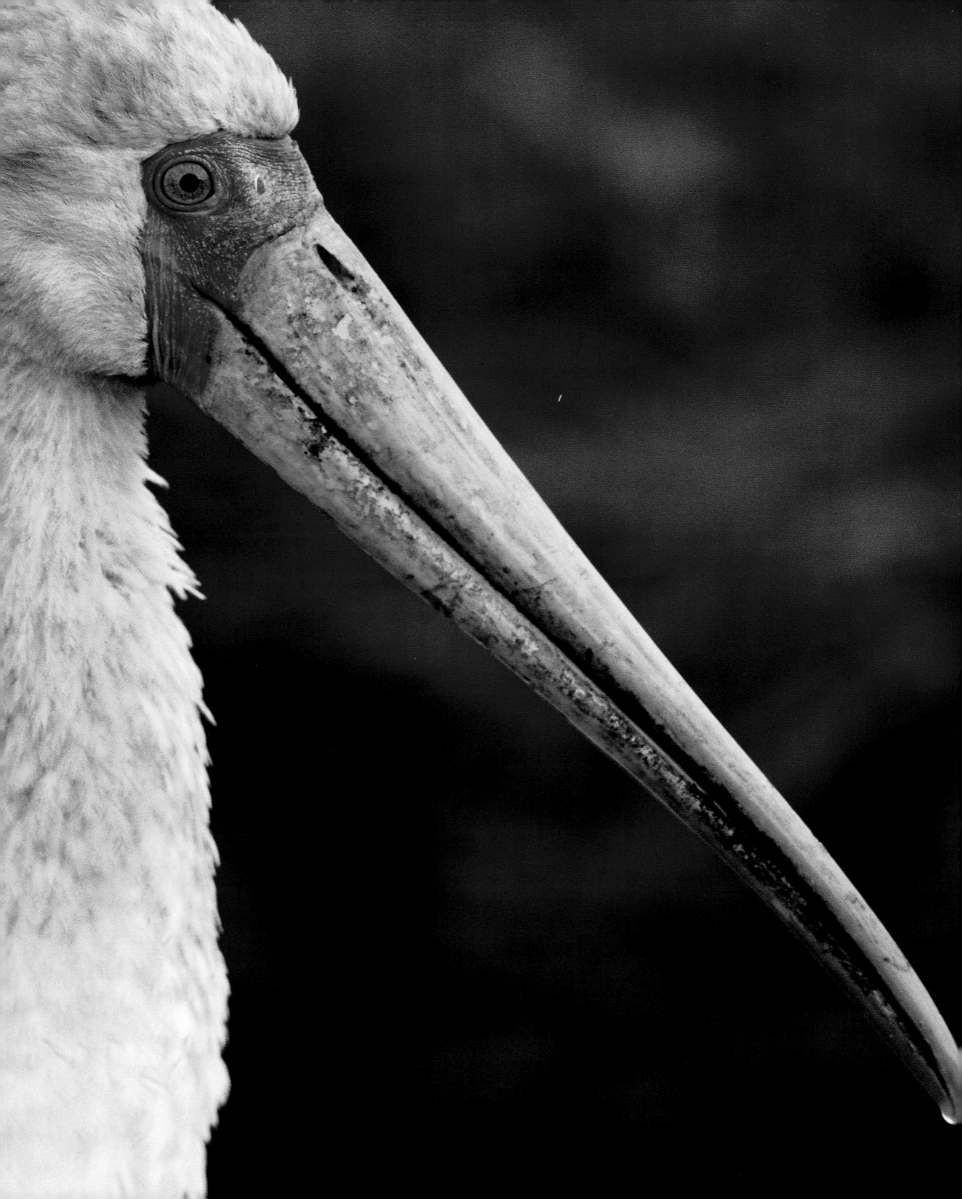

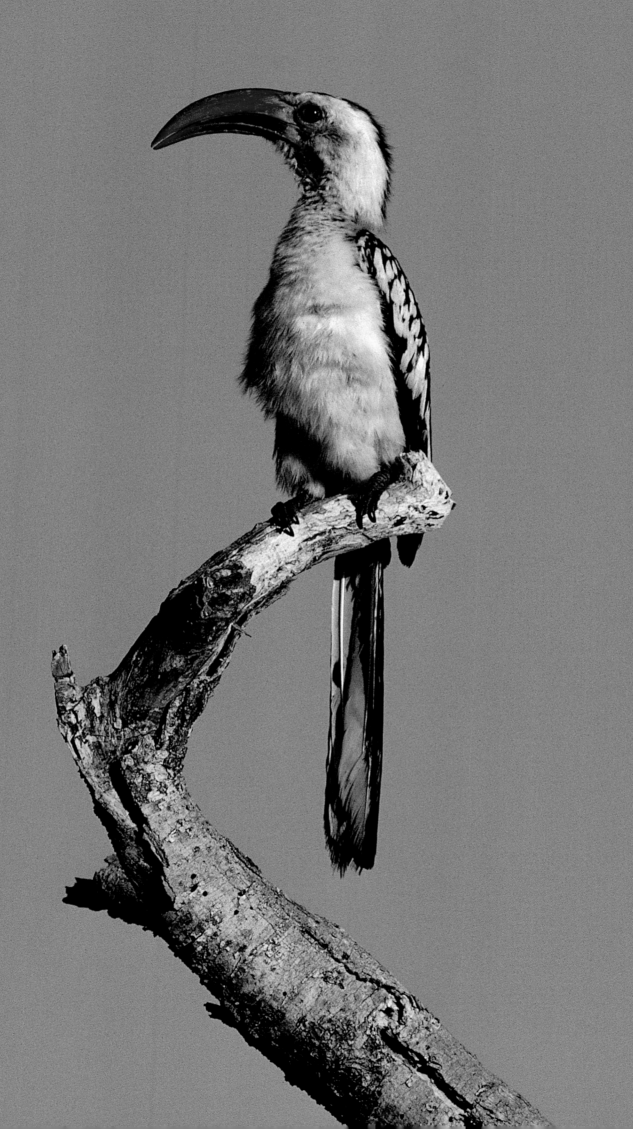

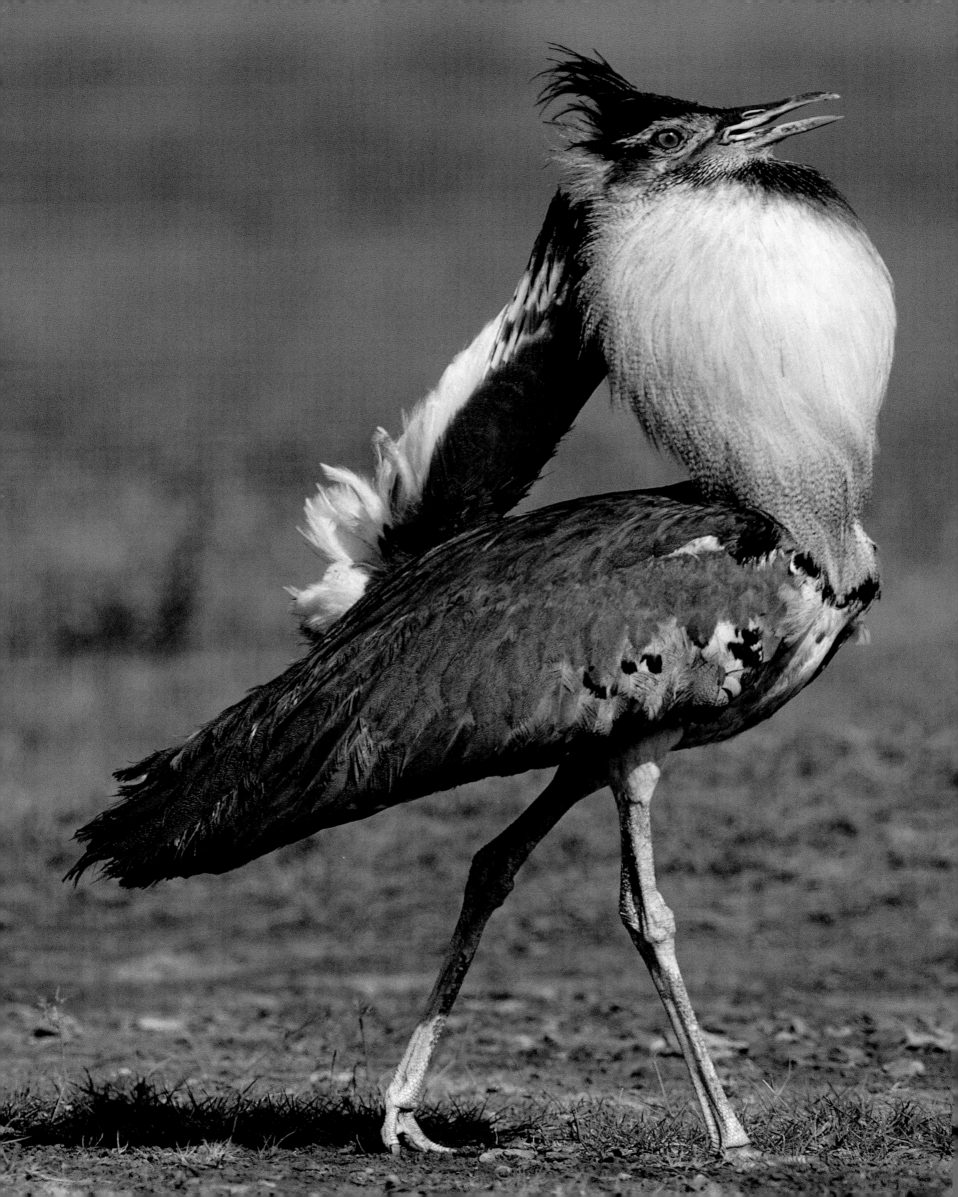

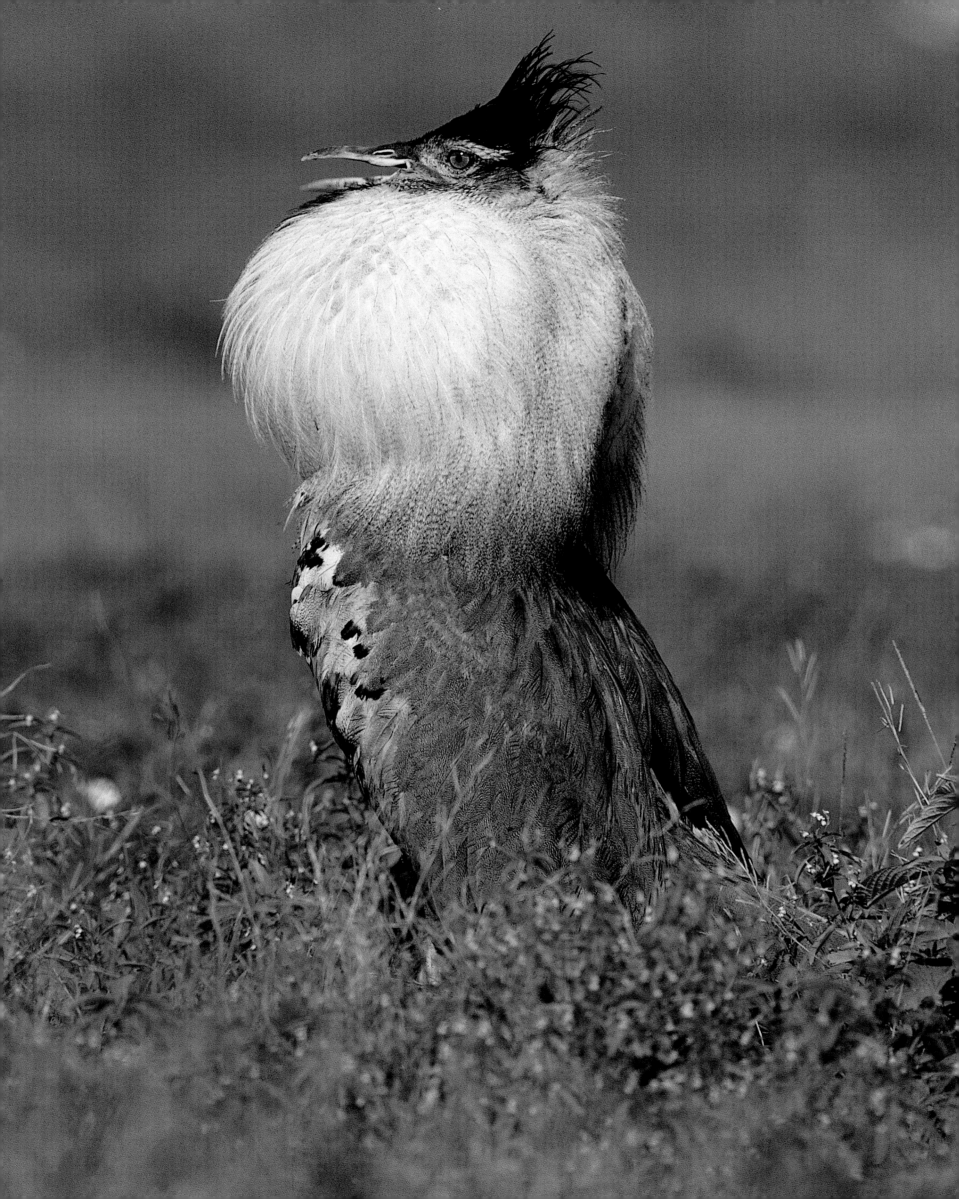

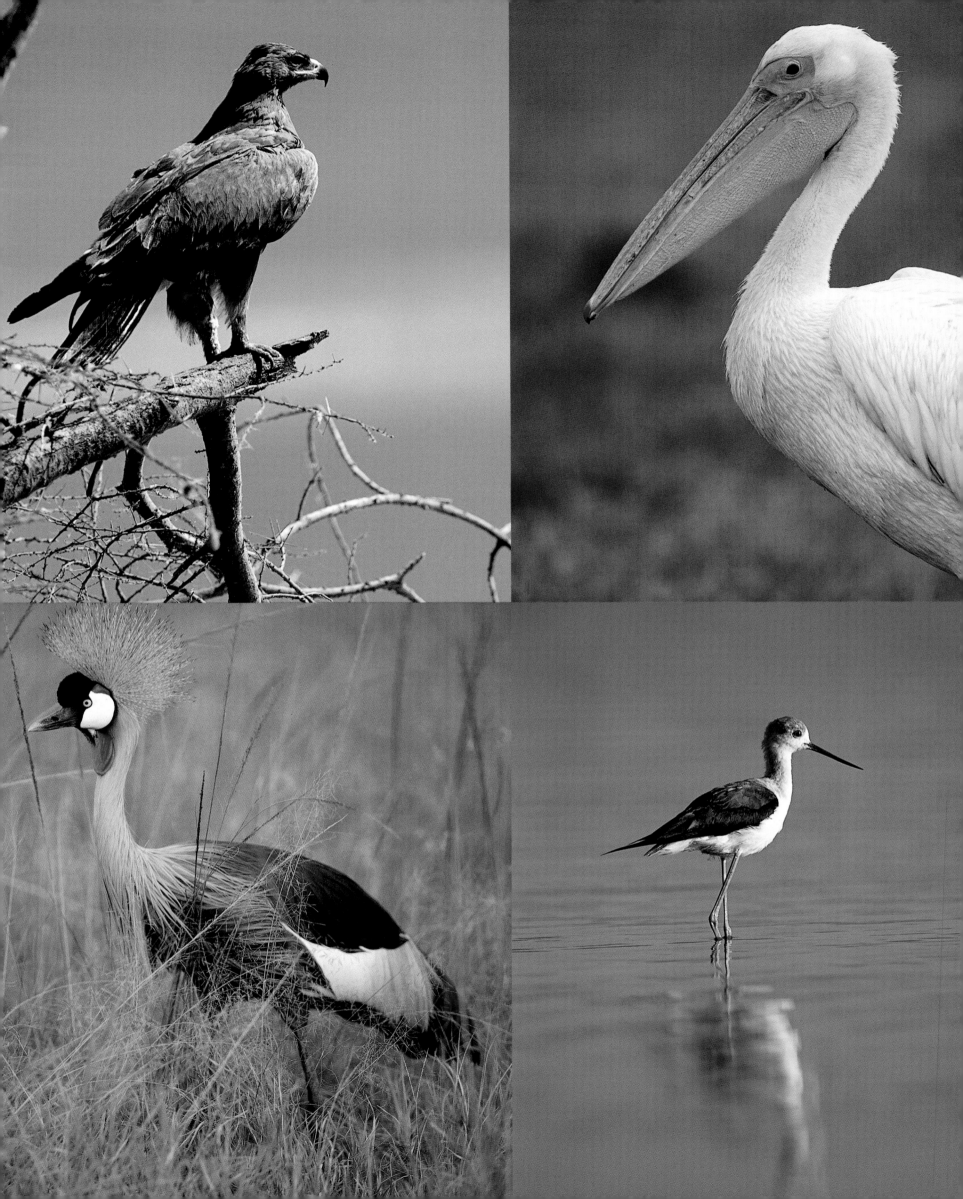

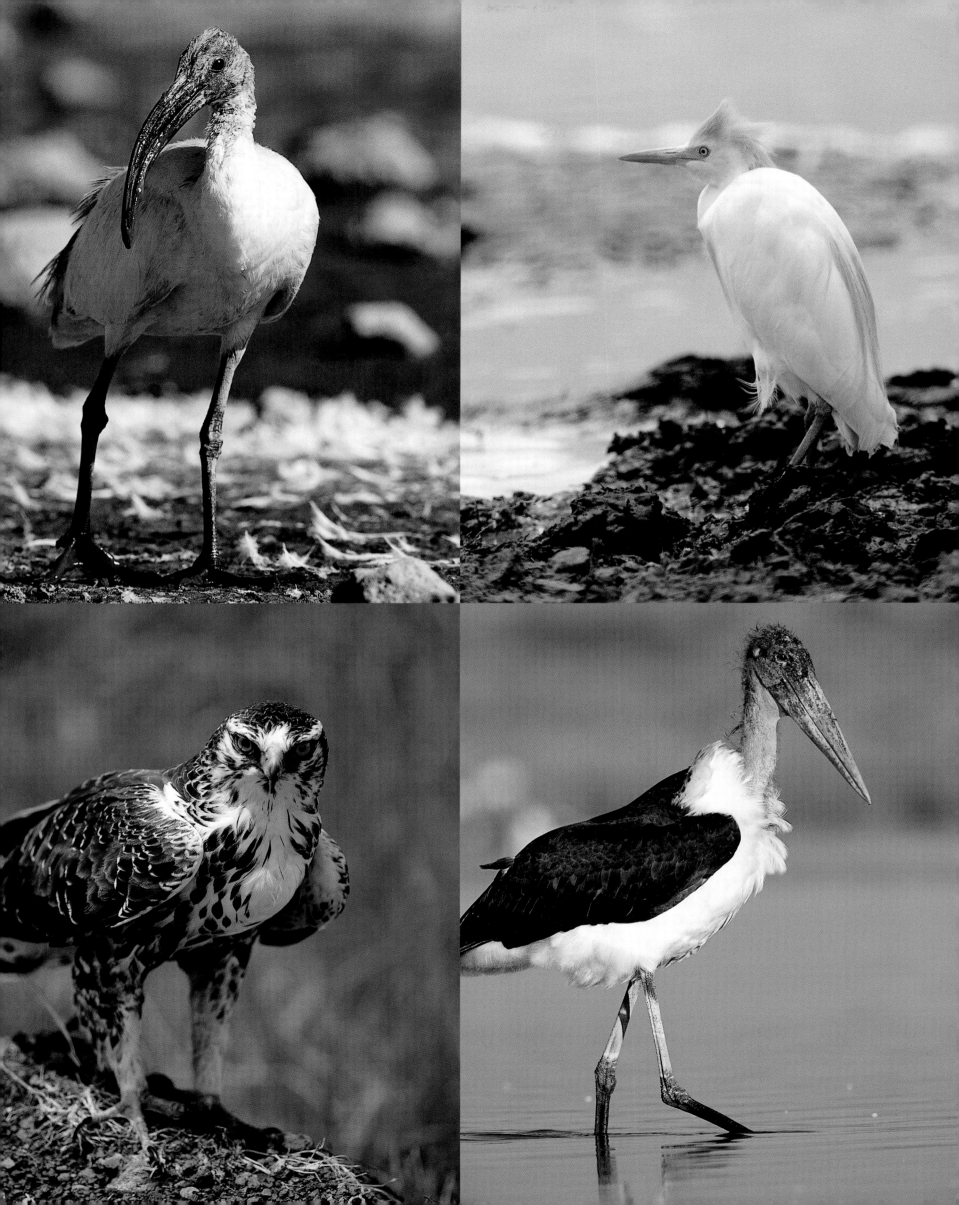

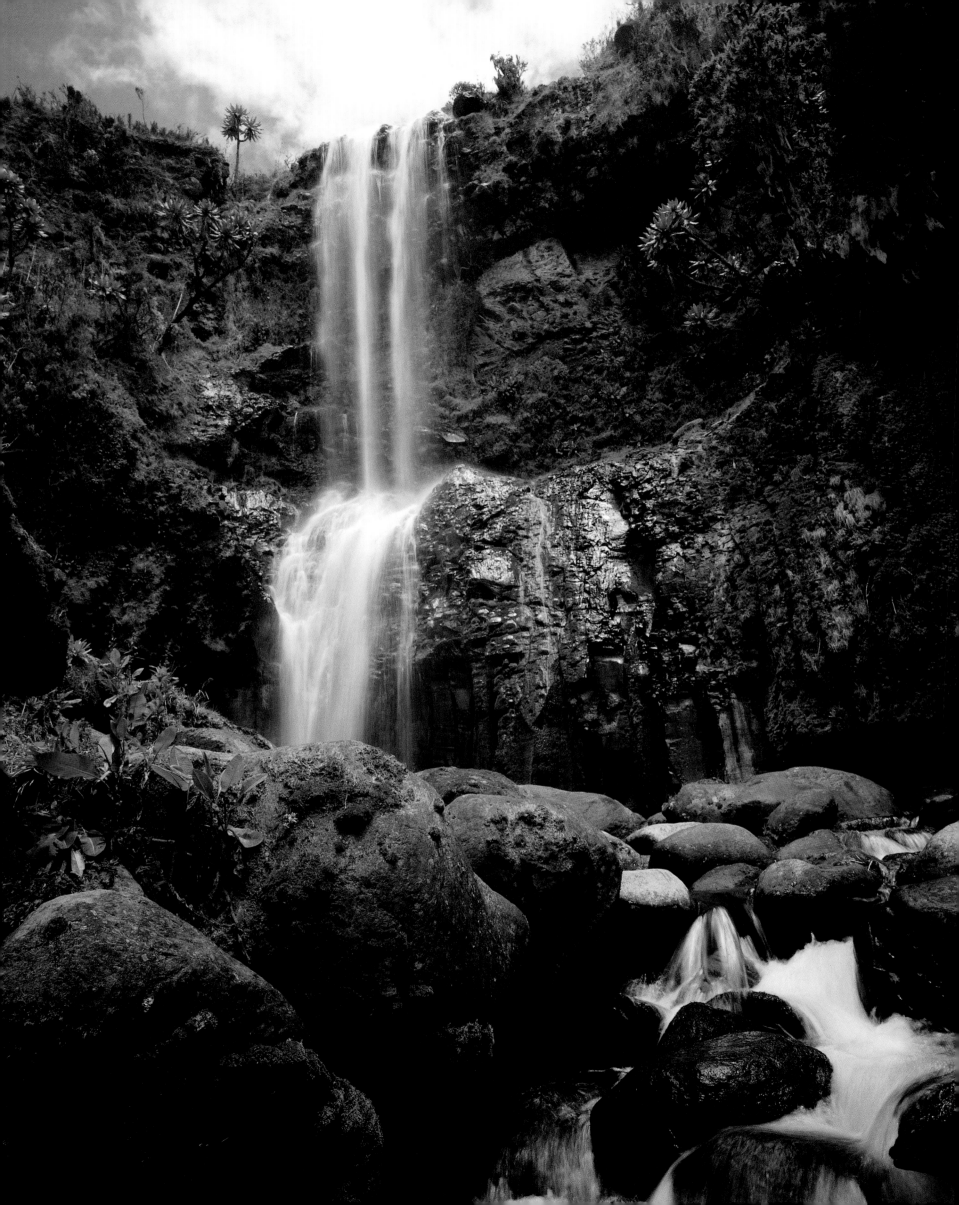

WATER: ELIXIR OF LIFE

Water is, without a doubt, the be-all and end-all of the savannah. Water justifies every risk. Giraffes put their lives at stake for it. They are protected from stroke by a sophisticated buffer mechanism when they are drinking; otherwise their normal hyper-high blood pressure (necessary to keep the head supplied with blood metres above the heart) would burst the fine veins in the brain when the animals drink with lowered heads. But the awkward, splayed-leg position into which they must contort themselves in order to drink makes the creature defenceless for a time against any attacks by lions or, more rarely, crocodiles.

The risk for hippopotamuses lies elsewhere. One wrong decision and a whole group is done for. When a watering hole threatens to dry out – becomes a muddy hole that can barely still provide the necessary moisture and essential protection from the sun – the leading animal has to decide whether to stick it out and hope that the rain will come in time, or to set off on arduous, nocturnal marches in search of a possibly non-existent alternative that could save them.

Zebras, rather like gnus, are capable of sustaining long, instinct-driven thirst marches to escape the drought. But the same applies to them: if they start too late, use up too much strength by making the legs of the journey too long, have too little energy in reserve for the long migration – all this is punishable by death.

One question occurs to the layperson: why these risky drives? Why don't these grazing animals stay where there is enough water all year round? The answer is obvious: the land would soon be overgrazed. And besides the young grass in areas with low rainfall is particularly juicy and enticing.

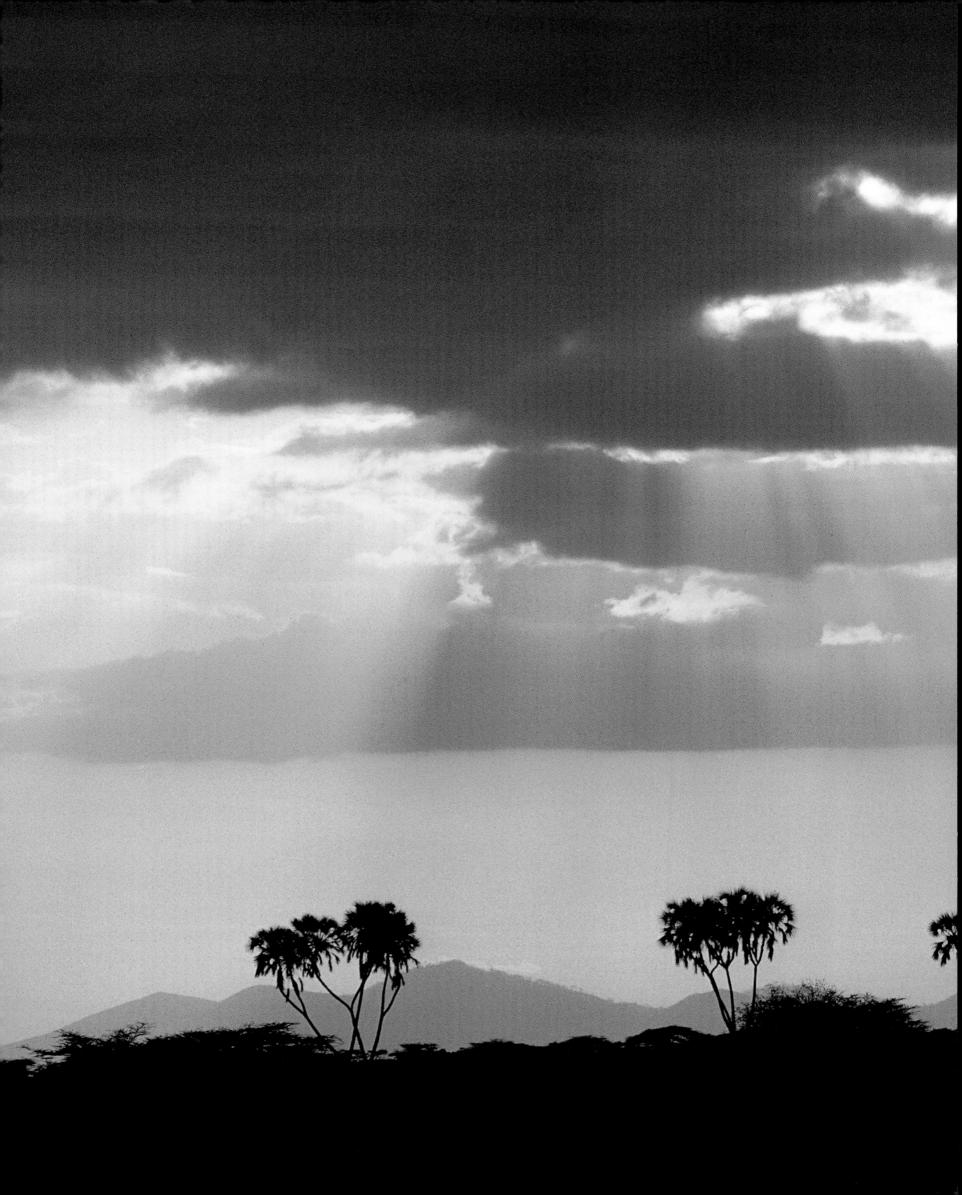

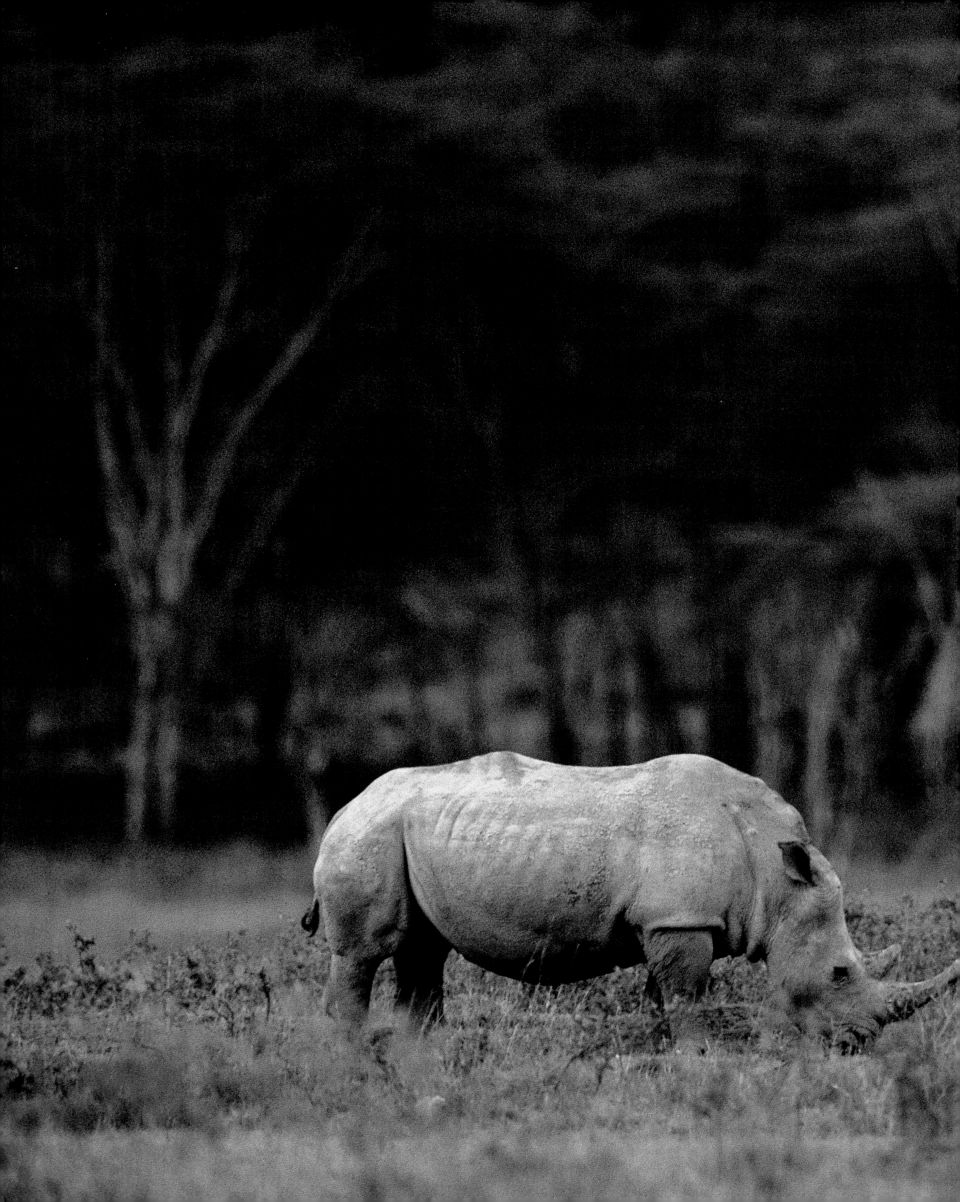

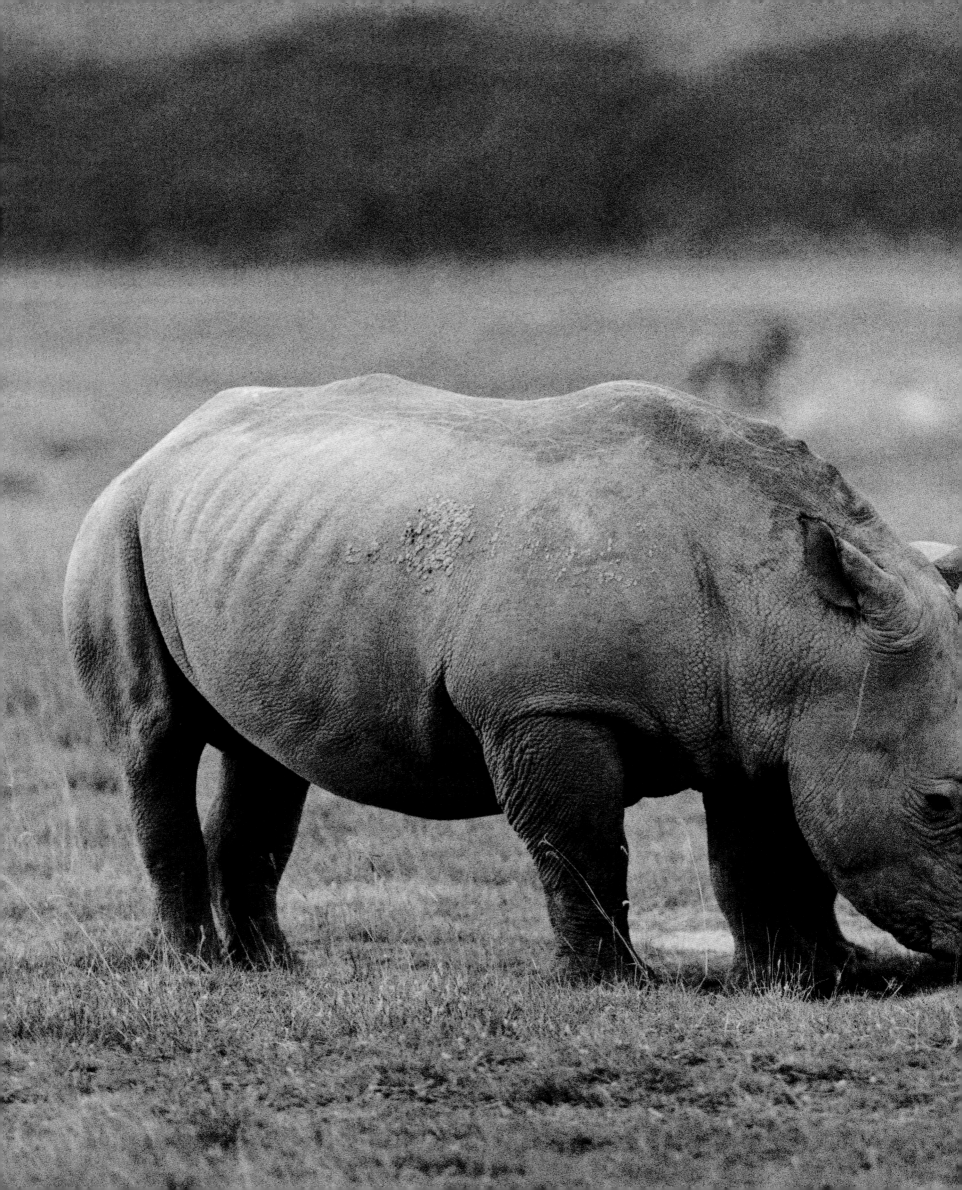

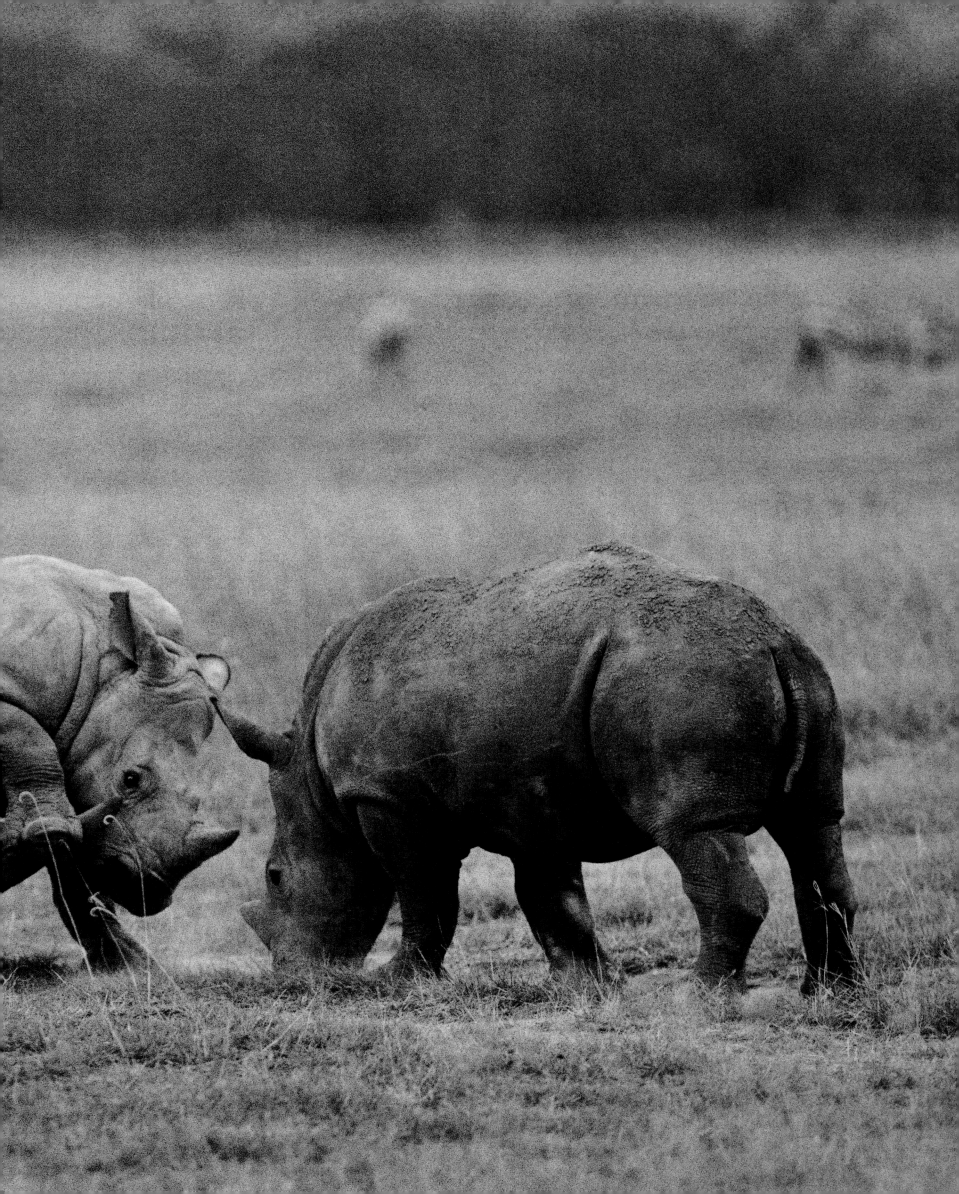

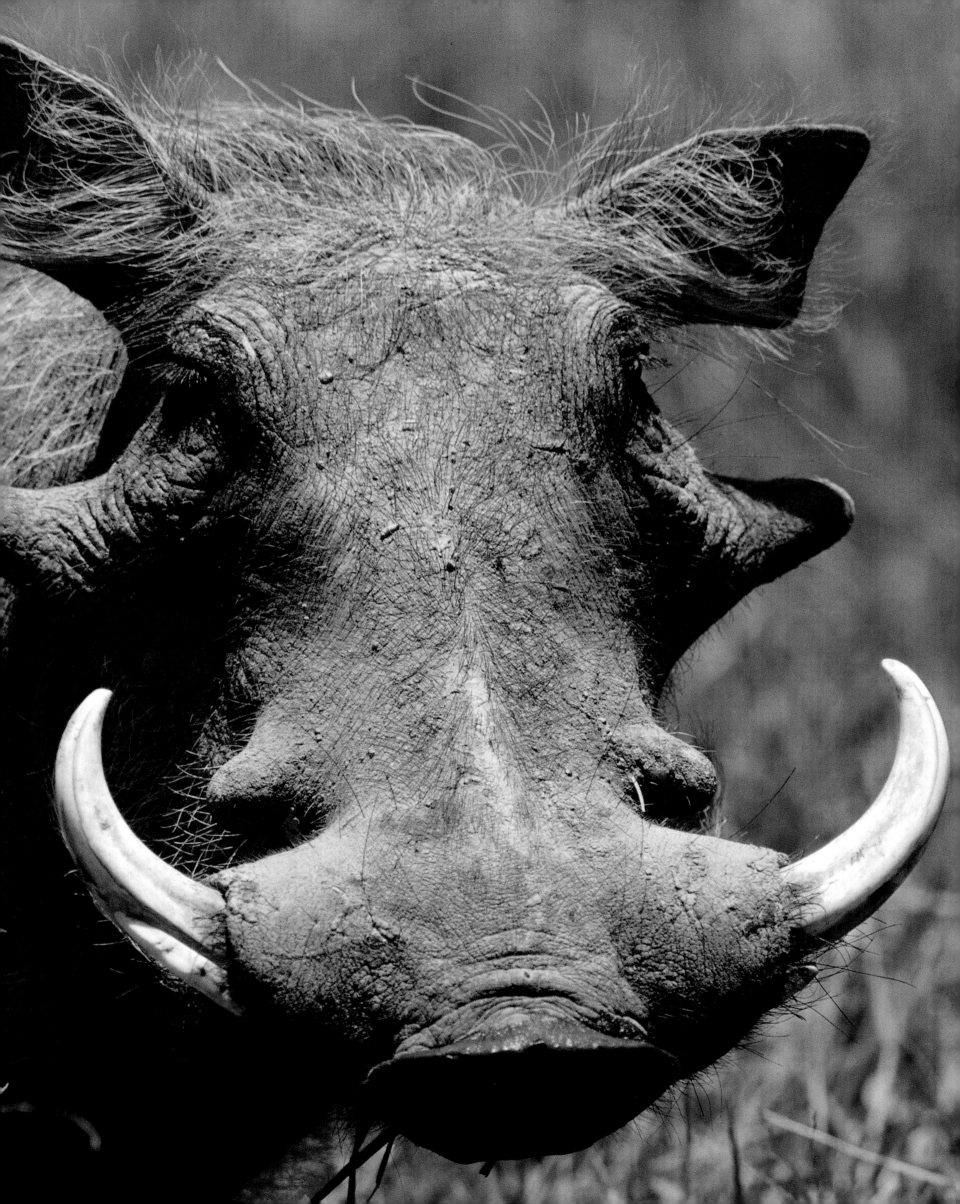

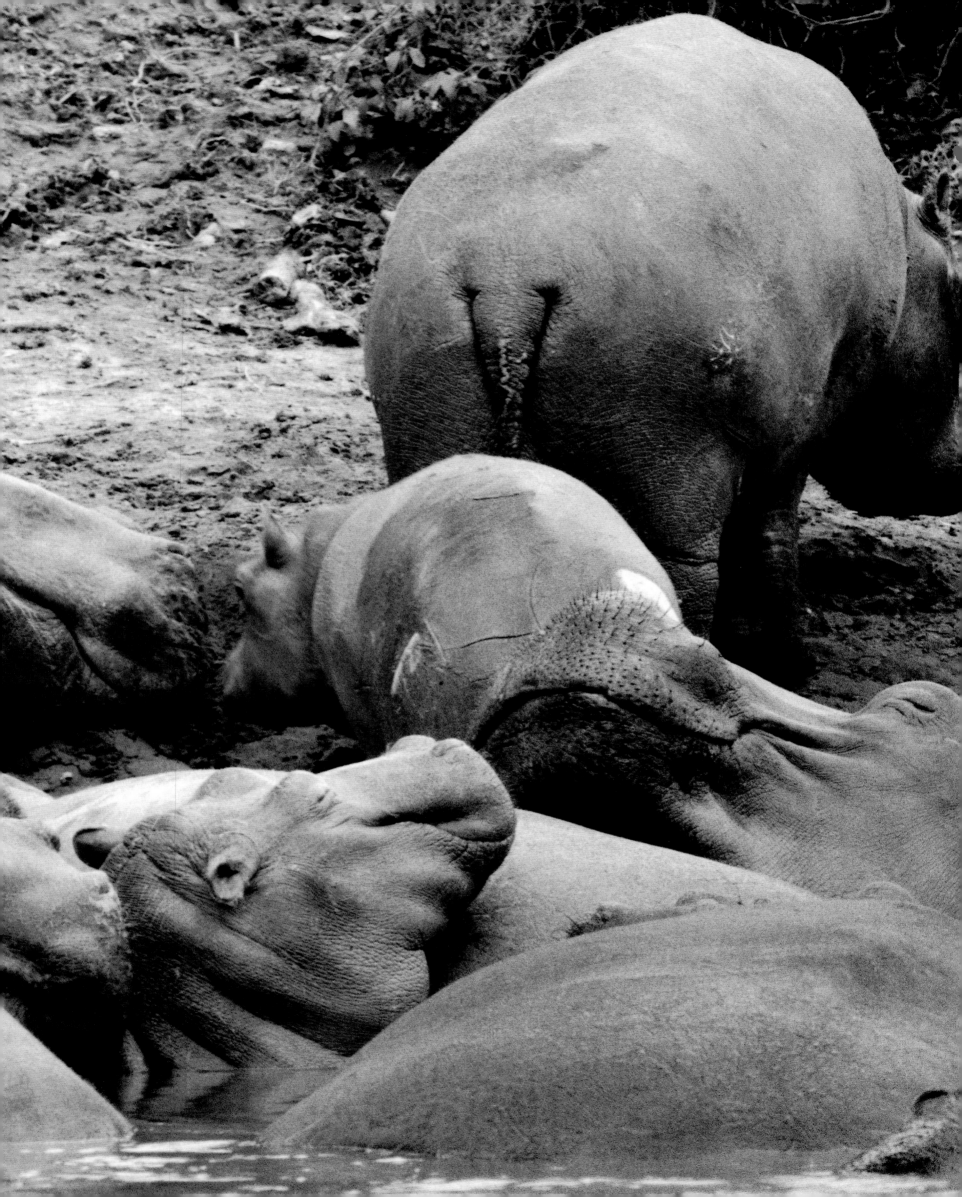

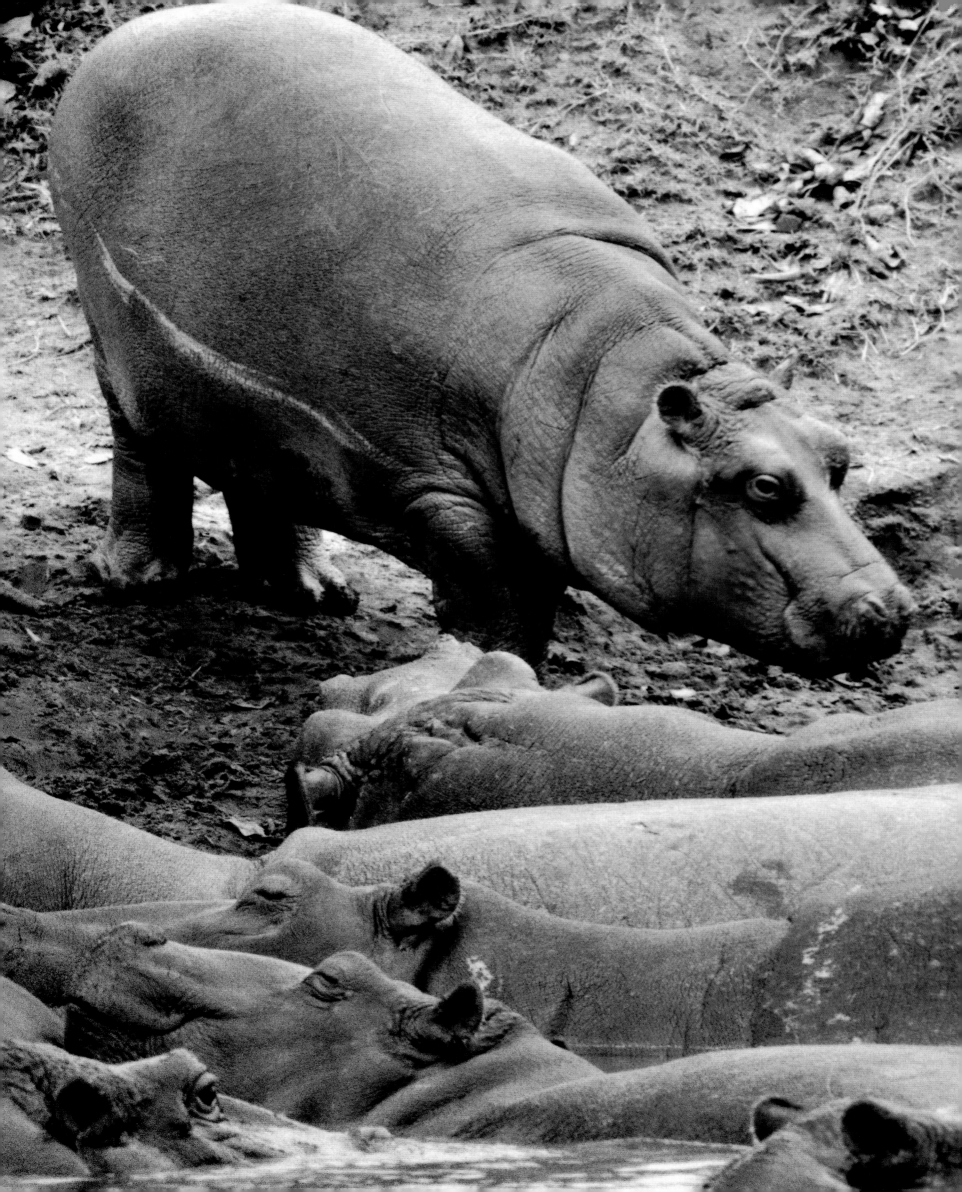

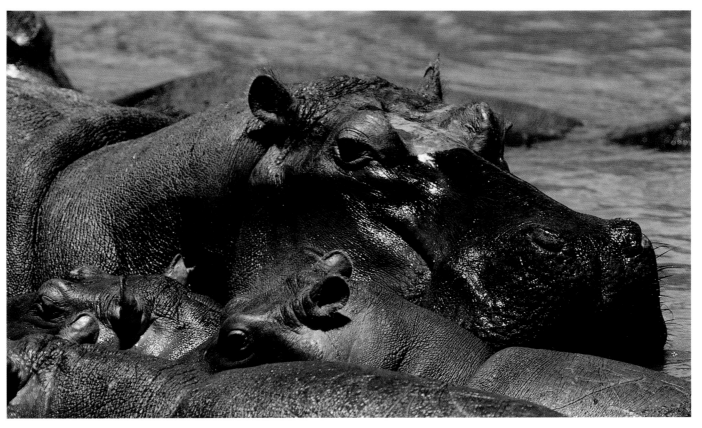

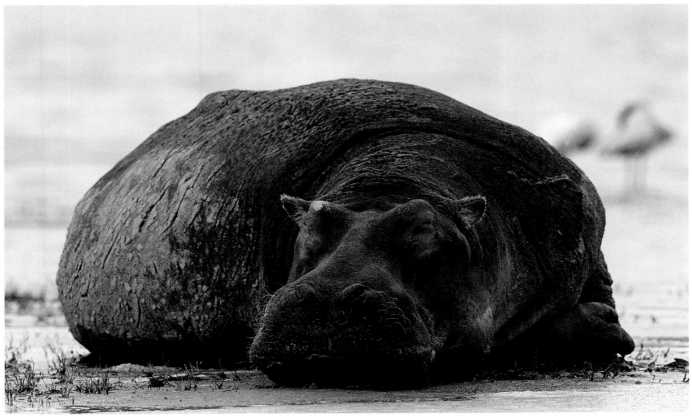

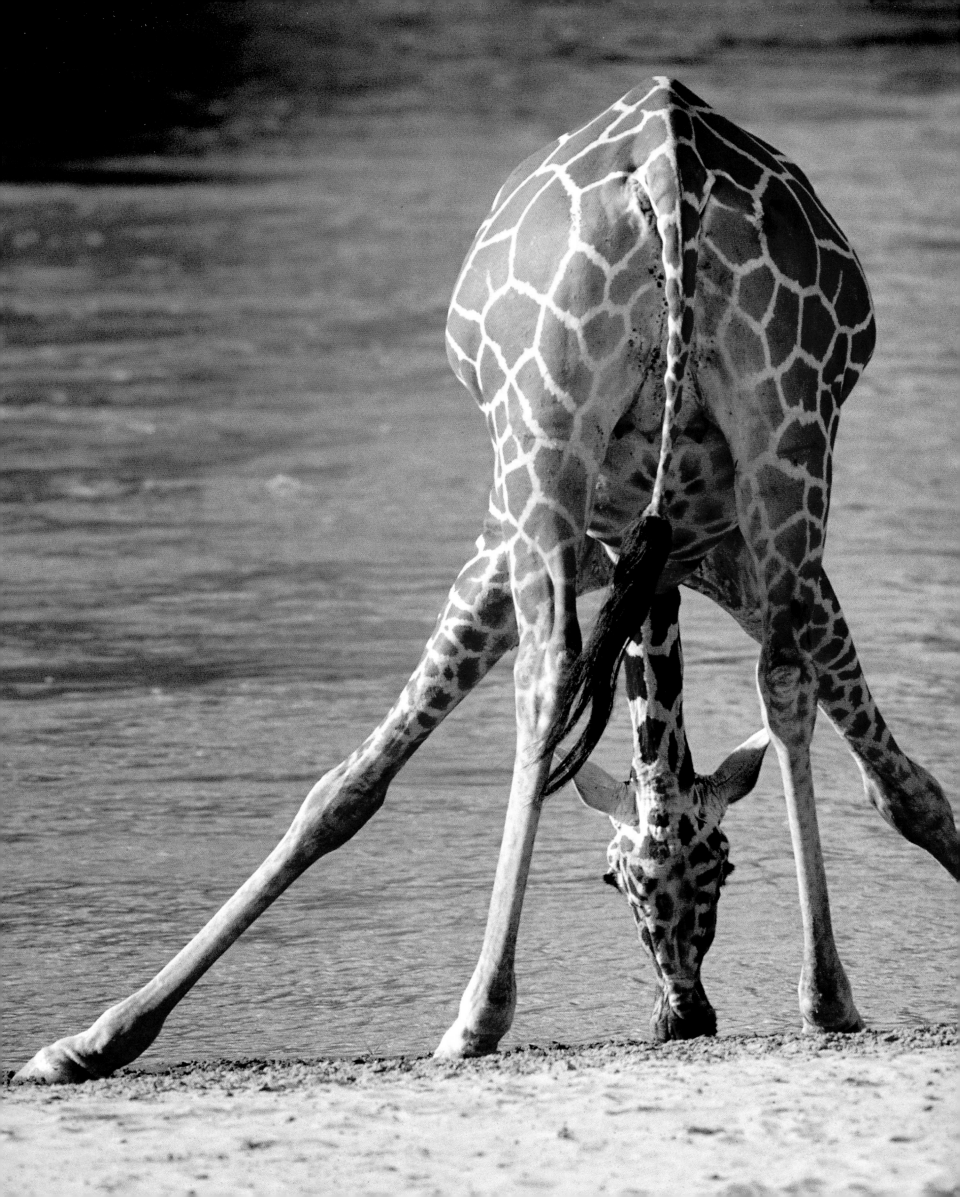

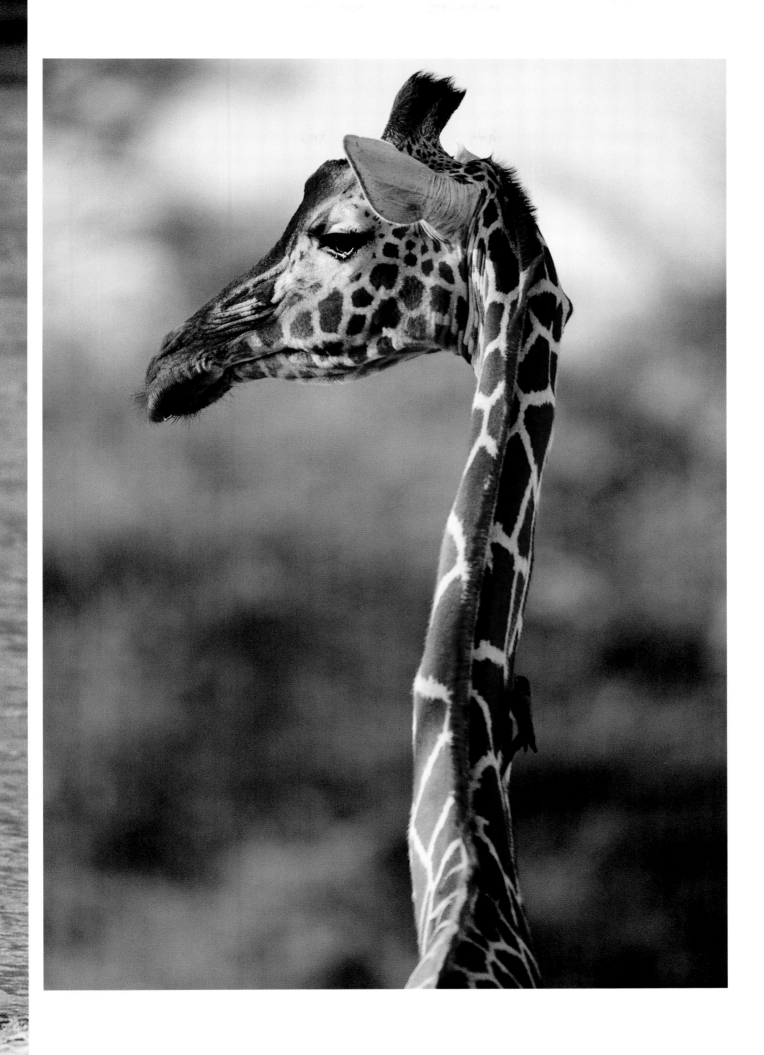

175

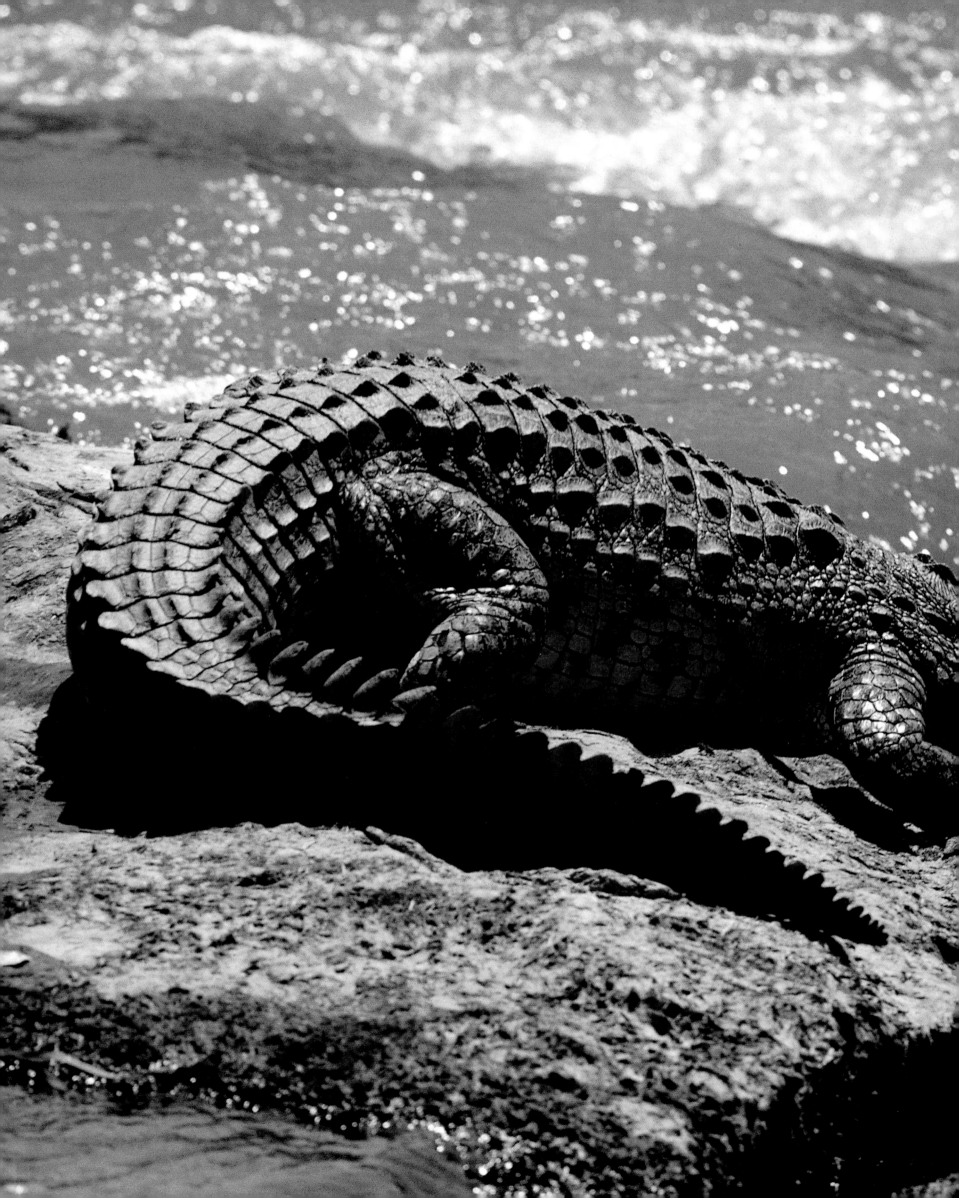

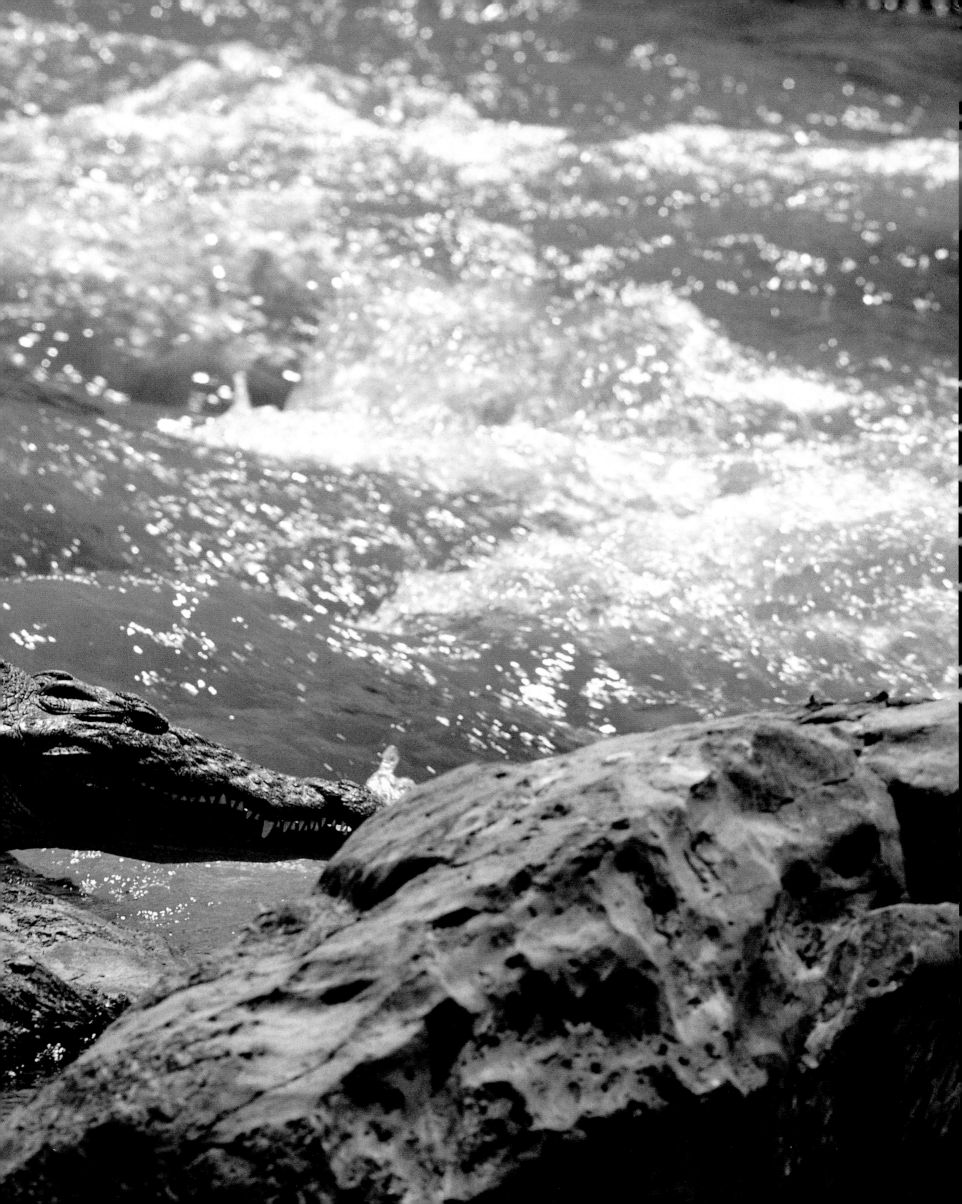

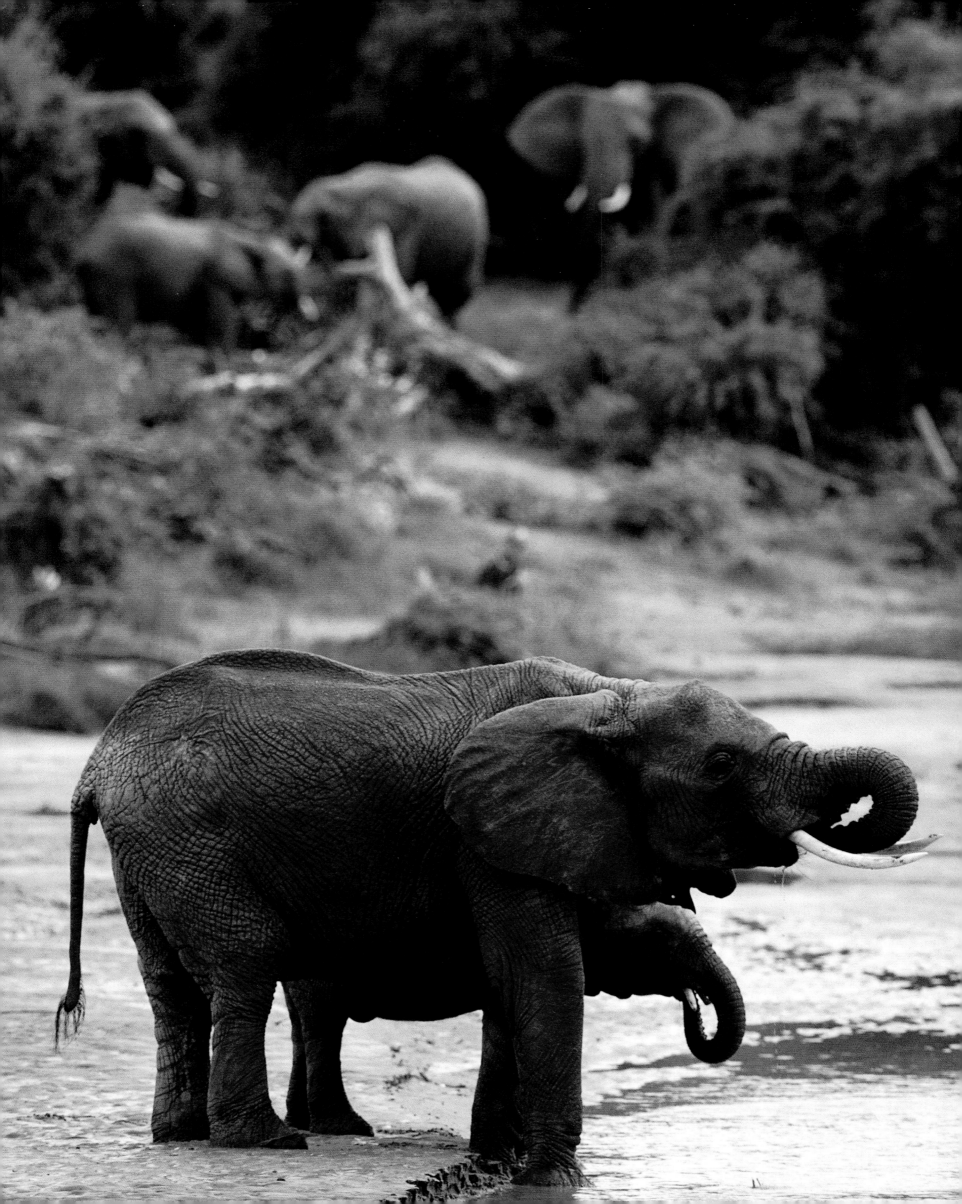

THE ELEPHANT:
A HUNTED GIANT

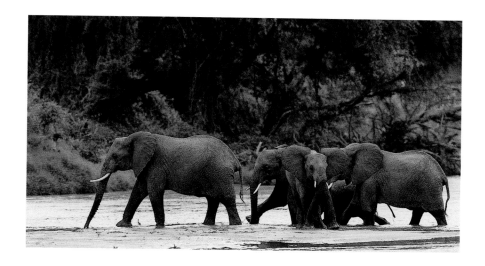

Alongside (teddy) bears, elephants are vivid animal characters in European children's bedrooms, where they enjoy a stable, unendangered biotope and are loved unreservedly. But real African elephants – at four metres high at the shoulder and weighing up to 6.5 tons the largest land mammals in the world – are by and large not so fortunate. Ivory poachers would have eliminated these pachyderms from the face of the earth in the second half of the 20th century if the international ban on "white gold" had not been imposed.

This is the paradox that wildlife management has to cope with today: there are too few and too many elephants. They do not occur at all in large areas of their hereditary home, then in the secure national parks they are sometimes on top of each other, quite frequently overstepping – no, overtrampling – the bounds of ecological sustainability.

When food becomes short, the herds move away to neighbouring farmland. A hungry herd of elephants can easily trample down and clear away the basis of a peasant family's existence in a single night.

The governments, which have no money for compensation as a rule, tend if need be to respond to the injured parties' cries for help by granting exceptional permission to shoot, which in turn infuriates animal- and species-conservationists.

However big Africa may be, it seems to have become too small for these grey giants. Though *Loxodonta africana* does have an enormous advantage vis-à-vis other endangered species: their positive image and world fame make it easier to launch expensive aid programmes than it is in the case of other species that are more threatened and less conspicuous.

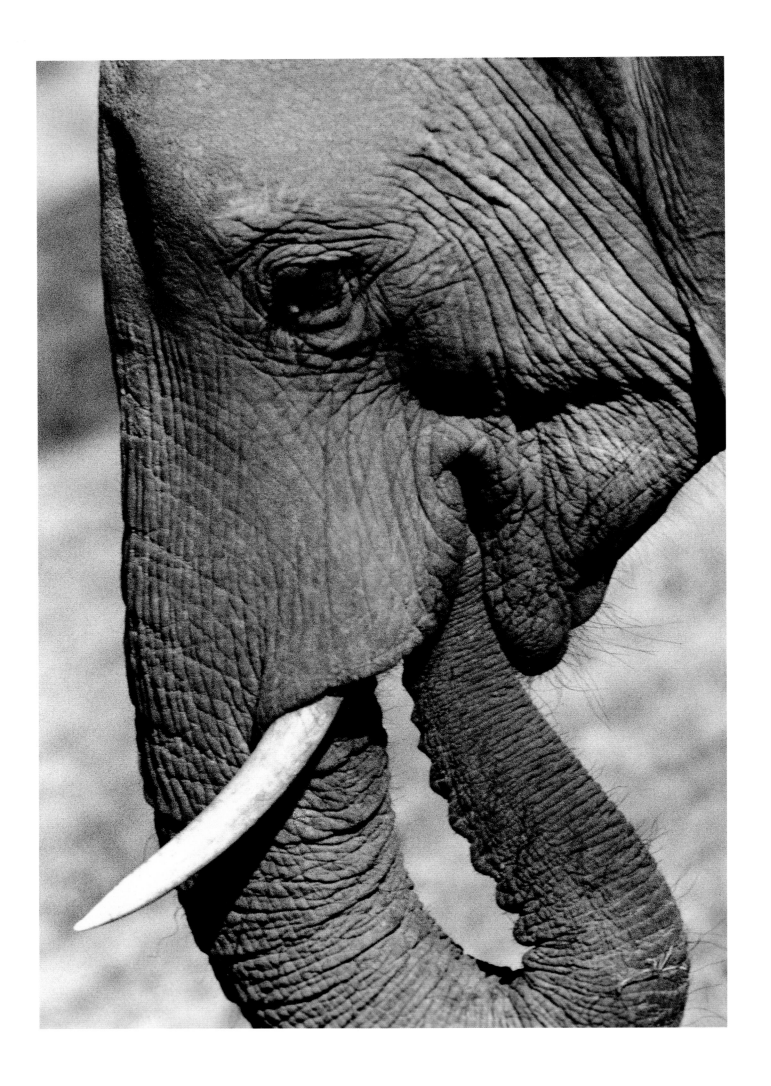

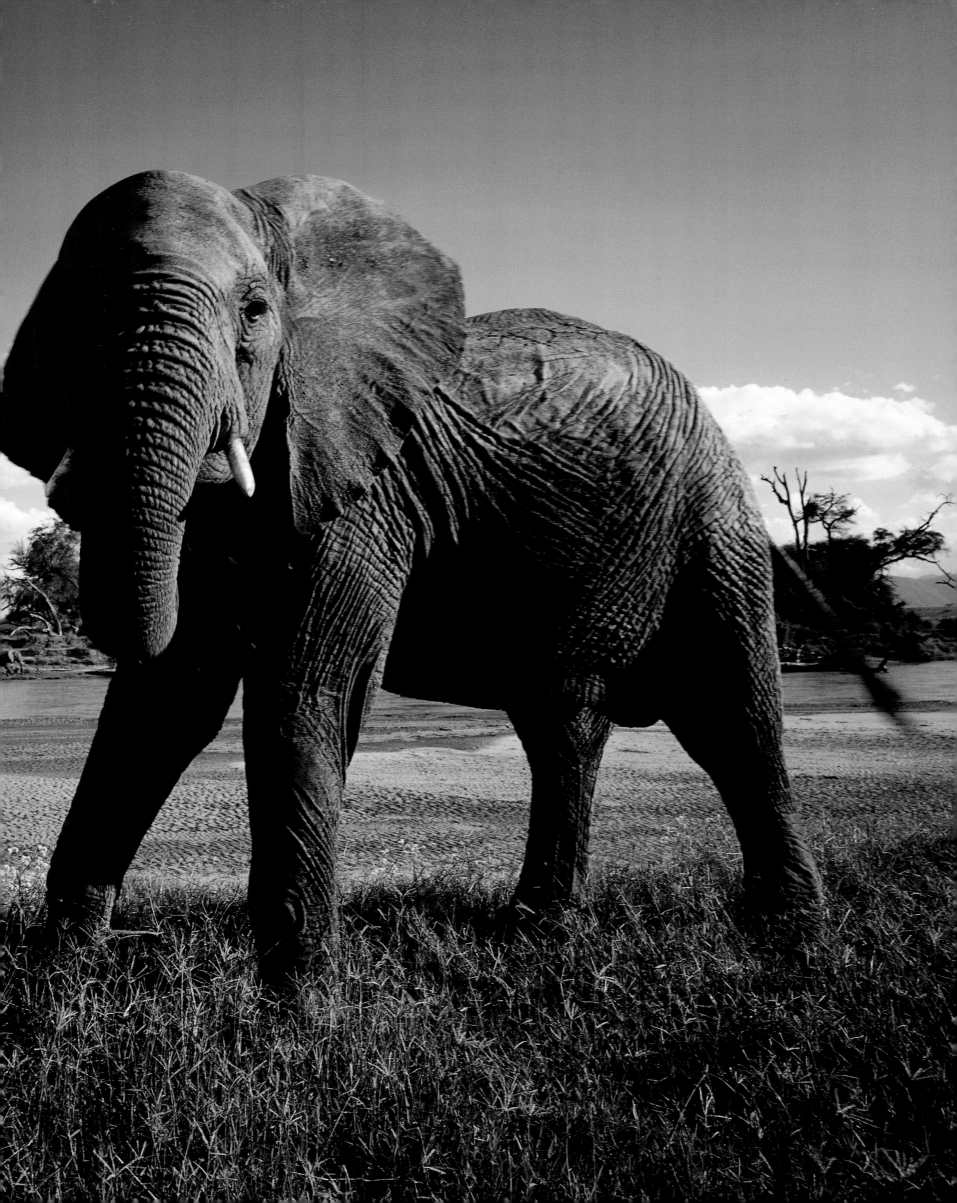

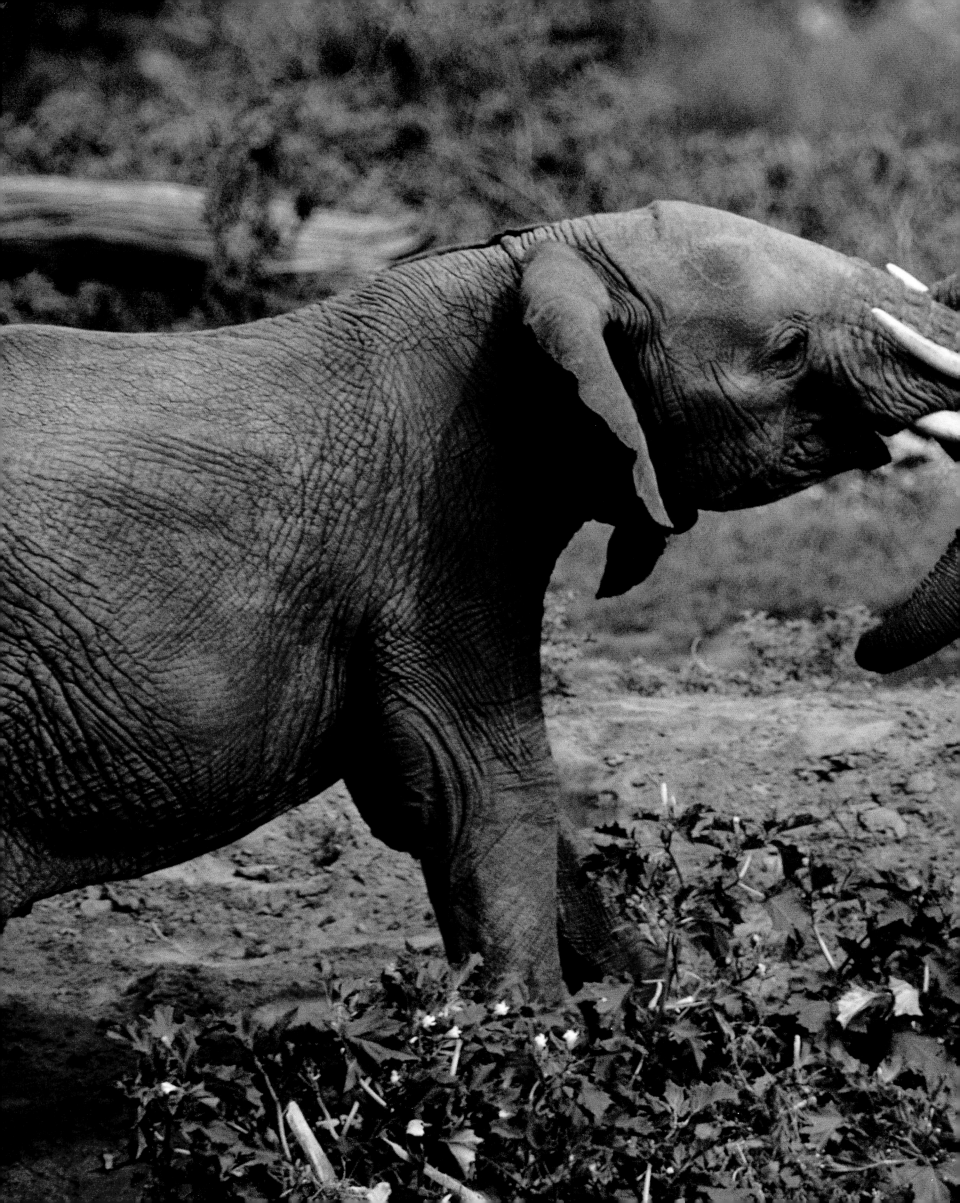

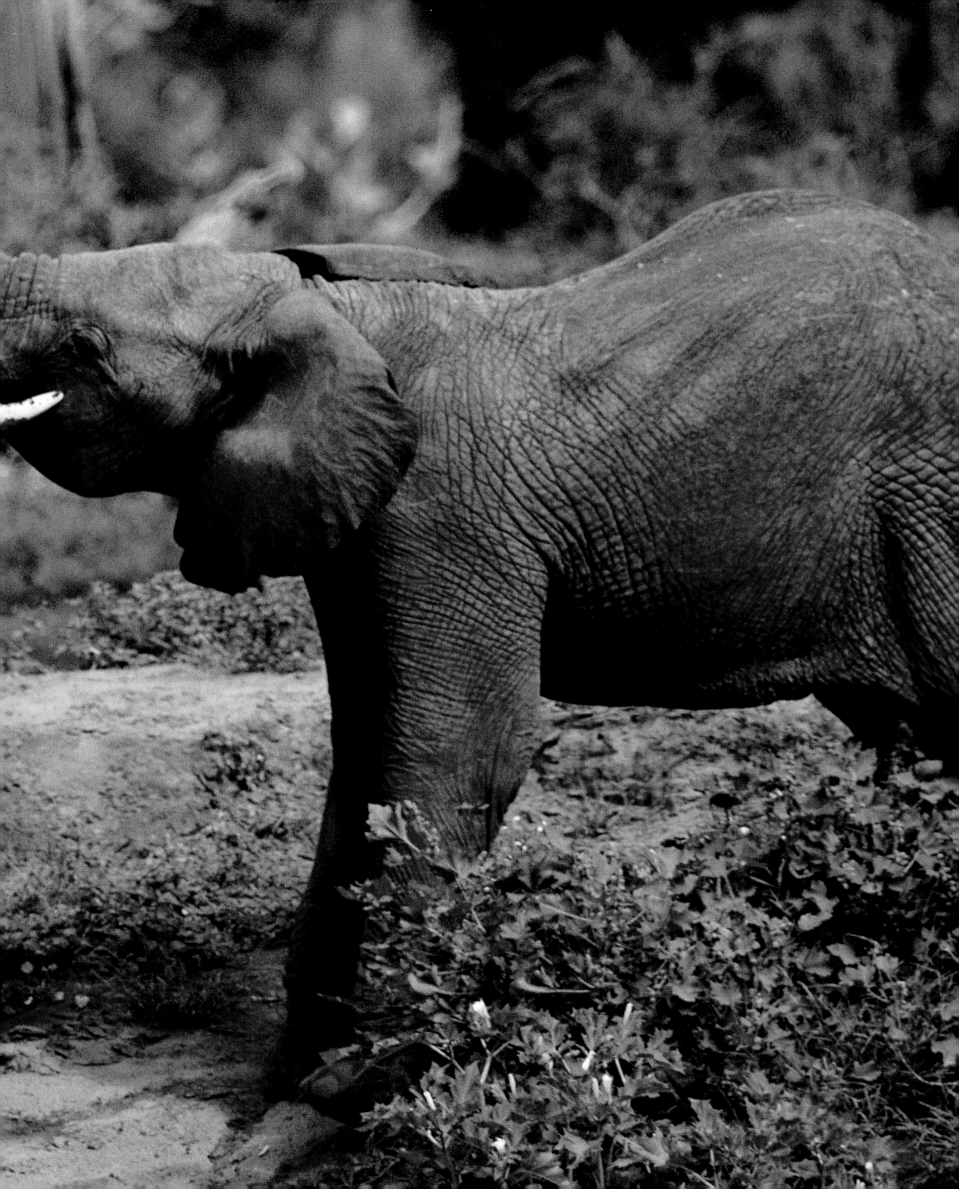

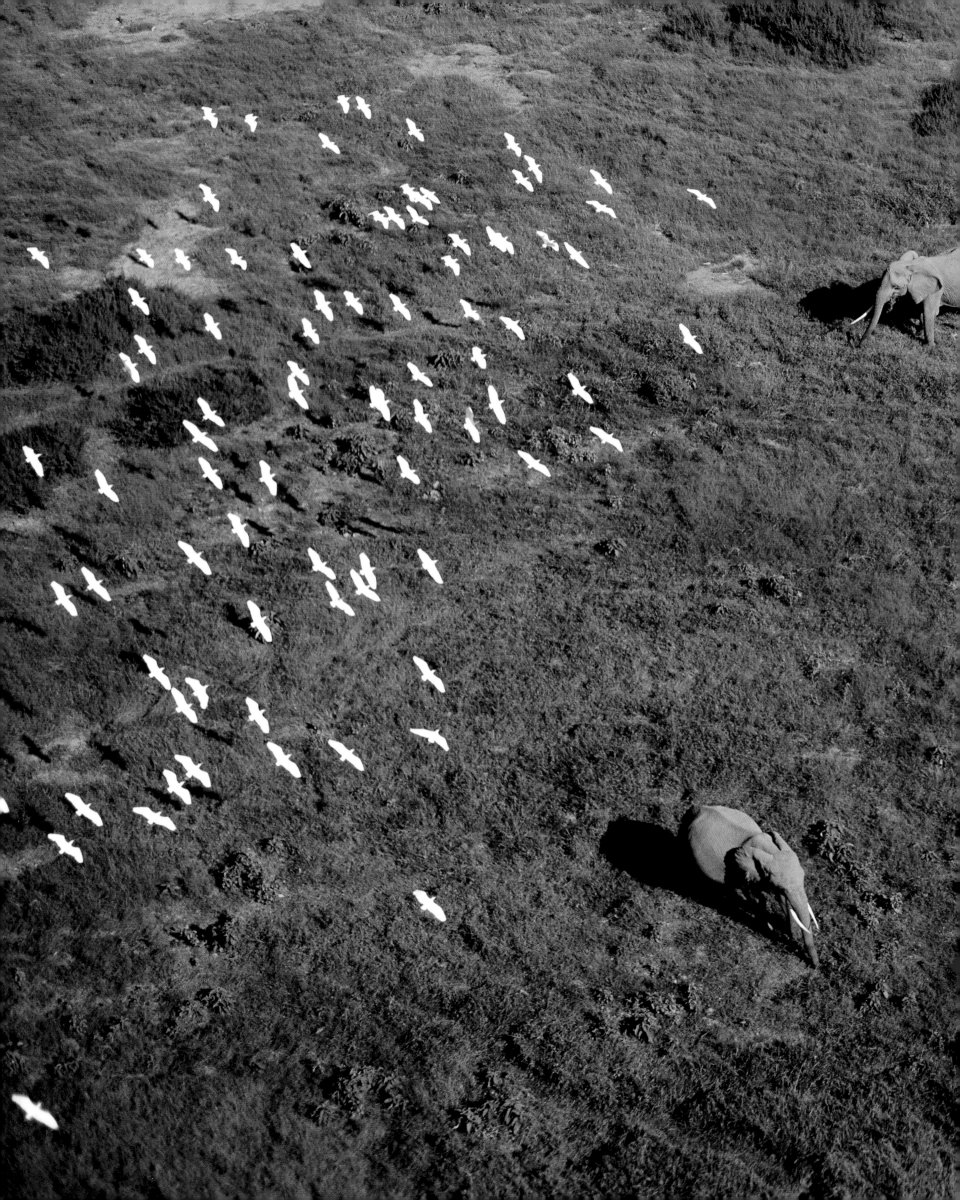

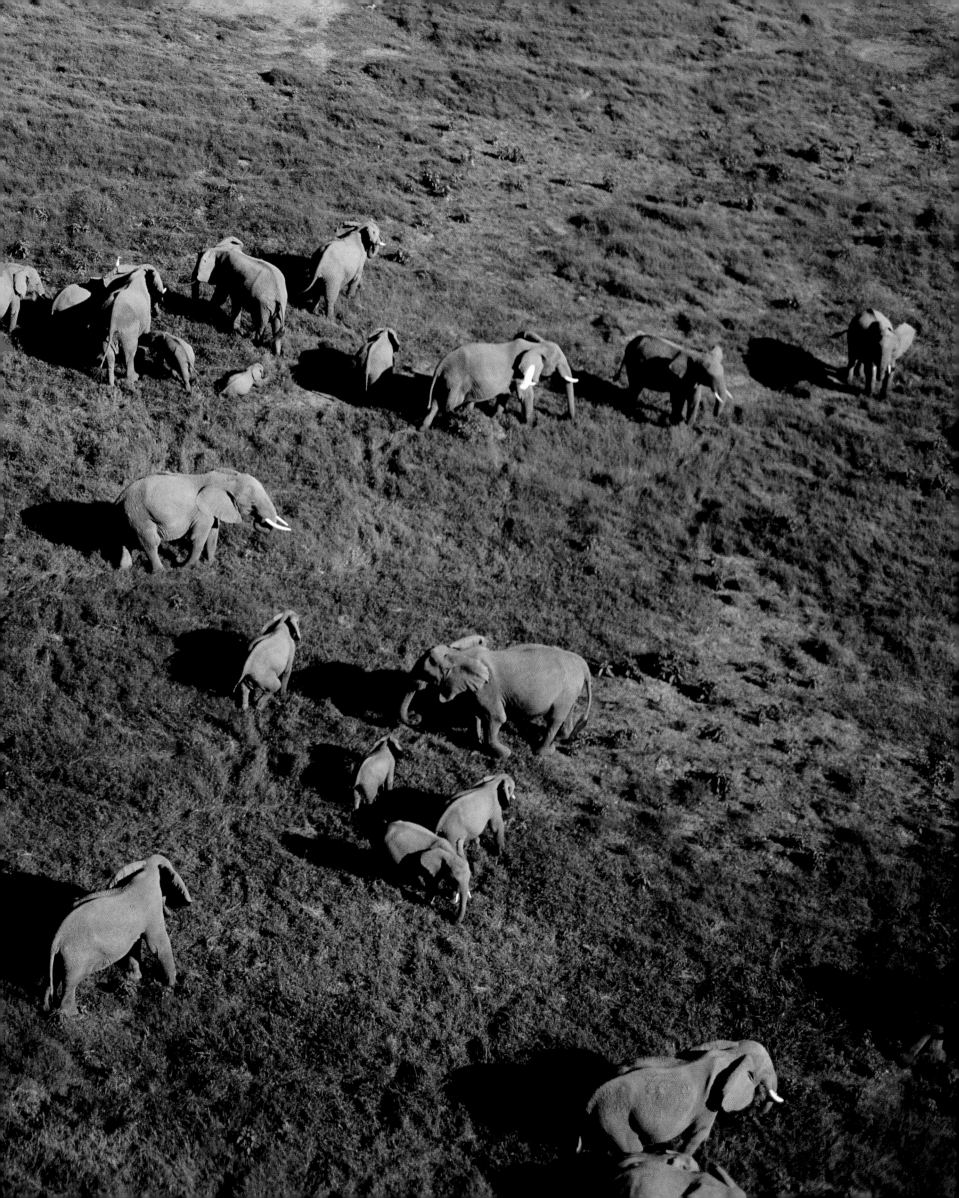

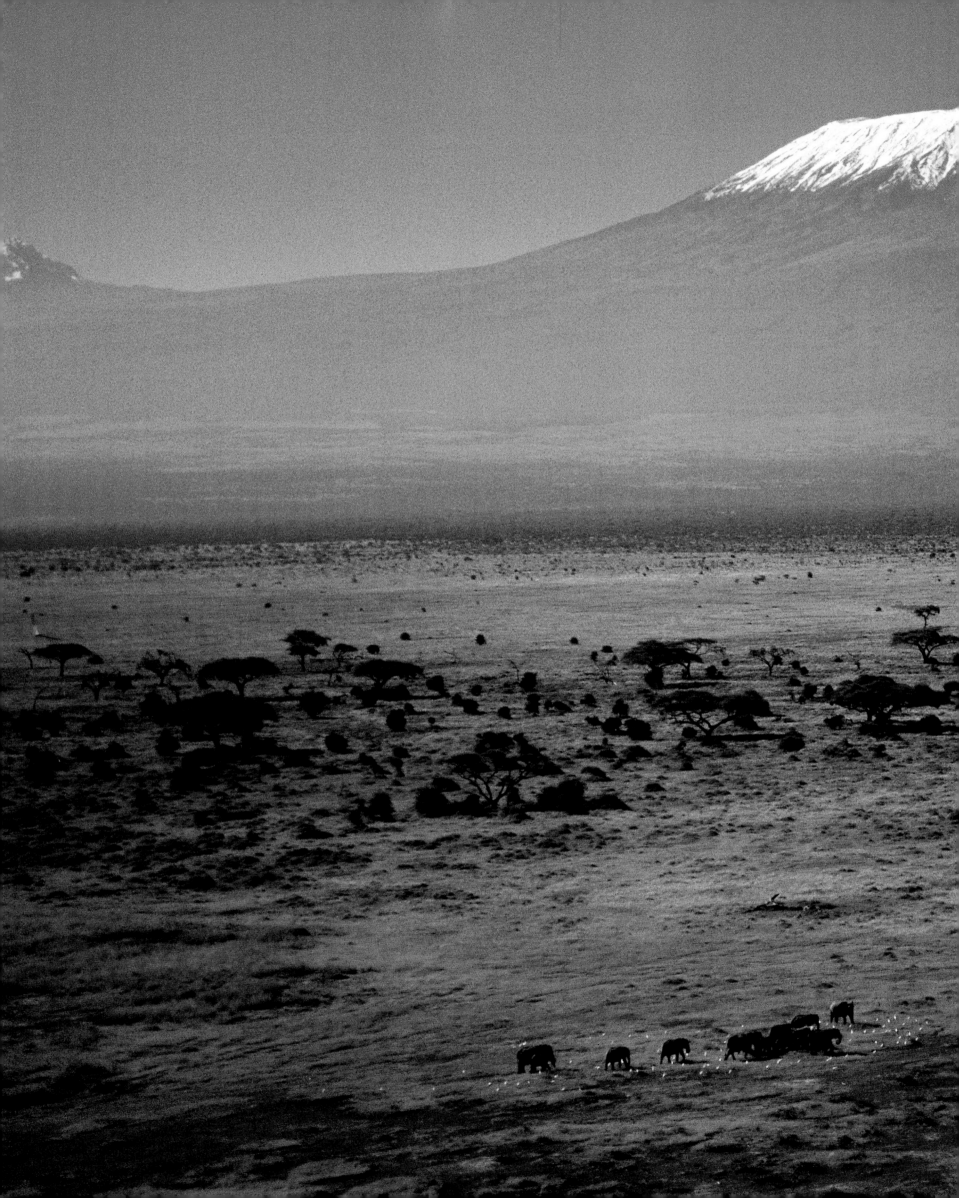

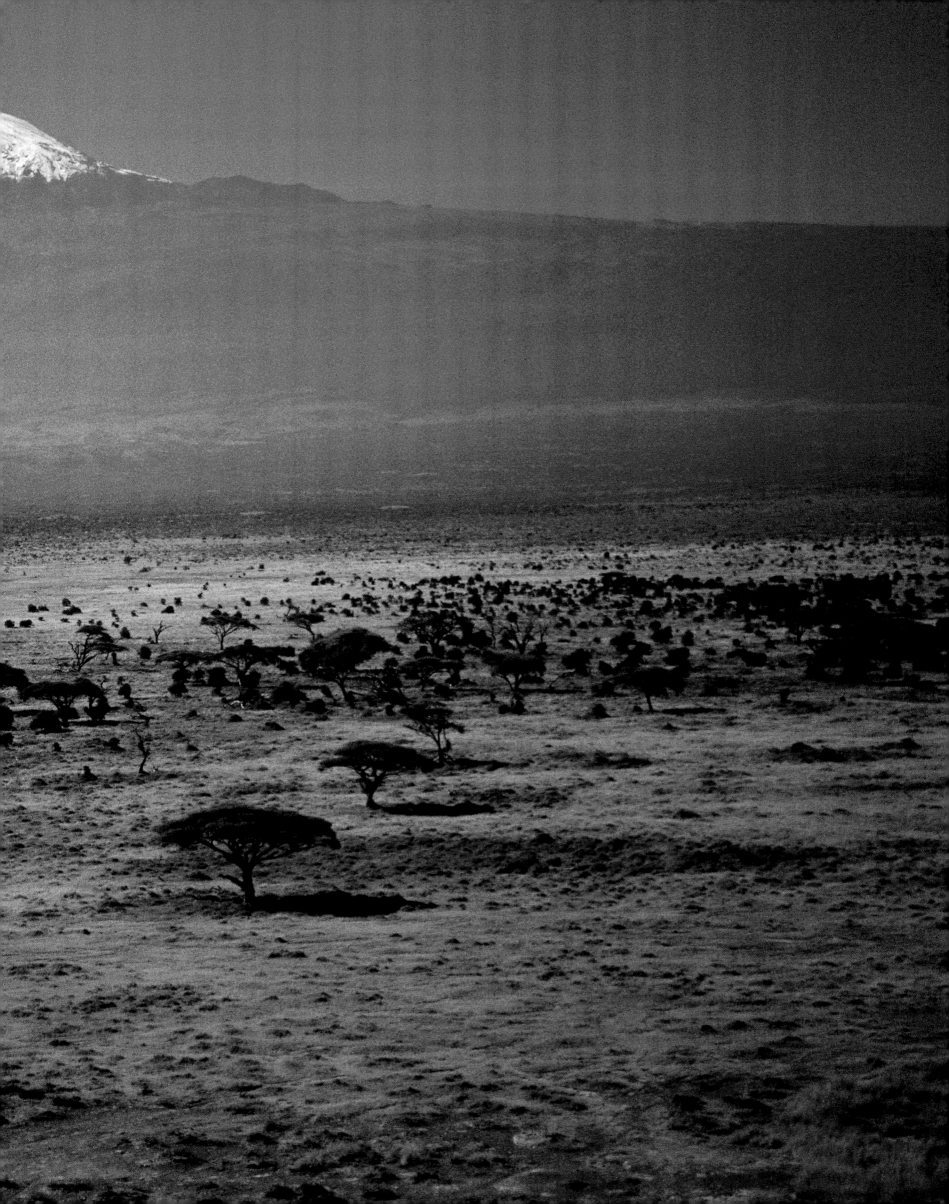

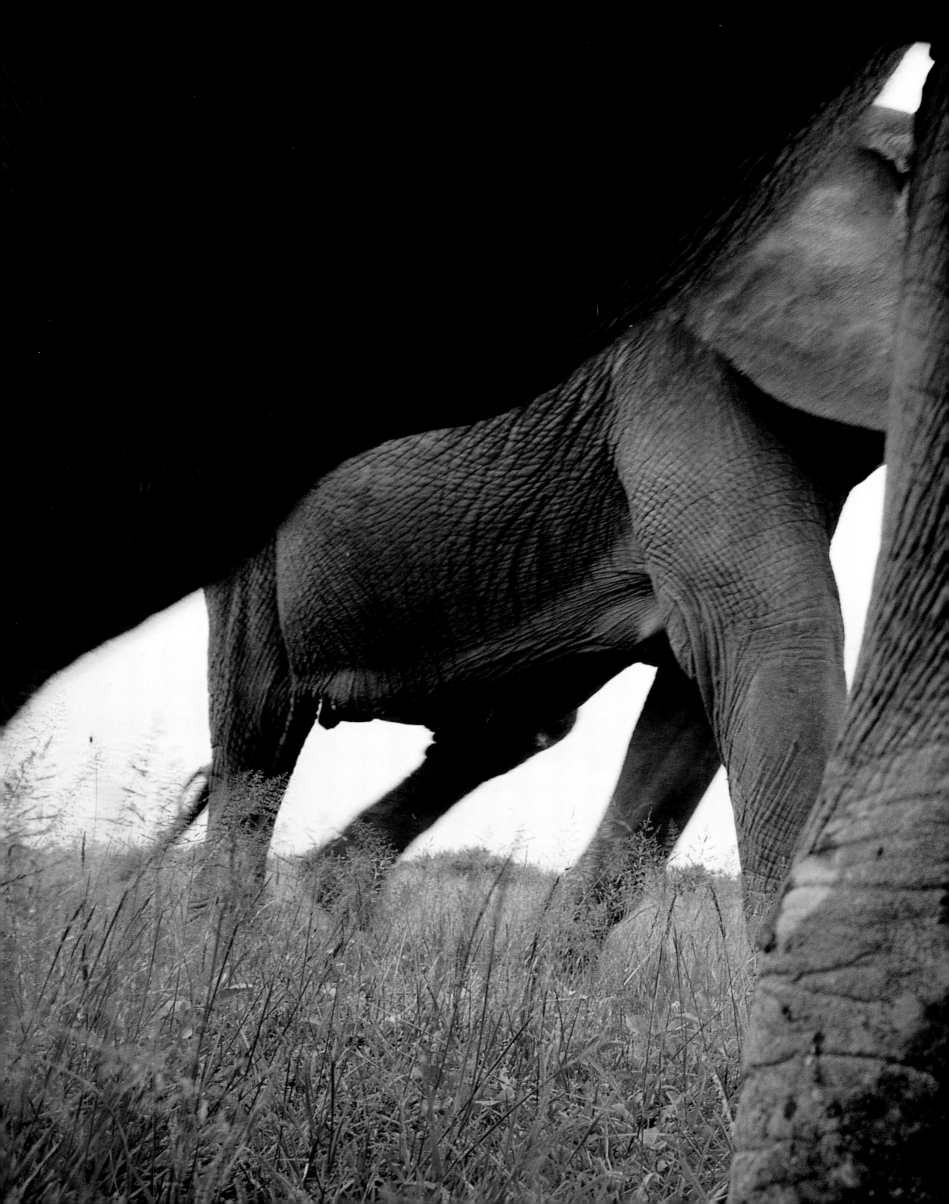

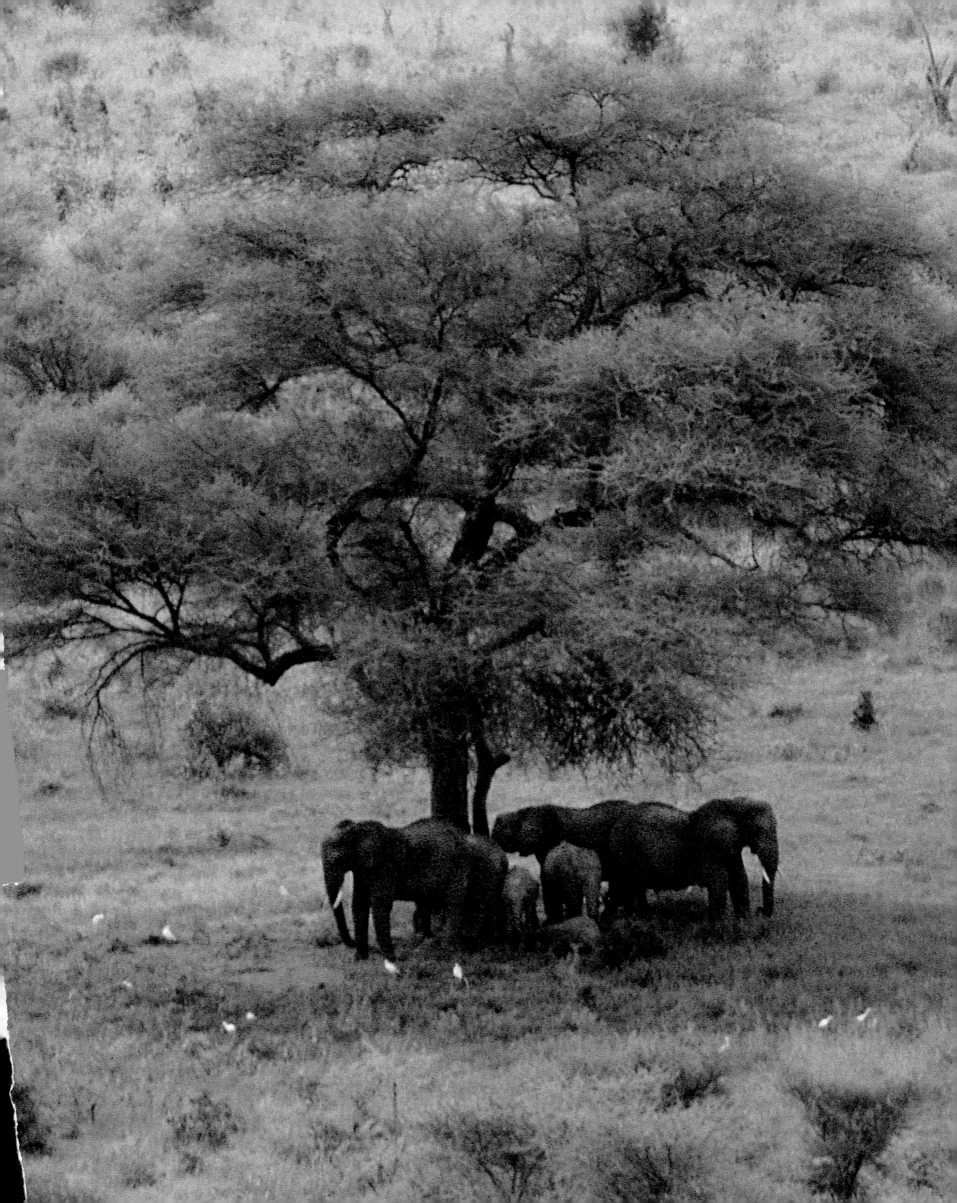

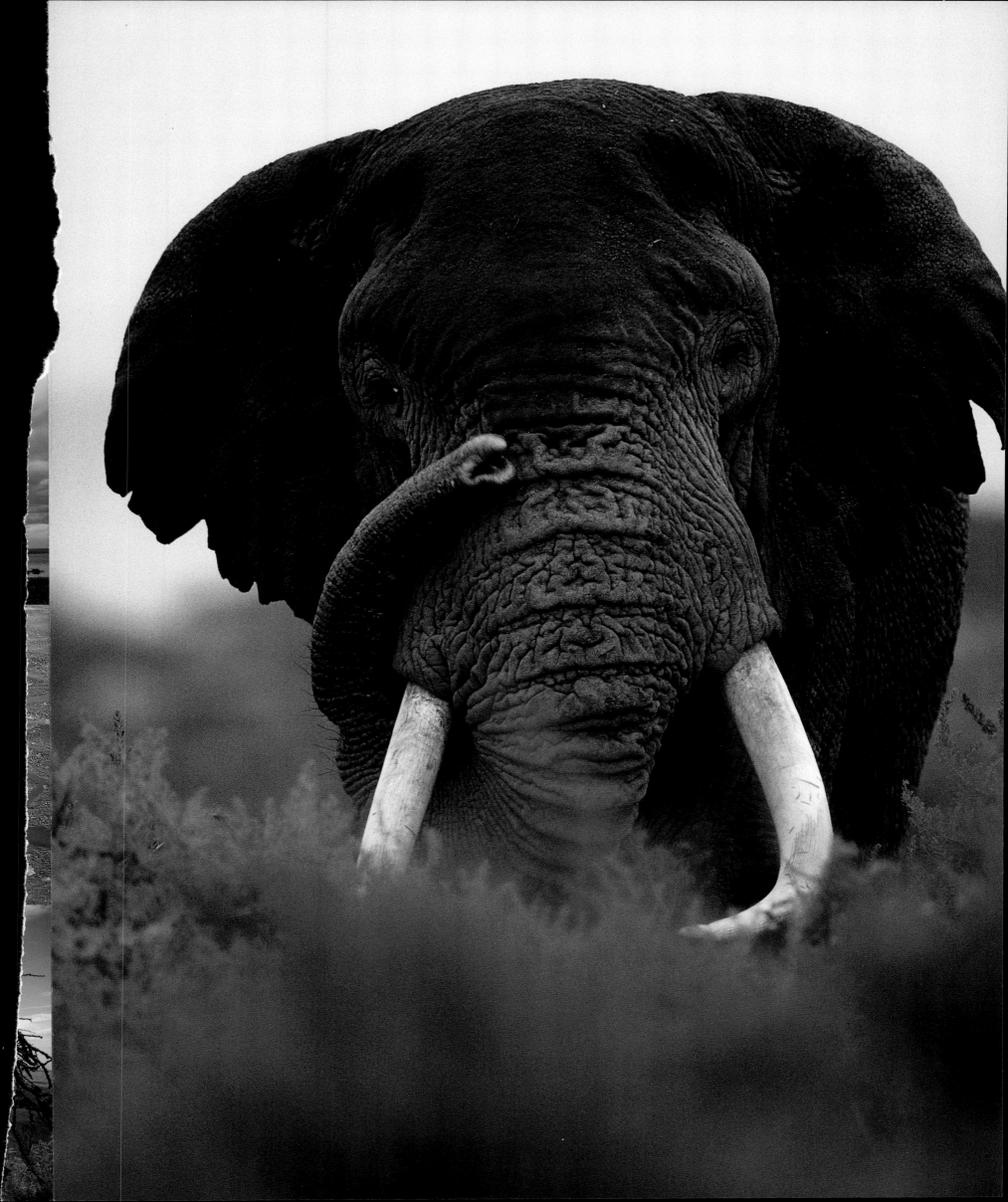

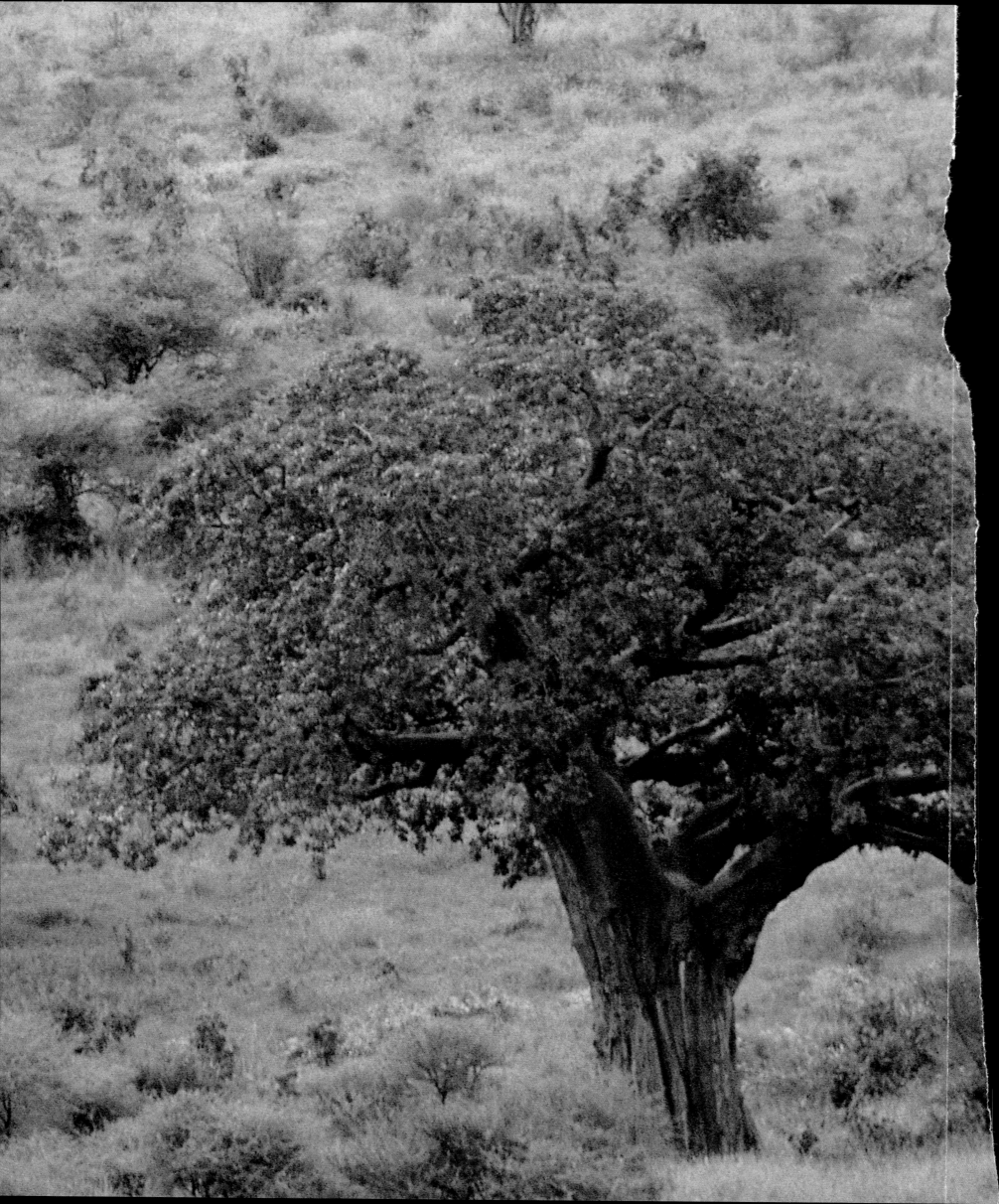

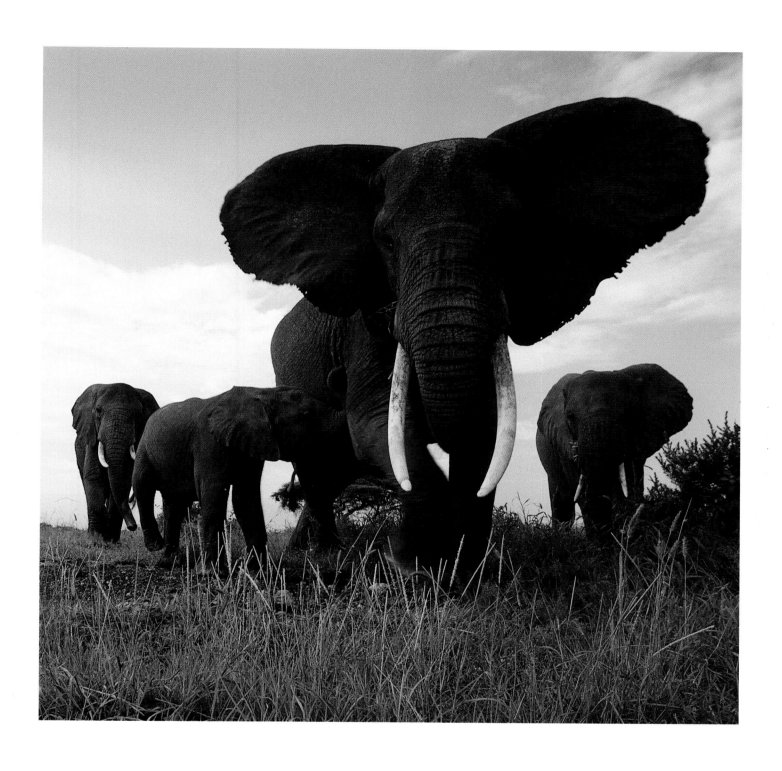

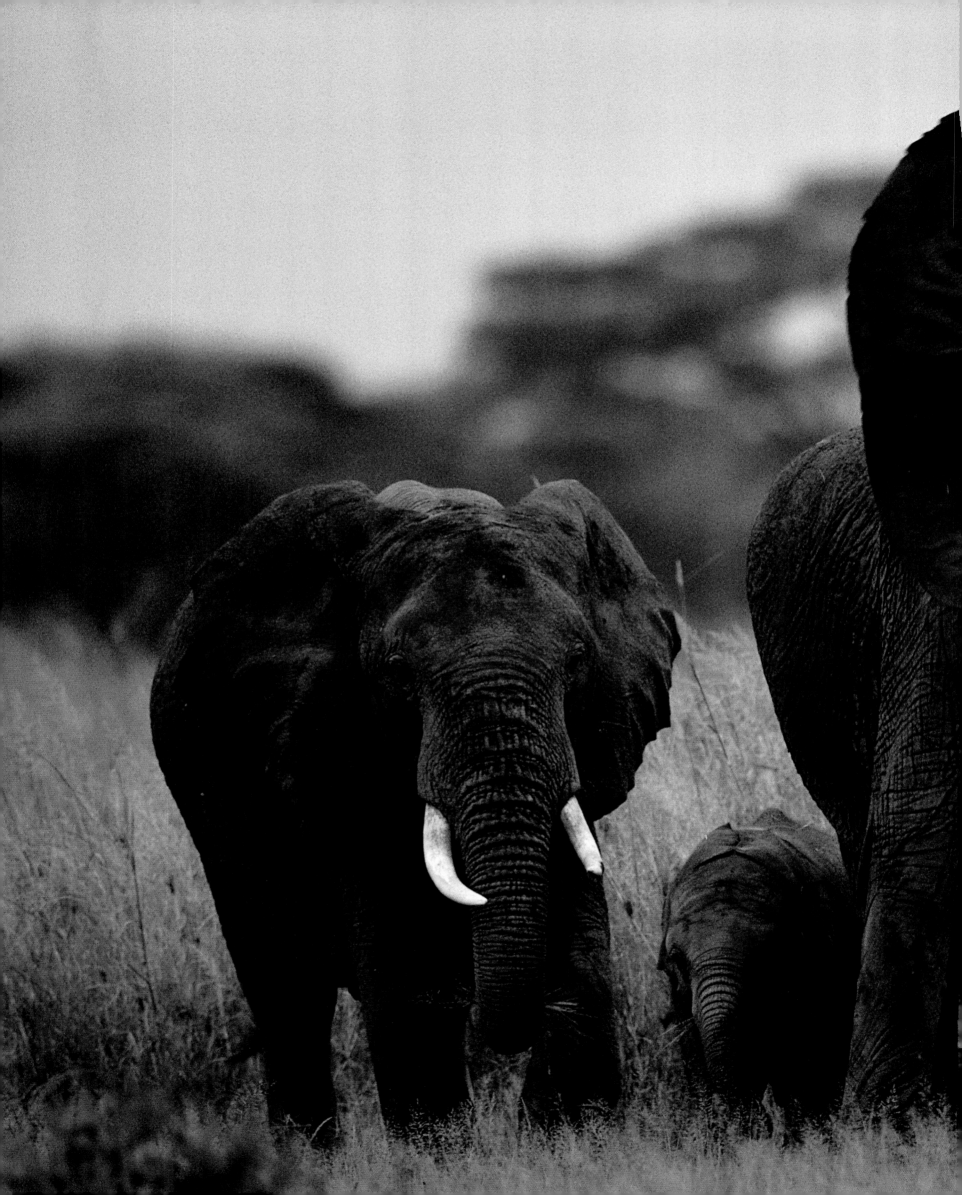

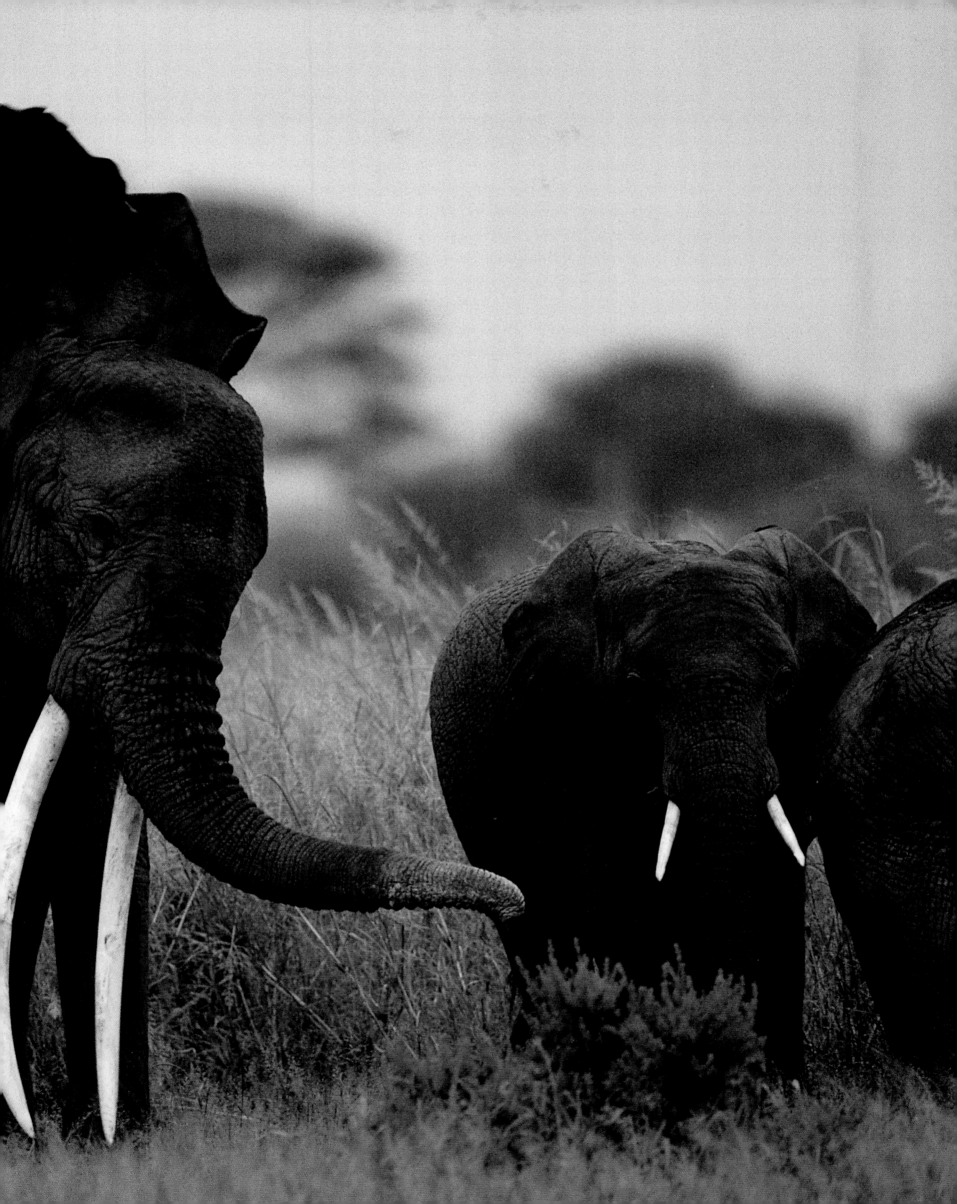

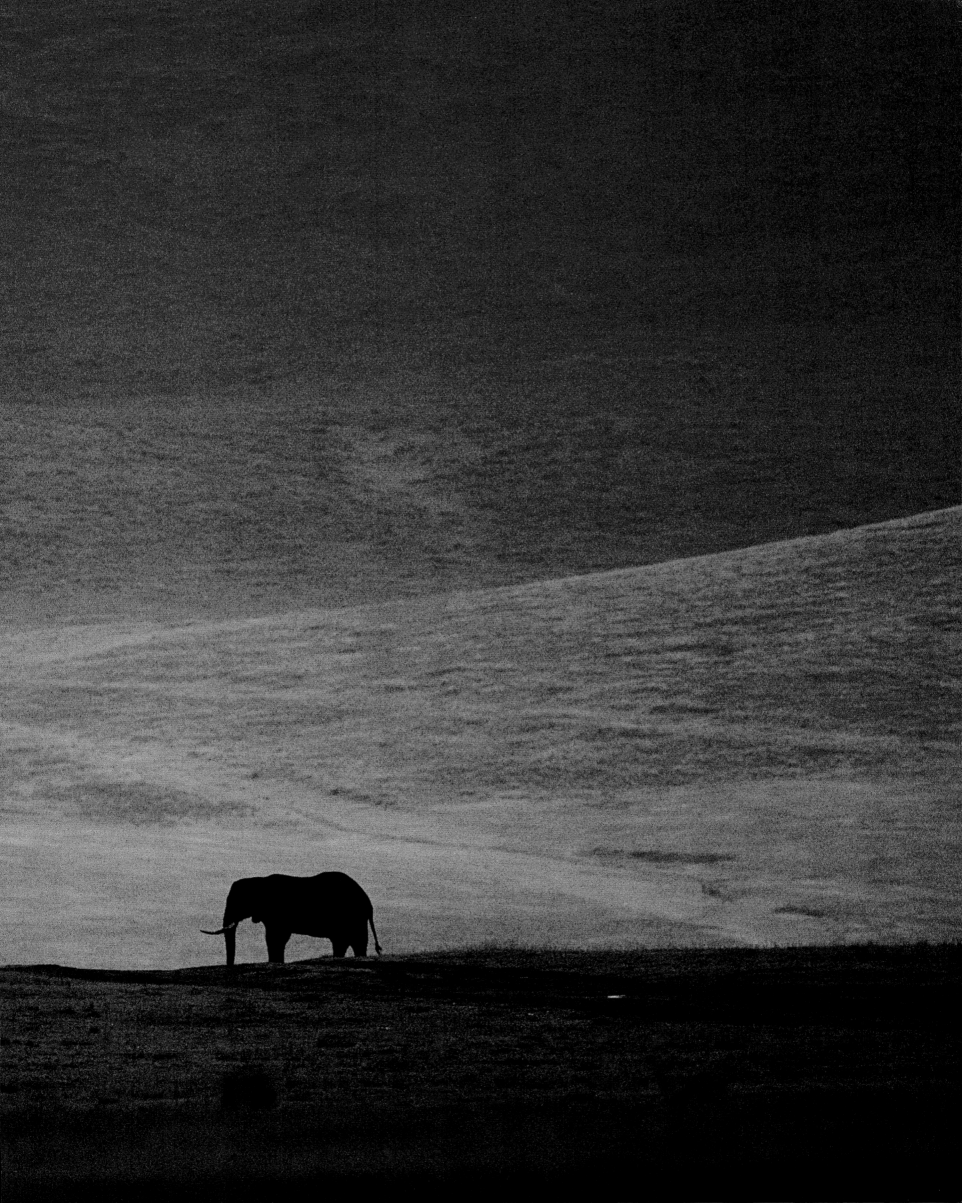

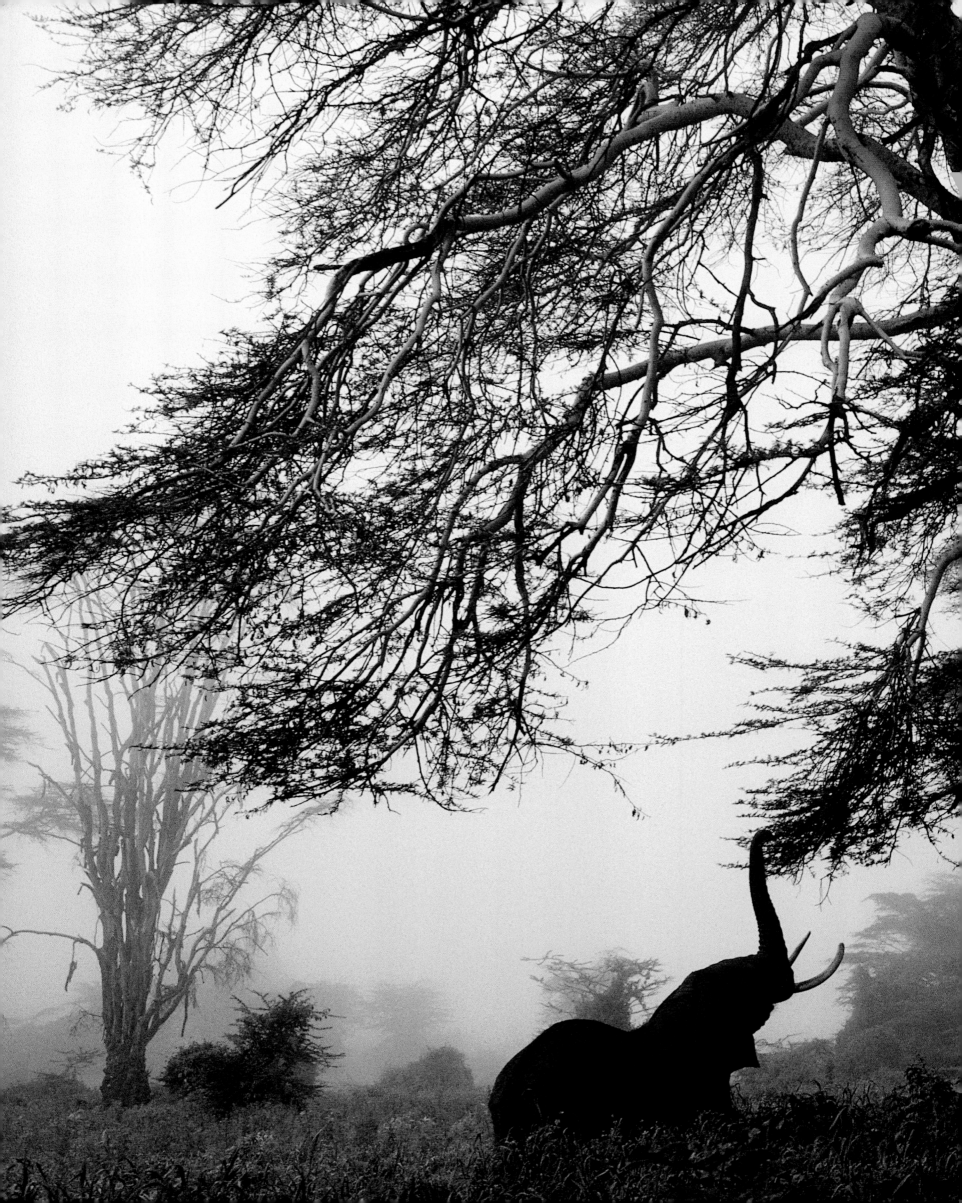

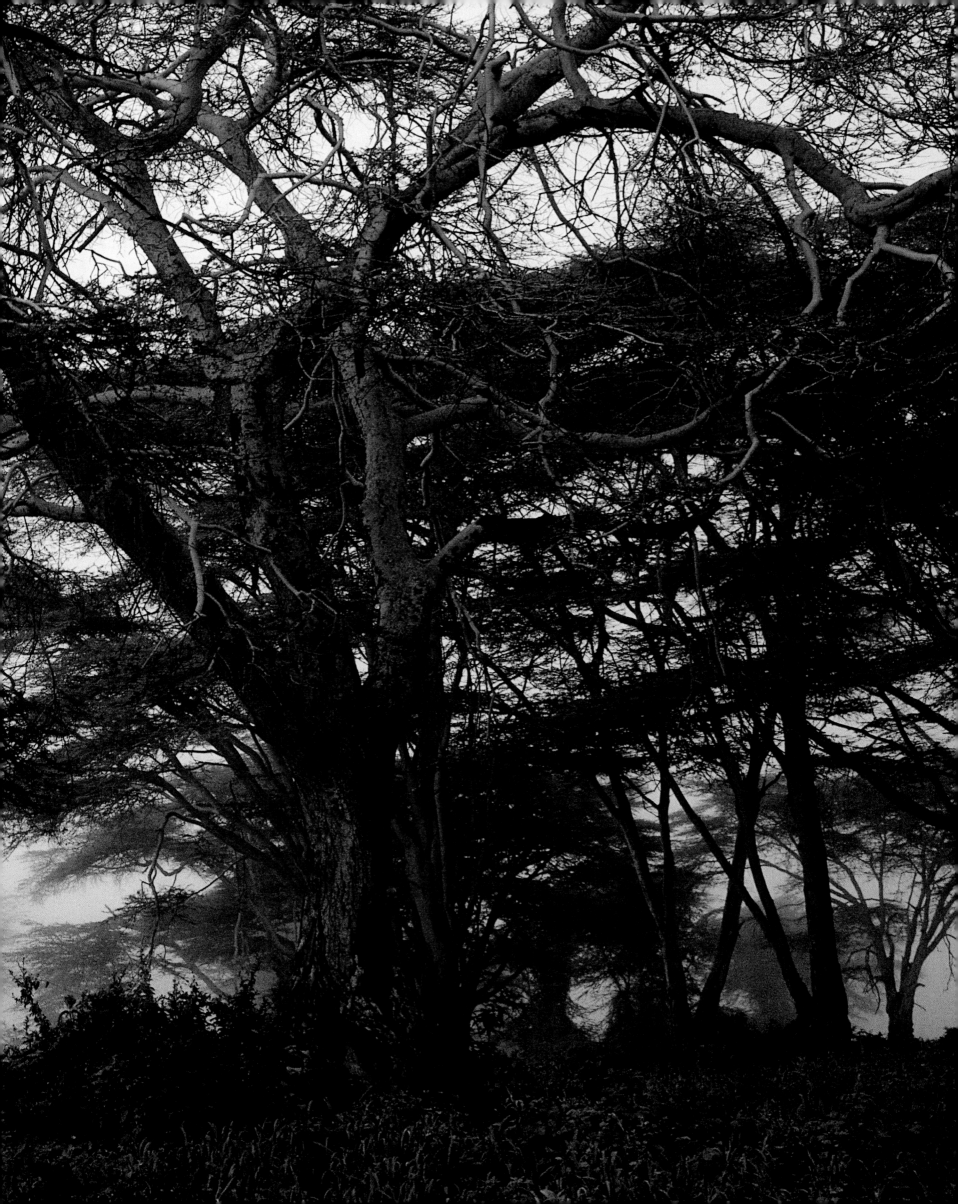

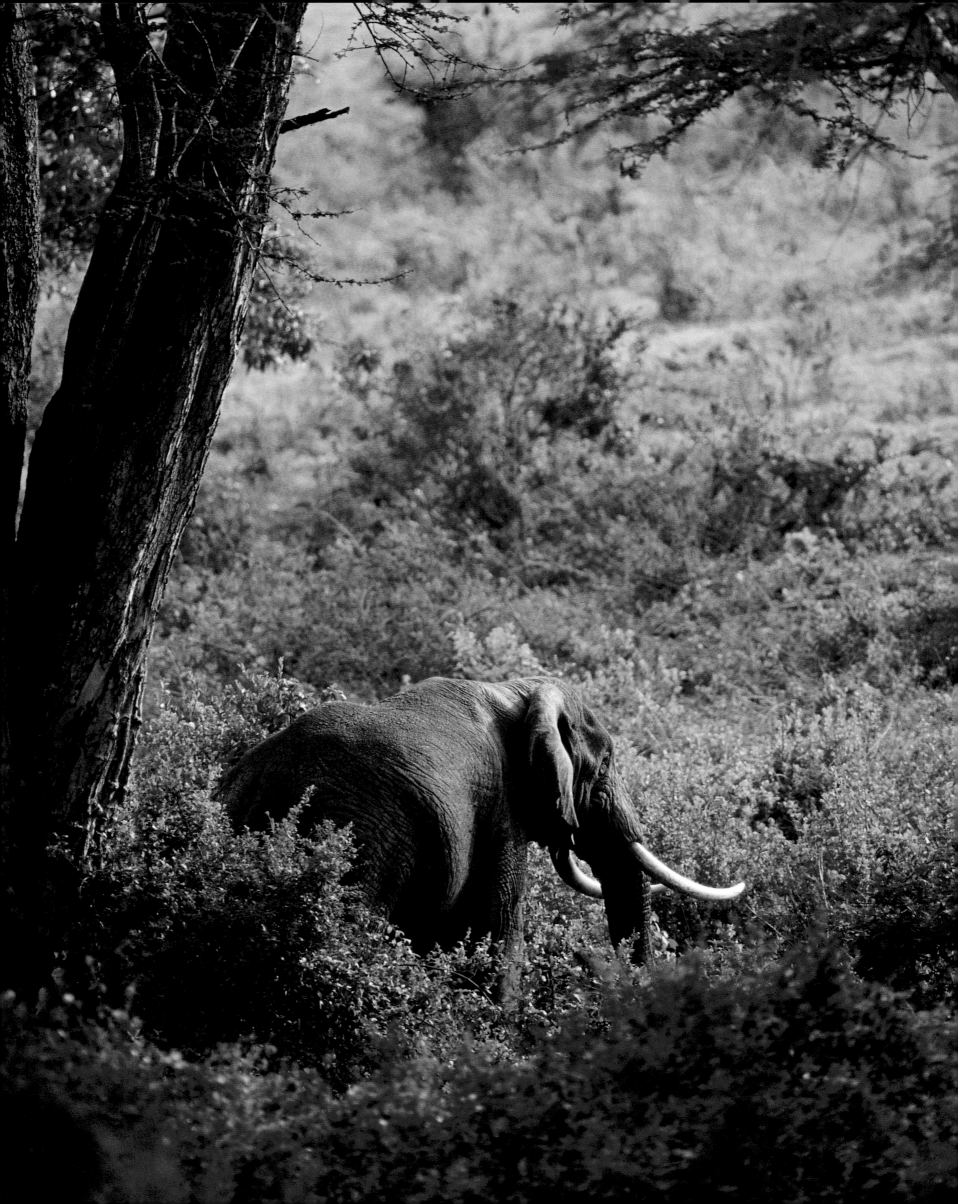

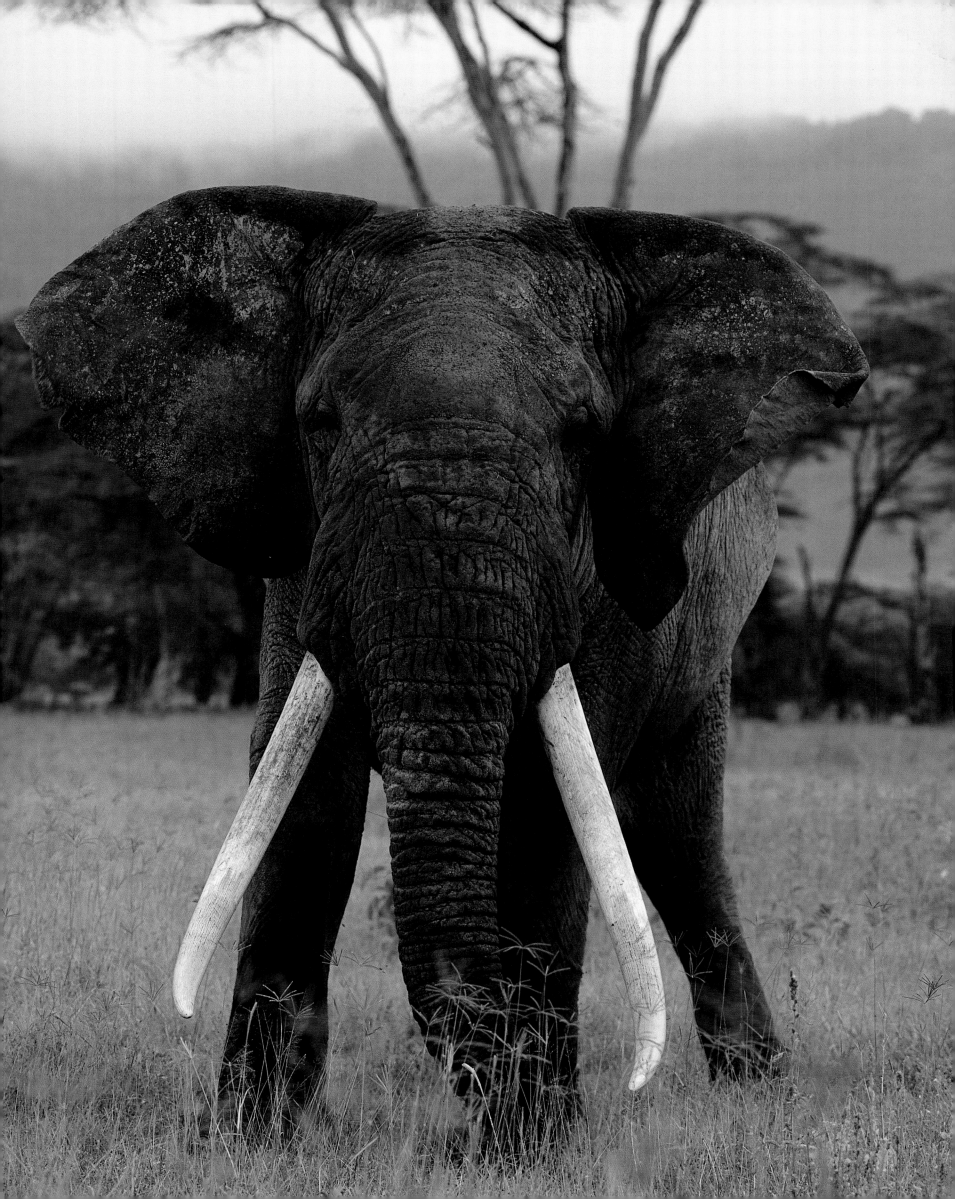

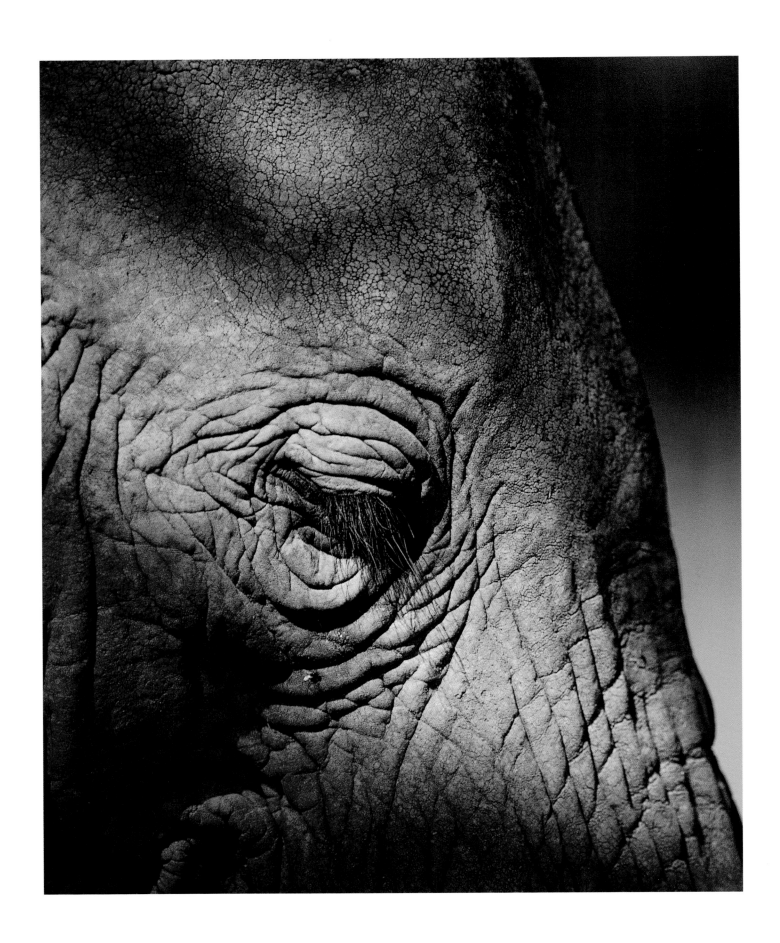

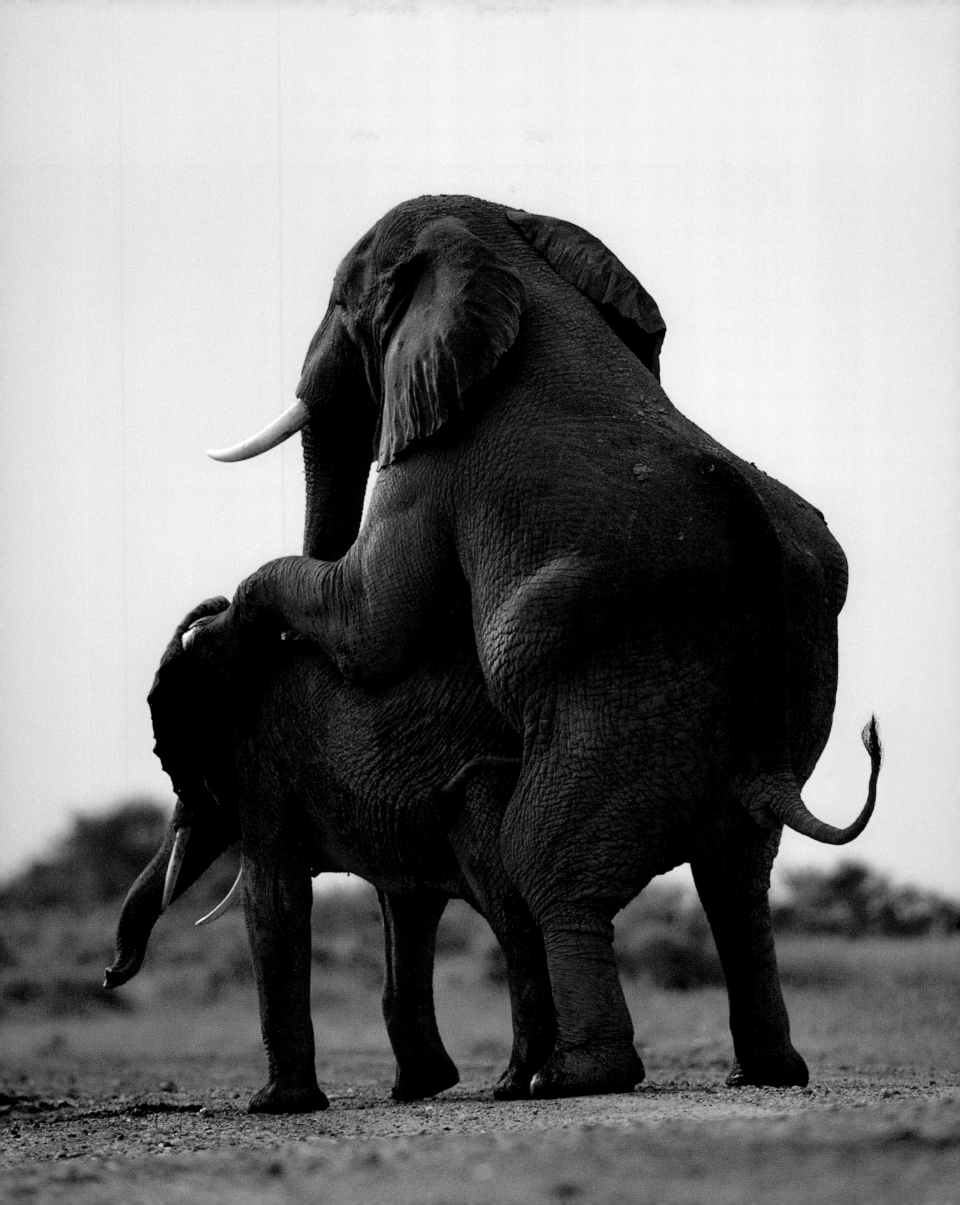

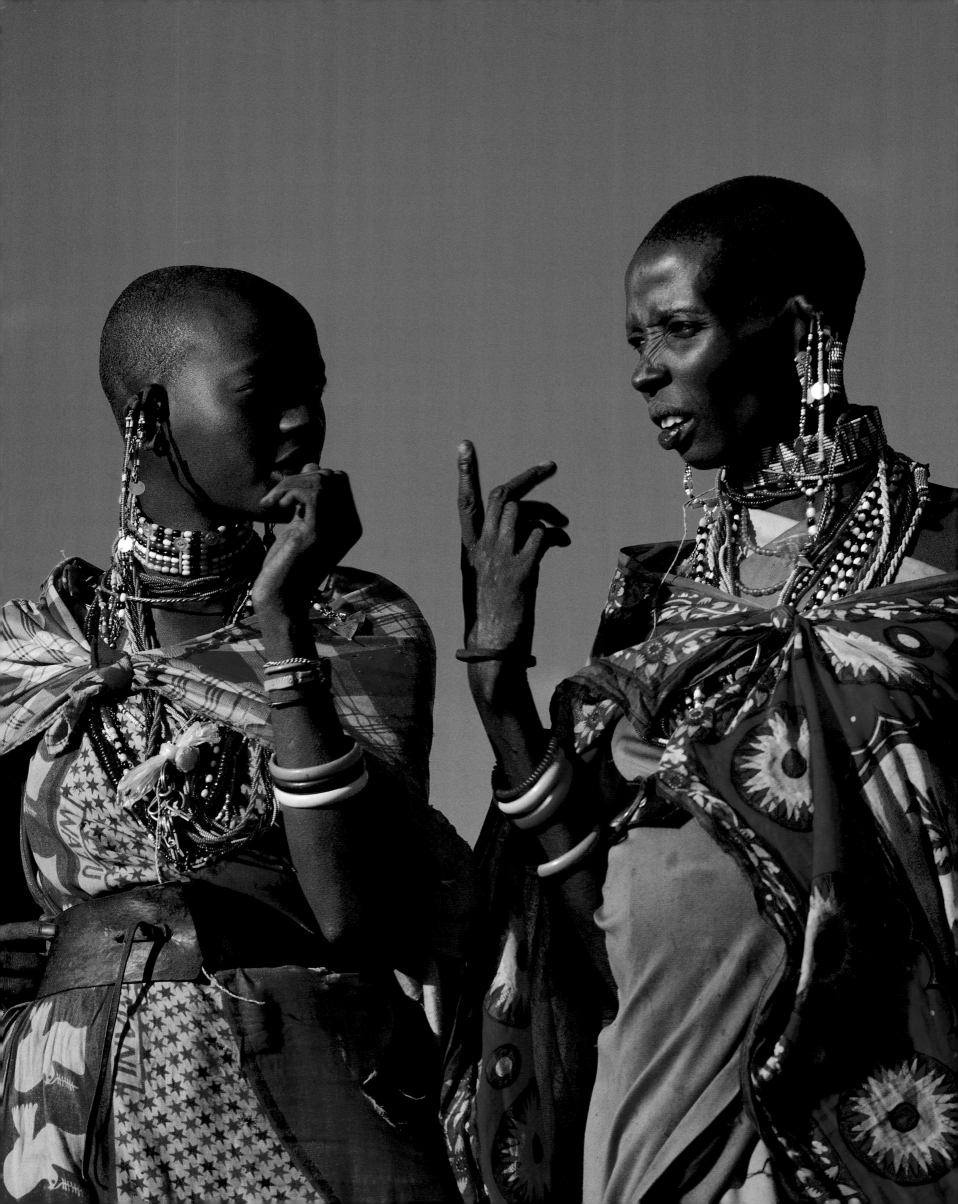

MAASAI

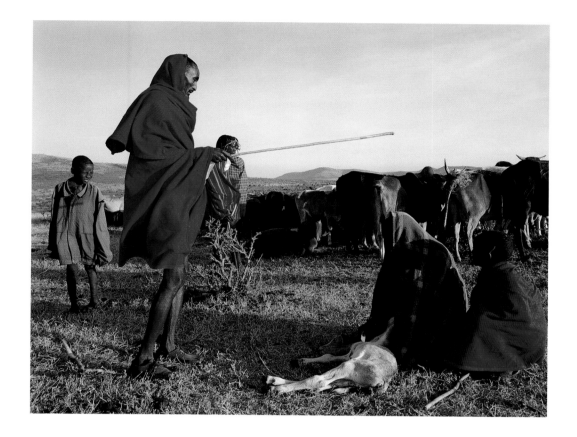

T here is a Maasai proverb that could explain why they have spread so successfully: "Well-travelled eyes are wiser". This pastoral tribe left present-day Sudan about five hundred years ago and conquered the East African savannahs. The settlement area of what is possibly Africa's best-known ethnic group includes southern Kenya and northern Tanzania.

In their endless search for fresh grazing land, the various Maasai groups came to regard each other as competitors, and even enemies. The ideal of the warrior, the *murran* (the equivalent of the Samburu *moran*), still defines a whole period of a young man's life. With the ceremonial initiation at puberty – which culminates in circumcision – an exciting time begins for every boy in his age set. But they have to start taking on some responsibilities as well. For example, it is their task to protect the community's settlements from enemy attack, to water the animals in the dry season, to convey messages, to accompany women on long journeys and a great deal more besides.

In the initiation phase the young men wear charcoal-blackened clothing, contrasting with the mask-like white face paint. After their two- to three-month trial in the bush is over they build – after going through a

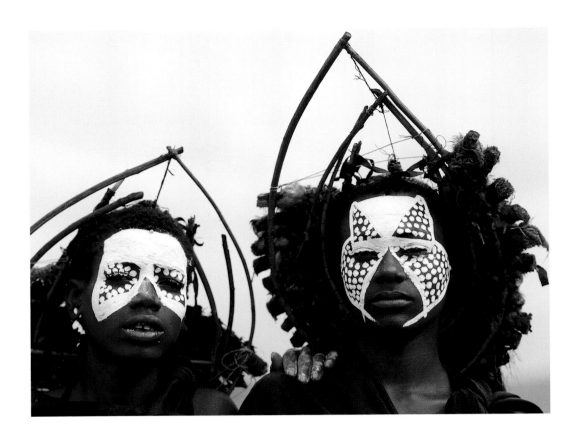

ritual that raises them to the rank of junior warriors – their own *manyatta*, a fortified bachelor village, away from their parents' farmsteads. They let their hair grow long, paying as much attention to looking after it as the Samburu. They are not allowed to marry during their many years as *murran*; but young girls are allowed to visit their friends in the *manyatta*.

These girls are still uninitiated. Their initiation ritual also takes place at puberty, on the day of their marriage to a much older man. The girls have to endure clitorectomy – total mutilation of the female genitals. This is in fact forbidden today, but many traditions are long-lived, as the fear of ultimately never marrying and growing old childless as an outcast on the fringes of society is often greater.

The end of the *murran* period is marked by a great ceremony and feast lasting many days. The mother cuts off her son's long hair; he will now be in his mid-twenties. The bare skin of his head is rubbed with ochre powder and fat. Baldness is the identifying feature of the elders. A brilliantly shiny skull symbolizes a "brilliant" social position. The junior and senior elder age sets play a key role in the community. They own the cattle, only they are allowed to marry, several women if they wish, and their advice is sought when making important decisions.

Some young Maasai who go to college or university (and thus spend only a short time as *murran*) see the many changes with which the nomads are faced as welcome opportunities to free themselves from the power of the elders.

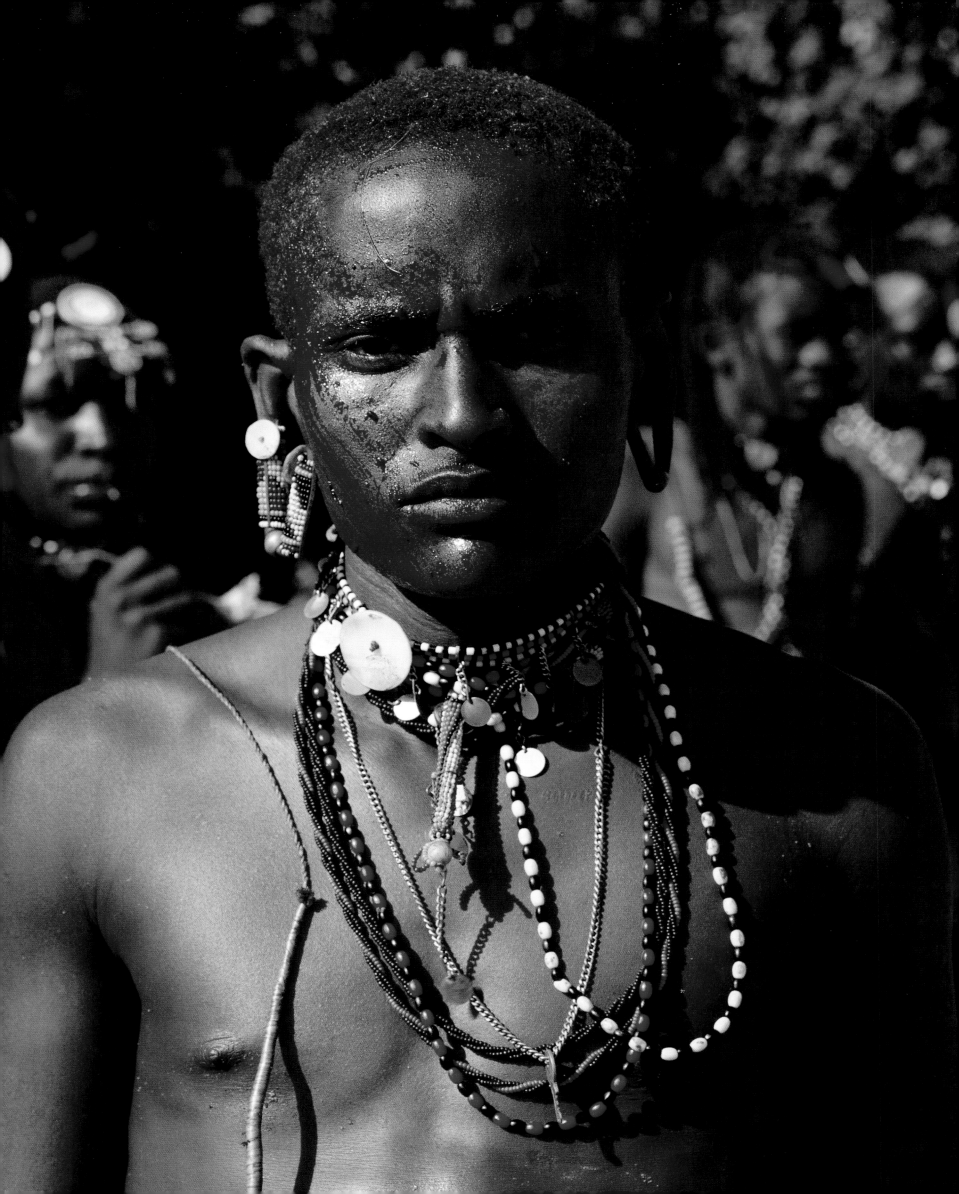

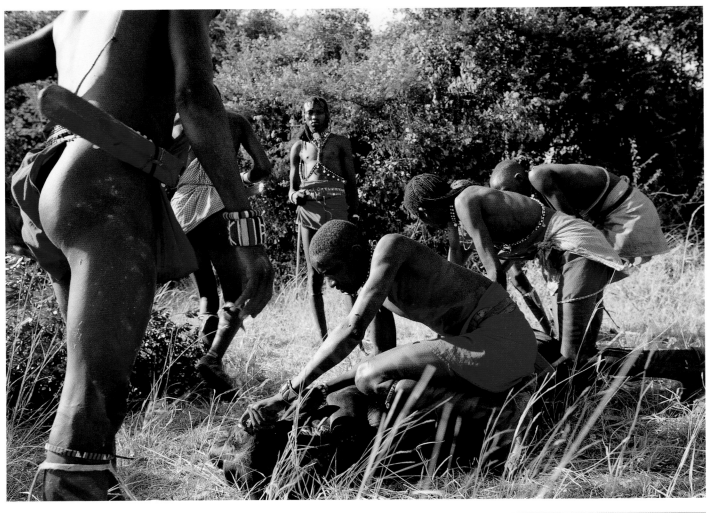

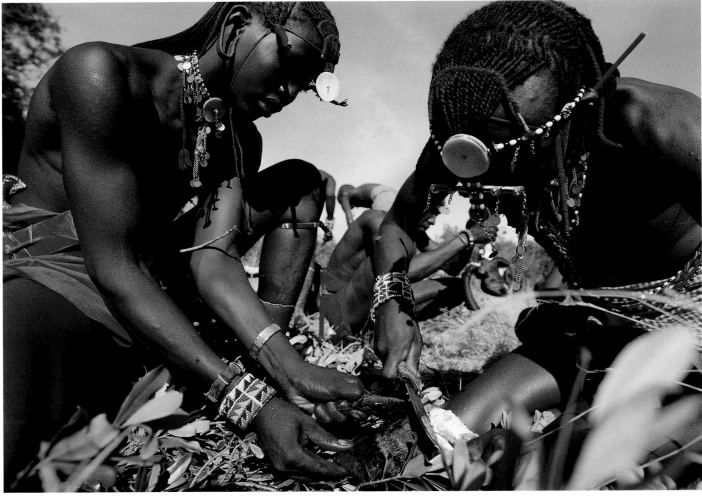

216

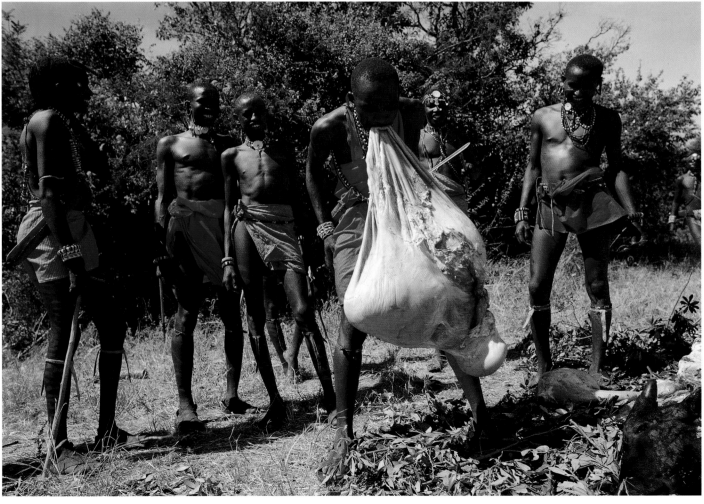

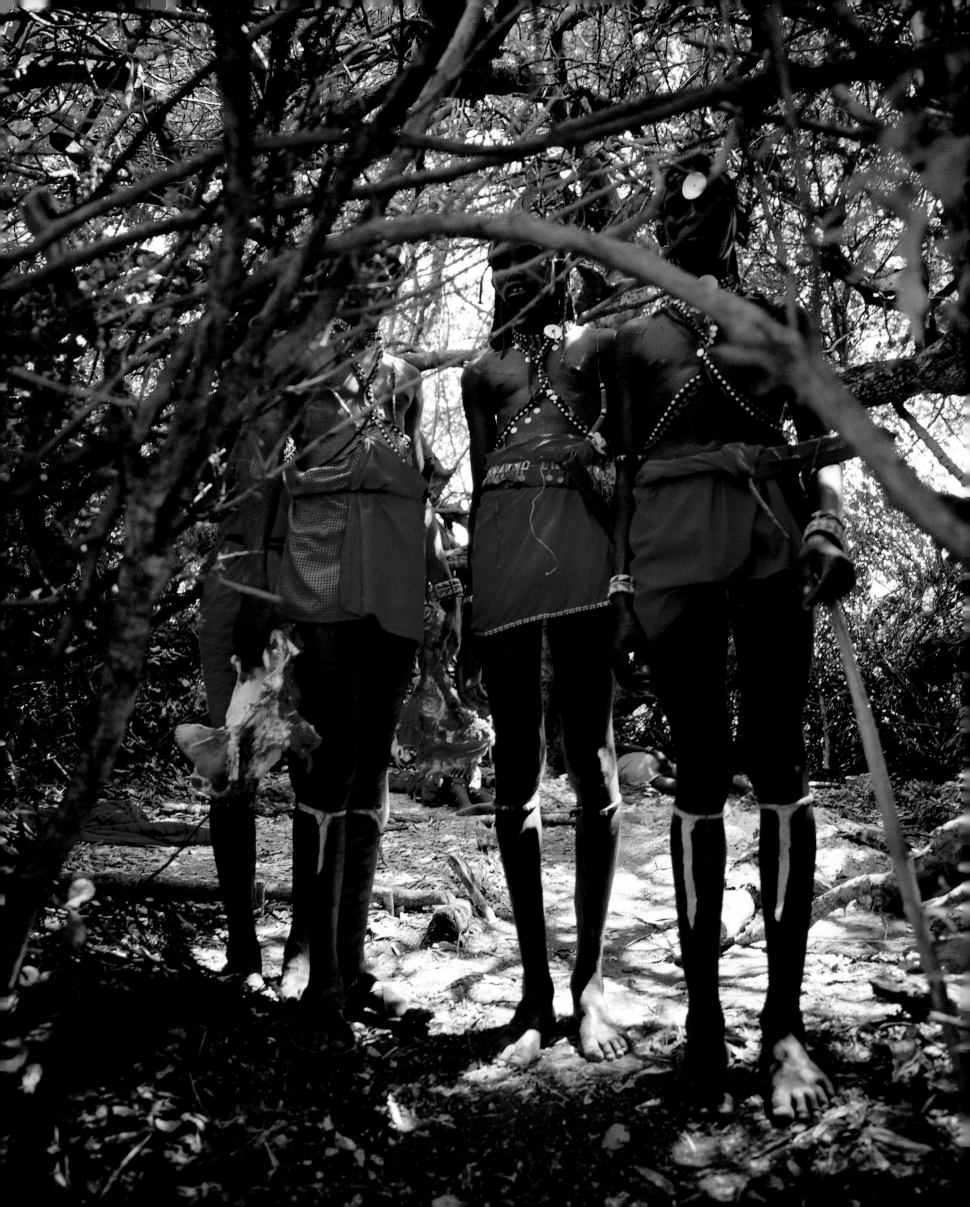

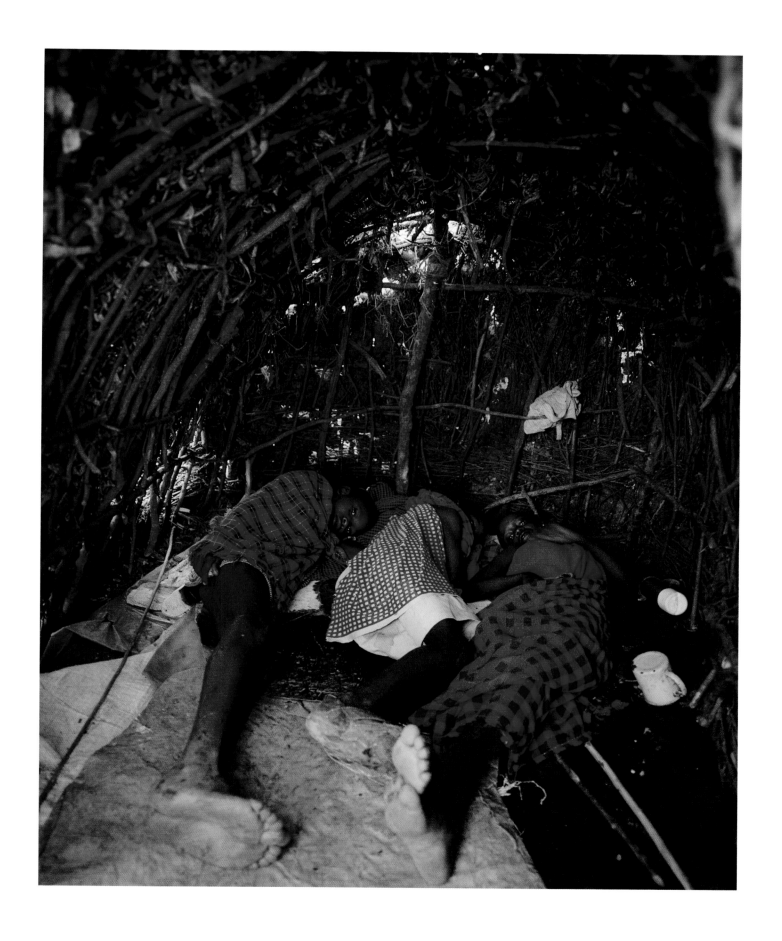

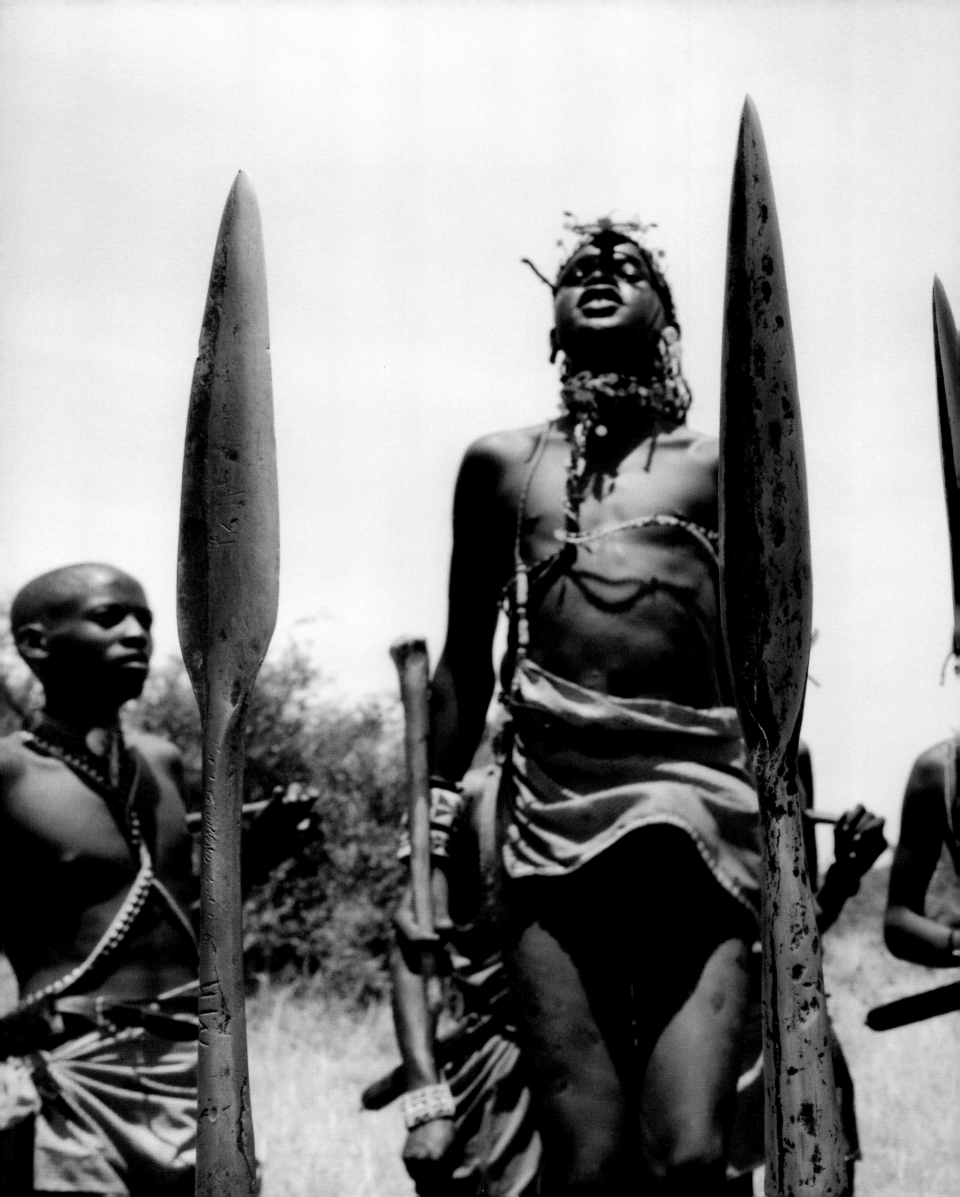

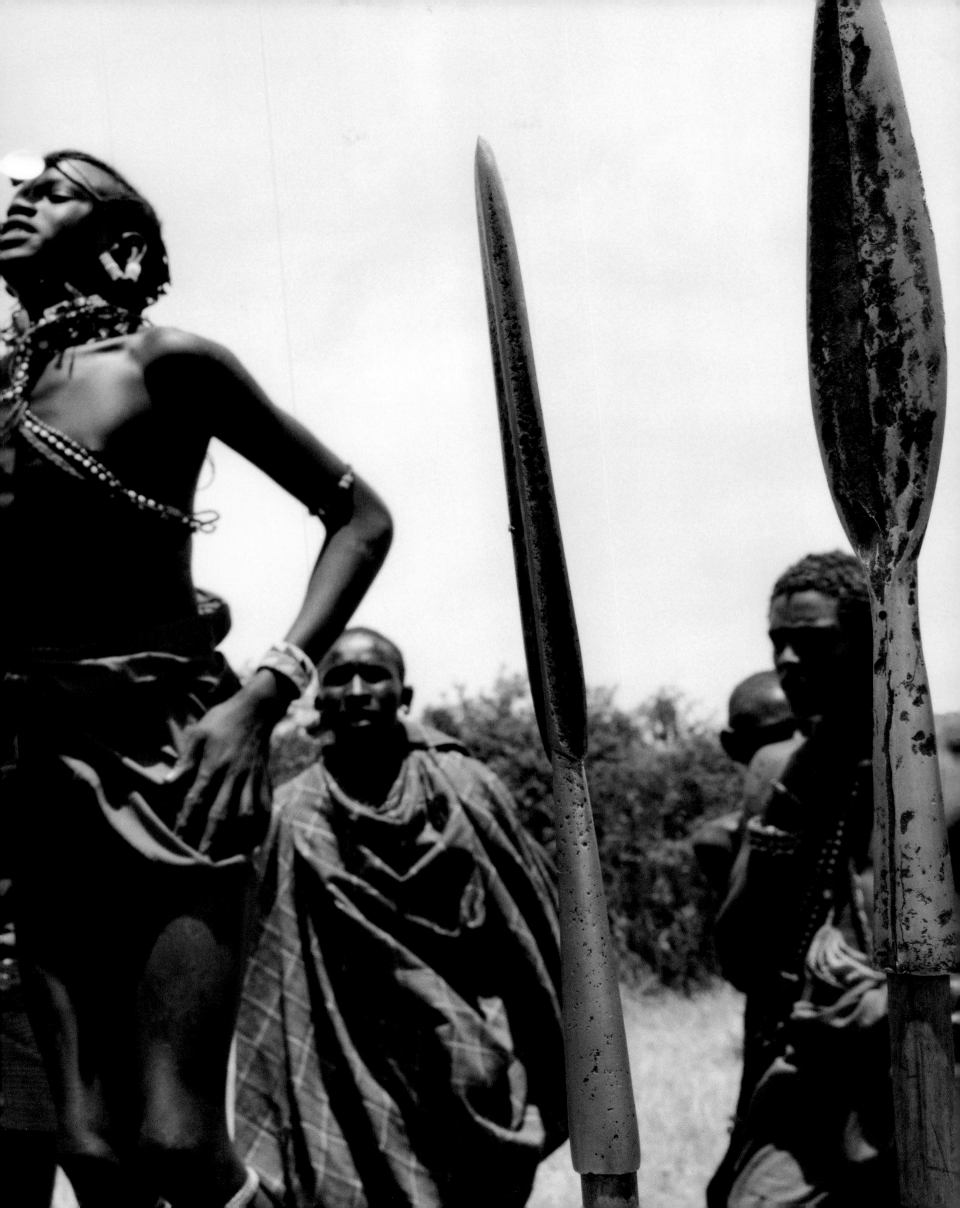

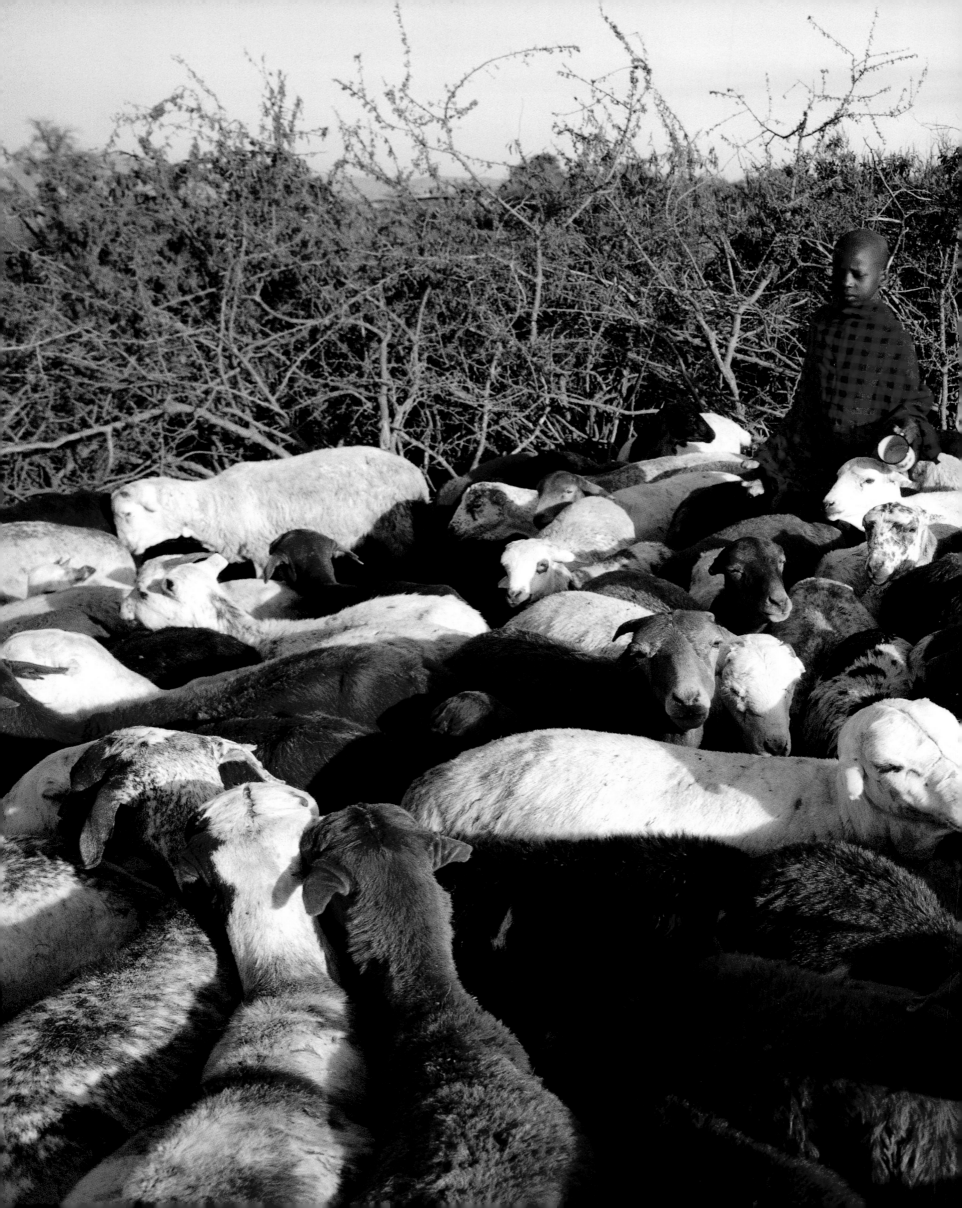

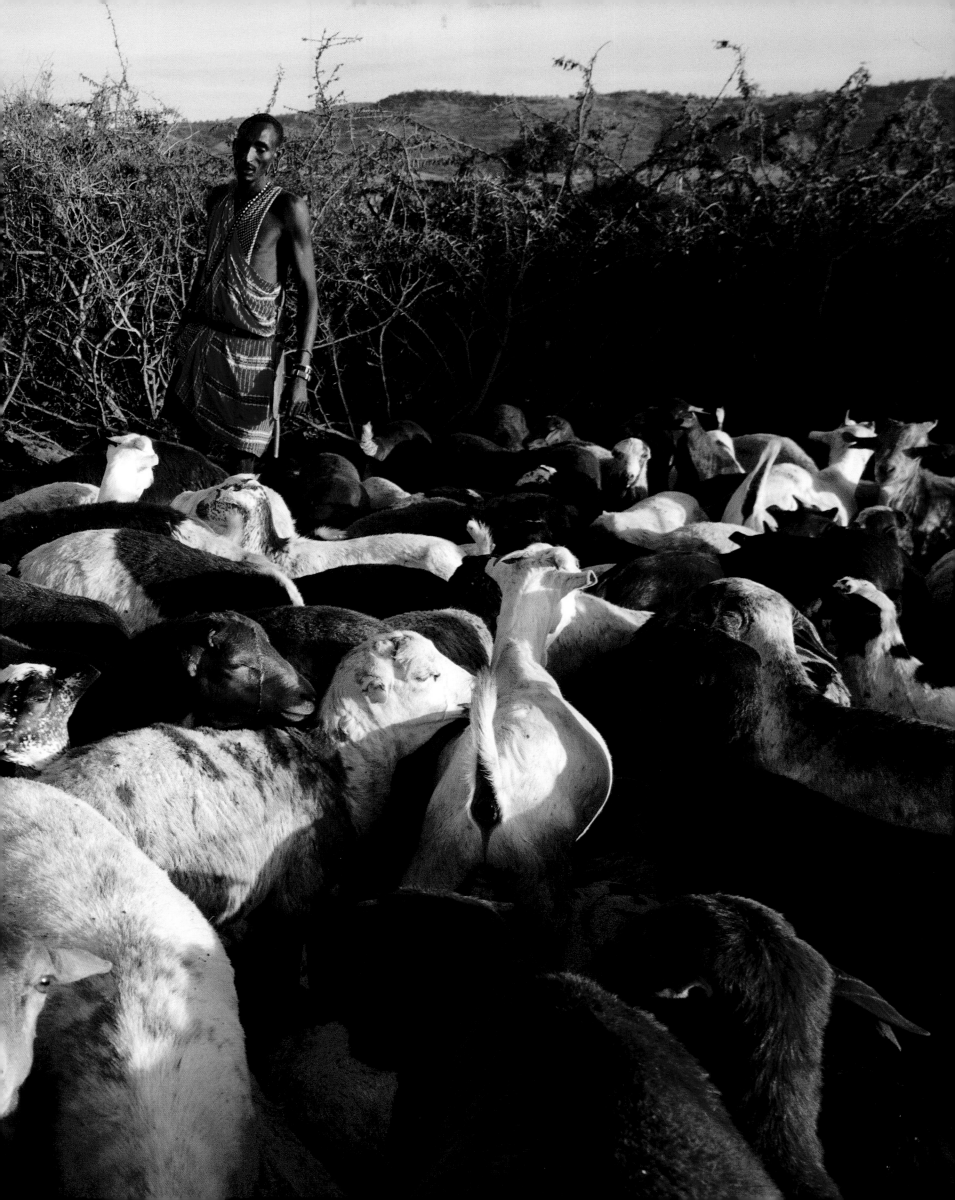

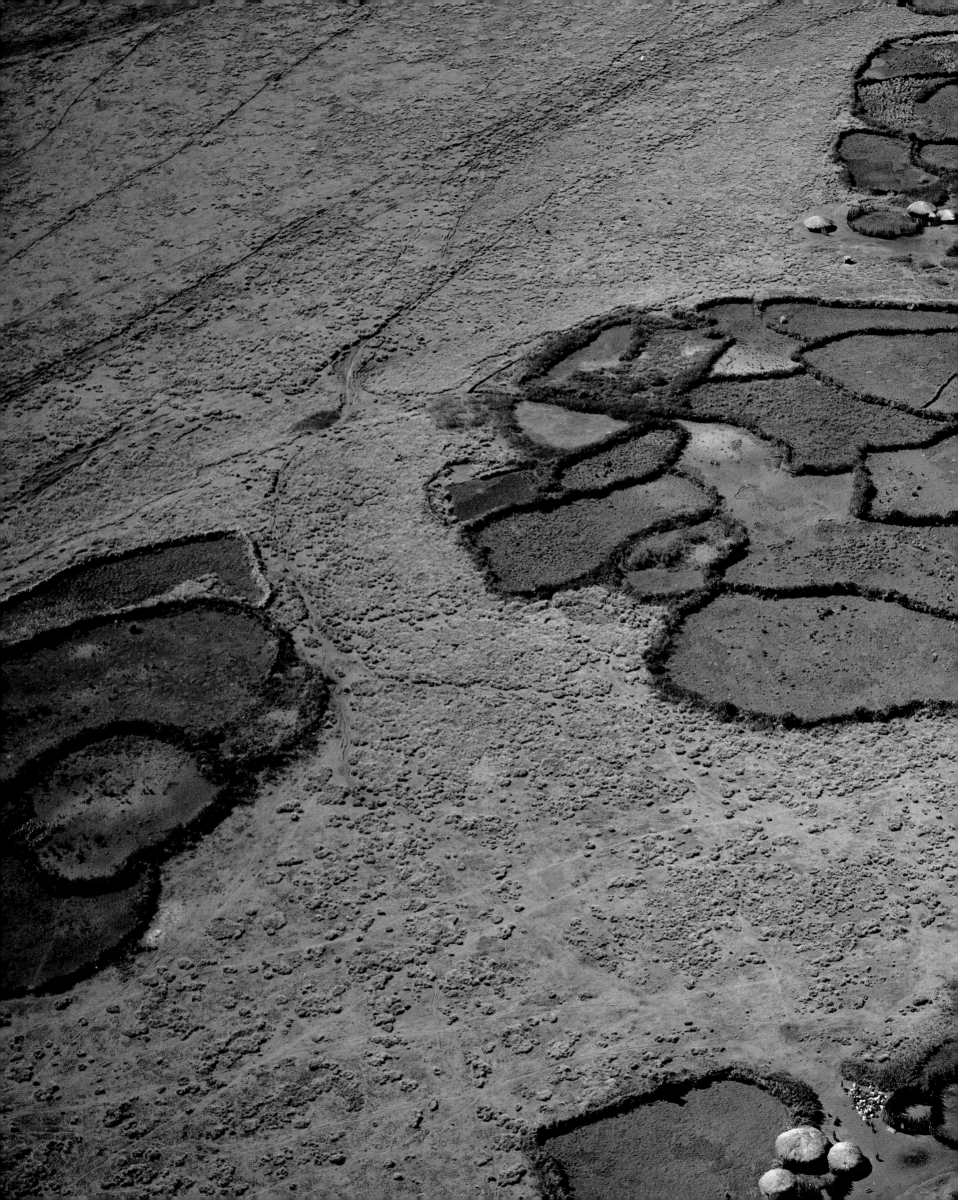

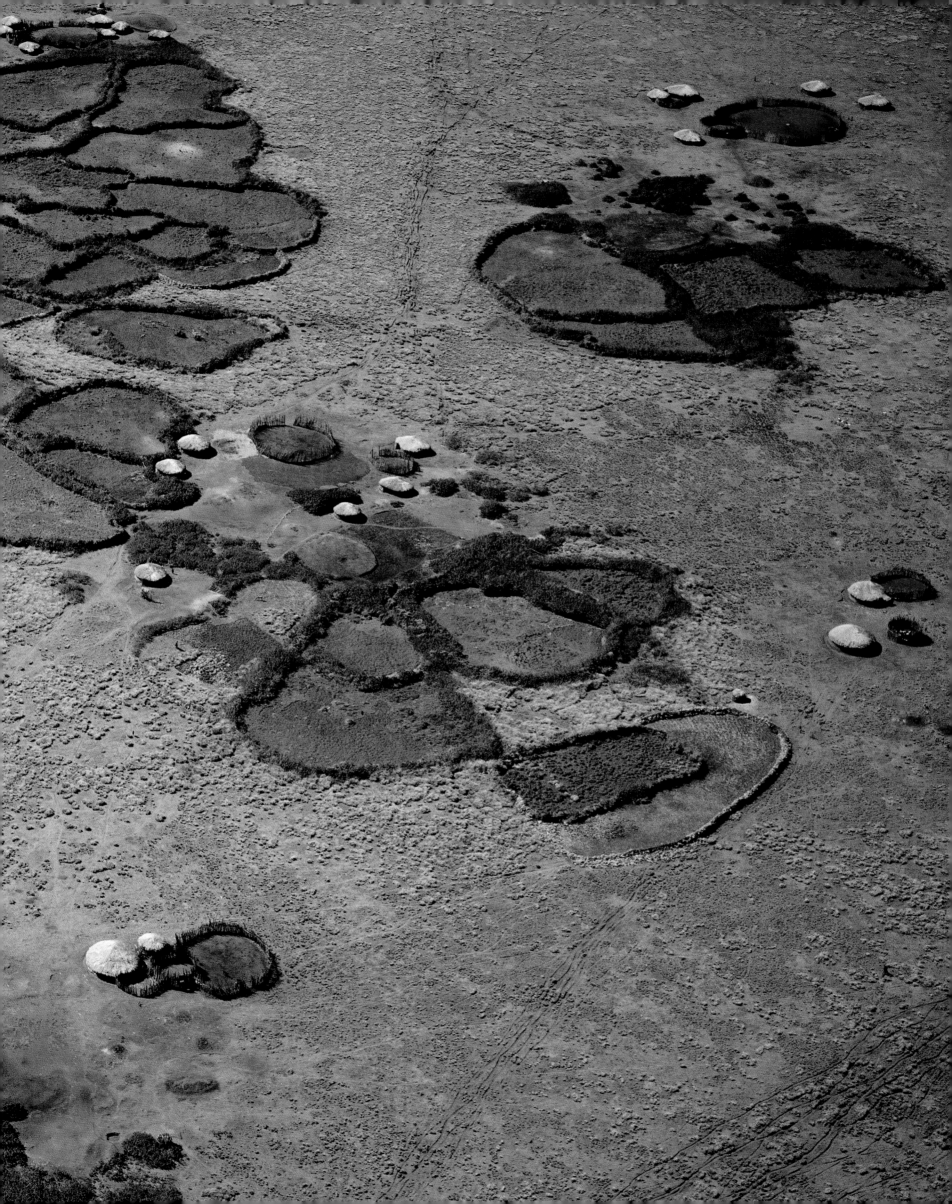

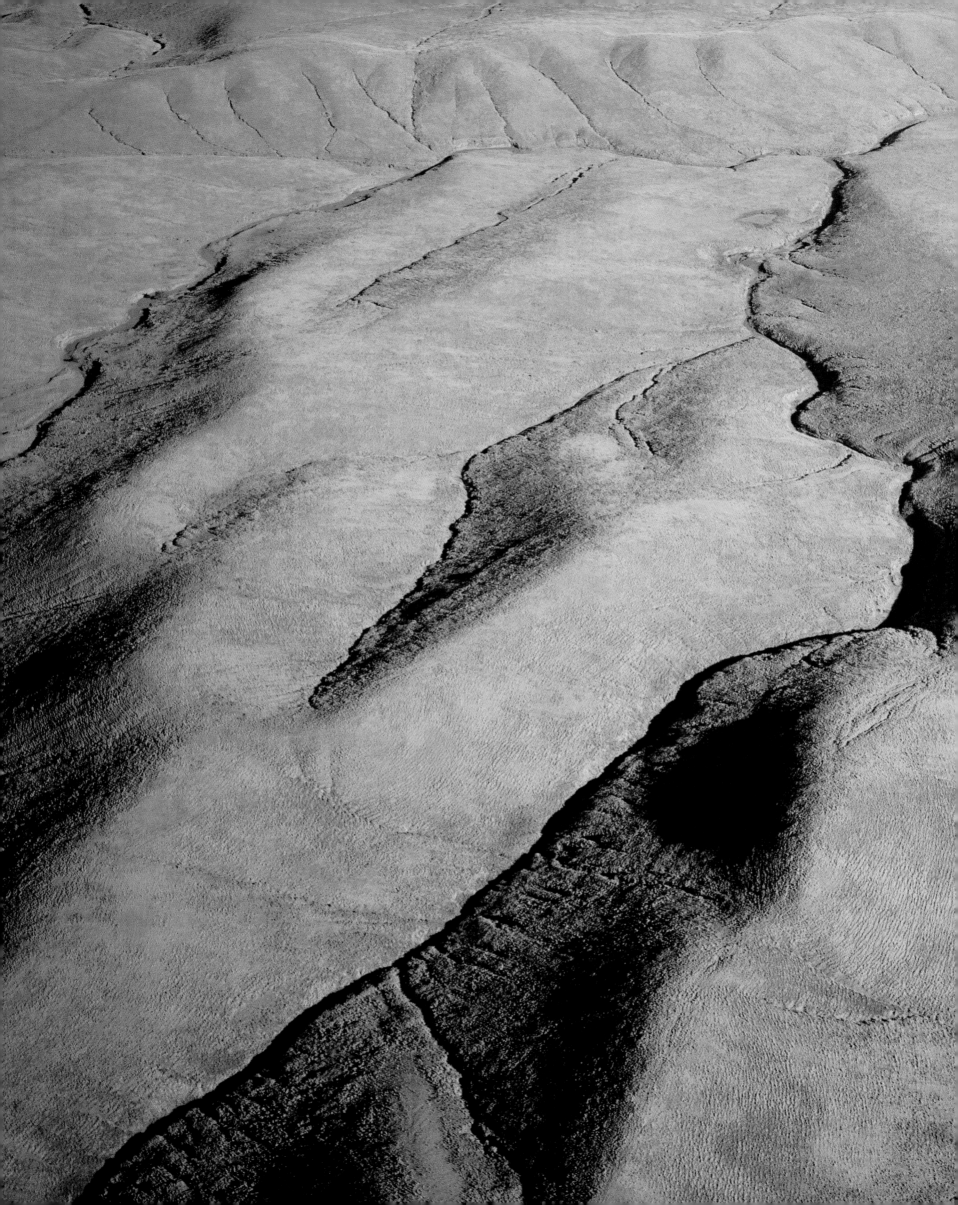

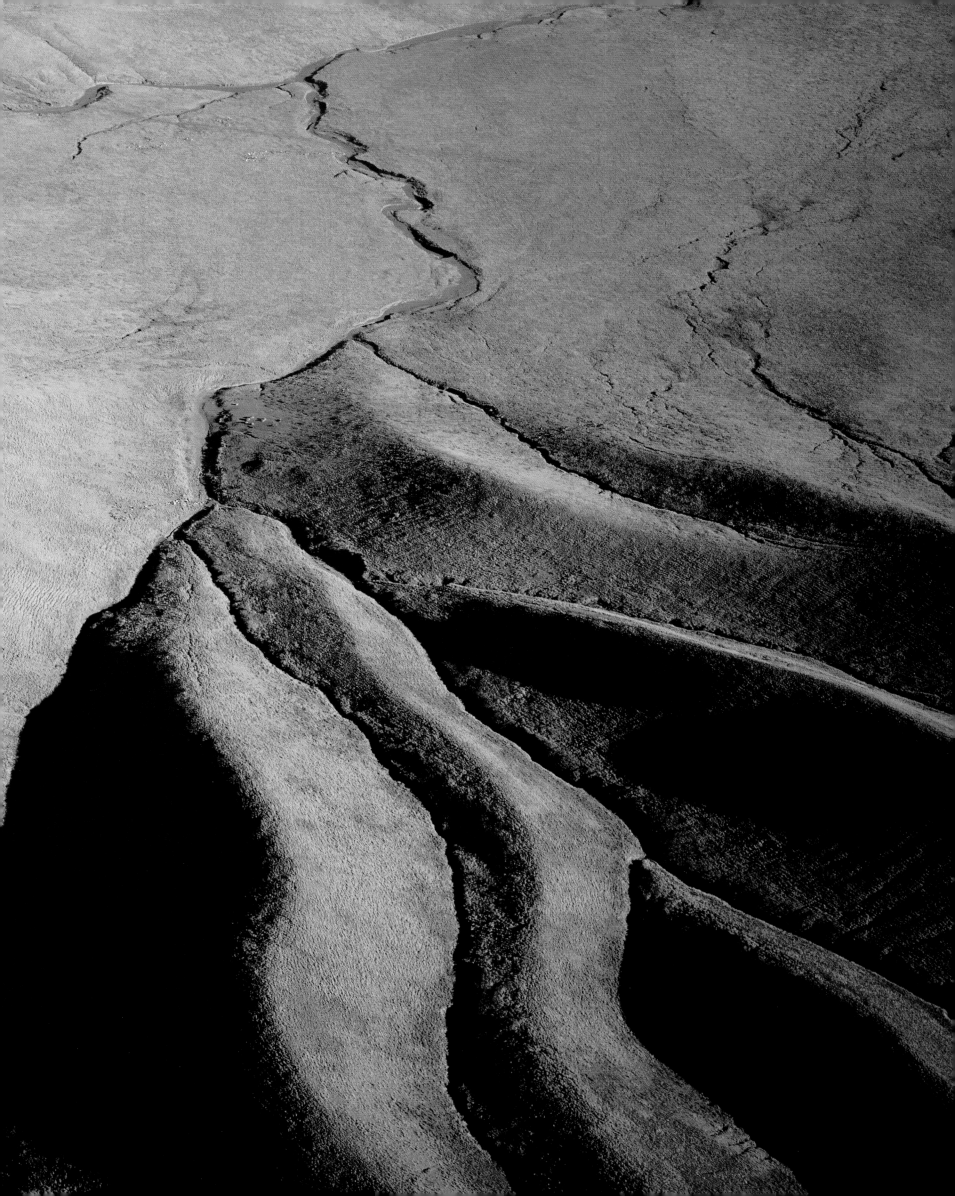

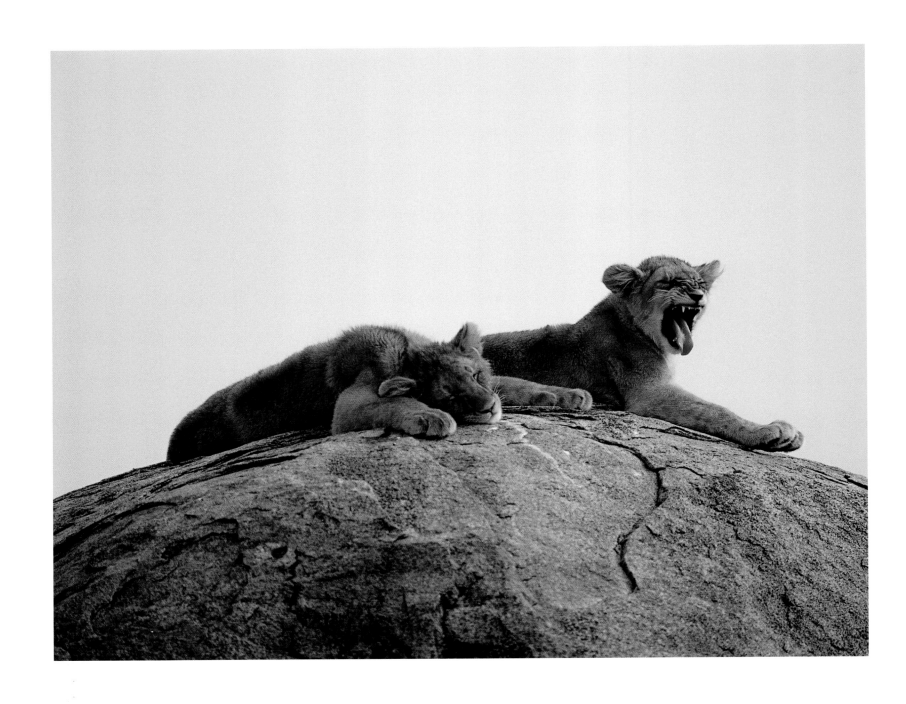

ANIMAL FAMILIES

The maned lion is seen as the king of beasts even in places where he does not occur. Looks are everything. Symbolists and poets have been carried away above all by the regal cape on the animal's neck and chest. But there are even more compelling grounds for the lion's fabulous status. For example, the good life he leads at the expense of others. The boss makes very little contribution to the pride's hunting, and yet he is assured of the lion's share of the prey, and first access to it. Even the powerful female hunters – on whom the king's well-being very much depends – hold back a little at the kill.

Behind every great man is one – or many, in the case of lions – extraordinary woman. His masculine splendour rests on an intact pride – and here, in particular, on the agility and hunting prowess of strong females. They form a group that shares a territory ranging from about 30 to 150 square kilometres. Daughters do not move up into the pride until a "permanent post" becomes available.

Countless young females and all the young males have to move away. The eminent lion scholar George Schaller called this existence "outside the family", usually on the fringes of a large pride, wretched and "nomadic".

In the pride, the choice of king – i.e. the decision as to which male may become the patriarch, and for how long – is more or less up to the women; the lionesses ultimately make the decision about whom they will put up with at their head.

This is similar among the yellow baboons in the African steppes and savannahs. They live in highly social, hierarchically structured groups that become particularly extensive in places where lions and leopards are rare or have been eradicated.

Giraffes associate comparatively loosely and on a temporary basis; they take advantage of a collective security system (lions occasionally hunt this long-legged prey), but avoid any kind of compulsive group formation.

Circumstances dictate what a good family is. Nature's perception of what is good is pragmatic, free of ideology or morals.

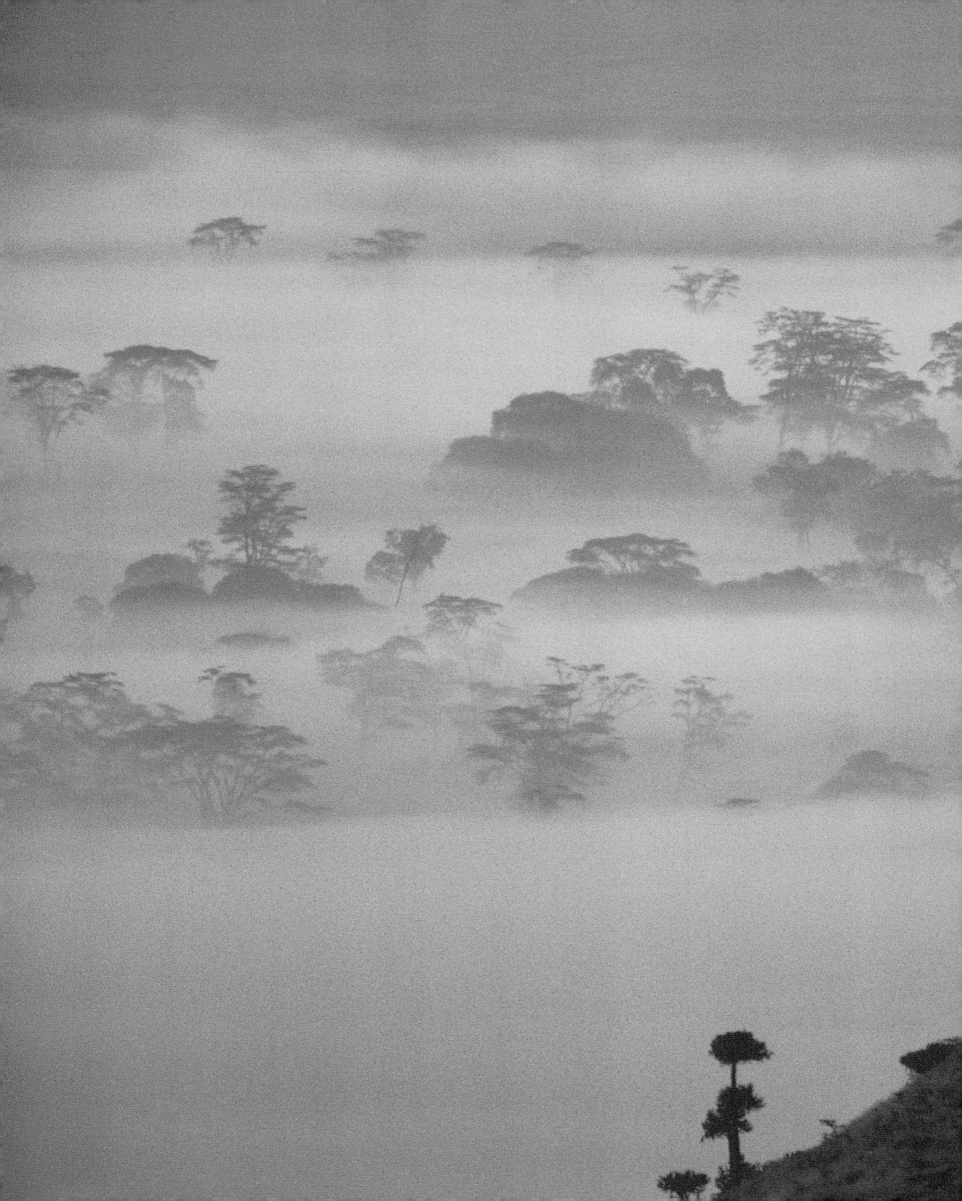

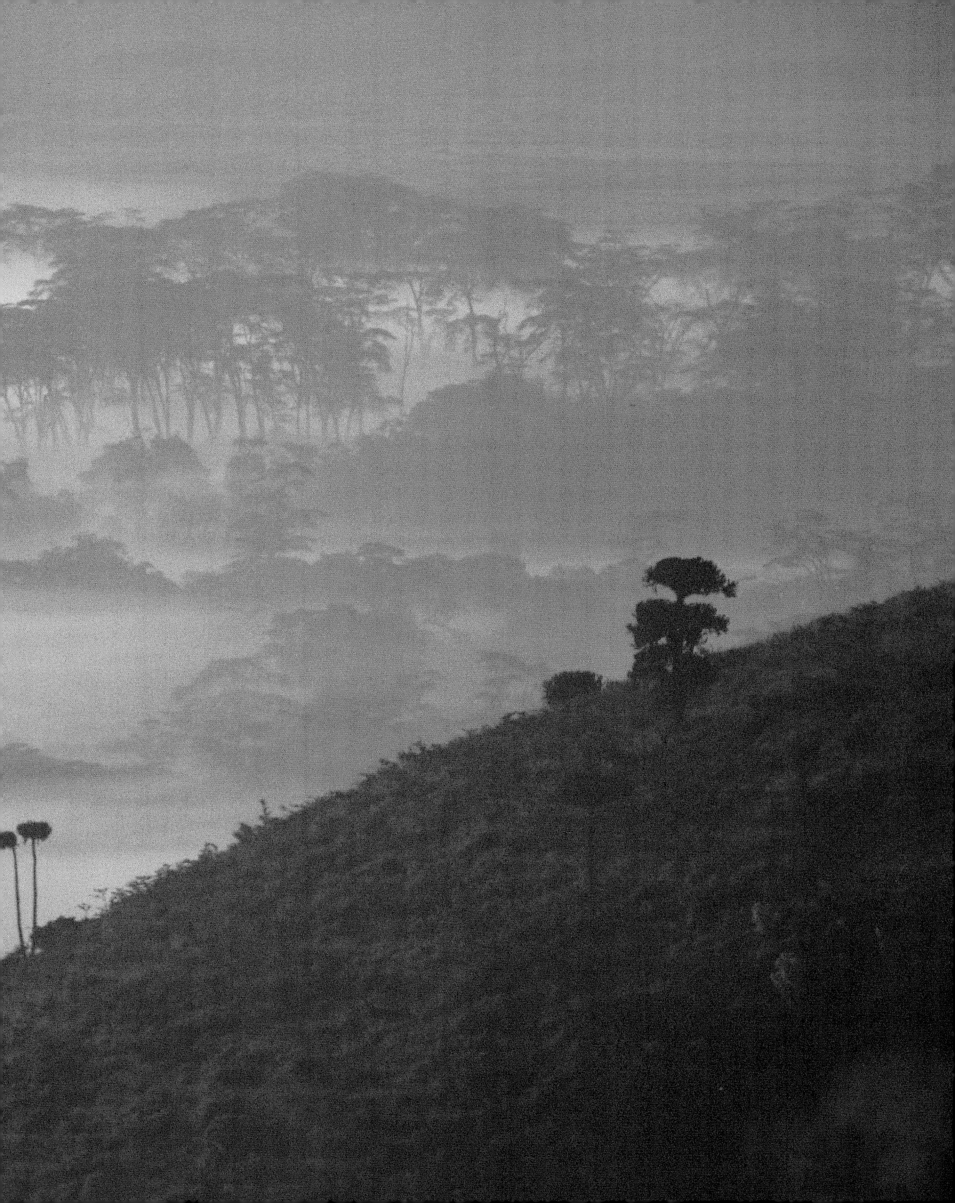

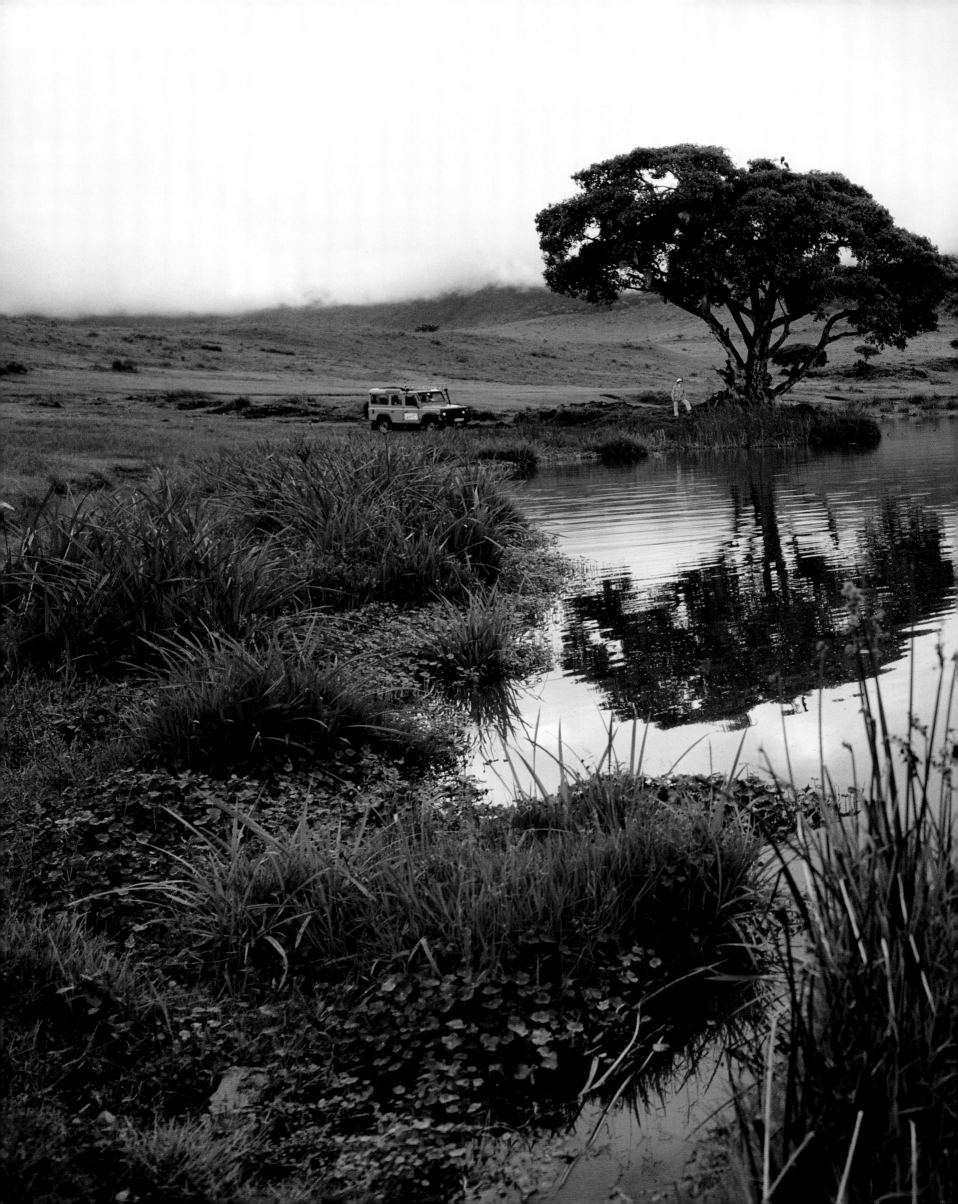

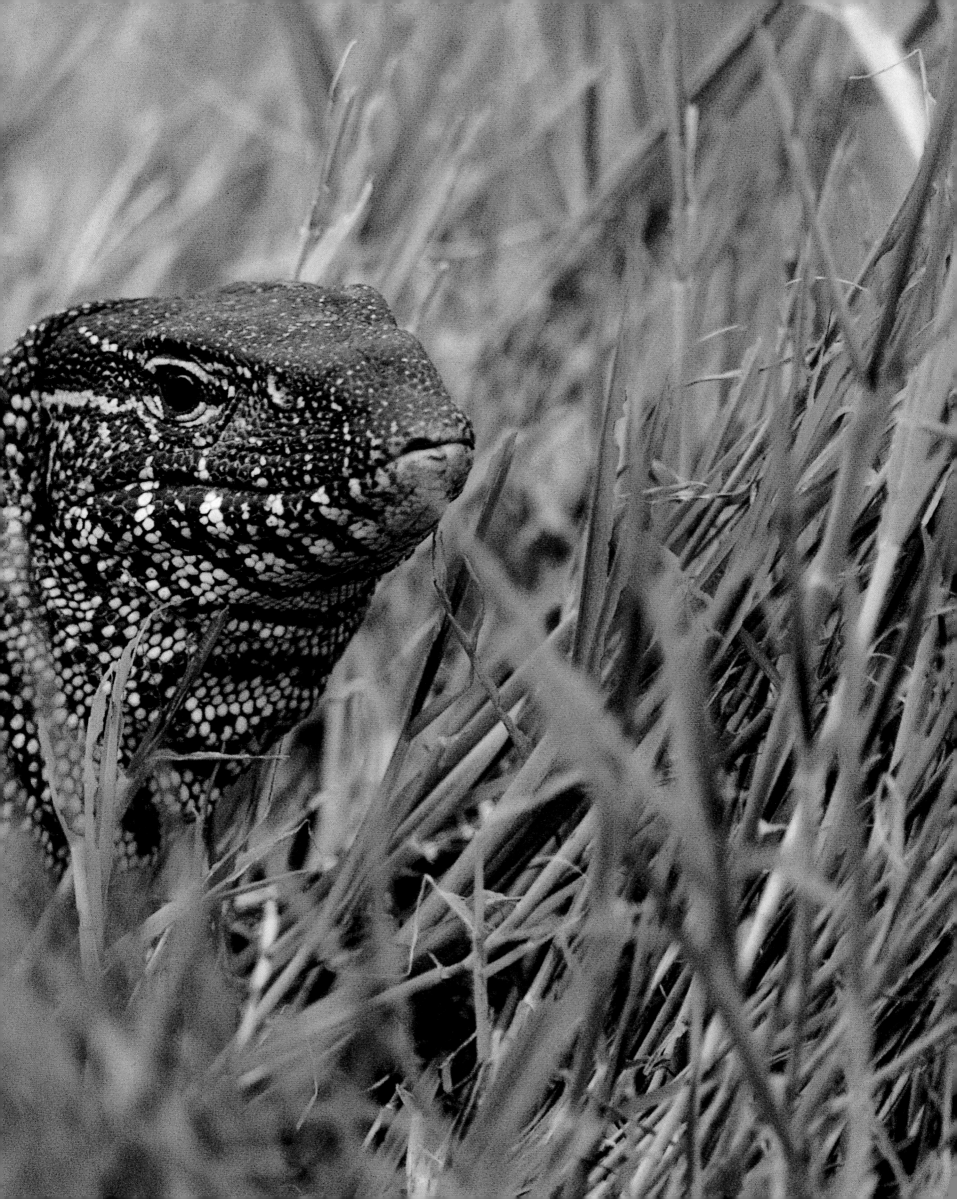

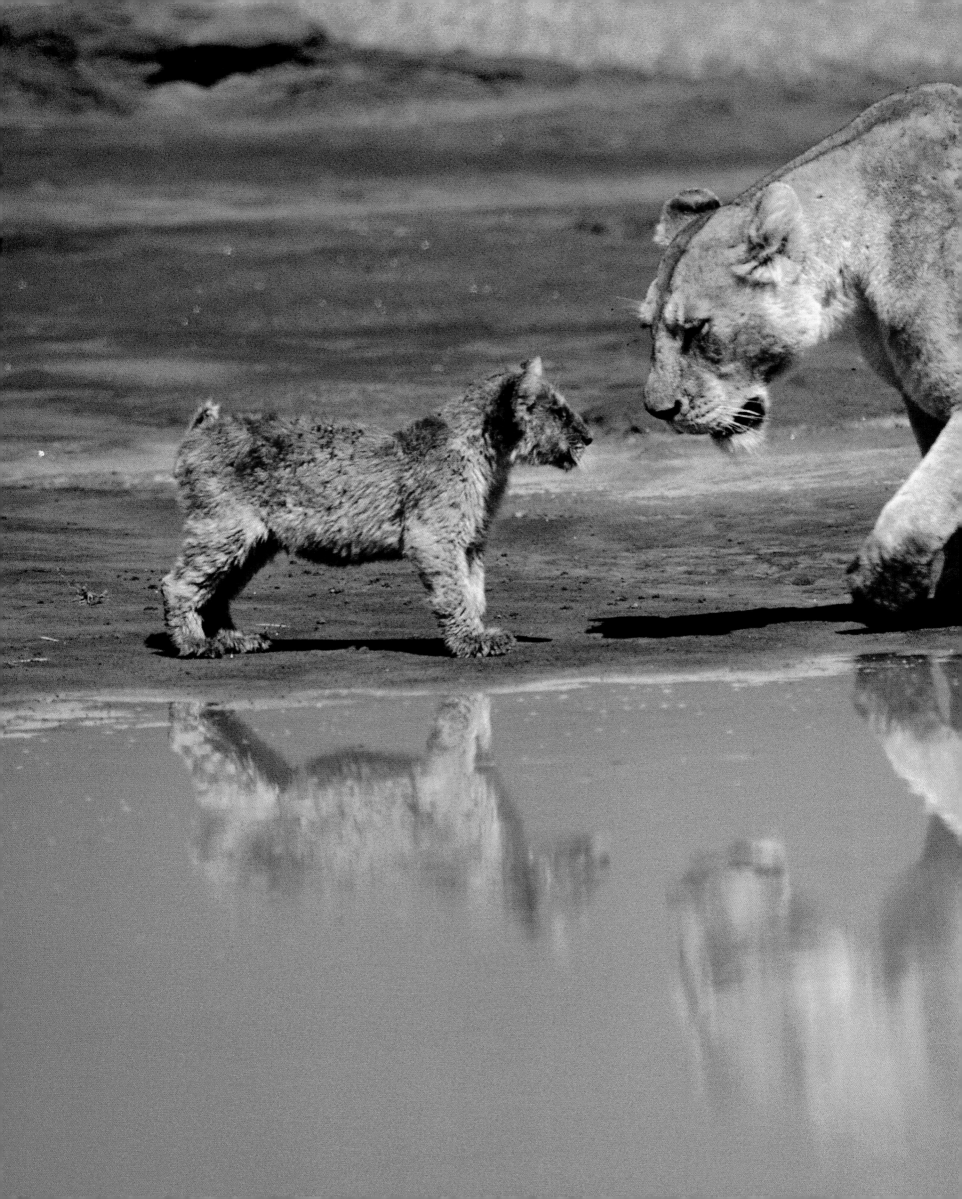

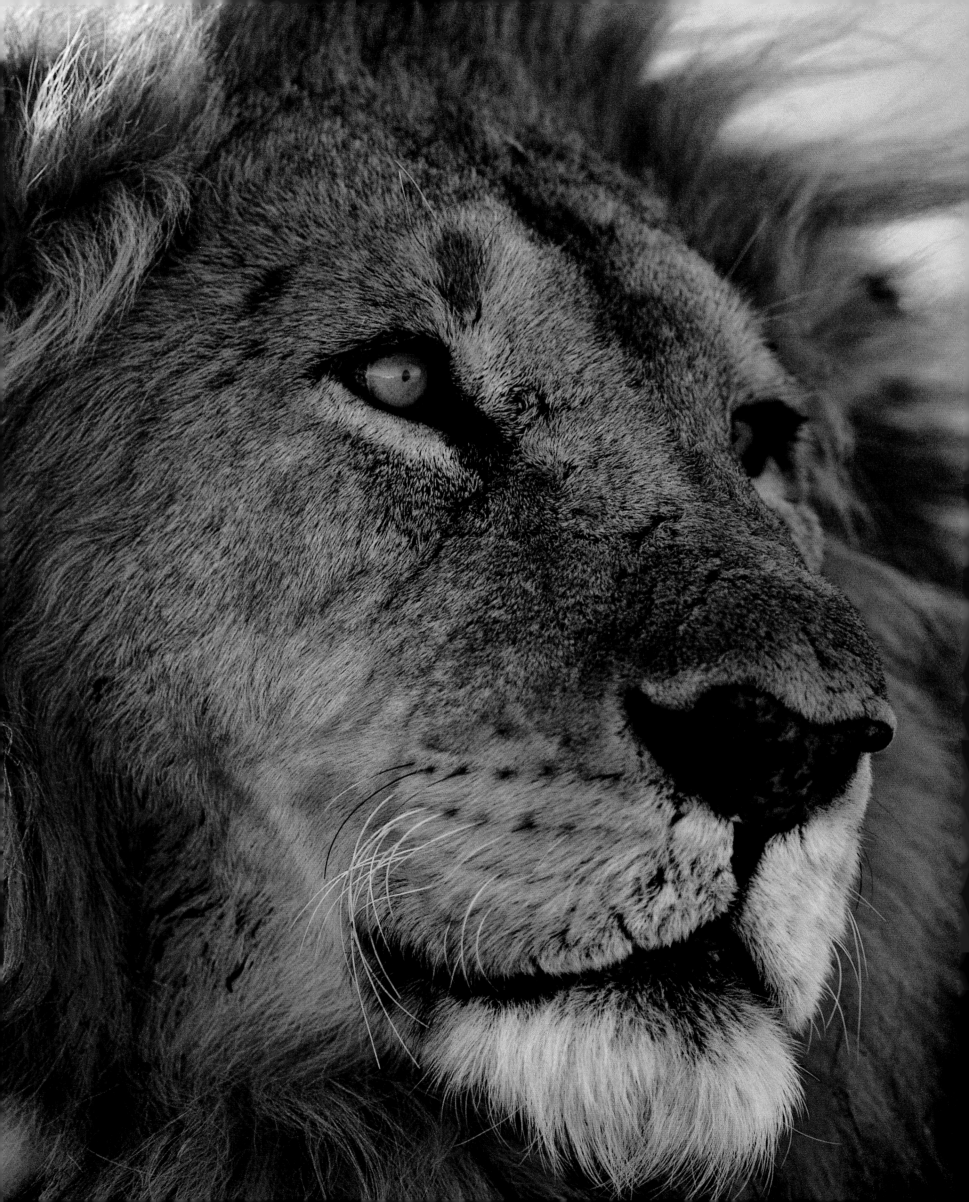

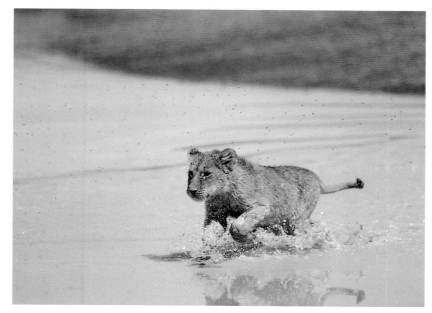

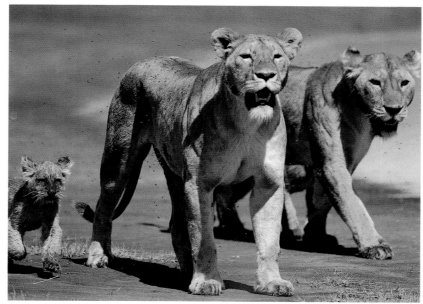

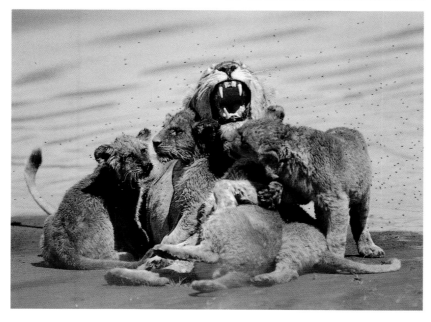

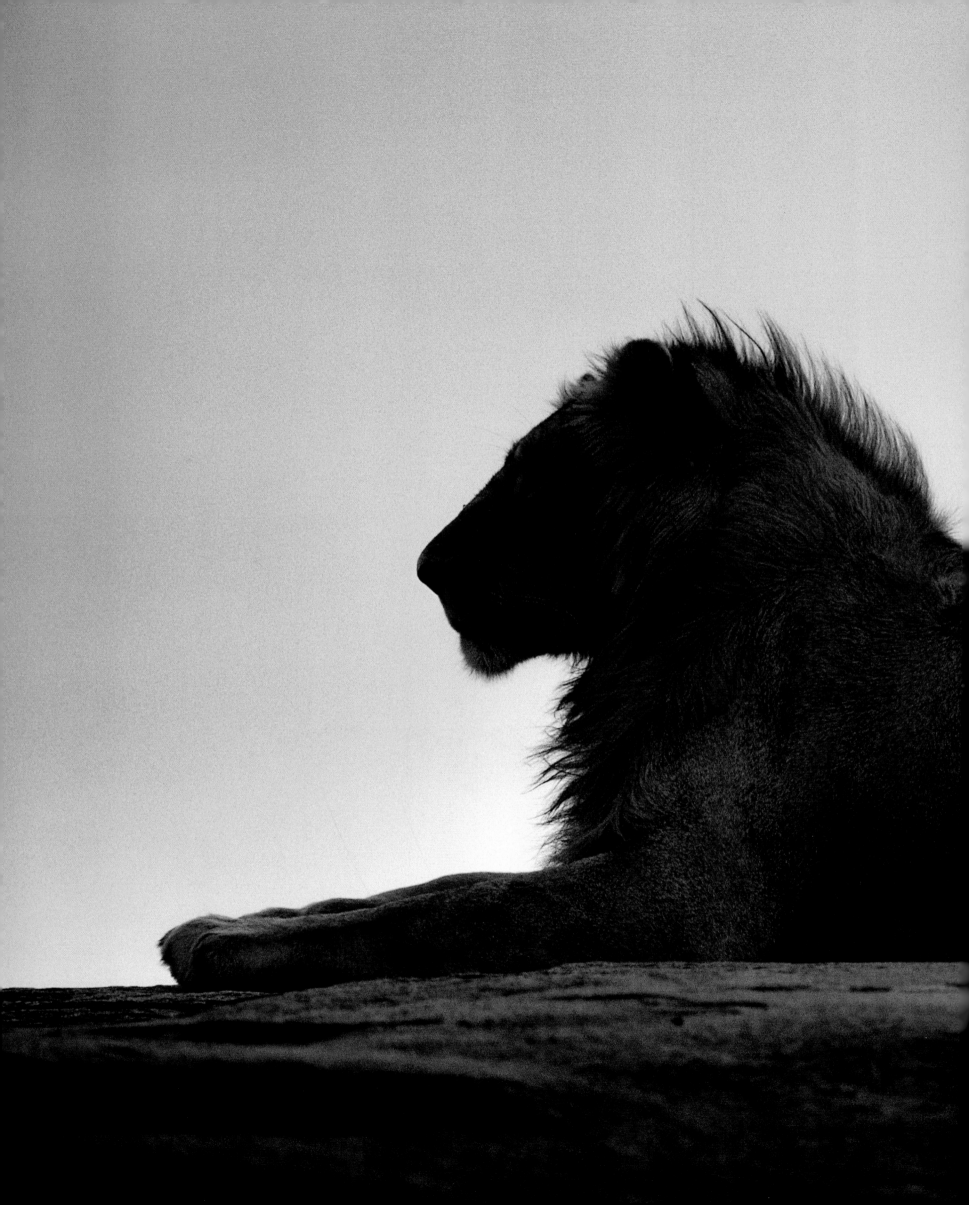

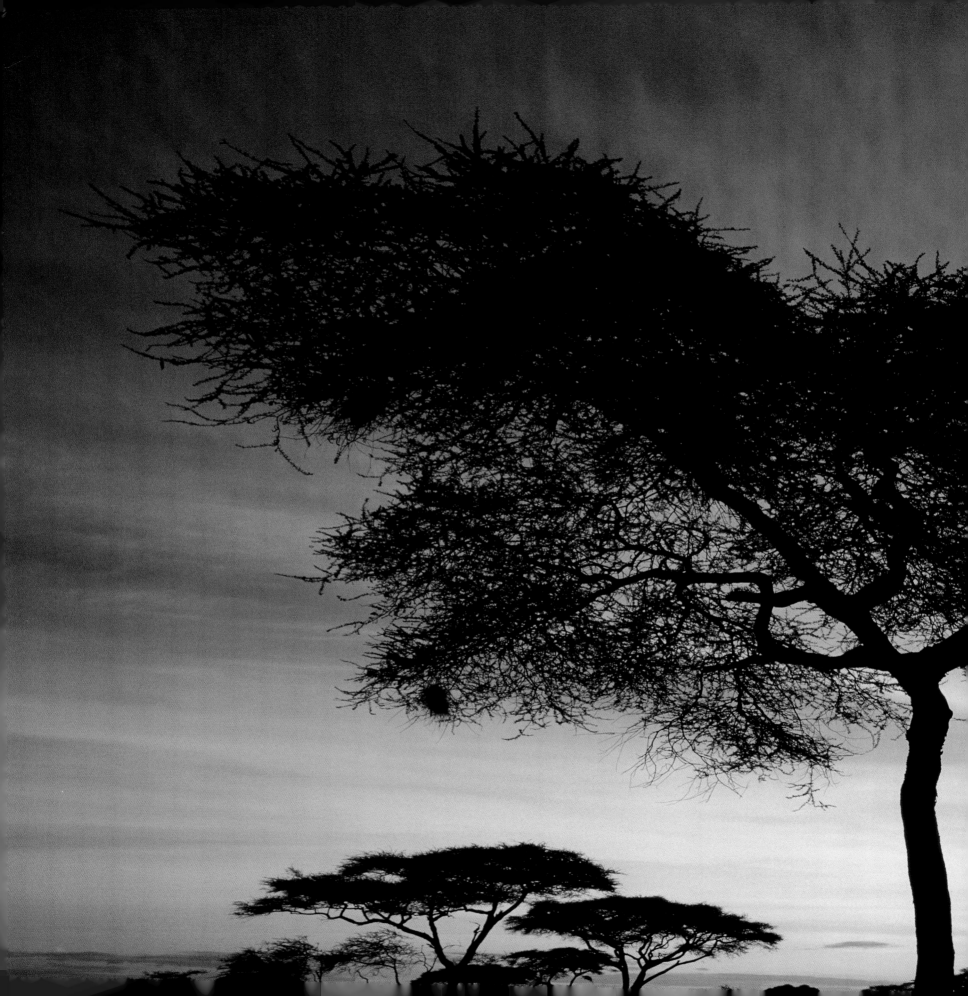

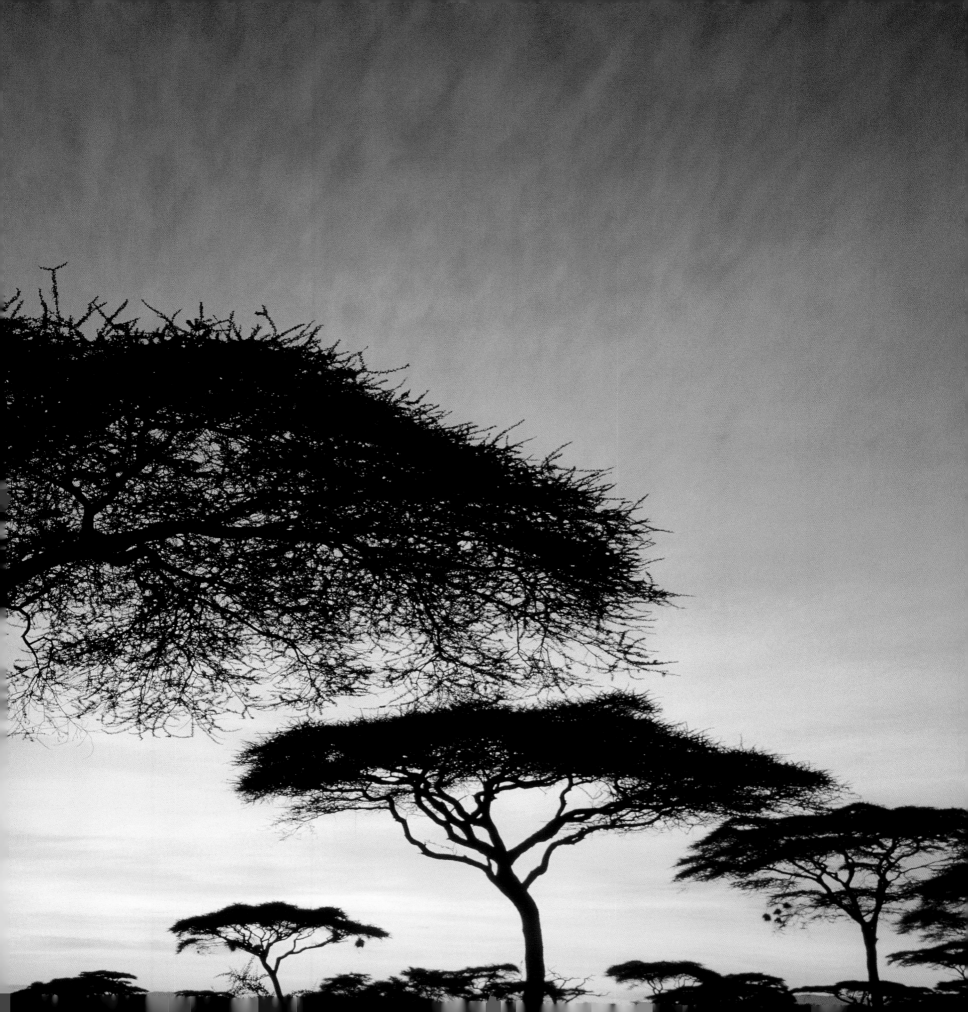

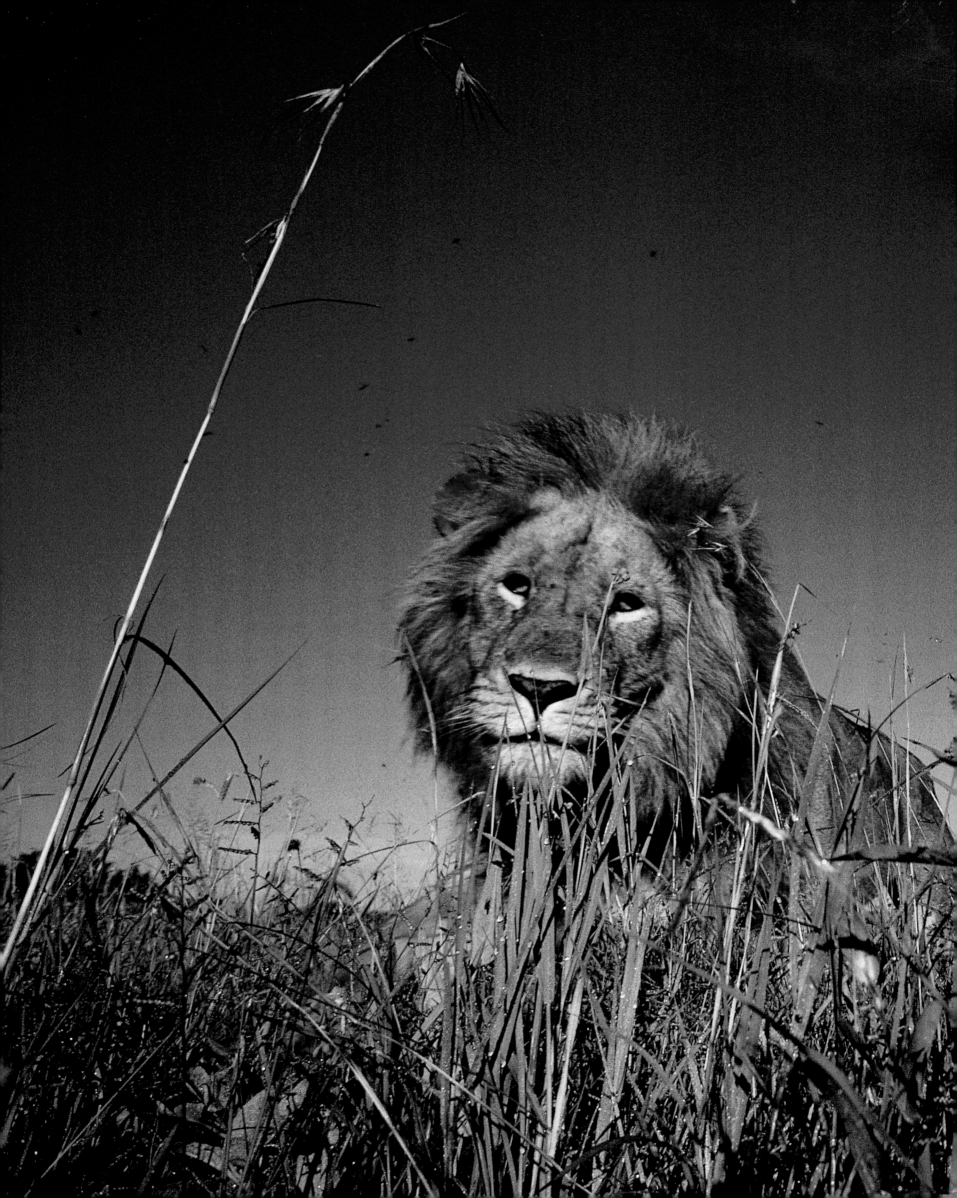

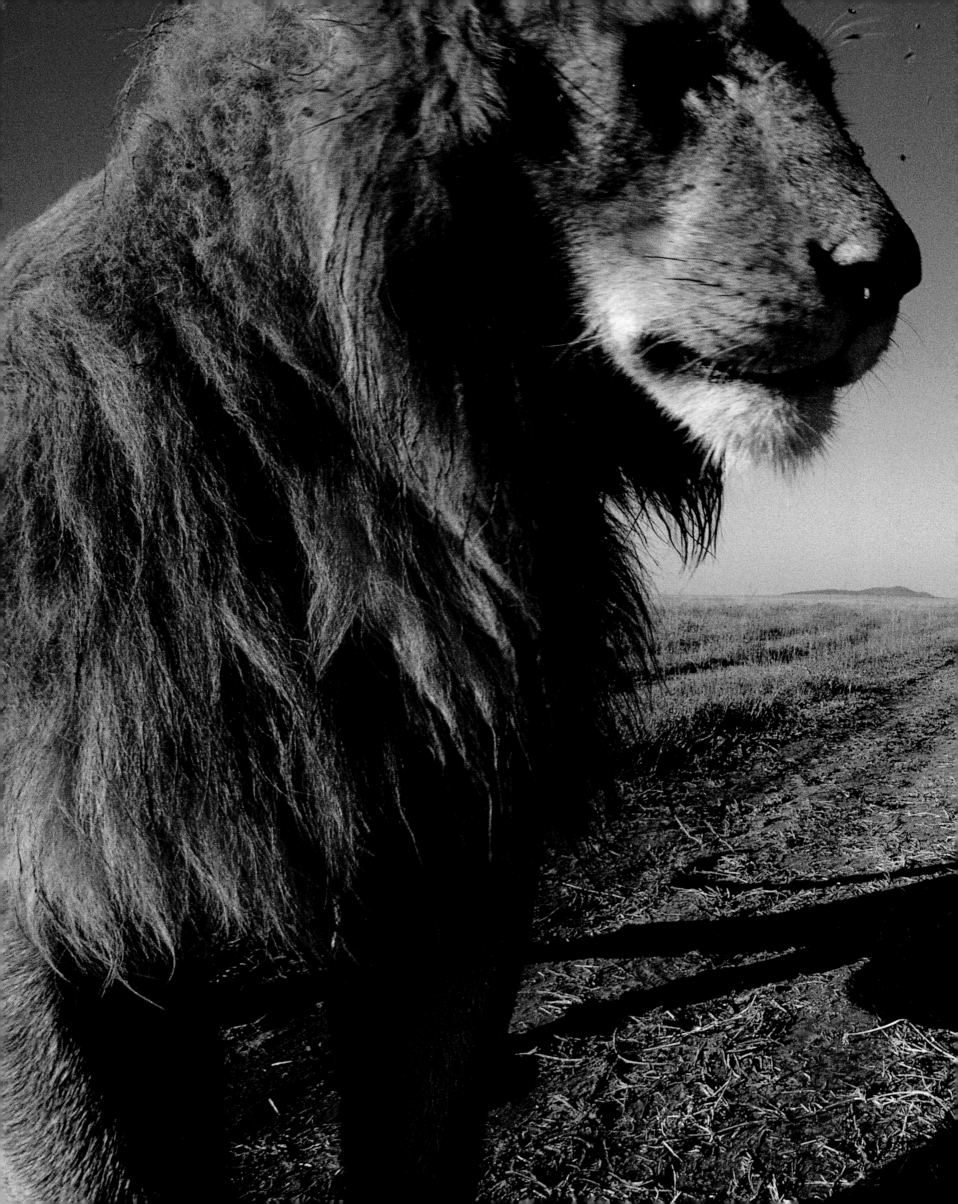

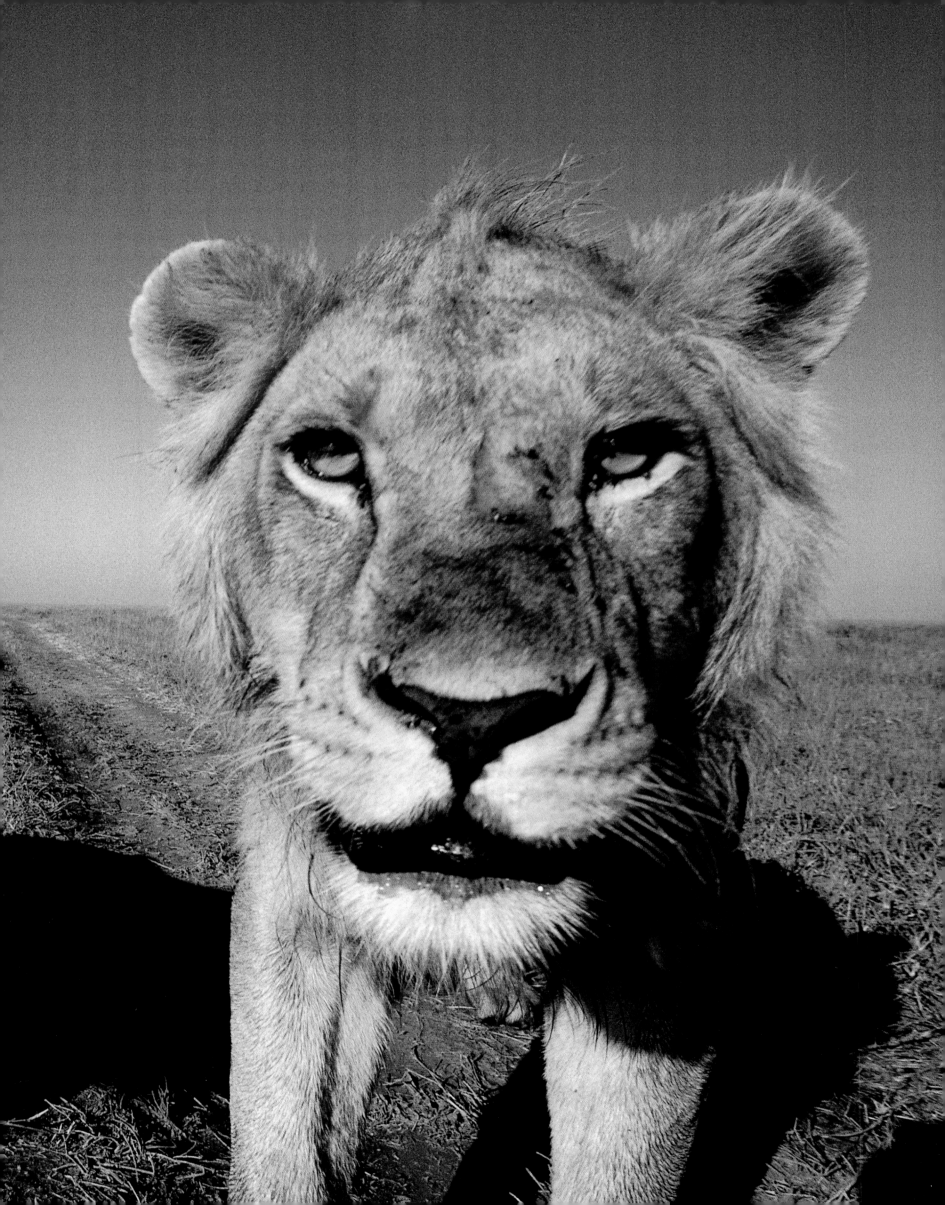

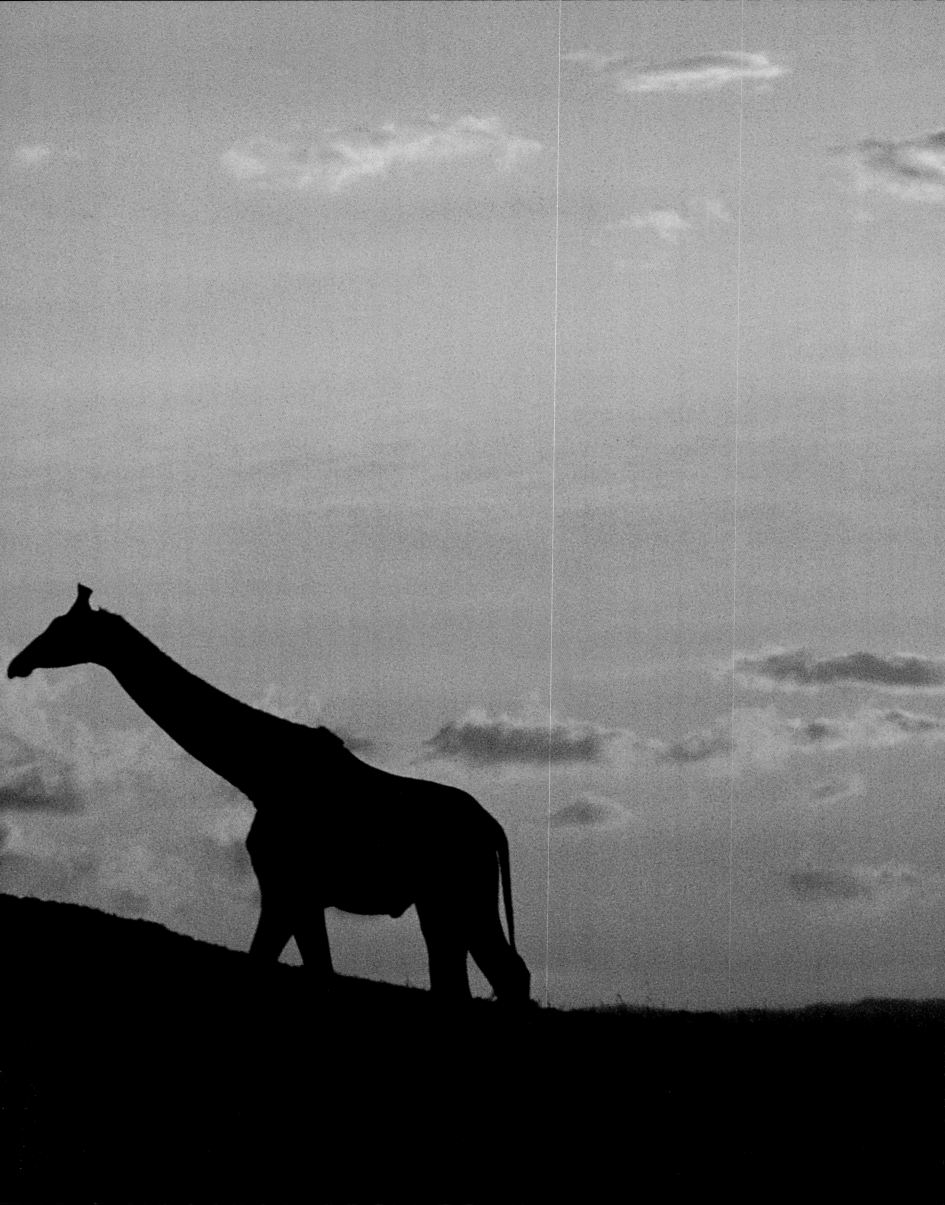

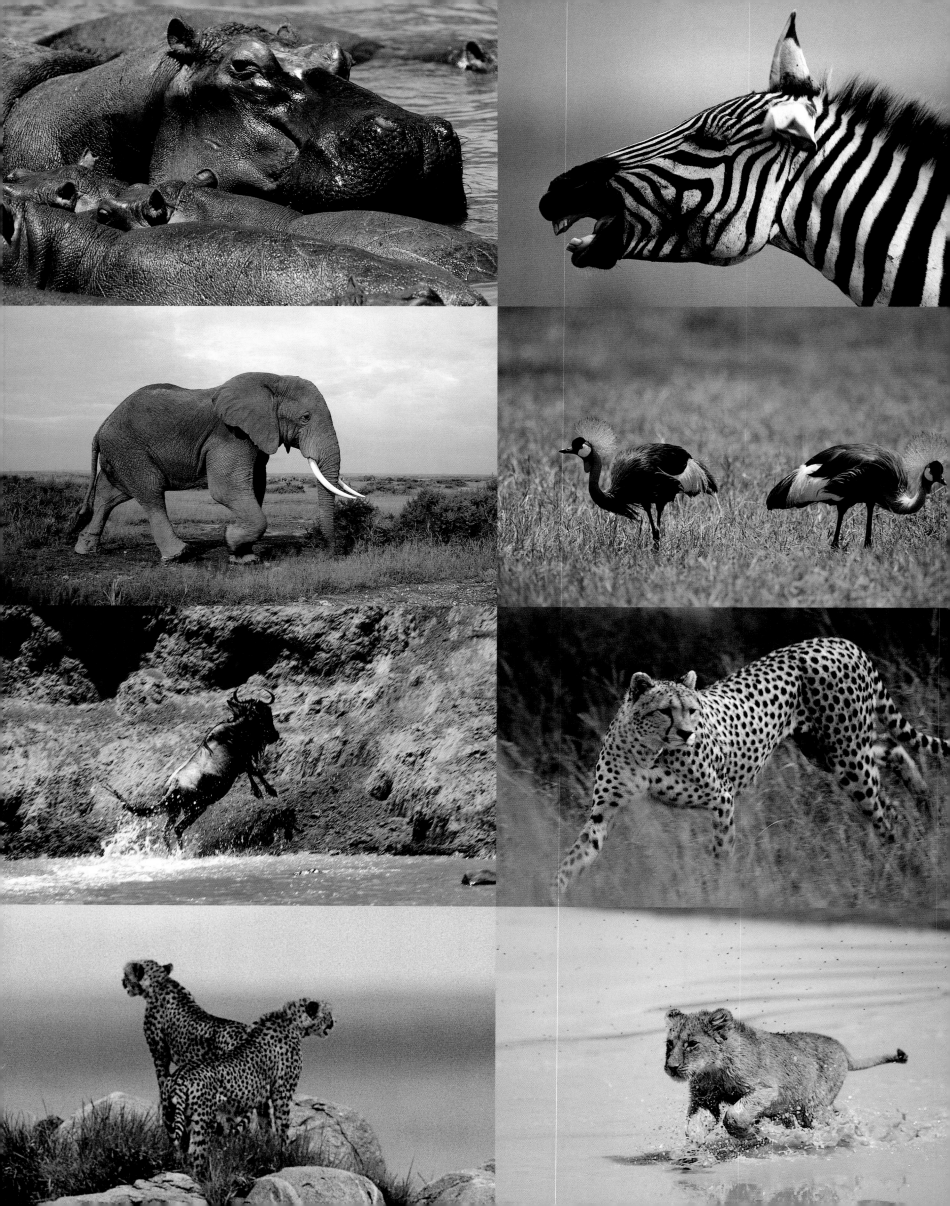

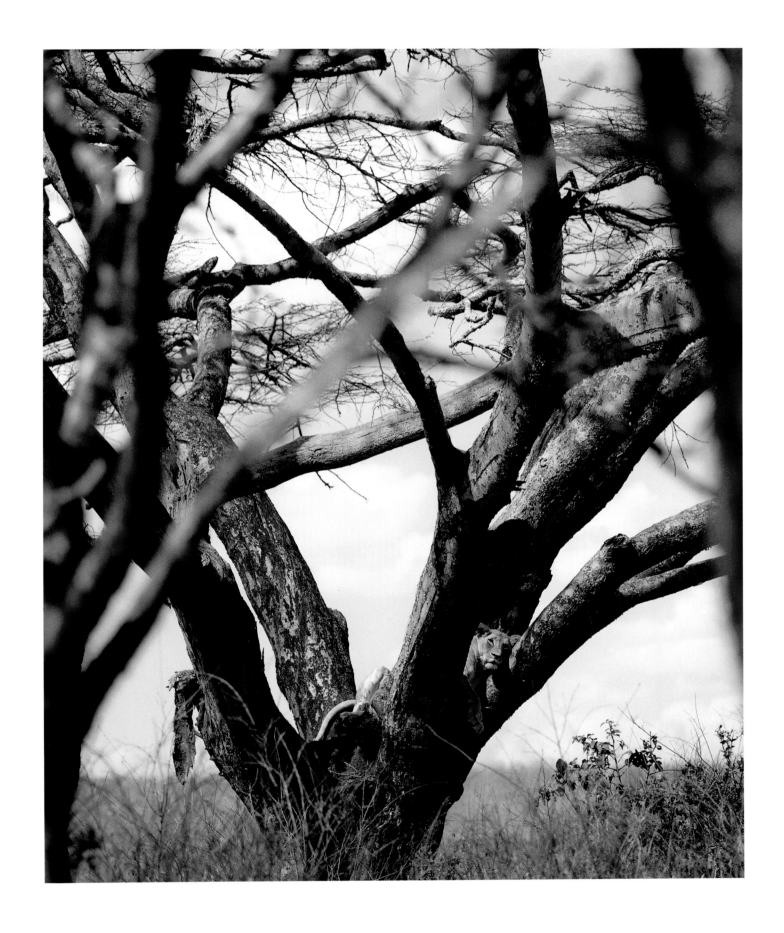

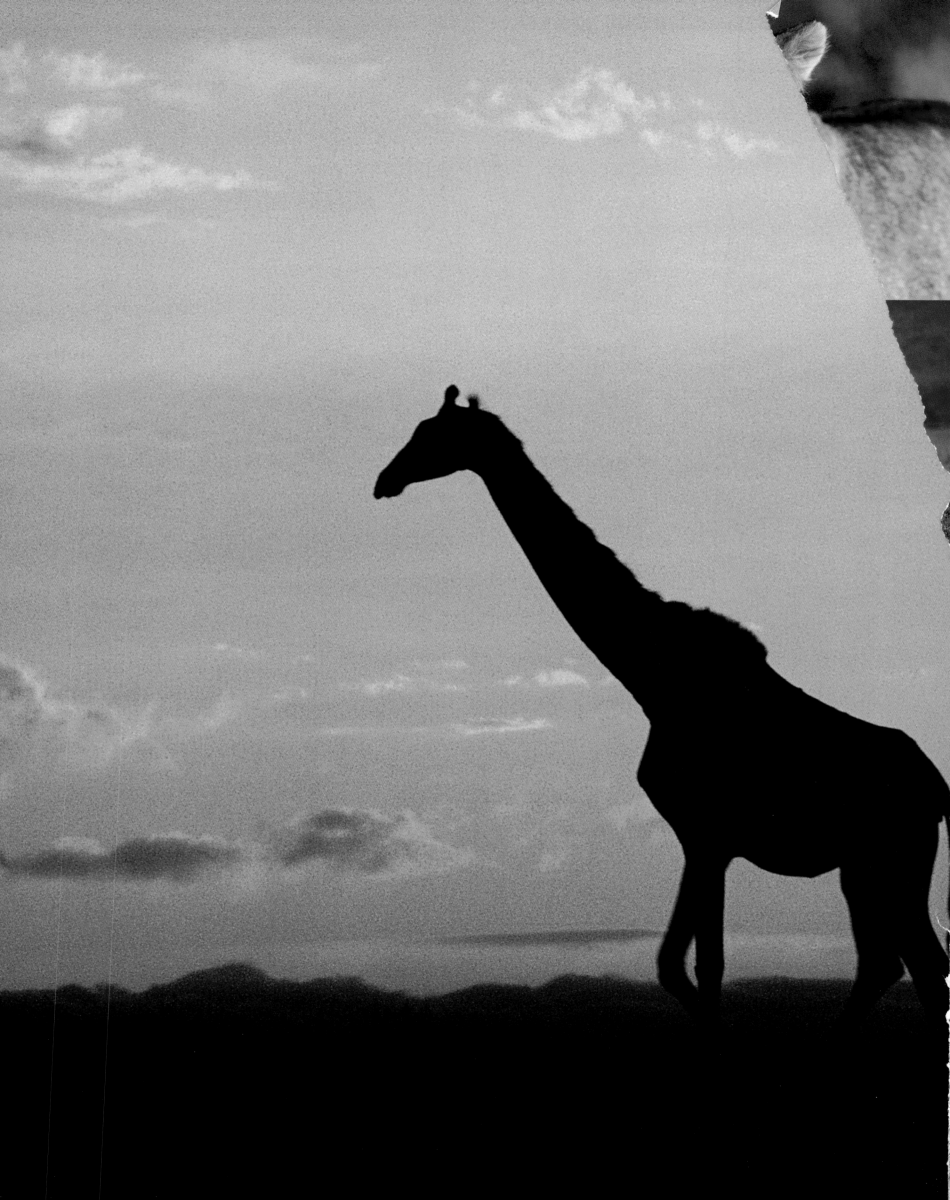

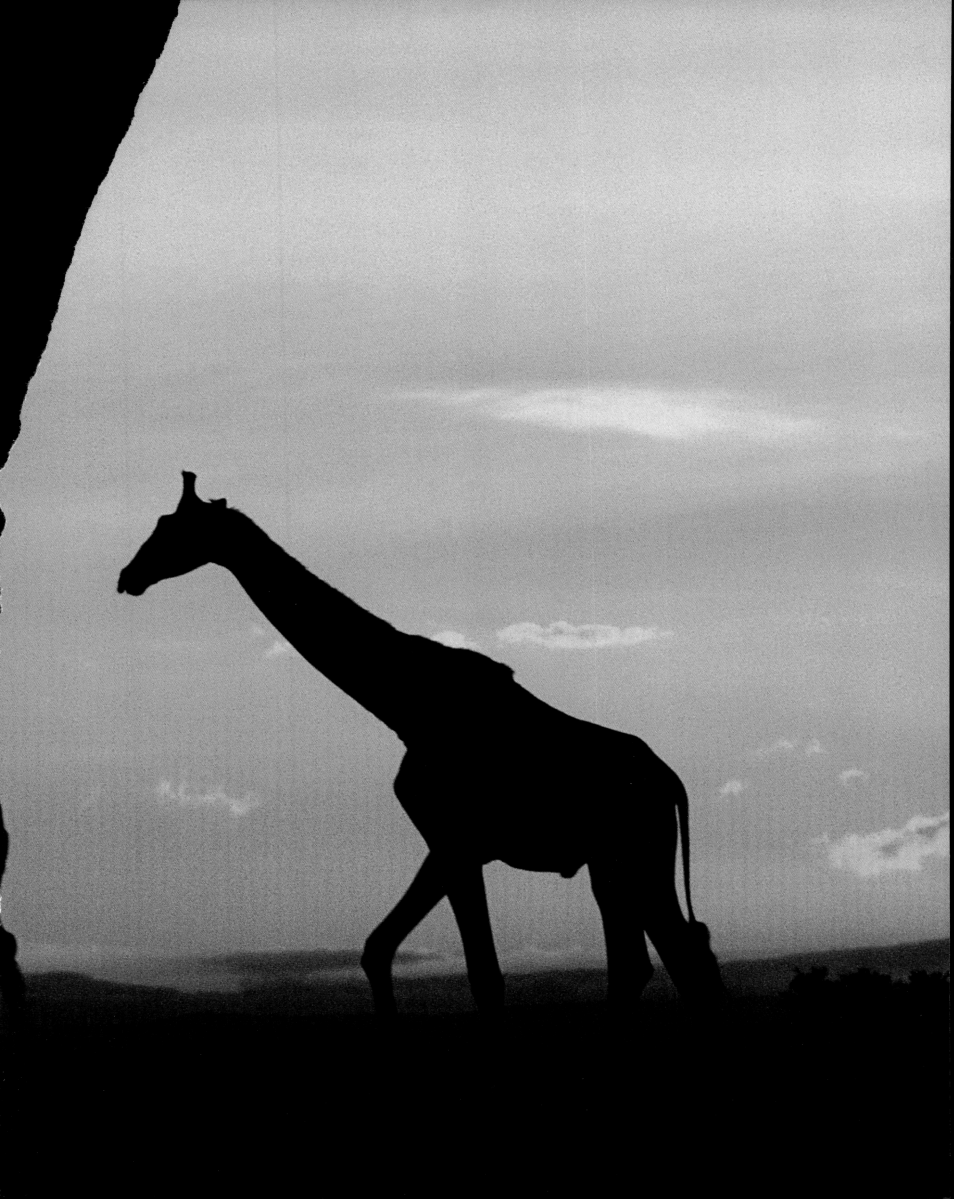

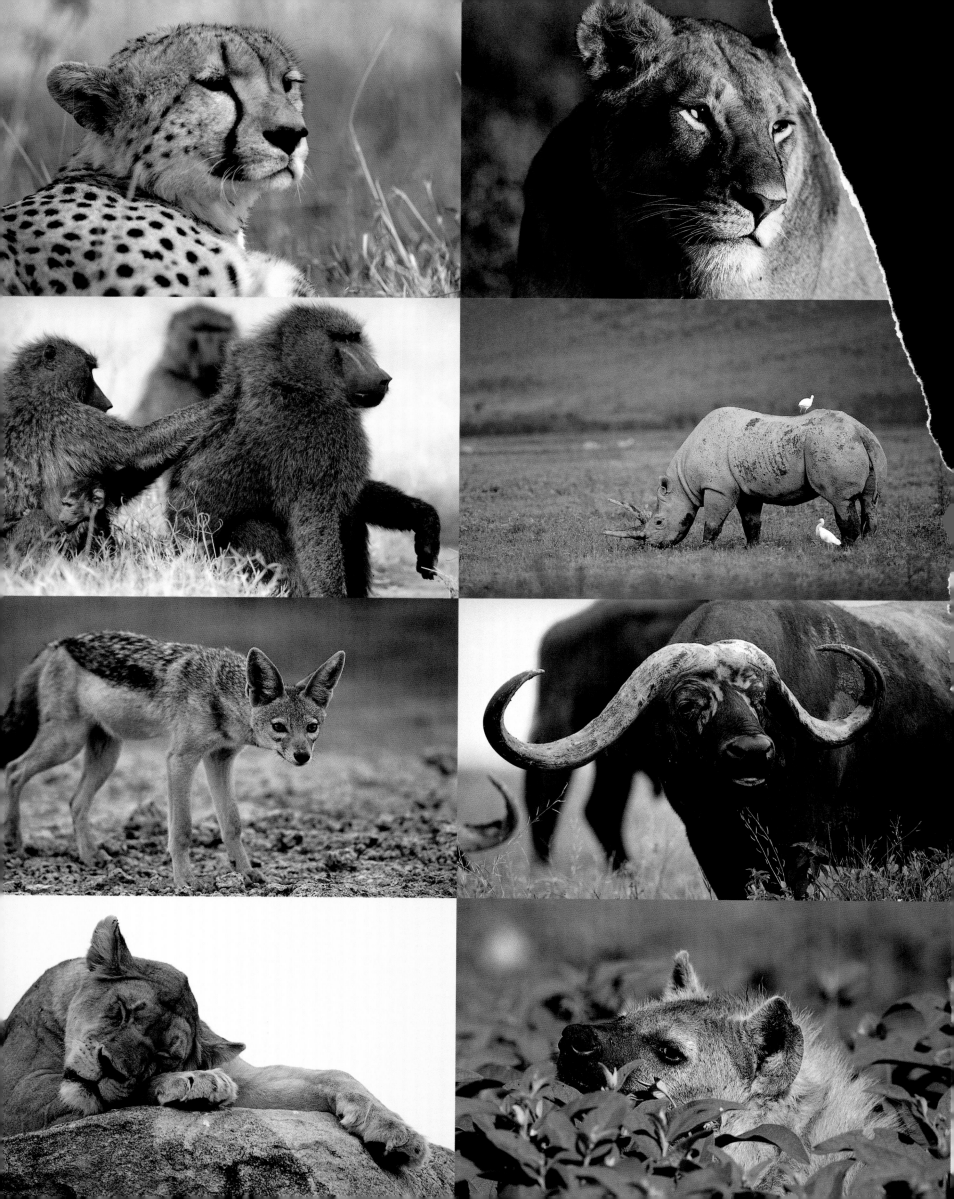

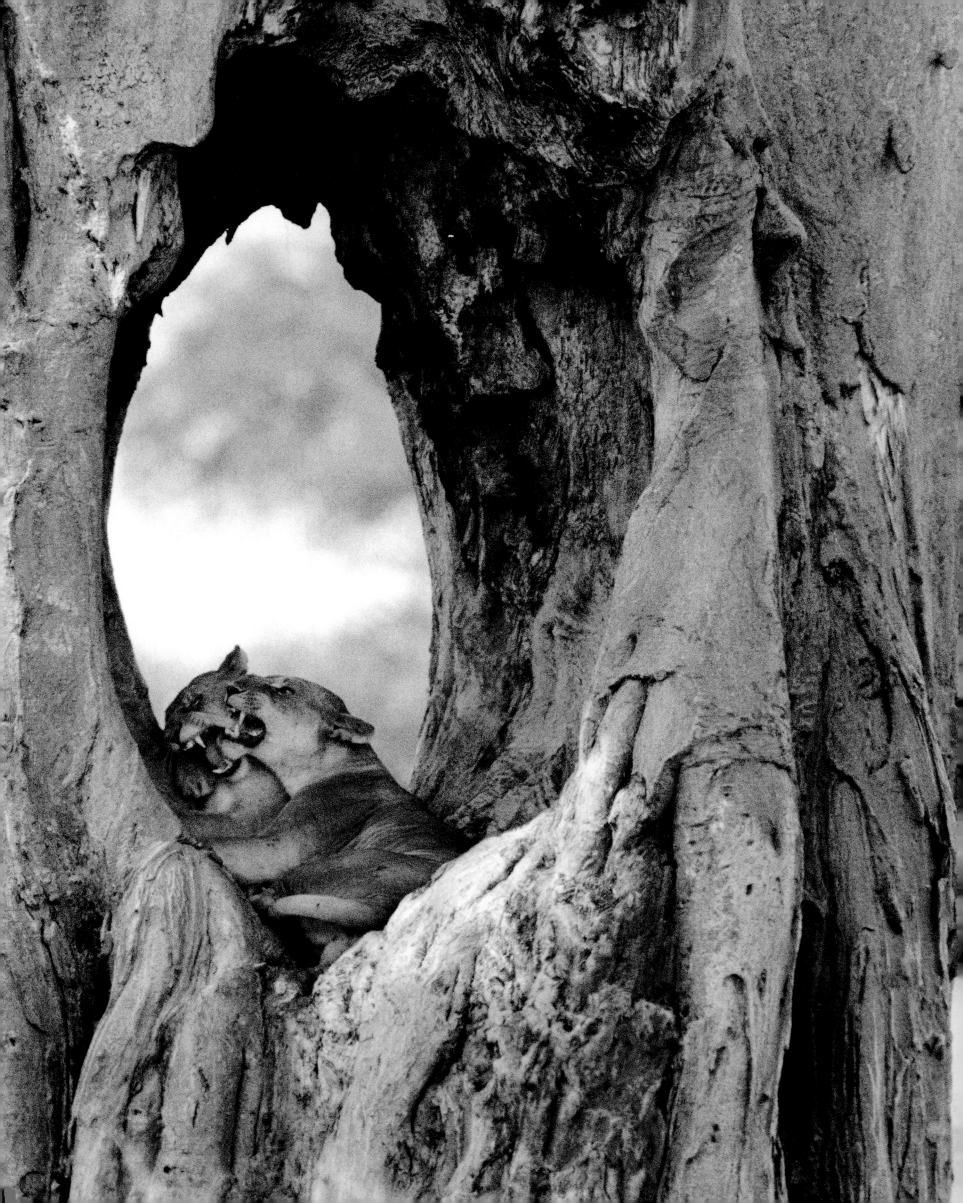

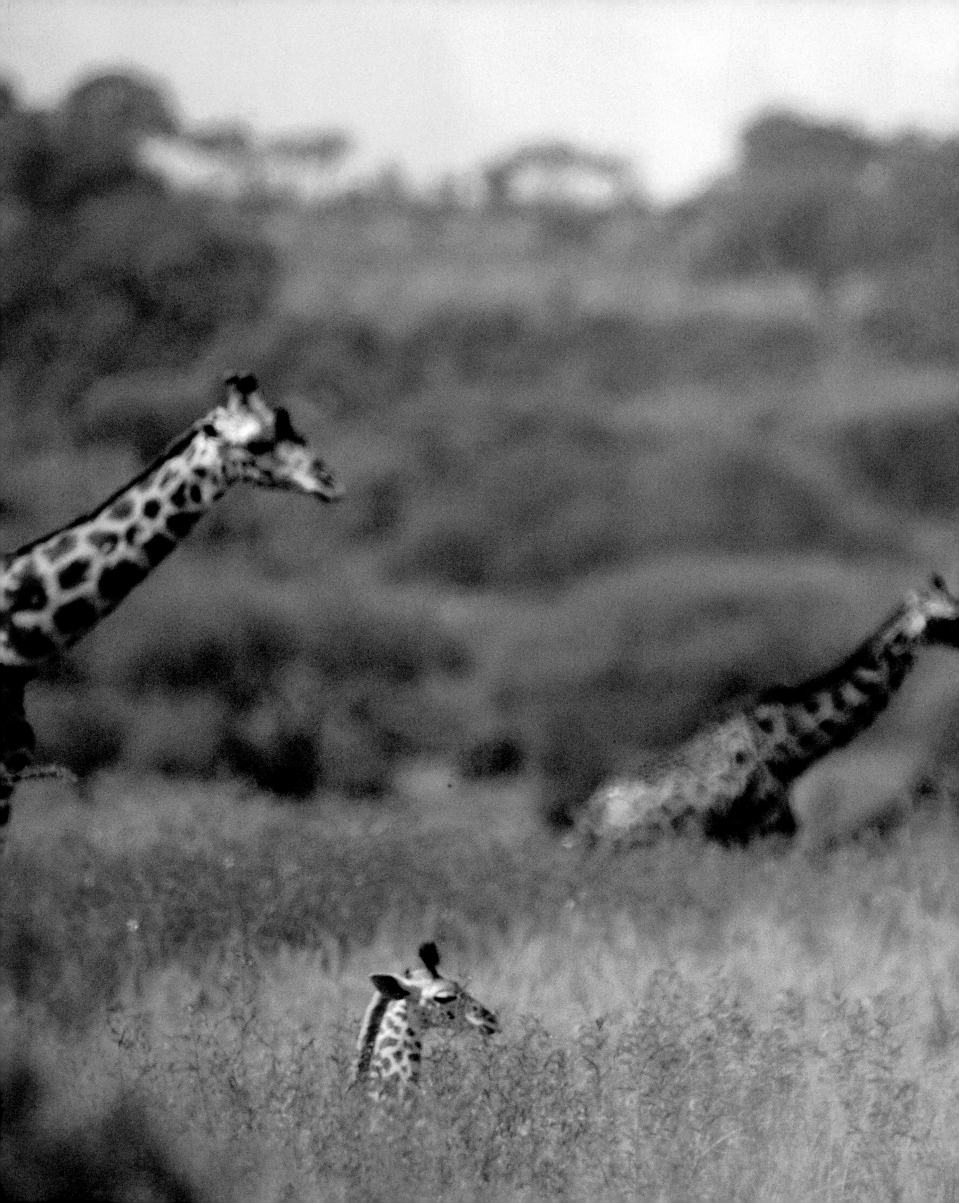

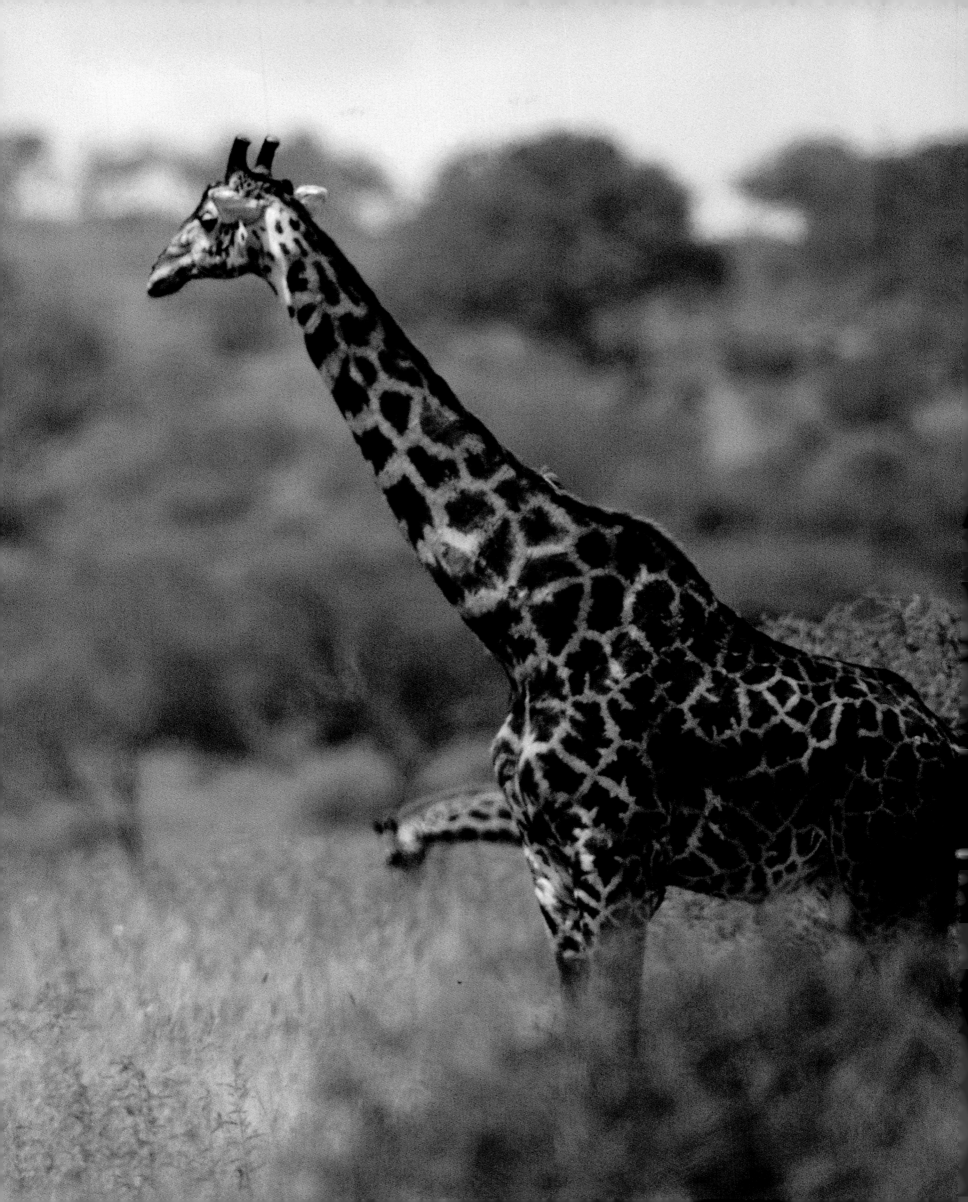

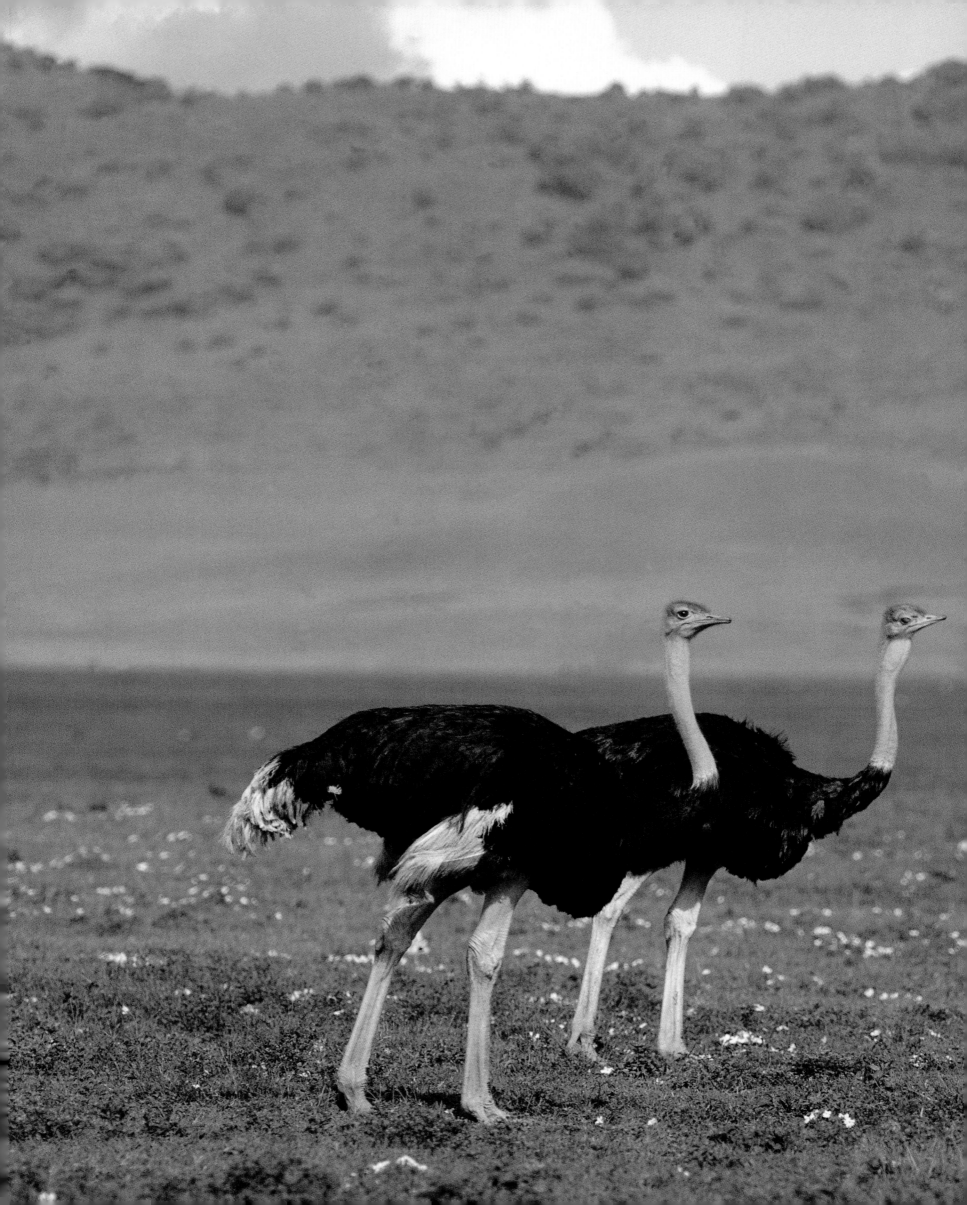

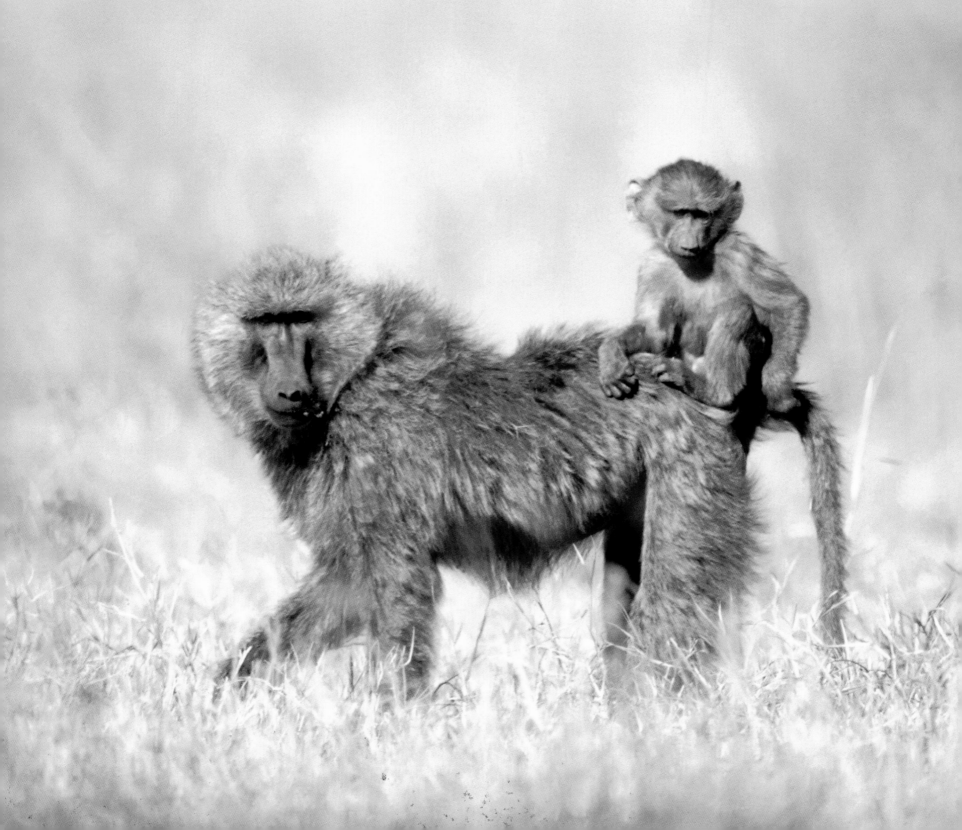

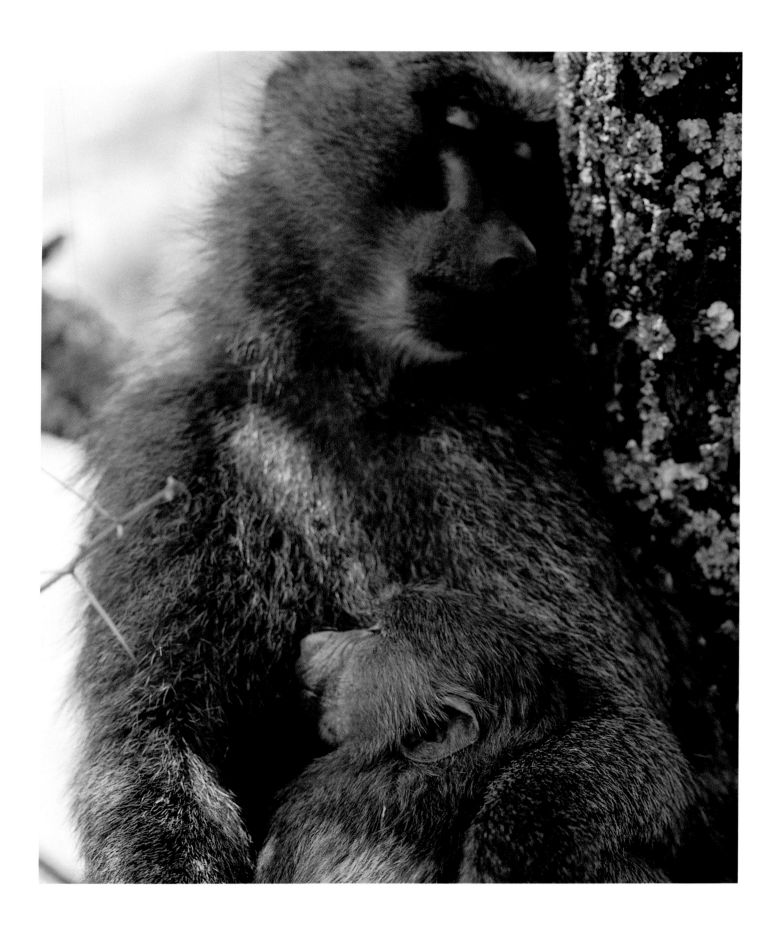

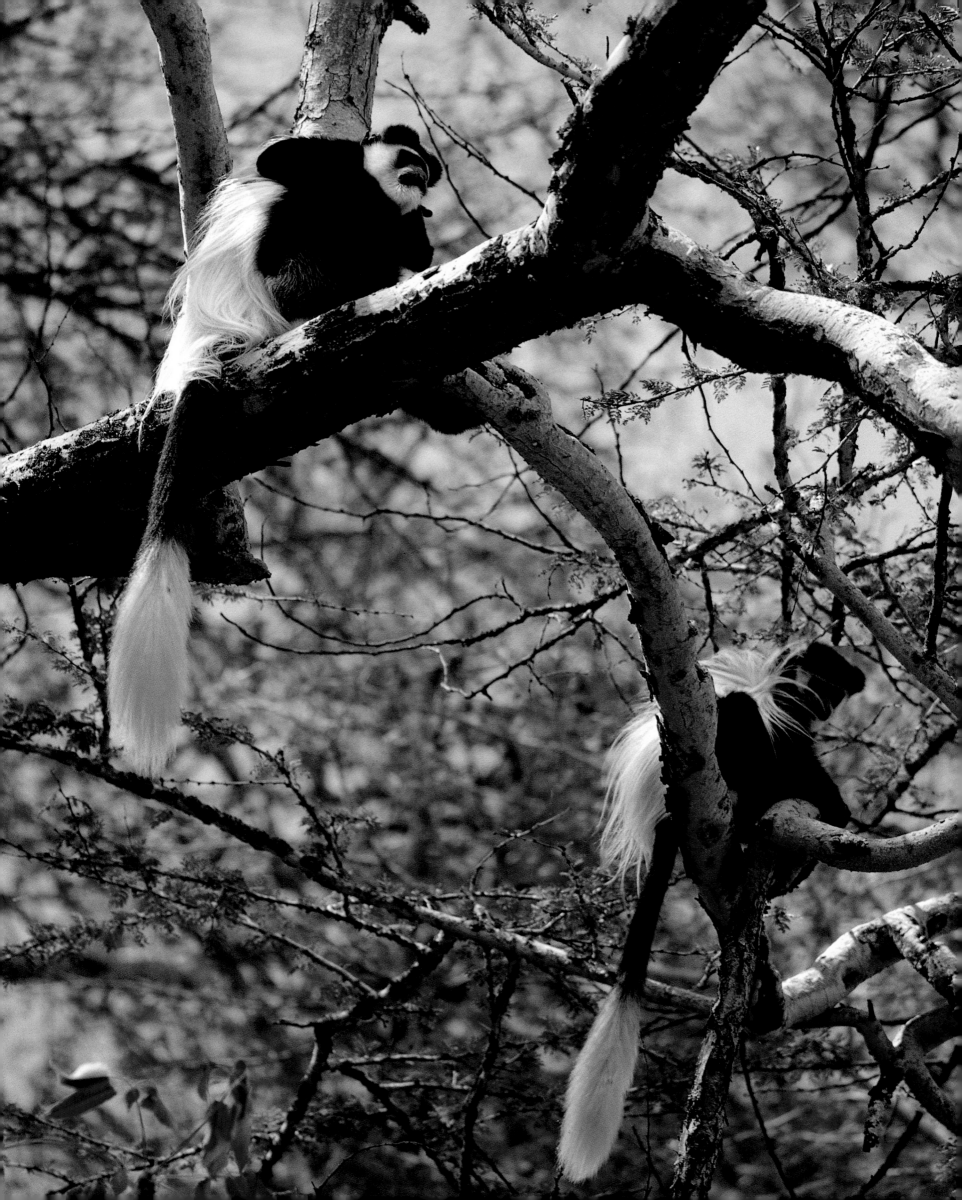

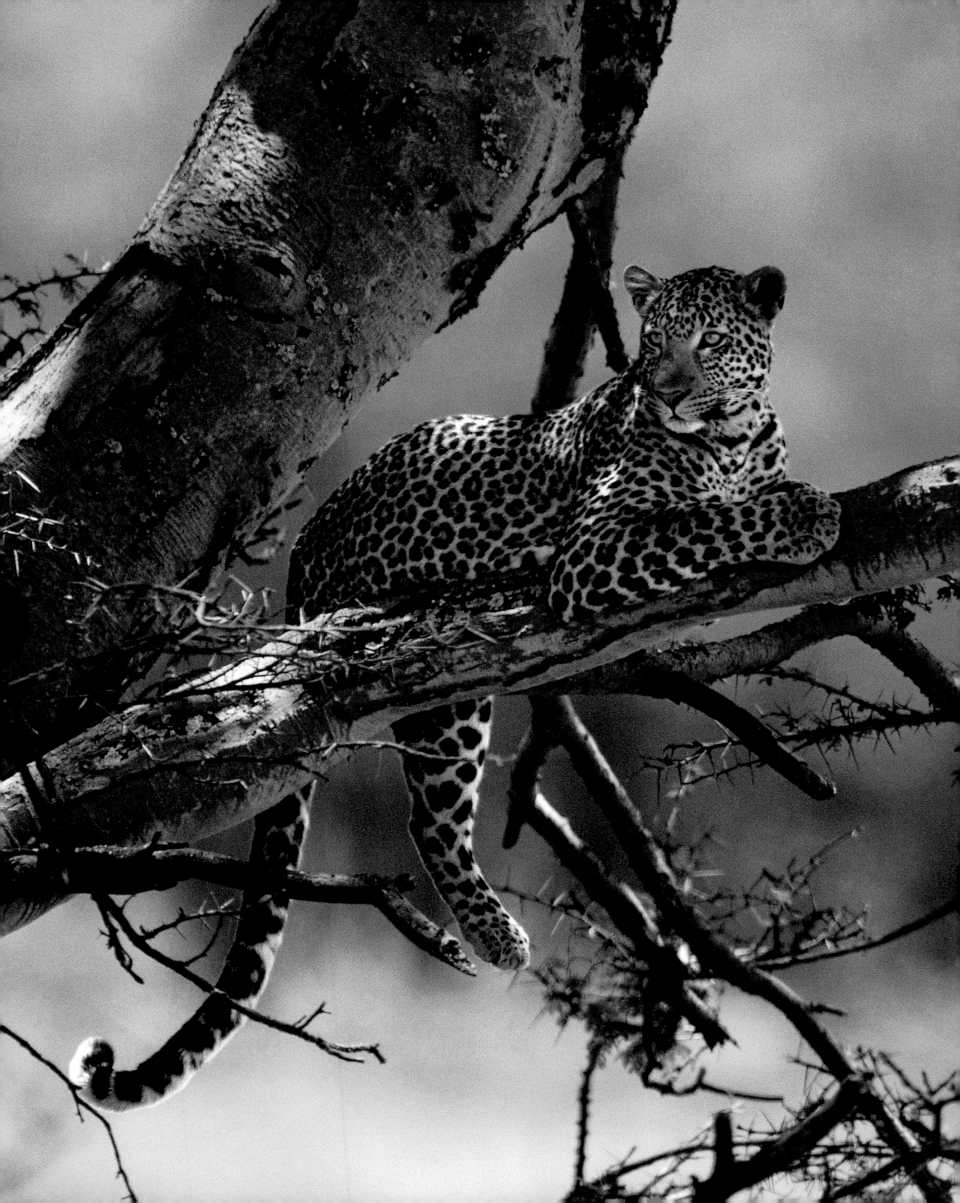

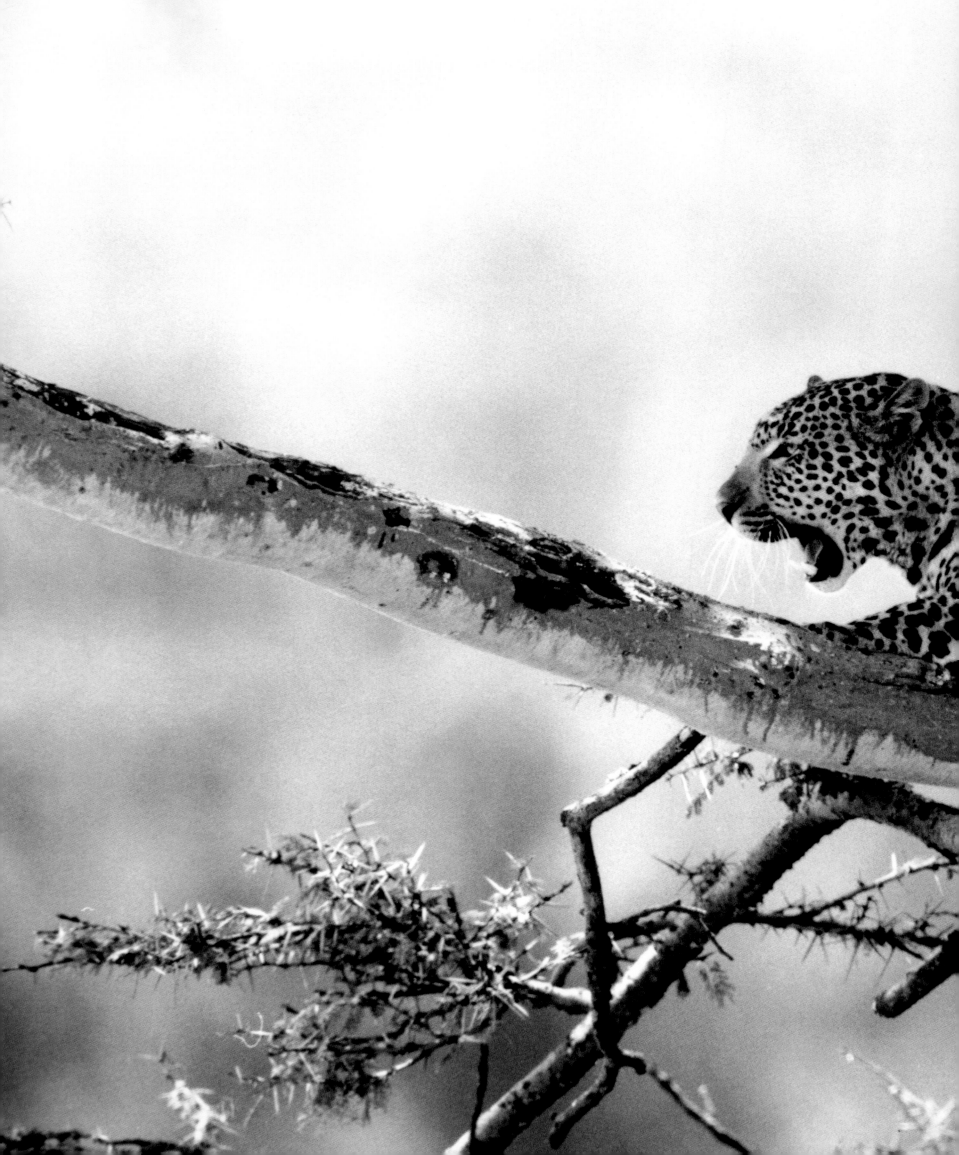

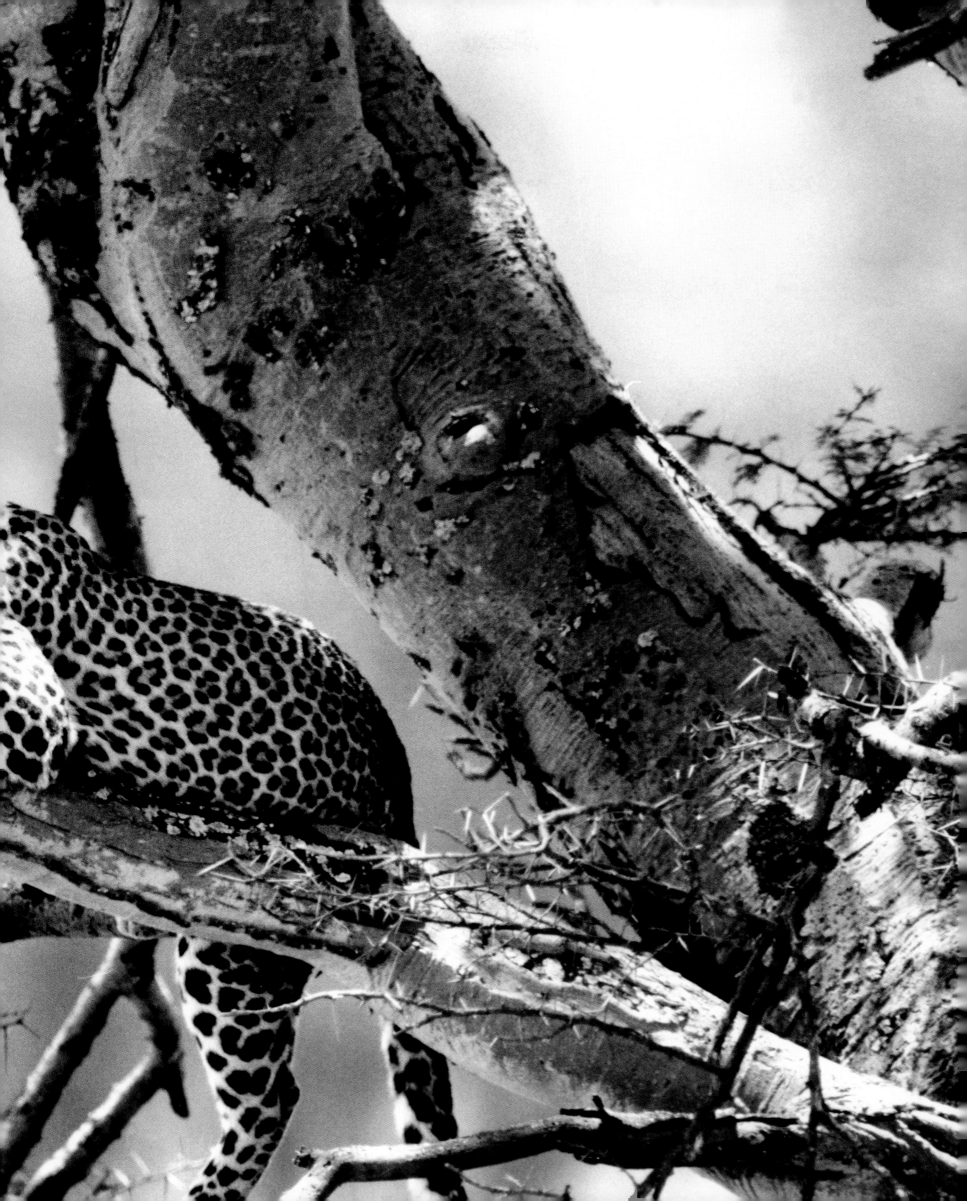

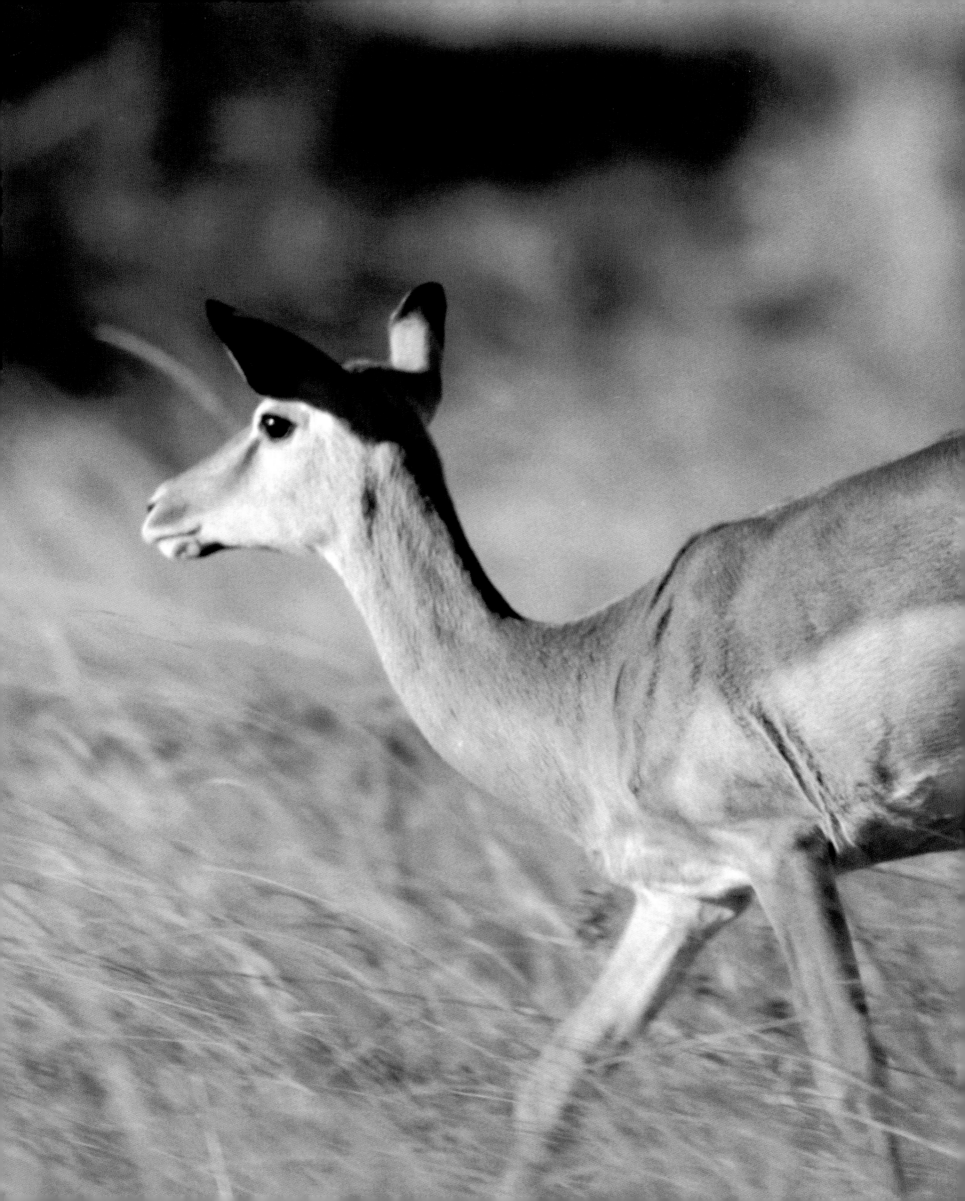

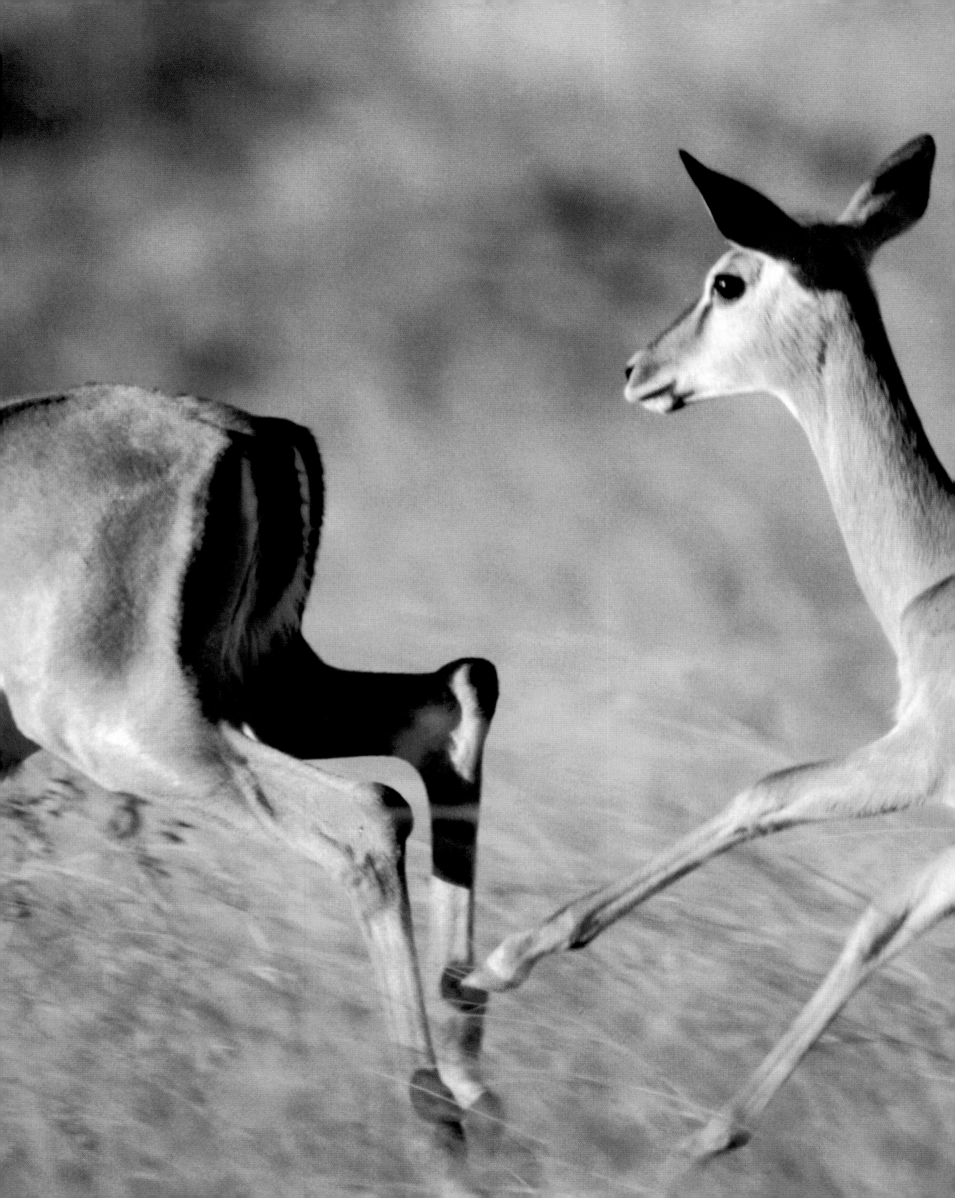

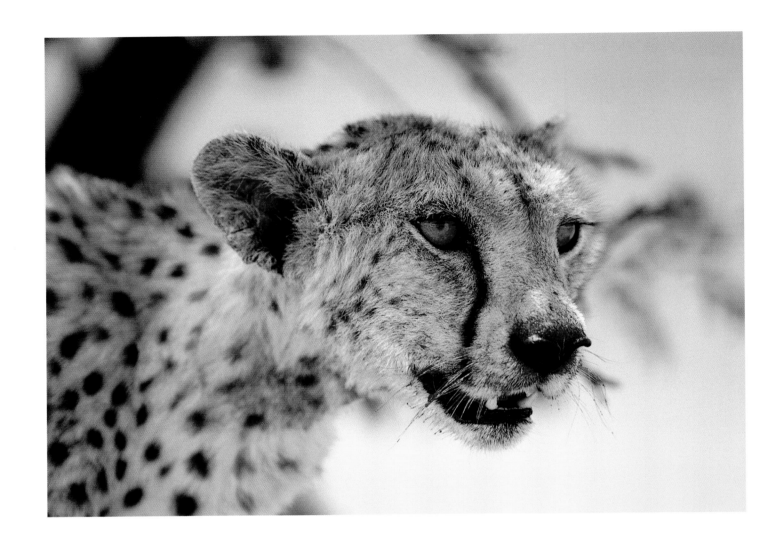

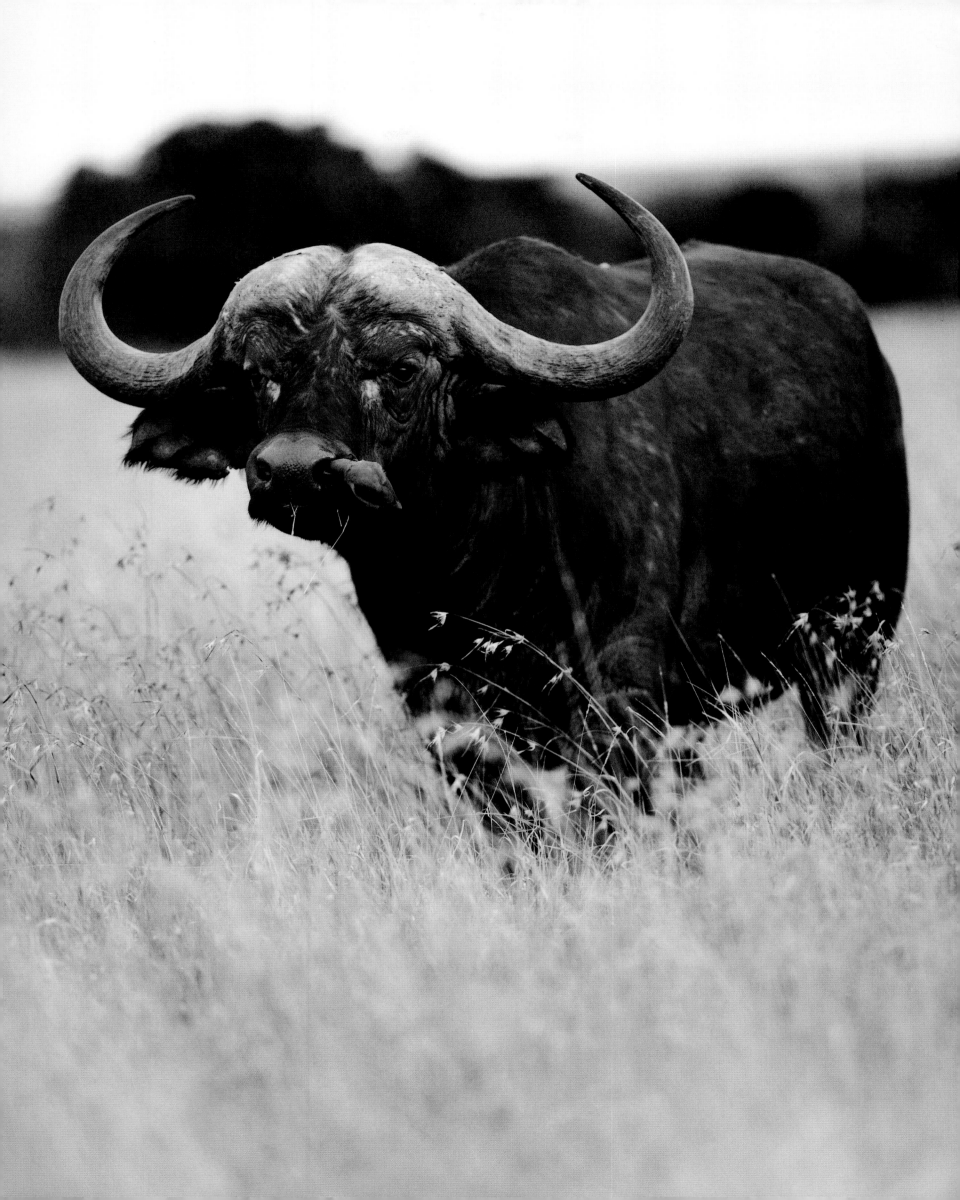

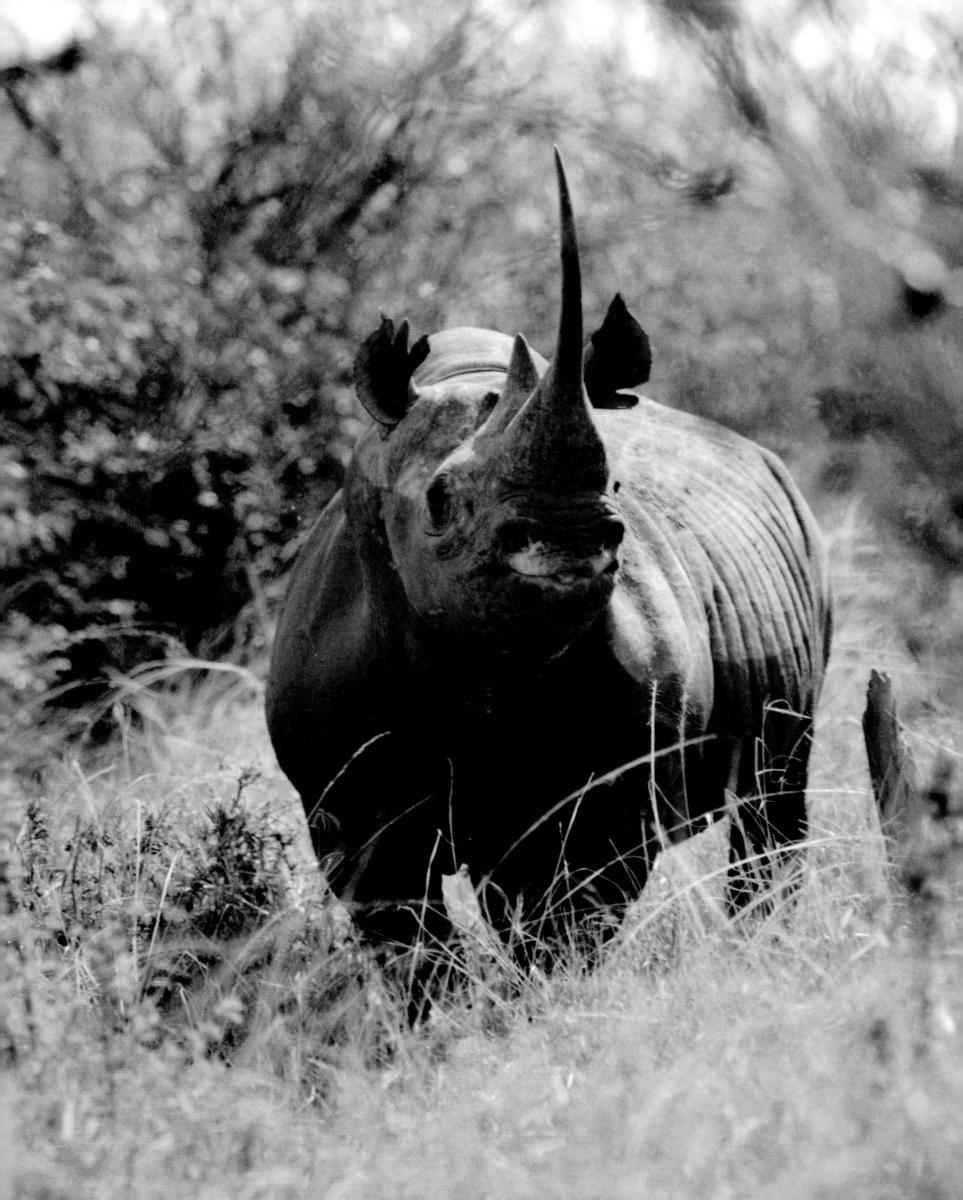

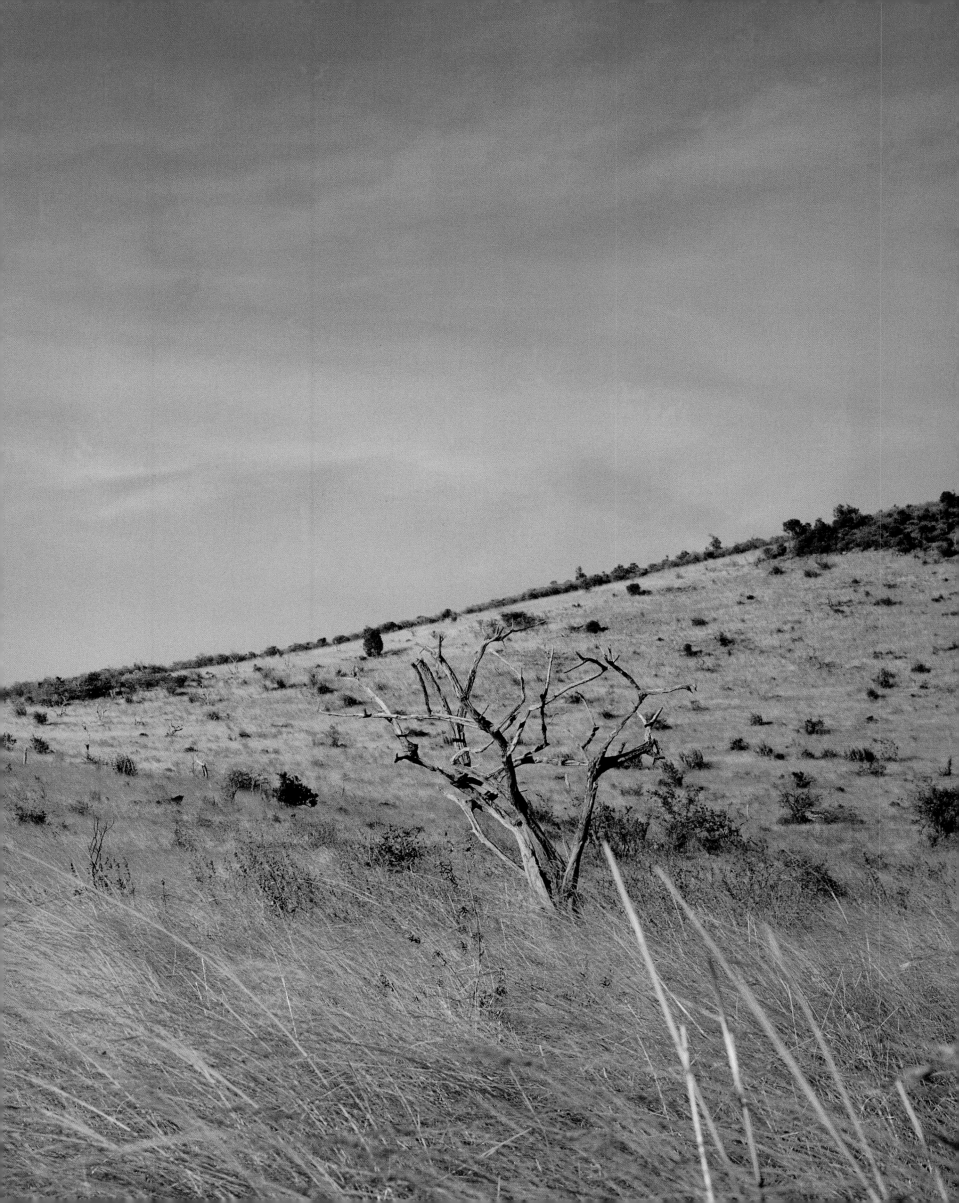

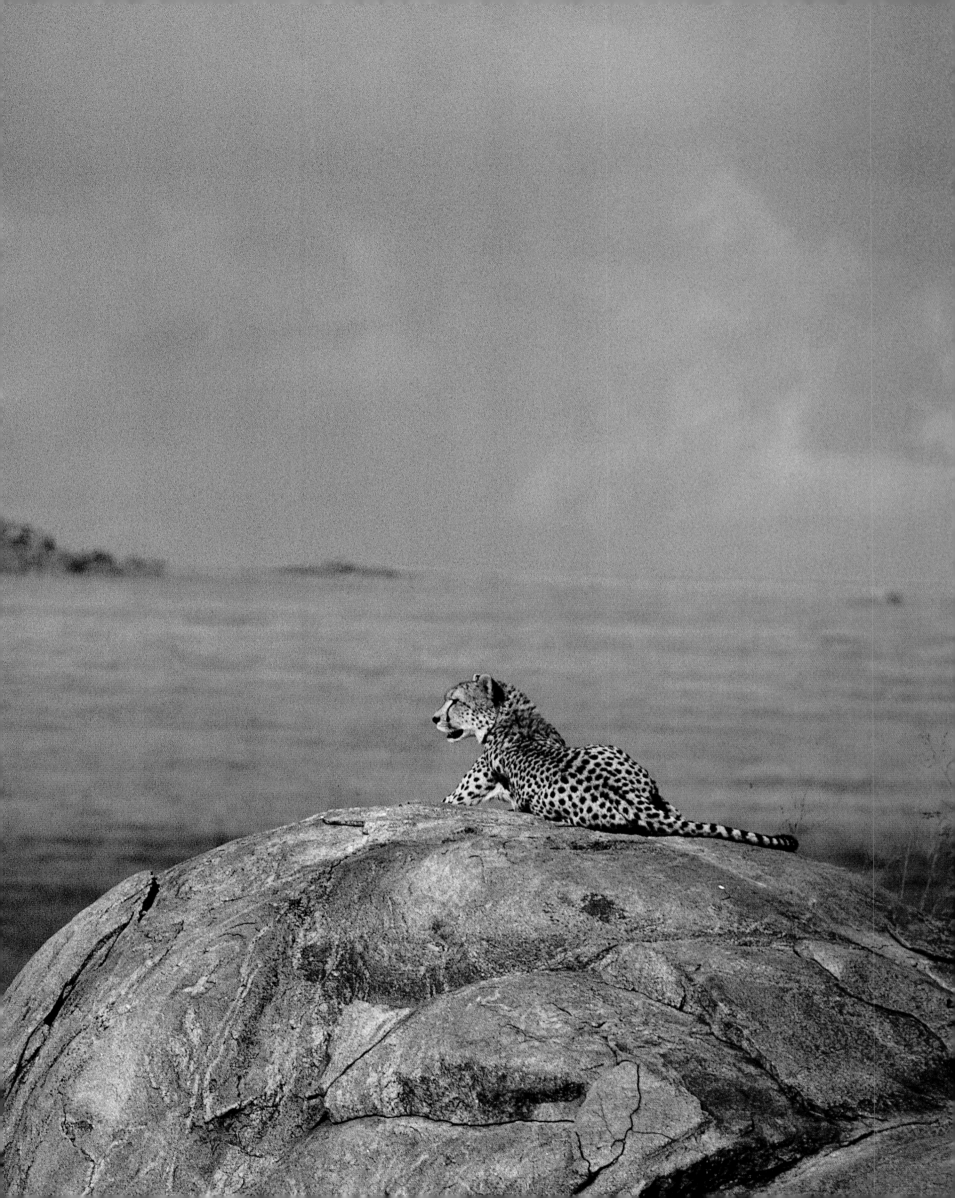

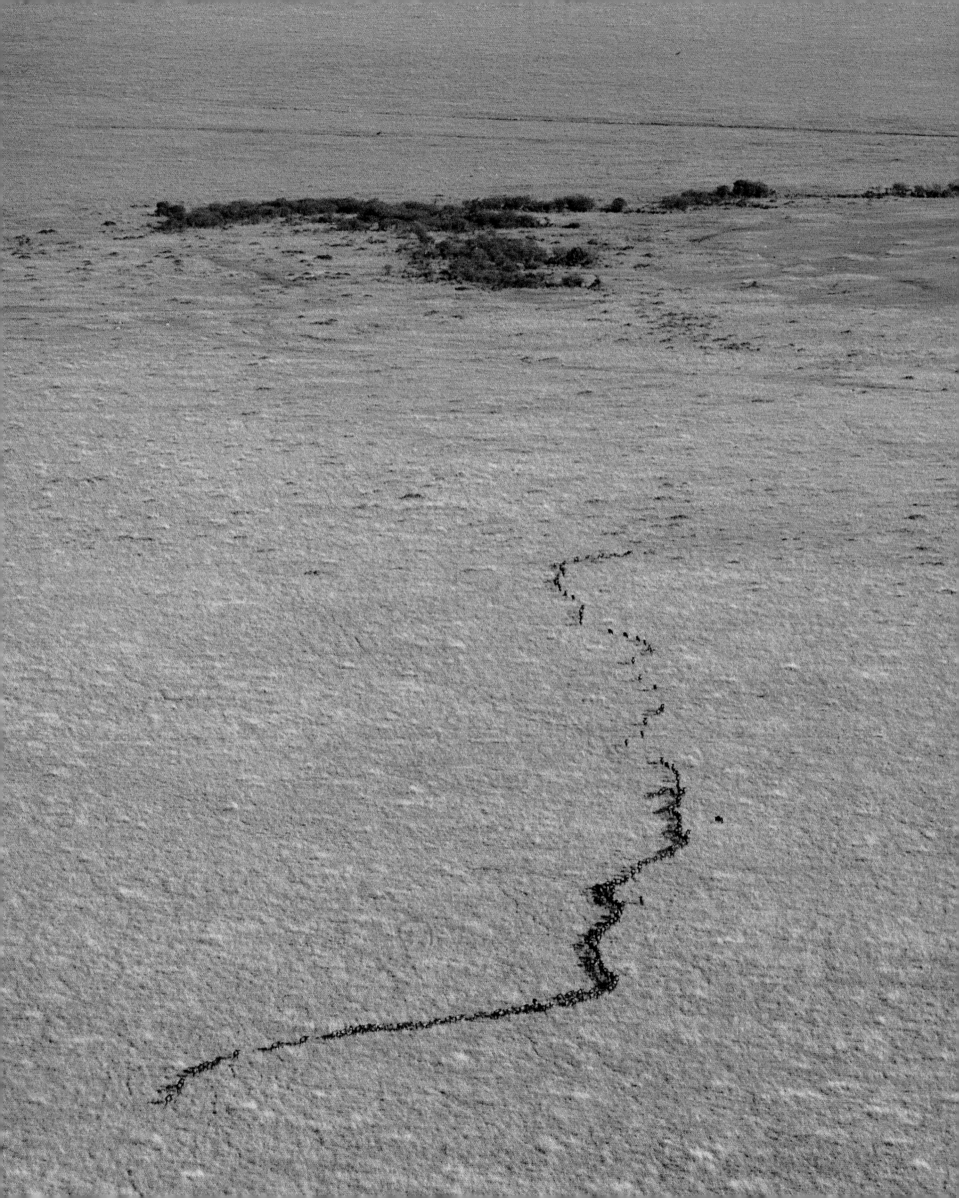

THE GREAT MIGRATION

I n African travel-guide prose, the Serengeti gnu migrations are among the "natural wonders of the world". And anyone who has ever seen these creatures' backs undulating from horizon to horizon and felt the savannah trembling under umpteen thousand hooves will scarcely feel that is an exaggeration. And in fact there is nothing comparable: buffalo on the North American plains are down to a few pathetic survivors, and the gigantic reindeer herds of the far north are made up of tame domestic animals.

The river crossings are among the visual high points of these crowd scenes with their thousands of performers. These herbivores seem to be brought almost to their knees by their horror of fast-flowing, opaque, crocodile-infested water before they are driven into the floods by the waves of animals following them; they then swim through the water packed tightly together and with eyes wide open in panic. Crocodiles reap a bloody harvest. The only safety for a gnu lies in crossing the treacherous river flanked on both sides by its peers.

It is only in the Serengeti/Maasai Mara ecosystem that the striped gnus embark upon this arduous migration of world fame. In areas where watering holes are fairly close together, they move at their leisure in small groups.

The animals need fresh, short grass of the kind that sprouts after rain and bush fires as well. This is one reason why many friends of the gnu regret that cattle- and gnu-herds living together is now a thing of the past almost everywhere: when it seemed necessary, the Maasai used to start savannah fires over a restricted area to create better grass for their animals.

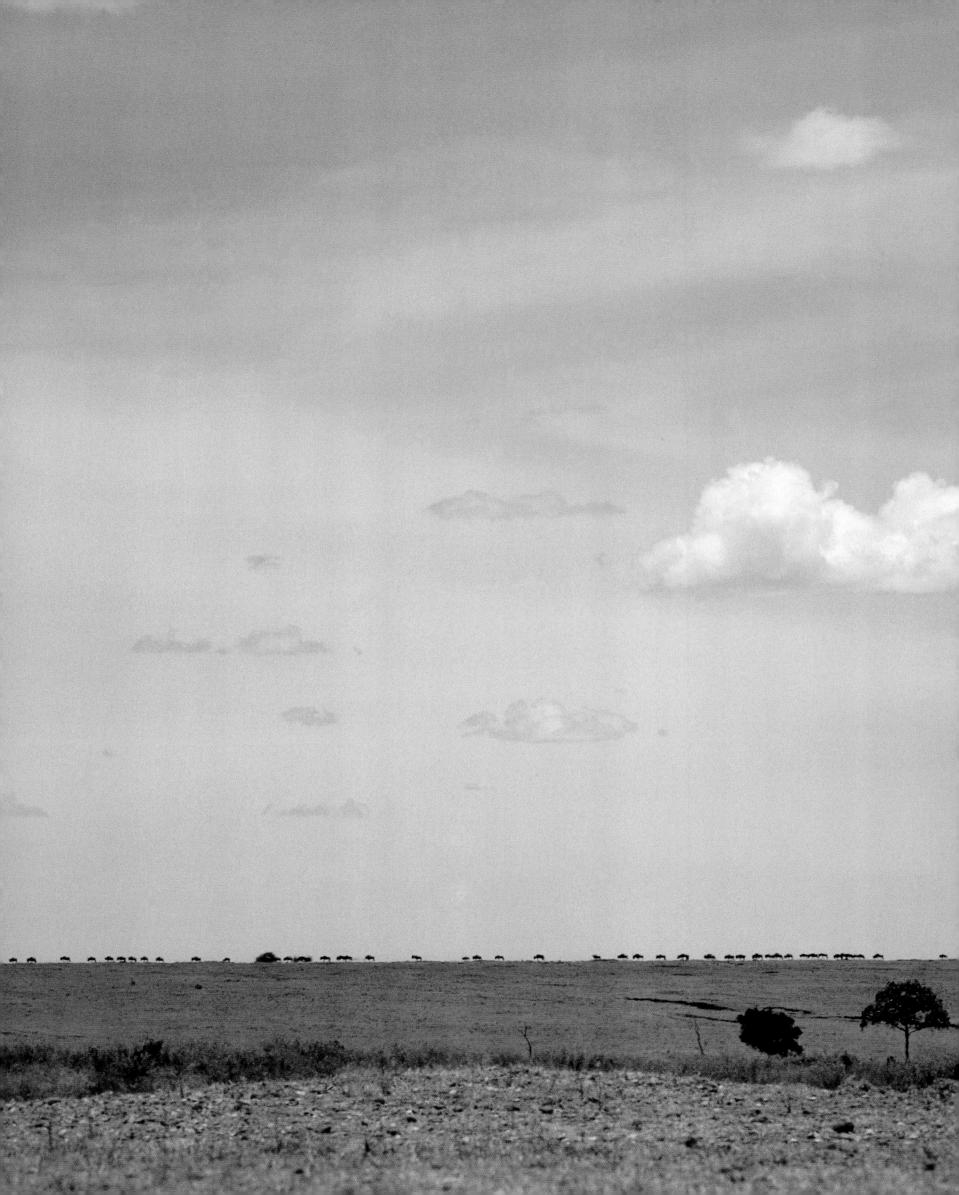

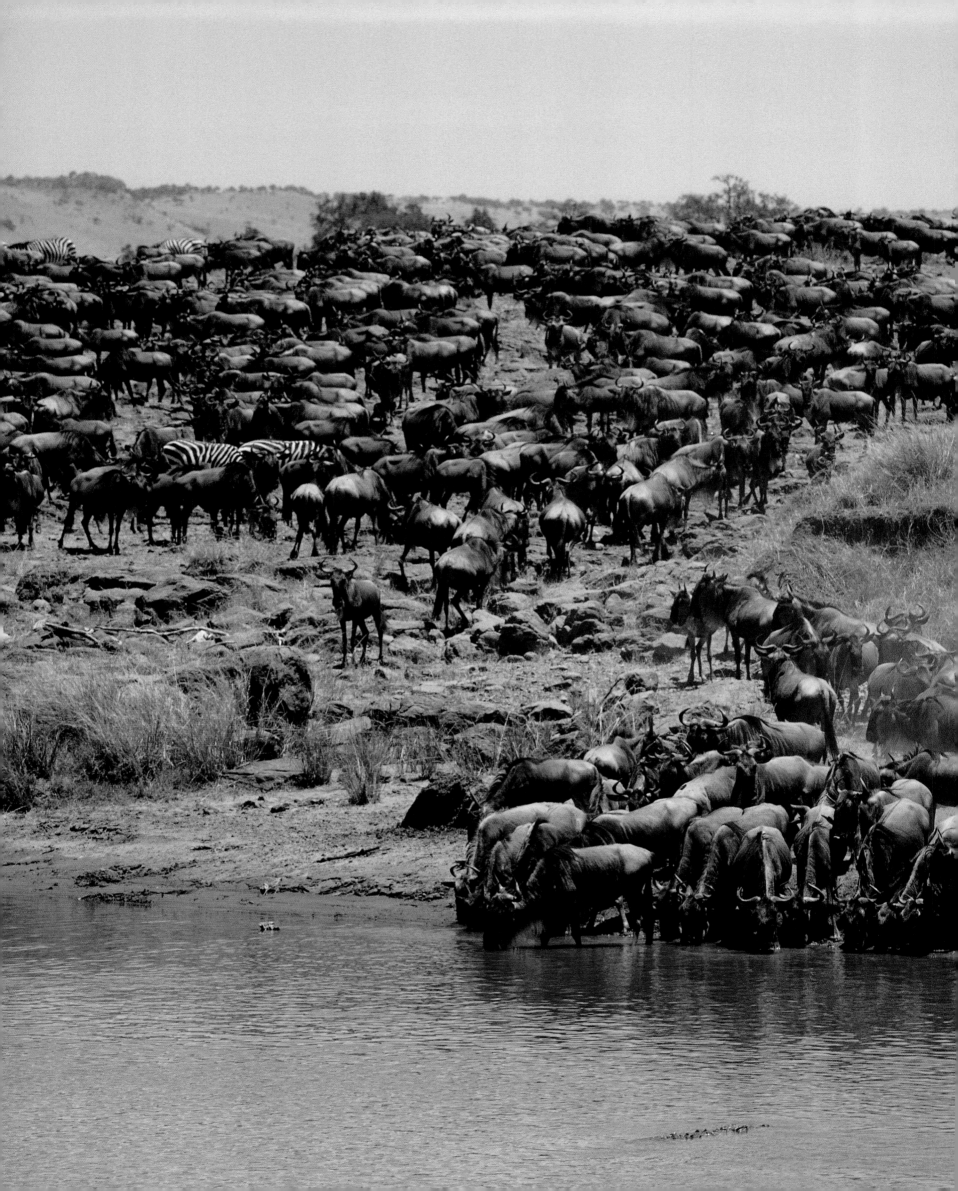

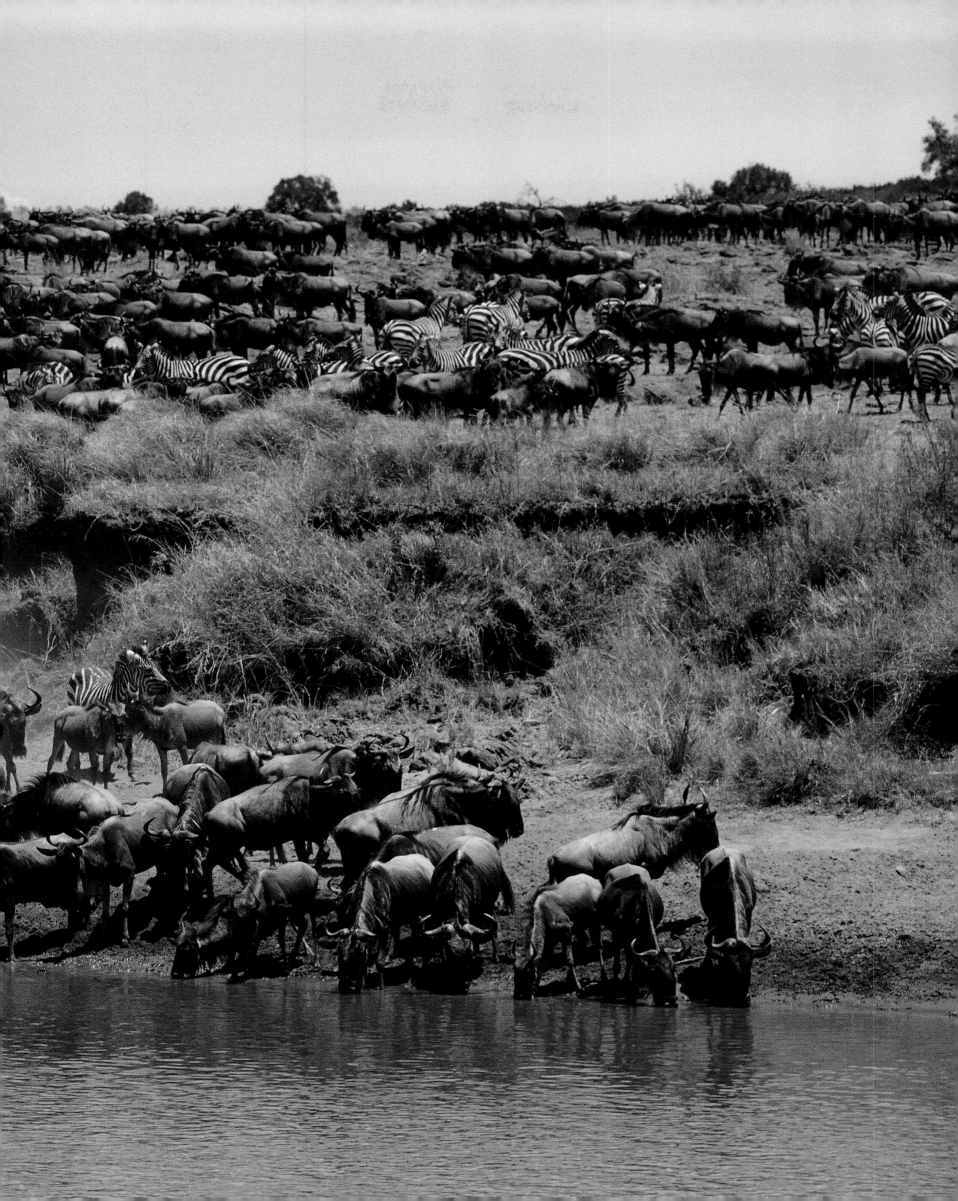

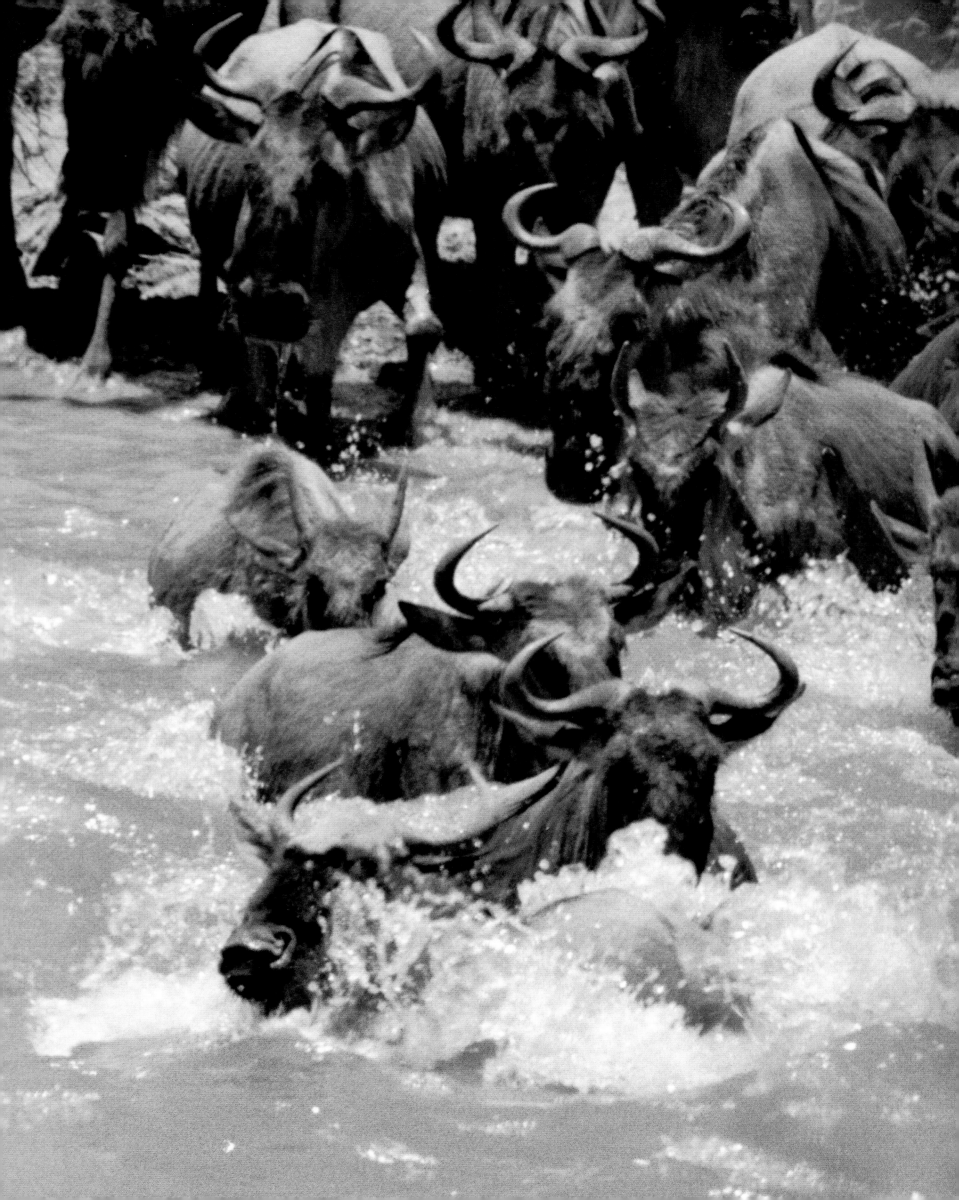

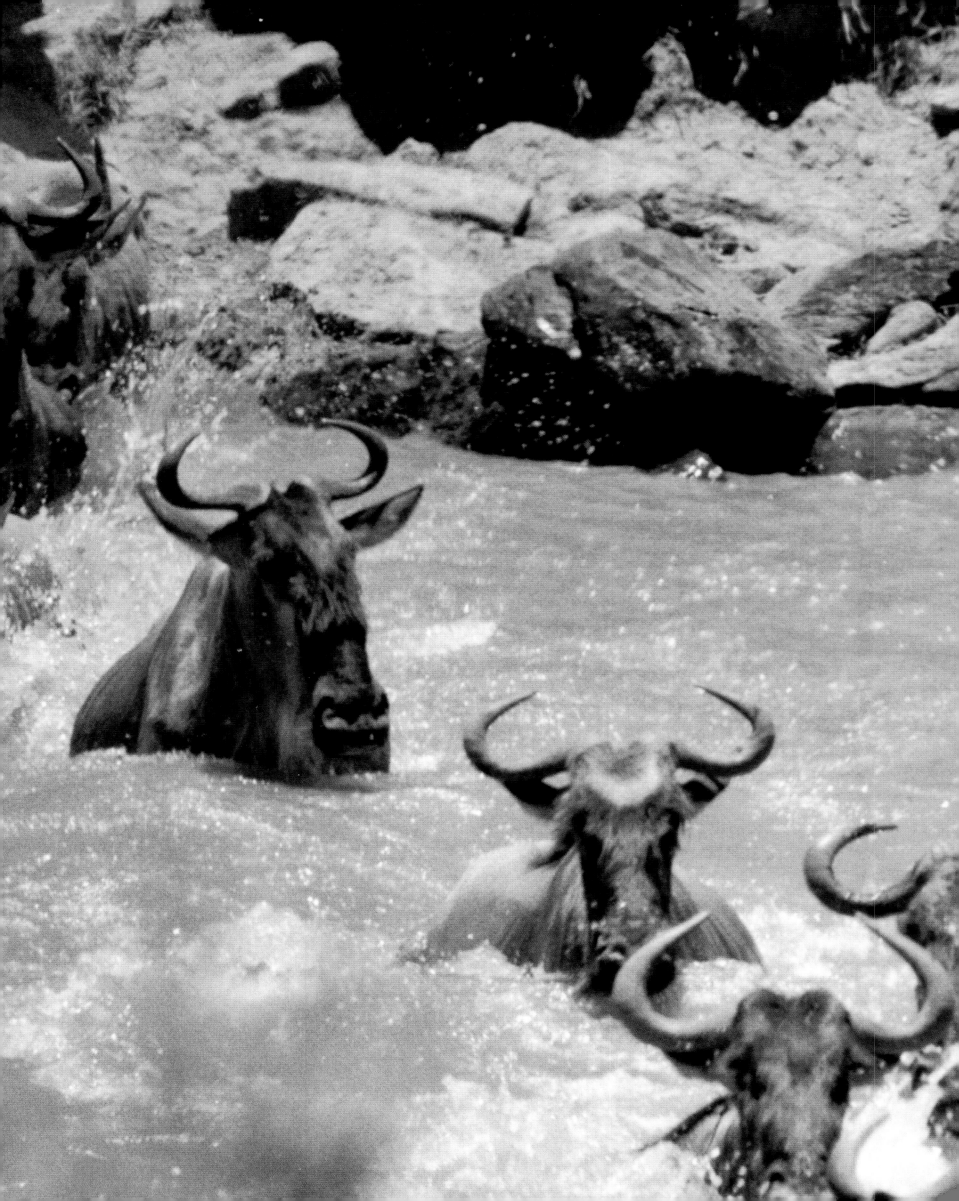

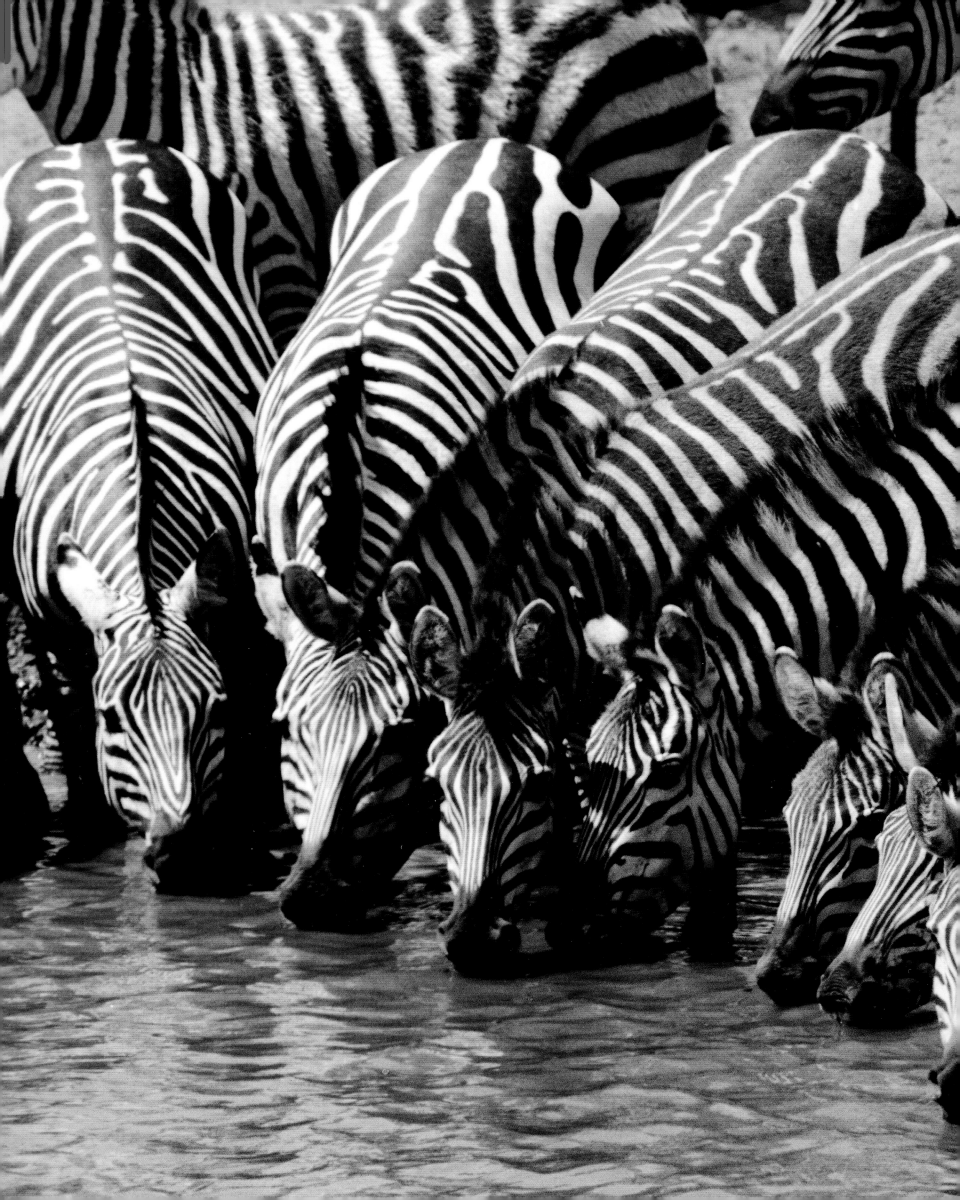

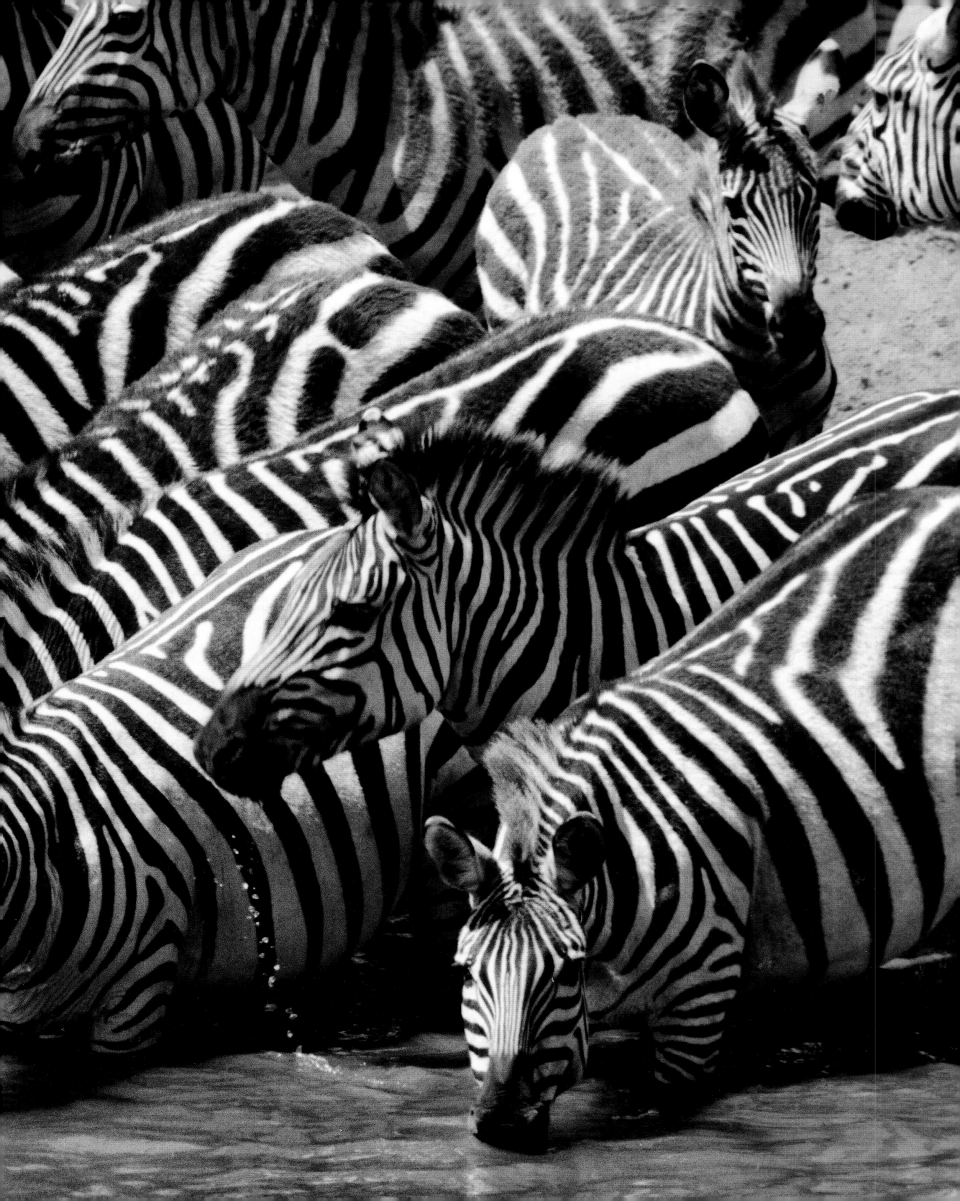

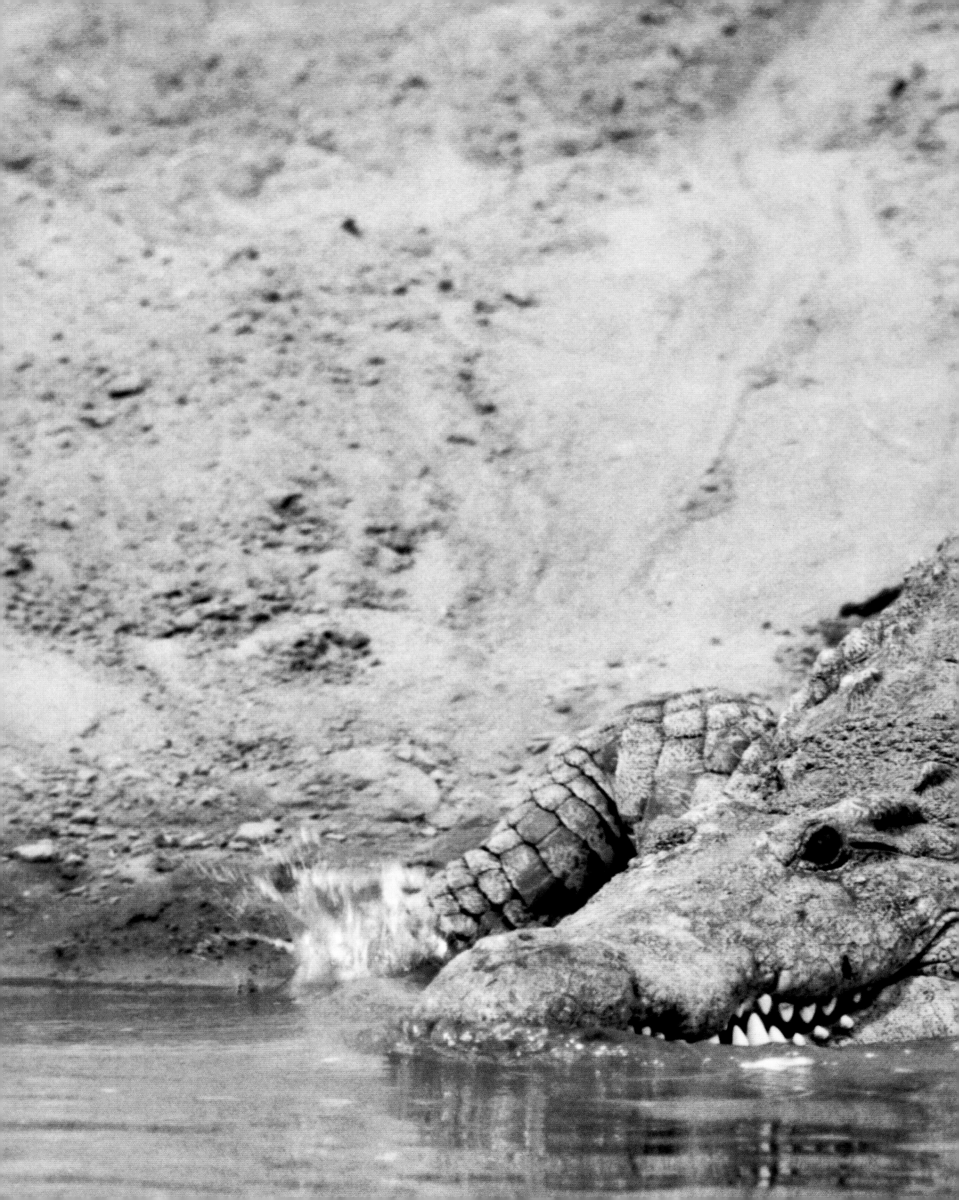

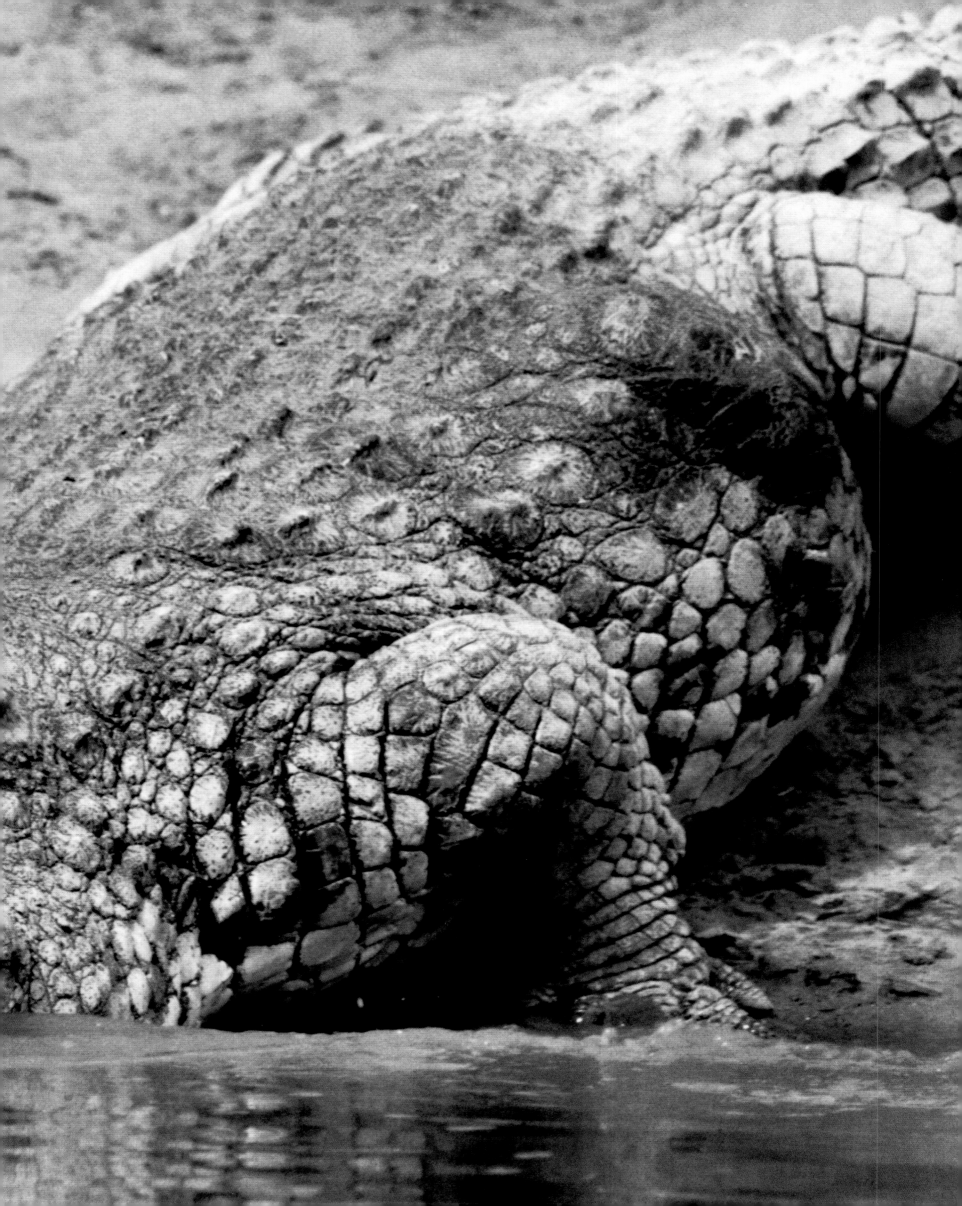

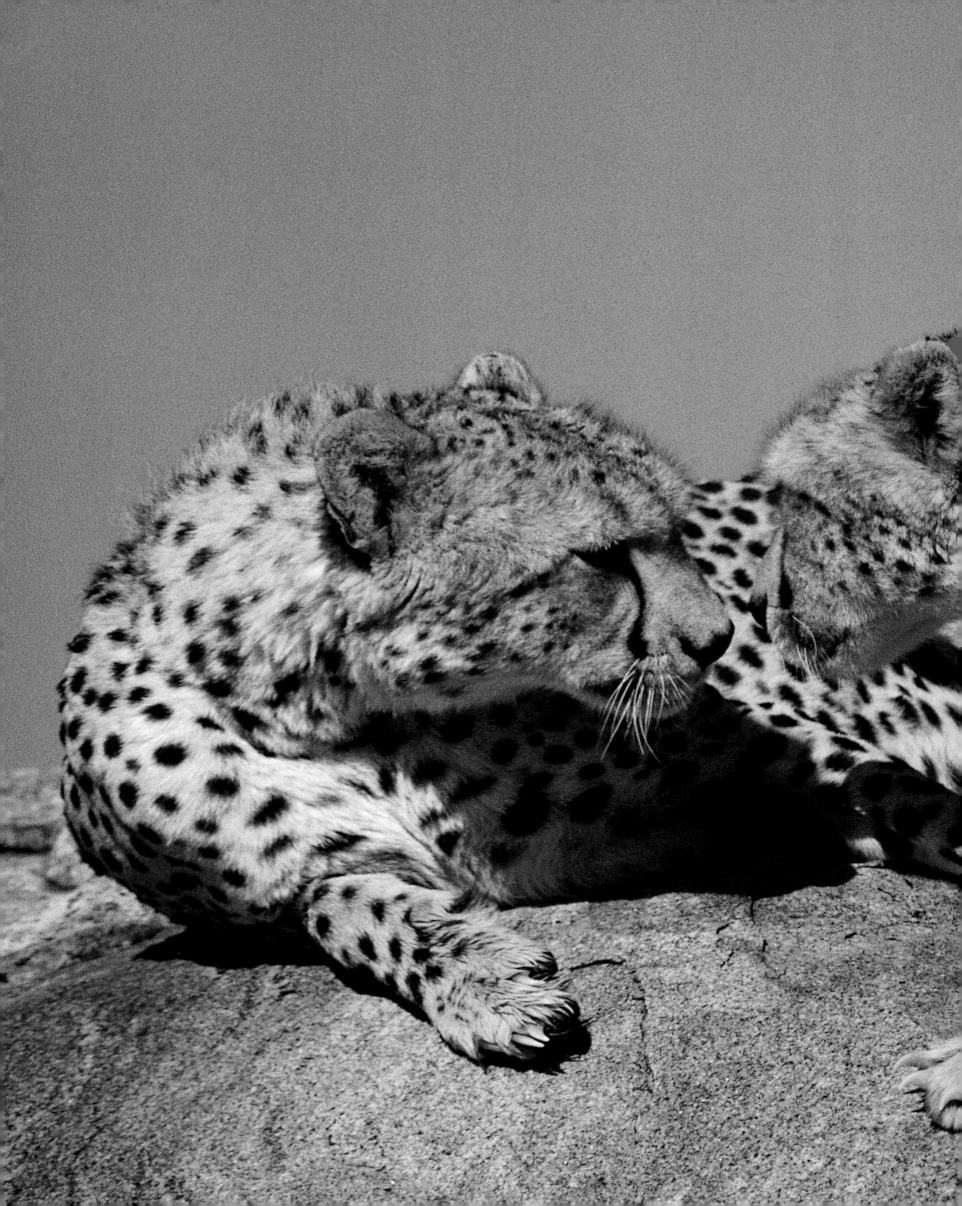

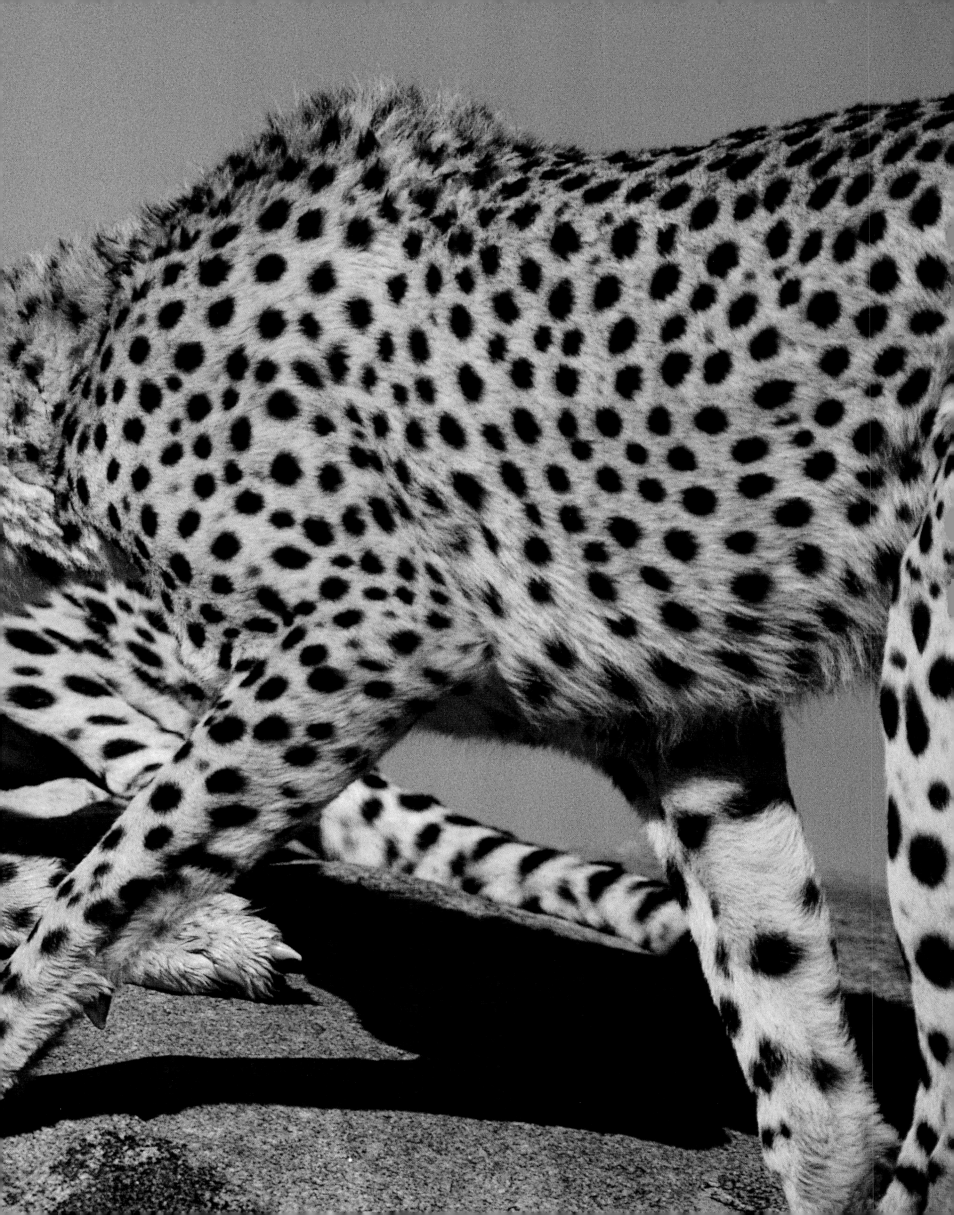

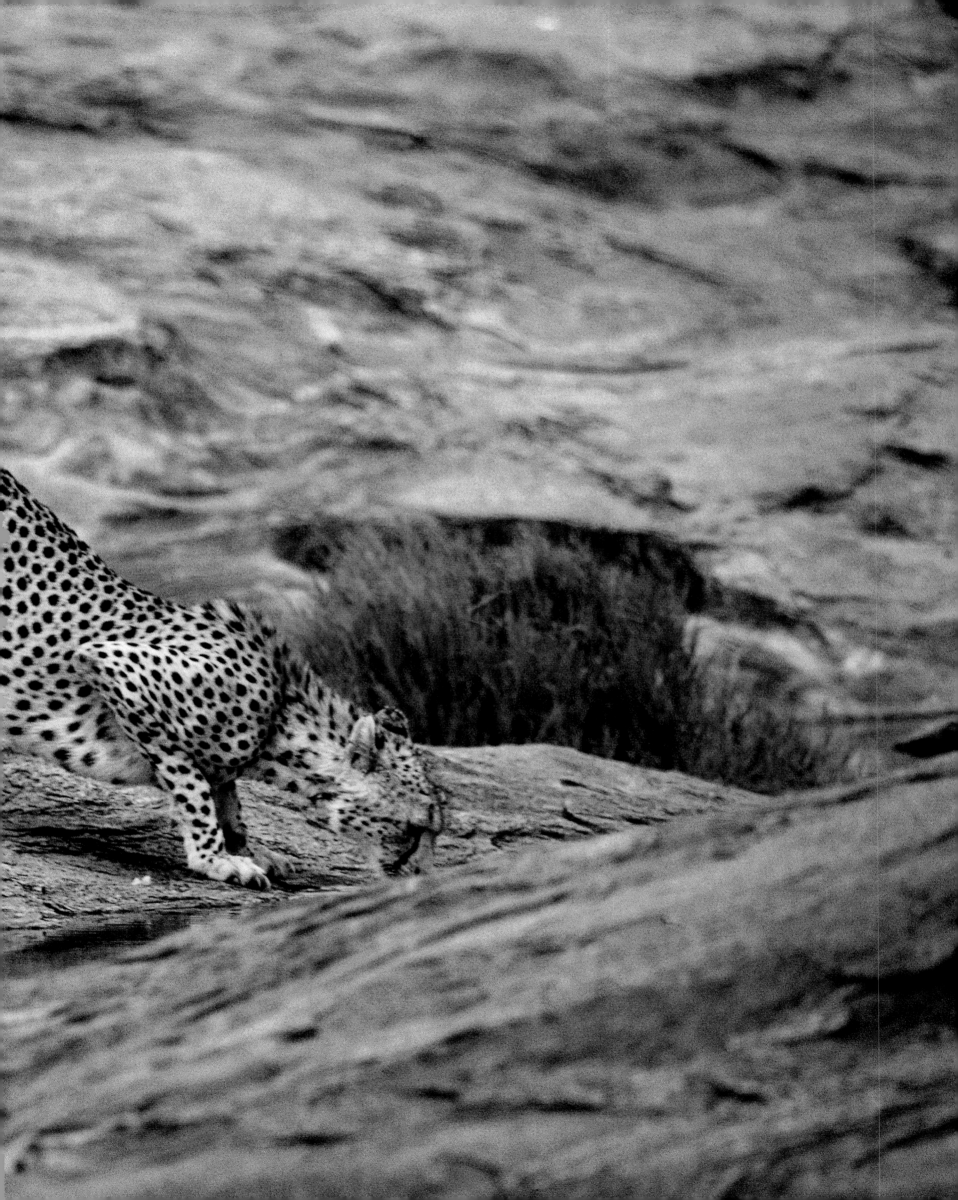

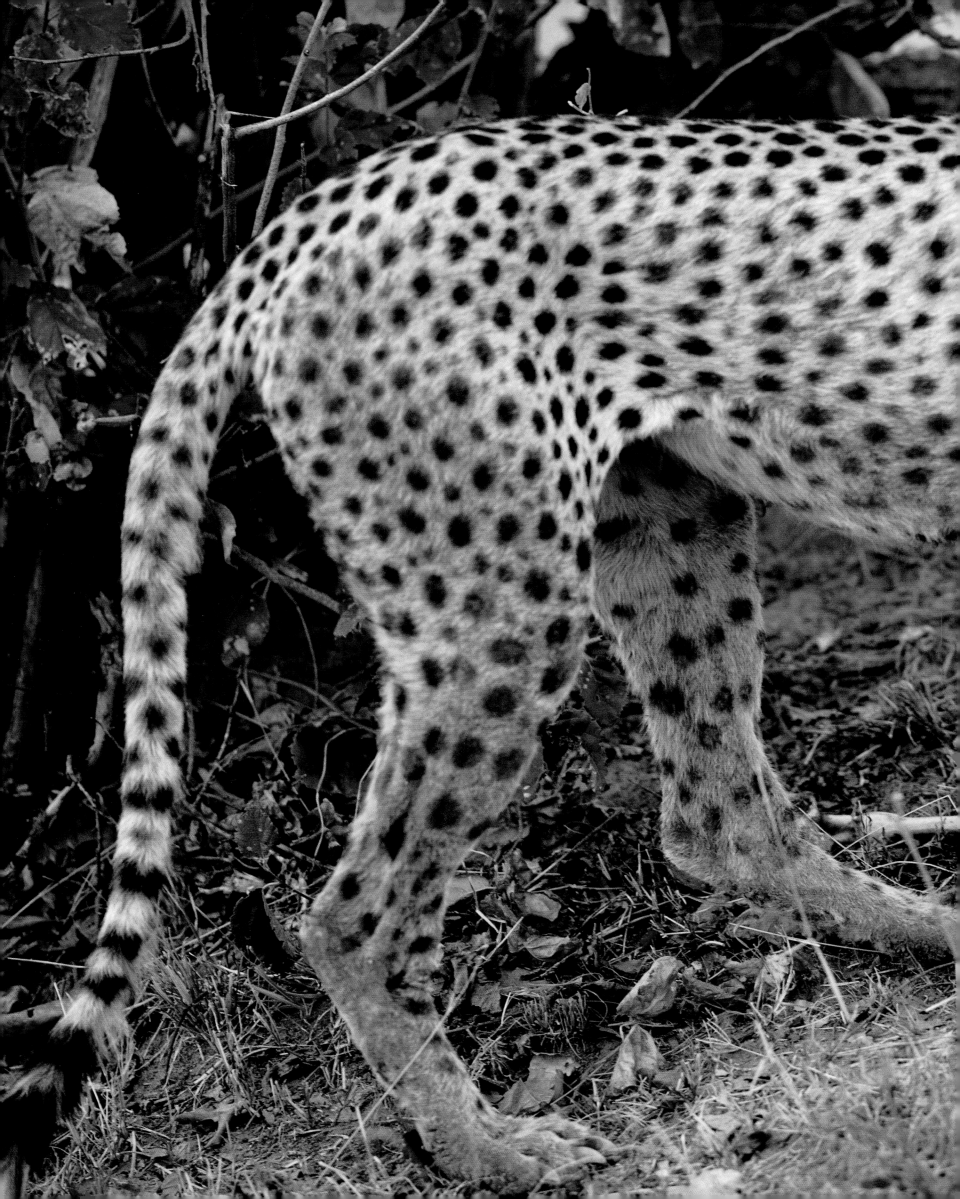

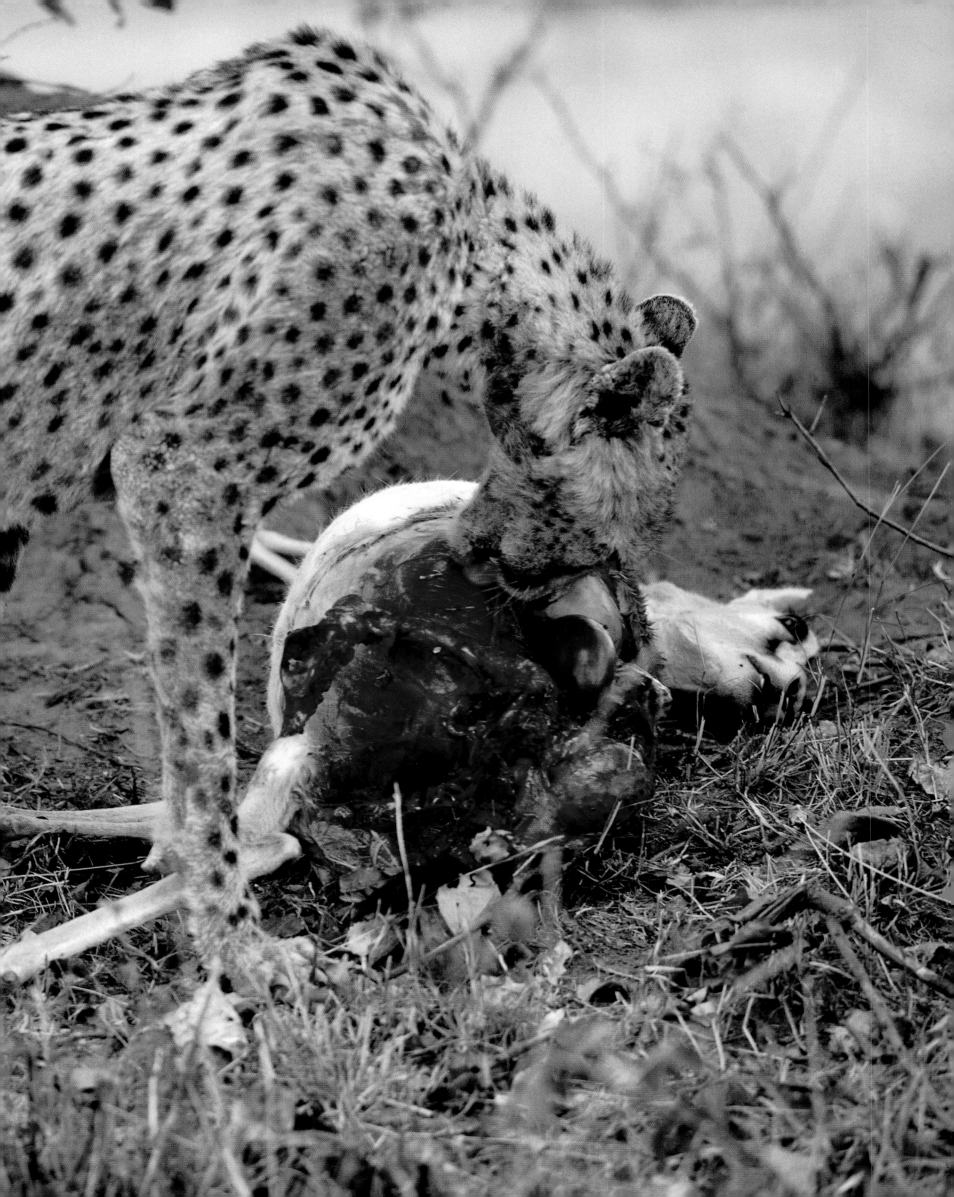

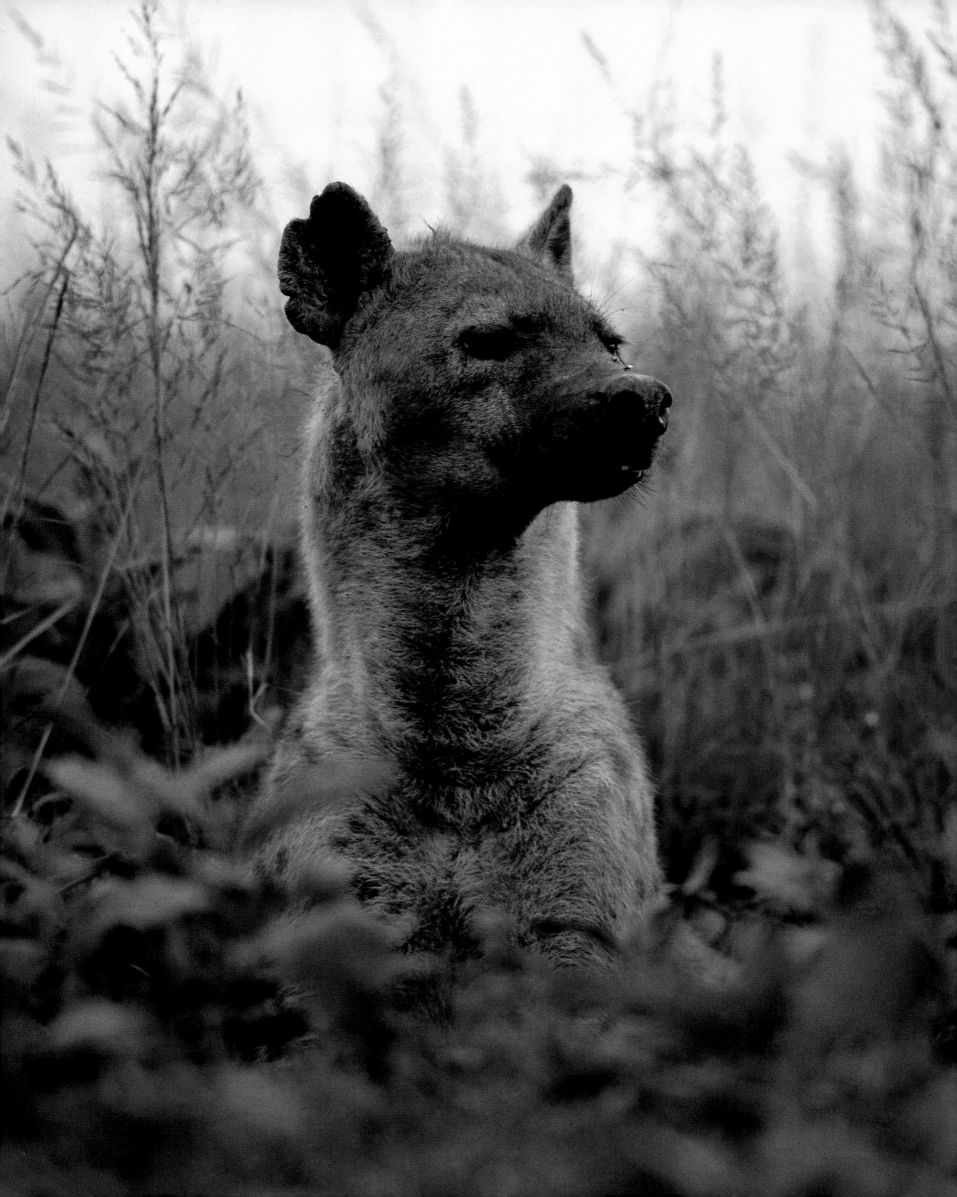

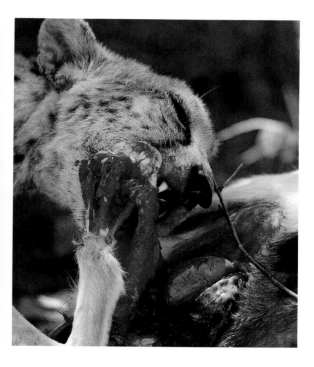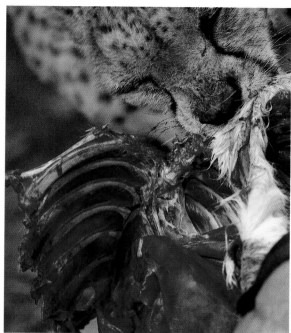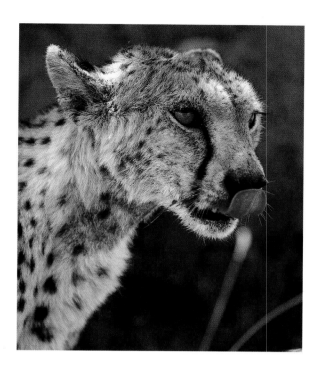

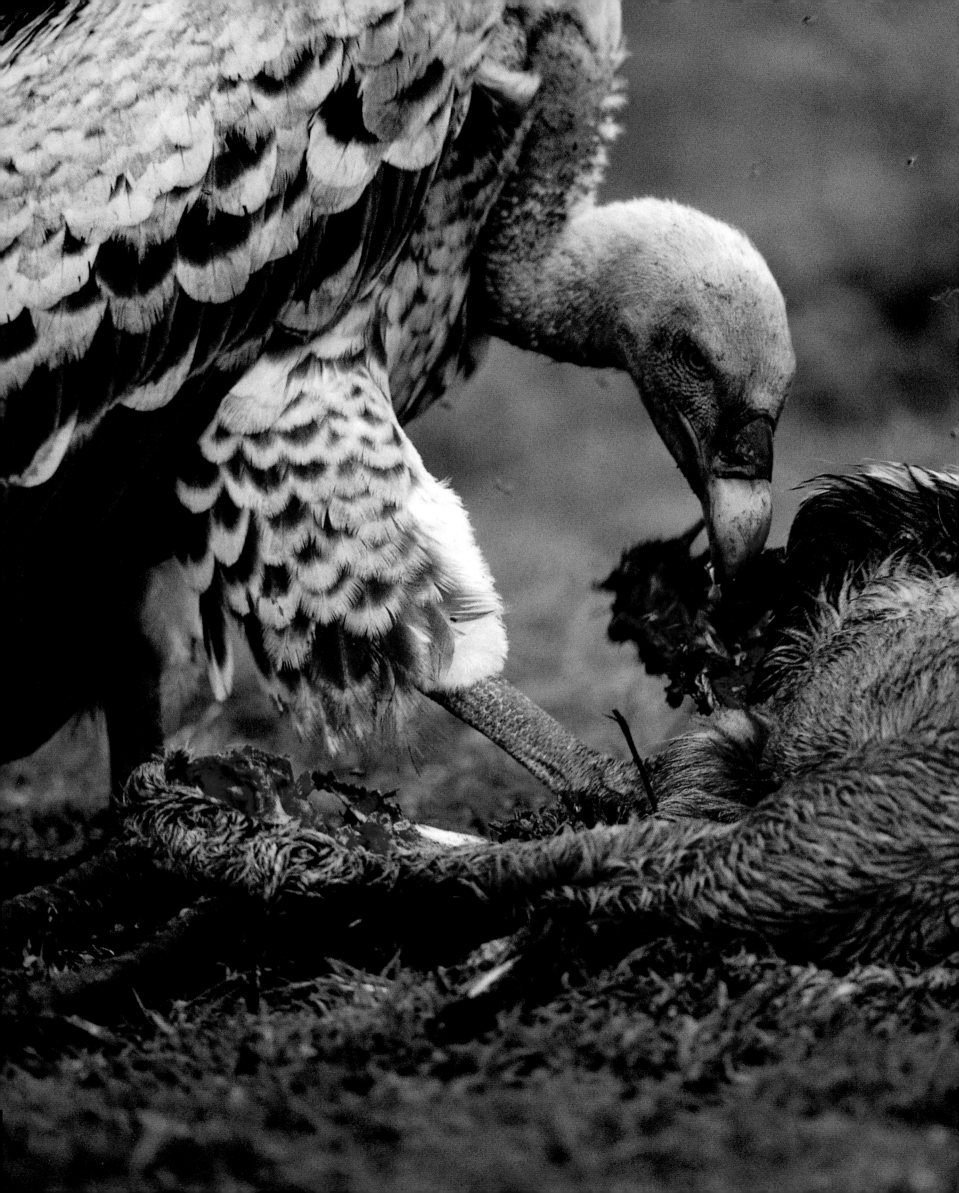

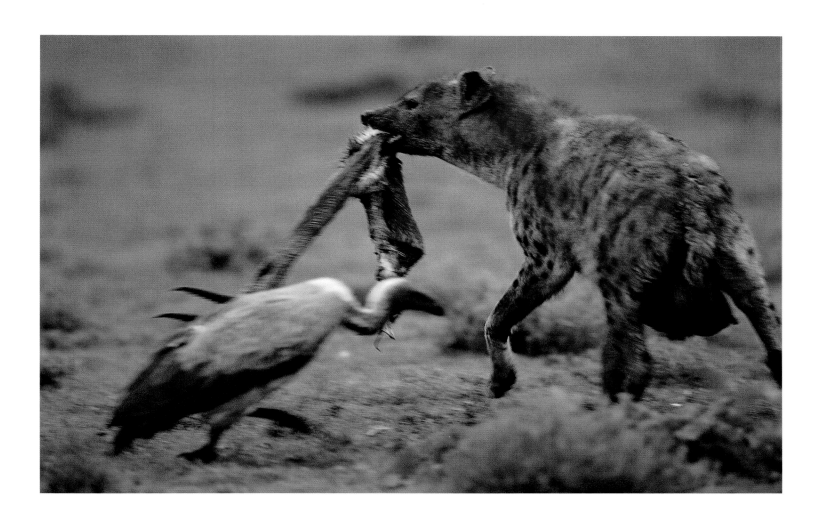

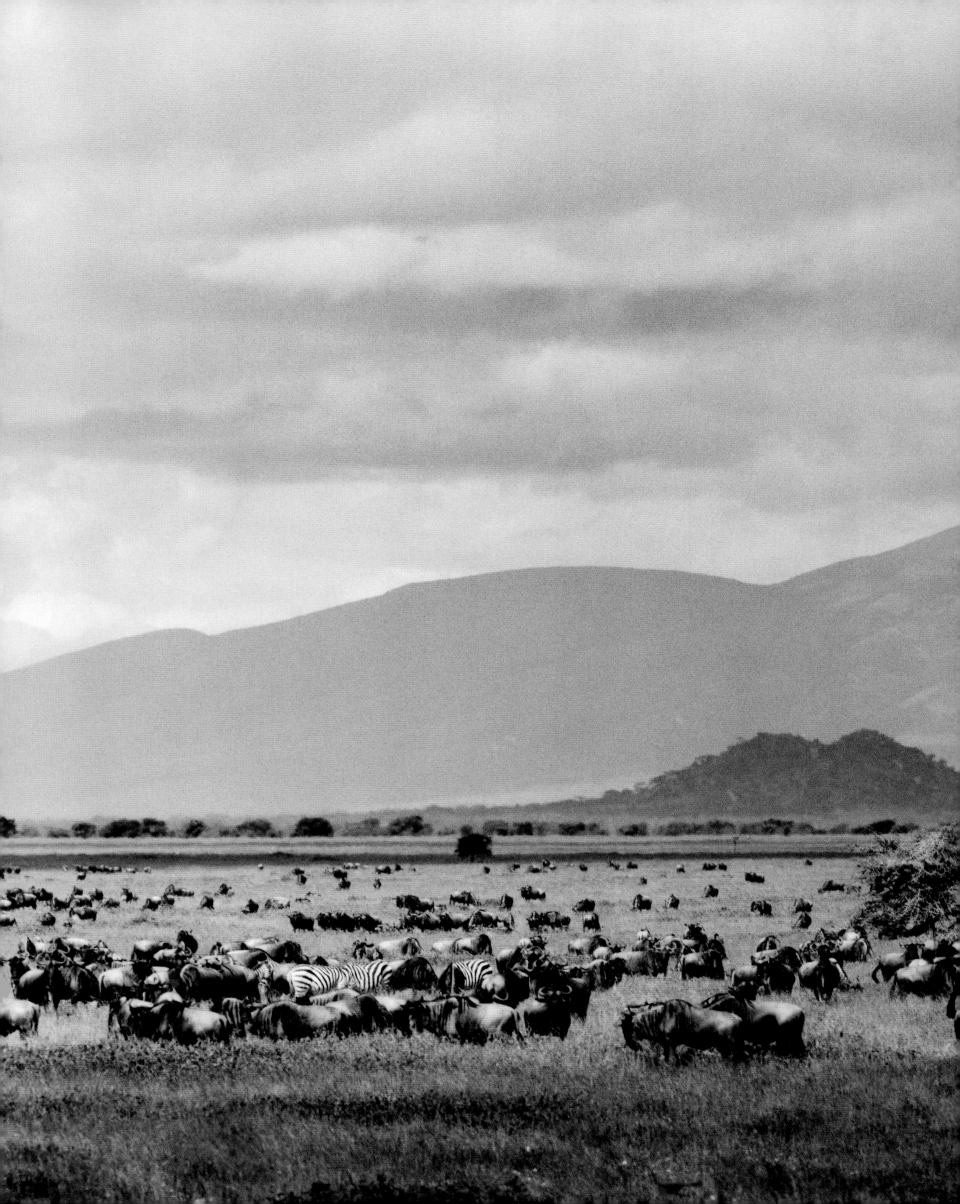

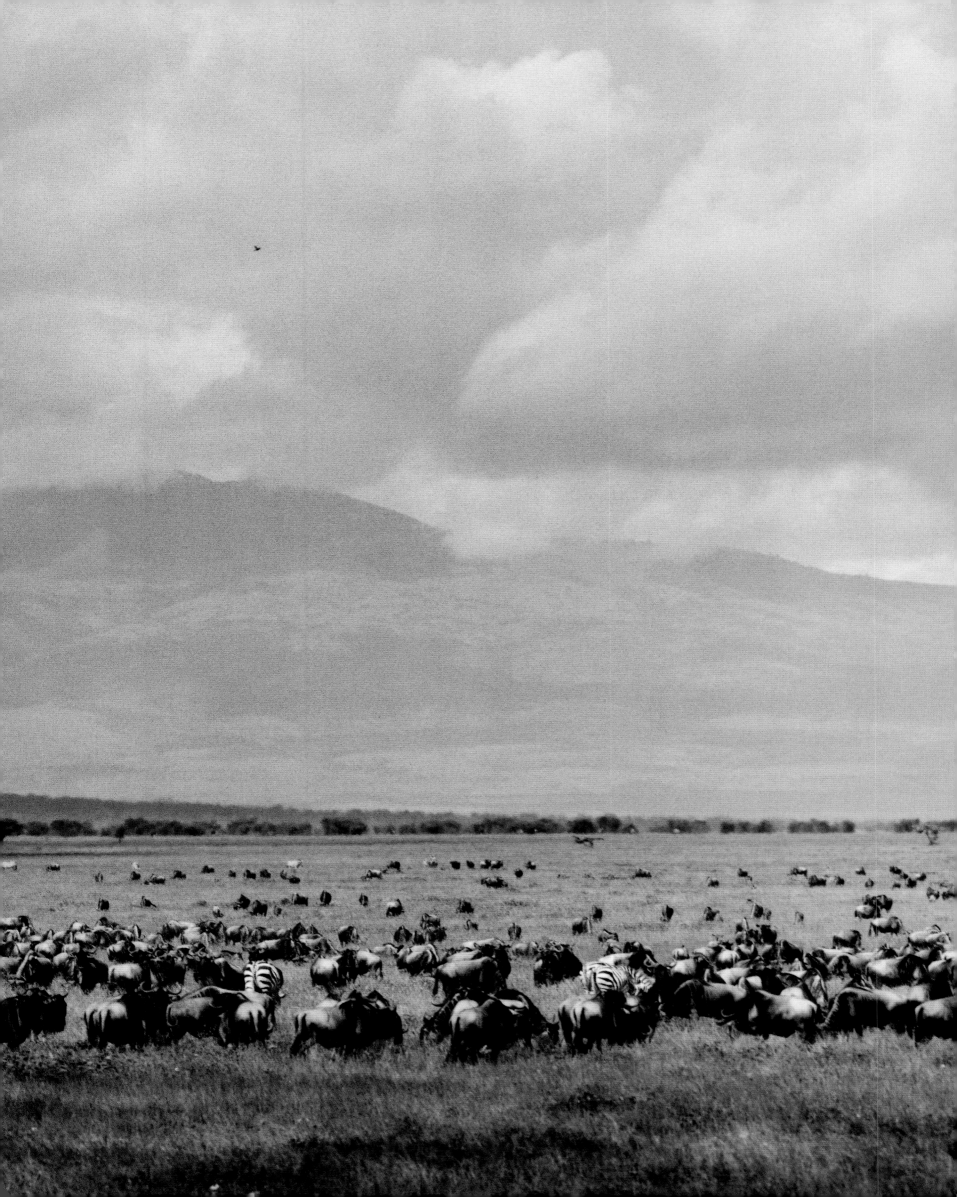

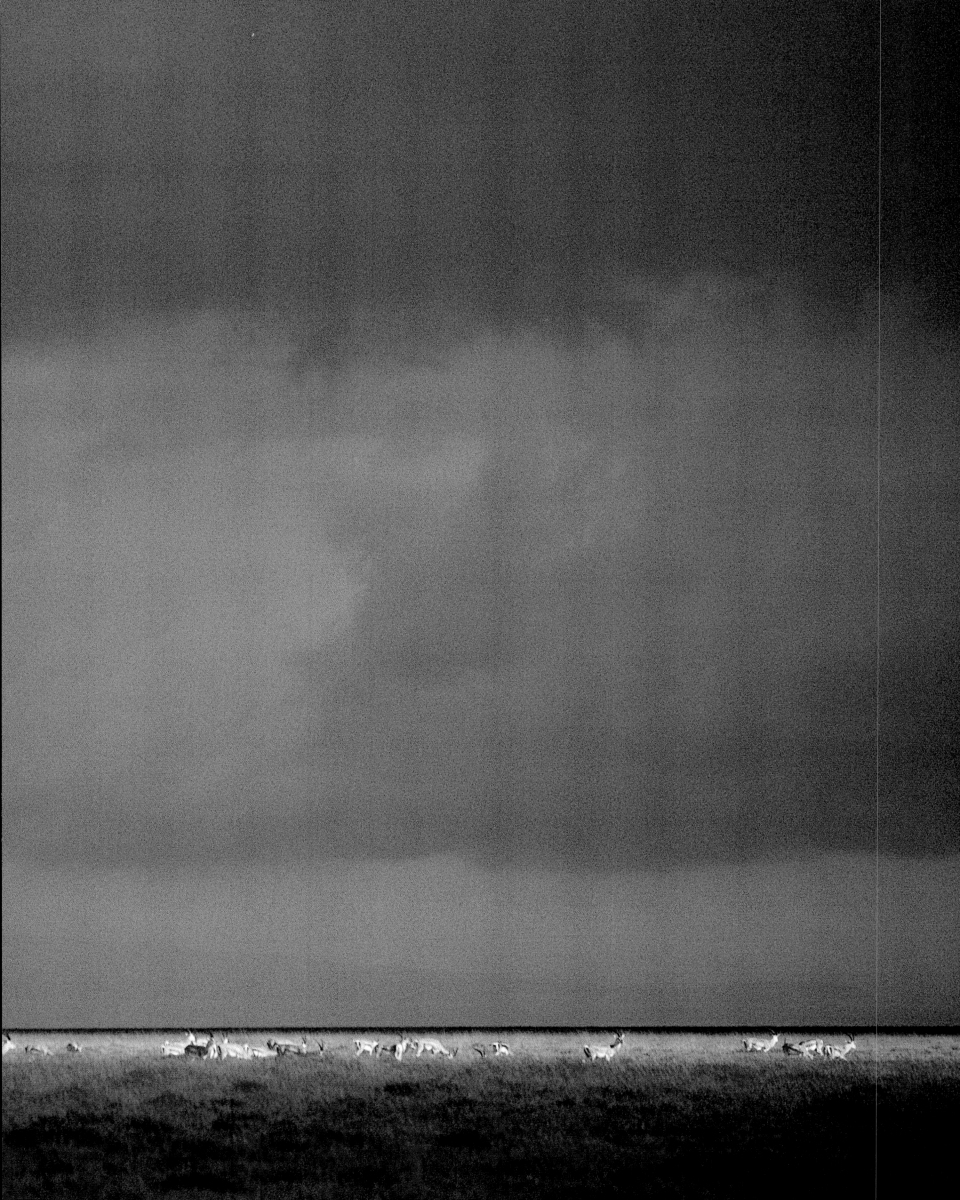

Carlo Mari
A FEW WORDS ON PHOTOGRAPHIC EQUIPMENT

I don't just take my cameras on long journeys, I carry them around every day, but I don't see them as an extension of my eyes, and I don't prefer any one particular type or make. They have to be practical, and help me to express my feelings as well as possible. I work with almost all film formats and often use them side by side during a single project. The right camera with the ideal format and the right lens at the right moment: that leaves my mind free to concentrate on the creative aspect of my work.

The photographic equipment I cart around with me in sturdy aluminium cases on my trips to Africa must weigh a few hundred kilos, to say nothing about the dozens of kilos of film stock. But never mind, I'm an exception. One camera body and two suitable lenses are often enough to take good photographs.

For wildlife photography I prefer the 35 mm format, 24×36 mm with long telephoto lenses with focal lengths of 600 millimetres f4 or 800 millimetres f5, f6, of course with autofocus and a motorized body. A motor can be a godsend, especially with moving subjects. In cases like this, automatic exposure can help as well, but I use this only when necessary, otherwise it's best to measure the exposure by hand.

With shorter focal lengths I use the medium 4.5×6 or 6×7 millimetre formats for the best possible picture quality and better detail in the shadows. I think good definition in shadows is very important, as our eyes tend to look for detail there, rather than in light areas.

With the 4.5×6 millimetre camera I use a super wide-angle lens with a focal length of 35 millimetres, a normal 80 millimetre lens and medium (140 and 210 millimetre) and long (350 to 500 millimetre) telephoto lenses.

For landscapes, panoramas and aerial photographs I use a 6×7 coupled rangefinder camera with a 45 millimetre wide-angle lens and a short focal length of 85 millimetres.

When I want to take special close-ups of animals in their natural habitats I opt for a motorized 35 mm camera, with – if the situation requires it – radio- or infrared-control. In particularly difficult cases I have used a remote shutter release connected to the camera with a cable running through the grass. This 35 mm camera has an 18 millimetre super-wide-angle lens with great depth of field, ensuring extremely high-definition images.

313

The light on the equator makes particular demands. The problem is that the sun moves very quickly and is at its zenith just a few hours after rising, so that the colour temperatures rise to over 10,000 degrees kelvin. Most daylight films are intended for a colour temperature of 5200 degrees kelvin. For this reason it is essential to mount colour correction filters (KR3 and KR6) on the lenses. This is the only way of achieving natural colours with normal developing processes.

In order to be able to make out maximum detail even with considerable enlargement, fine-grain transparency film is needed, with a medium to low speed of ISO 100 to 50.

Things are not quite as difficult when using black-and-white film. But in this case, too, it is best to take photographs in the early morning and late afternoon, when the sun is lower and not blazing down vertically and creating ugly shadows.

Moreover my film stock is always kept in suitable containers to protect it from the searing sun and other possible damage, and never stored in hot rooms, so that there will be no unpleasant surprises later, when it is developed.

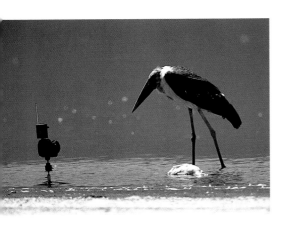
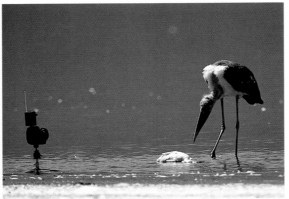
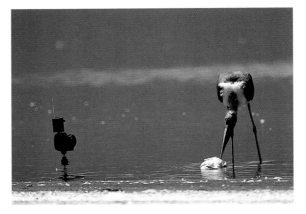

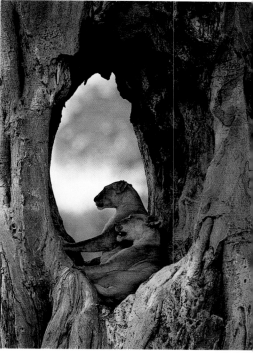

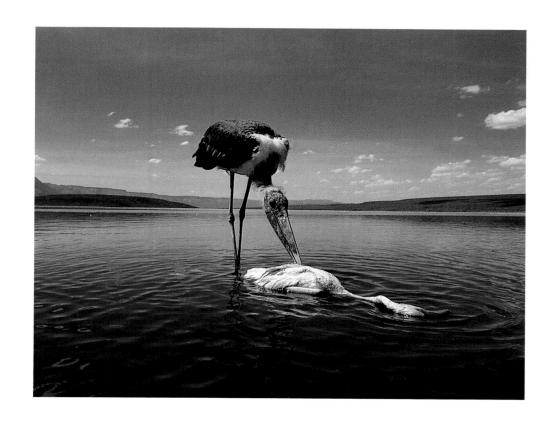

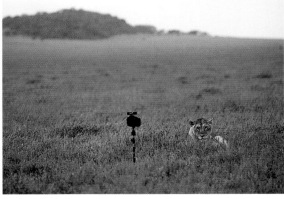

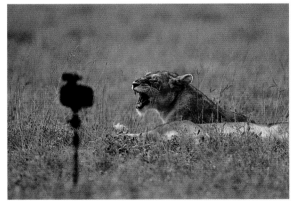

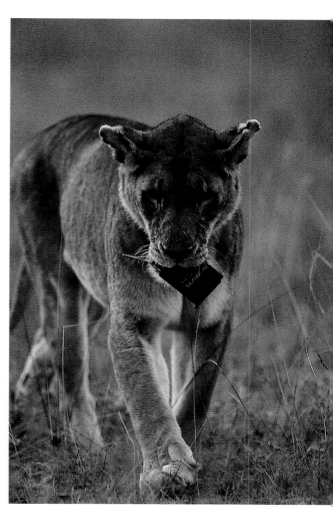

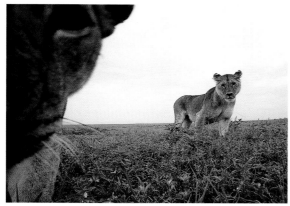

FACTS & FIGURES
ETHNIC GROUPS

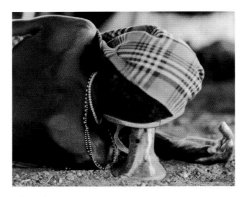

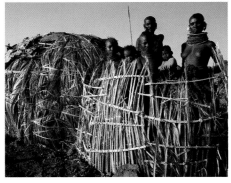

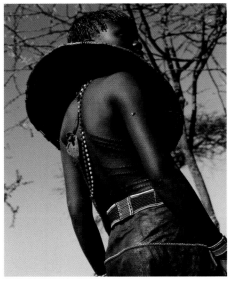

El Molo

Population: approx. 4000 (1994); one of the smallest ethnic groups in Kenya

Alternative names: Elmolo, Fura-Pawa, Ldes, Dehes, "Ndorobo"

Settlement area: near the Ethiopian border in northern Kenya (south-eastern end of Lake Turkana [formerly Lake Rudolf], Elmolo Bay, Marsabit District, Eastern Province)

Natural surroundings: semi-desert on the bare shore of Lake Turkana, volcanic islands

Predominant mode of life and subsistence economy: settled inland fishermen and crocodile hunters

Religion: traditional religion, Christianity

Language: El Molo (Cushitic language family); only 8 surviving El Molo speakers, all over 50 years old (1994); the overwhelming majority now speaks Samburu

Literacy: no statistics; one primary school from 1986

Note: they scarcely exist as an ethnic group any longer as their language has almost died out and their culture has become very similar to that of the Samburu

Turkana

Population: 340,000 (1994)

Alternative names: Bume, Buma, Turkwana

Settlement area: north-western Kenya and from lake Turkana to the Ugandan border (Turkana, Samburu, Trans-Nzoia, Laikipia and Isiolo Districts, Rift Valley Province, to the west and south of Lake Turkana and the Turkwel and Kerio Rivers)

Natural surroundings: semi-desert region in the lowland plains

Predominant mode of life and subsistence economy: nomadic herdsmen (cattle, camels, goats, sheep) and fishermen

Language: Turkana (Nilotic language family); most Turkana are monolingual, only a few can speak Swahili, Pokot or Daasenech

Religion: traditional religion, Christianity

Literacy: 25–50 %

Note: many armed conflicts with the Karamojong and the Pokot (arch-enemy); friendly relations with the Jie

Pokot

Population: 264,000 (1994); other Pokot in Uganda (statistically insignificant)

Alternative names: Suk, Pakot

Settlement area: western Kenya (and in eastern Uganda); Baringo and West Pokot District, Rift Valley Province

Natural surroundings: dry savannah in the lowland plains

Predominant mode of life and subsistence economy: semi-nomadic herdsmen (cattle, sheep, goats), field cultivation and honey products in some districts

Religion: traditional religion, Christianity

Language: Pokot (Nilotic language family)

Literacy: 15–25 %

Note: still live very traditionally

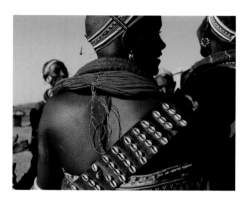

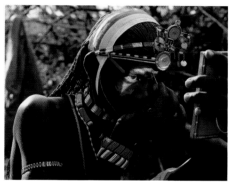

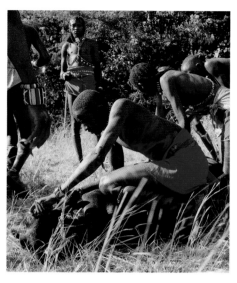

Rendille

Population: approx. 32,000 (1994)
Alternative names: Rendile, Randile
Settlement area: northern Kenya; Marsabit District, between Lake Turkana and Marsabit Mountain, Eastern Province
Natural surroundings: lowland semi-desert
Predominant mode of life and subsistence economy: nomadic herdsmen (camels, sheep, goats, cattle), increasingly settled since droughts in the 1970s
Religion: traditional religion, Islam, Christianity
Language: Rendille (Cushitic language family)
Literacy: 5−15 %

Samburu

Population: 128,000 (1994); also live in Tanzania
Alternative names: Sambur, Sampur, Burkeneji, Lokop, E Lokop, Nkutuk
Settlement area: eastern Kenya; Samburu District, and southern and eastern ends of Lake Baringo, Baringo District
Natural surroundings: semi-desert
Predominant mode of life and subsistence economy: semi-nomadic lifestyle, herdsmen (cattle, goats, sheep)
Religion: traditional religion, Christianity
Language: Samburu (Maa language; Nilotic language family)
Literacy: 15−25 %
Note: closely linked with the Maasai linguistically and culturally, also much intermarriage. The great drought of 2001 destroyed a large number of the Samburu's cattle

Maasai (Tanzania)

Population: 430,000 (0.6 % of the national population); an additional 453,000 live in Kenya (there 1.5 % of the national population) (1994)
Alternative names: Maasai, Maa, Lumbwa
Settlement area: northern Tanzania (and southern Kenya)
Natural surroundings: dry savannah in the highland plains
Predominant mode of life and subsistence economy: semi-nomadic herdsmen (cattle, sheep, goats), some groups are farmers
Religion: traditional religion, Christianity
Language: Maa language (Nilotic language family); majority bilingual (Swahili)
Literacy: no statistics
Note: the Maasai culture in Tanzania tends to be more traditional than that of the Kenyan groups

COUNTRIES

Kenya

Official name: Jamhuri ya Kenya (Swahili); English: Republic of Kenya
Population: approx. 31.5 million (2002)
Area: 582,646 sq km
Adjacent countries and territories: Sudan and Ethiopia to the north; Somalia and the Indian Ocean to the east; Tanzania to the south; and Uganda and Lake Victoria to the west. The region of north-western Kenya known as the Ilemi Triangle is subject to a claim by the Republic of Sudan
State system: republic with multi-party system
Independence: 1963; member of the British Commonwealth
President: Mwai Kibaki (December 2002)
Population distribution: almost 99% African, 1% Asian (mainly Indian), Europeans and Arabs

Ethnic distribution: 42 groups, the largest of which are the Kikuyu (22%), Luhya (14%), Luo (13%), Kalenjin (11%), Kamba (11%)
Average population density: 53 inhabitants per sq km
Average life expectancy: 47 years (2002)
Annual population growth: 3.6%
Urbanization: 33%
Major cities (2002): Nairobi (capital, pop. 2.3 million), Mombasa (most important port, pop. 465,000), Kisumu (port on Lake Victoria, pop. 185,000)
Highest elevation: Mount Kenya (5199 m)
Climate: hot (except in highlands) and relatively dry in the north; wet in the south on the coast; moderate in the highlands; and tropical around Lake Victoria
Languages: 4 language families: Bantu (e.g. Swahili, Kikuyu, Luhya, Kamba), Nilotic

(e.g. Luo), semi-Nilotic (e.g. Kalenjin, Maasai) and Cushitic (e.g. Rendille)
Official languages and lingua franca: Swahili, English
Religions (estimated): 38% Protestant, 28% Roman Catholic, 26% native religions, 7% Muslim, 1% other
Education and schooling: compulsory schooling from the age of 8; 5 higher education institutions
Literacy: 78.1%
Chief industries: agriculture, forestry and fishing
Chief exports: tea, coffee, petrochemical products, pineapple preserves, furs and hides, cement, sisal, soda and pyrethrum
Chief source of foreign currency: tourism (approx. 700,000 tourists a year; the most popular safari country in the world)
Currency: 1 Kenyan shilling = 100 cents

Tanzania

Official name: Jamhuri ya Muungano wa Tanzania (Swahili); English: United Republic of Tanzania; the name was formed from Tanganyika and Zanzibar, the two formerly separate, independent countries that it comprises
Population: 37.2 million (2002)
Area: 945,100 sq km, of which 942,626 sq km mainland; Zanzibar, Pemba and other islands in the Indian Ocean
Adjacent countries and territories: Lake Victoria and Uganda to the north; Kenya to the north-east; Indian Ocean to the east; Mozambique, Lake Malawi and Malawi to the south; Zambia to the south-west; Democratic Republic of Congo to the west (border Lake Tanganyika), as well as Burundi and Rwanda
State system: republic with multi-party system
Independence: 1961 (Tanganyika), 1964; member of the British Commonwealth
President: Benjamin William Mkapa
Population distribution: over 90% African, 10% Asian (mainly Indian), Pakistani, a small Arab population and Europeans
Ethnic groups: 120, the largest of which are the Sukuma, Nyamwezi, Haya, Ngonde and Chaga
Average population density: 39 inhabitants per sq km
Average life expectancy: 51.7 years
Annual population growth: 2.14%

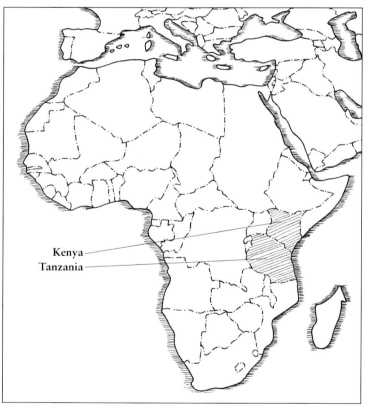

Kenya
Tanzania

Urbanization: 24%
Major cities: Dar es Salaam (most important port and industrial centre, pop. greater city area approx. 1.8 million), Mwanza (most important inland port, pop. approx. 233,000), Dodoma (capital, pop. approx. 203,833)
Highest elevation: Mount Kilimanjaro (5895 m), the highest in Africa
Climate: coastal plain: tropical and hot; high inland plain: hot and arid; islands: tropical
Languages and language families: Bantu (e.g. Swahili), para-Nilotic (e.g. Maasai)
Official languages and lingua franca: Swahili, English
Religions (estimated): approx. 33% Christian (mainly Roman Catholic, also Anglican and Lutheran), approx. 32% Muslim, approx. 32% traditional religions, approx. 3% Hindu
Education and schooling: compulsory schooling from the age of 8; 2 universities
Literacy: 91.8%
Chief industries: agriculture, forestry, fishing
Chief exports: coffee, cotton, sisal, cloves, tea, tobacco, cashew nuts
Chief source of foreign currency: tourism (approx. 459,000 tourists a year), food exports
Currency: 1 Tanzanian shilling = 100 cents
Notable features: one of the poorest countries in the world

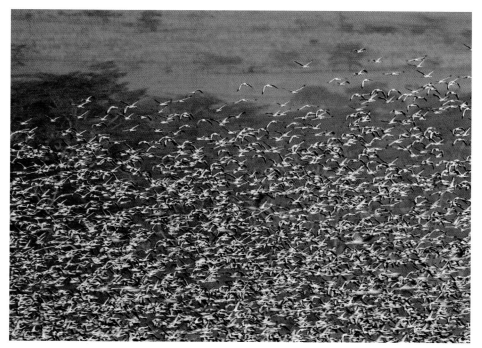

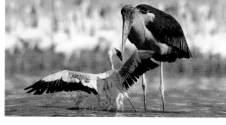

Marabou
(*Leptoptilus crumeniferus*; pages 122–25, 155, 314–15)
Family: Storks, Ciconiidae
Order: Ciconiiformes
Class: Birds, Aves
Habitat: Savannahs in tropical Africa
Mode of life: Giant stork, feeding mainly on carrion, but also on small vertebrates, fish and insects. As in the case of the vulture, the head and neck are bare with the exception of a little down; thus the marabou can plunge its powerful beak into the corpse of a large animal without getting blood on its feathers.

Lesser flamingo
(*Phoenicopterus minor*; pages 6–7, 116–23, 128–29, 139–42)
Family: Flamingos, Phoenicopteridae
Order: Phoenicopteriformes
Class: Birds, Aves
Habitat: Shallow inland watercourses, often with salty or brackish water
Mode of life: Sieves its food (entomostraca, algae, unicellular organisms) out of the water with its beak, which has been adapted as a filtering device. The female builds a nest of mud, stones and grass a few days before laying eggs.

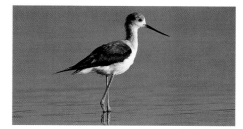

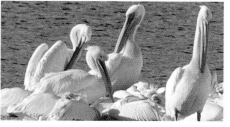

Black-winged stilt
(*Himantopus himantopus*; page 154)
Family: Recurvirostridae
Order: Charadriiformes
Class: Birds, Aves
Habitat: Tropical and subtropical wetlands
Mode of life: Migratory bird, just a winter visitor in tropical Africa. With its long legs it is able to stalk through shallow water of salt marshes and lagoons in the grass savannah, looking for water insects, molluscs and crustaceans, tadpoles and small fish. Has appeared more frequently in both southern and central Europe in recent years.

Great white pelican
(*Pelecanus onocrotalus*; pages 132–33, 154)
Family: Pelicans, Pelicanidae
Order: Pelicaniformes
Class: Birds, Aves
Habitat: Wetlands, large bodies of water, coast
Mode of life: Its wing-span of 2.5 m makes it one of the largest flying birds. The elastic throat pouch serves both as a scoop when gathering food and as a means of transporting it. The great white pelicans are highly gregarious creatures and frequently catch their prey together by forming a long chain, often including up to 100 birds, then swimming to the bank flapping their wings noisily, thus driving the shoals of fish close to the bank, where they can be scooped up.

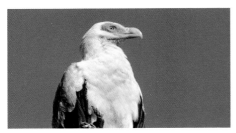

Palm-nut vulture – old bird
(*Gypohierax angolensis*; page 146)
Family: Accipitridae
Order: Accipitriformes
Class: Birds, Aves
Habitat: Rain forests, mangrove swamps and coastal areas in West, South and East Africa
Mode of life: Unlike other vultures, does not eat carrion; lives on the fruit of oil and raffia palms. It occasionally also hunts birds, small animals and fish, which along with its white plumage has earned its alternative name, "African fish eagle".

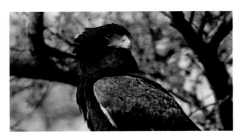

Bateleur eagle – old female bird
(*Terathopius ecaudatus*; page 147)
Family: Accipitridae
Order: Falconiformes
Class: Birds, Aves
Habitat: Semi-desert, savannah, open woodland
Mode of life: Predatory bird related to serpent eagles (Circaetinae) that lives on mammals, reptiles and snakes, which it hunts patiently on long reconnaissance flights, and sometimes also on carrion. Thick black plumage with red beak and white undersides to the wings. The name (*bateleur*: tumbler, buffoon) alludes to the bird's acrobatic manoeuvres in mid-flight: a canting movement made almost without flapping its wings; when courting, in particular, it executes astounding swoops, rolls, dives and loops.

Weaver birds' nests
Family: Ploceidae; page 148
Order: Passeriformes
Class: Birds, Aves
Habitat: Mainly savannah
Mode of life: The nests of the weaver birds, which are often wonderfully colourful creatures, are among the most curious animal constructions. As protection against enemies such as rats or snakes they are suspended from branches and provided with a downward-facing entrance tube. Ever-increasing numbers of these birds build their nests close together, often producing enormous colonies.

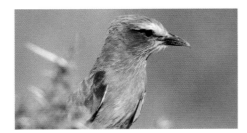

Lilac-breasted roller
(*Coracias caudata*; page 149)
Family: Coraciidae
Order: Coraciiformes
Class: Birds, Aves
Habitat: Tree savannah, open bush; occurring primarily in Asia and Africa
Mode of life: Highly colourful predator of small animals; it keeps a lookout from its perch for small vertebrates like lizards and large insects, which it catches on the ground or in the air. A close relative of the lilac-breasted roller, the European roller (*Coracias garrulus*) lives in our latitudes.

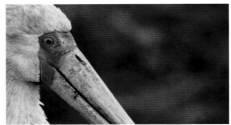

Wood ibis
(*Mycteria ibis*; page 150)
Family: Storks, Ciconiidae
Order: Ciconiiformes
Class: Birds, Aves
Habitat: Inland African migratory bird that lives near water
Mode of life: Member of the stork family; finds fish, amphibians and water insects in shallow water by stirring up the mud with its beak.

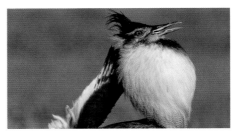

Kori bustard – old male bird
(*Ardeotis kori*; pages 152–53)
Family: Bustards, Otididae
Order: Gruiformes
Class: Birds, Aves
Habitat: Grass savannah
Mode of life: The heaviest flying bird of all, weighing up to 18 kg. They tend to walk across the savannah at a stately pace, alone or in pairs, constantly on the lookout for insects and small vertebrates. The males perform spectacular courtship dances.

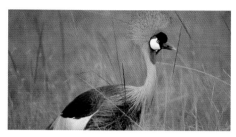

Crowned crane
(*Balearica pavonina*; pages 154, 250)
Family: Cranes, Gruidae
Order: Gruiformes
Class: Birds, Aves
Habitat: Savannahs and other dry areas
Mode of life: Lives for most of the year in dry areas, where it forms large groups. But it needs marshy terrain to breed; here the birds trample the plants down over several square metres and build a heap of stalks rising 30 to 40 cm above the surface of the knee-deep water and up to 1.5 m wide, and construct the nest on top of this. The pair will not tolerate any members of their own species in their nesting area of several hectares.

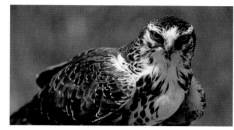

Ayres' hawk eagle
(*Hieraaetus ayresiii*; page 155)
Family: Accipitridae
Order: Accipitriformes
Class: Birds, Aves
Habitat: Rain forest/savannah
Mode of life: Strictly seasonal. Leaves the dense forests of Central Africa in the rainy season to migrate to the open tree savannah and coastal areas of East Africa. It preys mainly on pigeon. Close relative of Bonelli's eagle and the booted eagle.

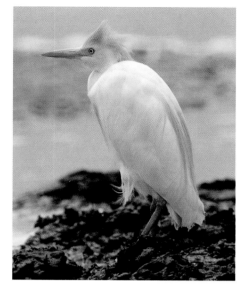

Cattle egret – old bird in brooding plumage
(*Bubulcus ibis*; page 155)
Family: Herons, Ardeidae
Order: Ciconiiformes
Class: Birds, Aves
Habitat: Swamps, marshes, grassland, always close to large mammals
Mode of life: Likes to co-exist with grazing cattle, where it feeds on insects. It used to follow only wild herds, but has now become accustomed to domestic cattle, following people working in fields or removing parasites directly from the skin of grazing cattle. Sometimes hundreds of birds will gather on a single tree to sleep, which from a distance looks as though it is covered with snow – and this in the middle of the savannah!

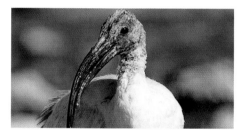

Sacred ibis
(*Threskiornis aethiopicus*; page 155)
Family: Ibises and spoonbills, Threskiornitidae
Order: Ciconiiformes
Class: Birds, Aves
Habitat: Wetlands; widely distributed, especially in East Africa
Mode of life: Lives on small creatures that it unearths from moist sediment with its pincer-like beak. Breeds in large colonies. The ibis has been extinct for over a century in Egypt, where it was worshipped in antiquity as the god of wisdom and buried as a mummy. Related species still live in India and Australia.

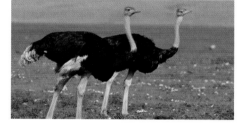

Common ostrich – two adult cocks
(*Struthio camelus massaicus*; pages 260–63)
Family: Ostriches, Struthionidae
Order: Ostriches, Struthioniformes
Class: Birds, Aves
Habitat: Savannahs, semi-deserts
Mode of life: A typical running bird of the East African savannah, almost 3 m tall and weighing up to 150 kg, thus the largest living bird. It can outrun lions, leopards and hyenas, reaching speeds of up to 50 km per hour, which it can sustain for about half an hour. The cocks' necks and legs become intensely red in the mating season.

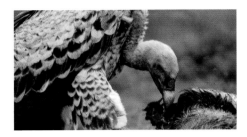

Rüppell's vulture
(*Gyps rueppellii*; page 304)
Family: Acciipitridae
Order: Accipitriformes
Class: Birds, Aves
Habitat: Grass steppes, savannahs, rocky areas
Mode of life: Extremely gregarious, often nests in large colonies and tall trees. Largely avoids human settlements.

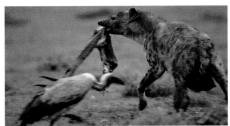

White-backed vulture
(*Gyps africanus*; page 305)
Family: Accipitridae
Order: Accipitriformes
Class: Birds, Aves
Habitat: Grass steppes, savannahs
Mode of life: The largest vulture in East Africa by a long way, though it now occurs almost exclusively in the large game reserves. It is physically inferior to other vultures when it comes to fighting over a corpse, but makes up for this by superiority in numbers.

Spotted hyena
(*Crocuta crocuta*; pages 255, 302, 305)
Family: Hyenas, Hyaenidae
Order: Carnivores, Carnivora
Class: Mammals, Mammalia
Habitat: Savannahs, semi-deserts
Mode of life: The largest, strongest and commonest variety of hyena. Hunts in large groups that attack herds of zebra and gnu in the twilight, reaching speeds of up to 65 km per hour. As hyenas also eat corpses, they contribute significantly to maintaining ecological equilibrium.

Kirk's dik-dik – adult male
(*Madoqua kirkii*; page 166)
Family: Bovids, Bovidae
Order: Even-toed ungulates, Artiodactyla
Class: Mammals, Mammalia
Habitat: Dry woodland, stony slopes
Mode of life: Very small antelope that does not usually exceed 5 kg, with a proboscis-like nose and long tufts of hair on its forehead. It feeds on foliage, fruit, pods and blossoms. Lives alone, in pairs or in small family groups.

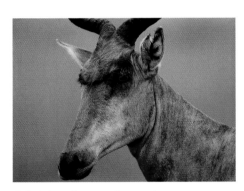

Coke's hartebeest or kongoni
(*Alcelaphus buselaphus cokei*; page 166)
Family: Bovids, Bovidae
Order: Even-toed ungulates, Artiodactyla
Class: Mammals, Mammalia
Habitat: Grass savannah
Mode of life: Cow antelope, active predominantly in the early morning and late afternoon. Eats only grass. Harem herds occupy the best places; bucks like to stake their territorial claims by standing on termites' nests.

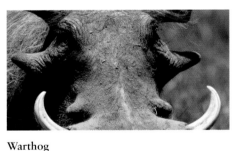

Warthog
(*Phacochoerus aethiopicus*; page 167)
Family: Pigs and hogs, Suidae
Order: Even-toed ungulates, Artiodactyla
Class: Mammals, Mammalia
Habitat: Open savannah, light bush and grass steppe
Mode of life: Typical herbivore; its teeth are essentially a grinding device. The only pig that goes down on its forelegs to eat. Outside the mating season several females live together in small groups with their young. The boar can weigh up to 150 kg, and its canines grow to a length of up to 35 cm; they are feared by many animals, even leopards and hyenas are wary of them. The name comes from three pairs of facial warts that become cartilaginous and can measure up to 15 cm in length.

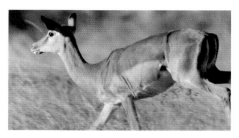

Impala
(*Aepyceros melampus*; pages 272–73)
Family: Bovids, Bovidae
Order: Even-toed ungulates, Artiodactyla
Class: Mammals, Mammalia
Habitat: Tree savannah
Mode of life: Medium-sized antelope, also known as a black-faced impala; very common in the large game reserves. Only the males have the large, lyre-shaped horns. There are harem herds, which have only one sexually mature male, as well as pure bachelor herds. The animals have a characteristically high and long leap when in flight.

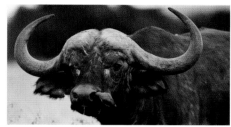

Cape buffalo
(*Syncerus caffer*; pages 255, 275)
Family: Bovids, Bovidae
Order: Even-toed ungulates, Artiodactyla
Class: Mammals, Mammalia
Habitat: Savannahs, woodland, near water
Mode of life: Herbivore, grazing mainly at night: they are content with grass, herbs, foliage and even reeds. During the day, the herds migrate to new grazing land, resting in the shade in the heat of the day or wallowing in extensive mud-baths. Cape buffalo are constantly accompanied by oxpeckers, which clamber all over them and keep them free of insects.

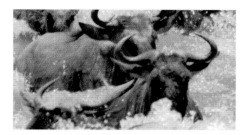

Blue wildebeest, brindled gnu
(*Connochaetes taurinus*; pages 288–91)
Family: Bovids, Bovidae
Order: Even-toed ungulates, Artiodactyla
Class: Mammals, Mammalia
Habitat: Tree savannah
Mode of life: A herbivore through and through. Prefers areas with short, fresh grass, as found after a bush fire or rain. The enormous herds that follow the seasonal rain in the East African Serengeti are a regional phenomenon, however. Otherwise gnus tend to be settled and rarely form large herds.

Agama lizard
(*Agama agama*; page 277)
Family: Agamoids, Agamidae
Order: Lizards and snakes, Squamata
Class: Reptiles, Reptilia
Habitat: Stony terrain in savannahs and semi-deserts
Mode of life: Diurnal, sun-loving lizard living in large parts of Central Africa. Often occurs near human settlements. They are usually dark-hued at night and in the cool morning hours, but they can completely change their colouring within a very few minutes: the body becomes steely-blue when they are hot or excited.

Nile monitor
(*Varanus niloticus*; pages 236–37)
Family: Monitors, Varanidae
Order: Lizards and snakes, Squamata
Class: Reptiles, Reptilia
Habitat: Bodies of water of all kinds
Mode of life: Typical amphibian, spending the majority of its time in water. Can reach a length over 2 m. Its preferred food is fish, amphibians and crocodile eggs. It frequently lays its own eggs in termites' nests.

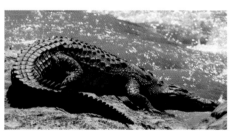

Nile crocodile
(*Crocodylus niloticus*; pages 176–77, 294–95)
Family: Crocodiles, Crocodylidae
Order: Crocodiles, Crocodilia
Class: Reptiles, Reptilia
Habitat: Bodies of water of all kinds in tropical Africa
Mode of life: In East Africa, Nile crocodiles are to be found in almost every body of water of any size, where their bronze-green scales provide them with perfect camouflage. The creatures reach up to 8 m in length, and eat fish, turtles and birds, but also antelopes or young hippopotamuses. They prefer to nest on sandy beaches with few stones and low banks. They dig their nesting holes about 2 m above the waterline, in which the female lays 30 to 50 hen-size eggs. The same brooding area is often kept for years.

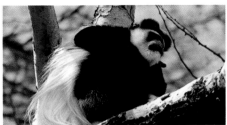

Black-and-white colobus, guereza
(*Colobus guereza*; page 268)
Family: Old World monkeys, Cercopithecidae
Order: Primates
Class: Mammals, Mammalia
Habitat: Tropical forests and tree savannahs
in Central and East Africa
Mode of life: Lives in trees, covering large
distances in agile leaps. For food, the
animals pull branches towards them with
their hands and bite off bunches of leaves.
They usually feed on one or two trees for
several days, then move on to another one.
There is no particular hierarchy within the
groups; a strong male plays the part of
leading monkey. Old World monkey groups
have relatively small, well-defined territories.
They do not leave their territory even when
chased, and mark the borders by calling.

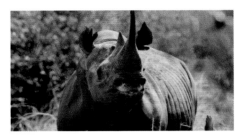

Black rhinoceros
(*Diceros bicornis*; page 276)
Family: Rhinoceroses, Rhinocerotidae
Order: Odd-toed ungulates, Perisodactyla
Class: Mammals, Mammalia
Habitat: Steppes and savannahs
Mode of life: Vegetarian. Unlike the white
rhinoceros, which grazes on grass, its
pointed mouth and equally pointed lips
are ideally suited for plucking leaves and
twigs. Black rhinoceroses can have young
all year round. The young animals are
usually suckled by their mother for 2 years
and stay with her for about 3 1/2 years.
The black rhinoceros has almost been
eliminated in East Africa; even though the
surviving animals are under strict protection
in the reserves, they are still hunted by
poachers.

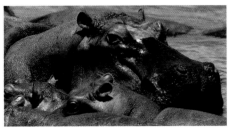

Hippopotamus
(*Hippopotamus amphibius*;
pages 170–73, 250)
Family: Hippopotamuses, Hippopotamidae
Order: Even-toed ungulates, Artiodactyla
Class: Mammals, Mammalia
Habitat: Rivers of all kinds, particularly in
East Africa
Mode of life: Females and their young usually
live in herds of up to 50 animals, the bulls
mainly alone. As a rule, hippopotamuses
coexist peacefully with other river-dwellers,
such as crocodiles or birds. They attack
with their mouths and formidable teeth
only when they feel threatened. Although
they are amphibians they are not good
swimmers; they prefer to stay in shallows,
where they are covered with water but have
contact with the bed. They go on land to
graze at night.

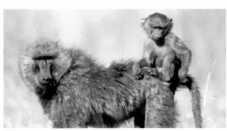

Yellow baboon
(*Papio cynocephalus*; pages 255, 264–67)
Family: Dog-faced baboons, Cythopithecidae
Order: Primates
Class: Mammals, Mammalia
Habitat: Steppes and savannahs
Mode of life: Omnivore. Their food includes
grass seeds, roots, tubers, fruit, insects and,
on rare occasions, young ungulates. Baboons
live in large groups with a clear hierarchy.
In areas where lions and leopards have
been eliminated, baboons have become
so numerous that they are regarded as a
nuisance by farmers.

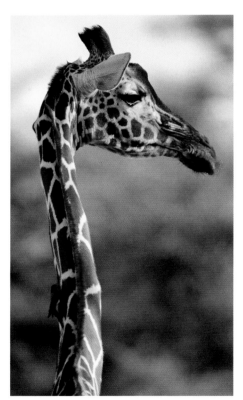

Giraffe
(*Giraffa camelopardis*; pages 174–75,
251–54, 258–59)
Family: Giraffes, Giraffidae
Order: Even-toed ungulates, Artiodactyla
Class: Mammals, Mammalia
Habitat: Bush and tree savannahs
Mode of life: Prefer to eat from trees because
of their height (over 5 m). Like most steppe
animals they are gregarious, grazing with
ostriches, zebras and antelopes. Because
of their long legs and necks, eating grass
or drinking water is something of a contor-
tionist's act. They have particularly muscular
blood vessels to compensate for this.

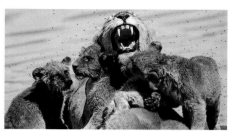

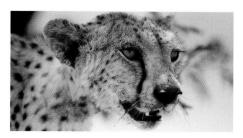

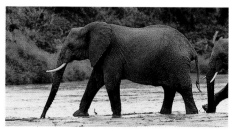

Lion
(*Panthera leo*; pages 228, 238–43, 246–50, 255–56, 315–17)
Family: Felids, Felidae
Order: Carnivores, Carnivora
Class: Mammals, Mammalia
Habitat: Steppes and savannahs
Mode of life: Male lions are the only large cats with a full mane – a show object and protection against opponents' blows. The hunt is organized by a division of labour: the males drive the prey, the females kill them. The strongest lion in the pride is always given the choicest share of the food, even if he was not involved in the hunt. After a gestation period of about 100 days, the female gives birth to 2 to 5 young, which are suckled by other females in the pride. Lions now live almost exclusively in the large game reserves.

Cheetah
(*Acinonyx jubatus*; pages 255, 274, 282–83, 285, 296–301, 303)
Family: Felids, Felidae
Order: Carnivores, Carnivora
Class: Mammals, Mammalia
Habitat: Steppes and savannahs, especially dry savannahs
Mode of life: Excellent runner, effortlessly reaching speeds of 75 km per hour and a top speed of up to 110 km per hour. Hunting mainly gazelles, antelopes, rodents and birds, the cheetah stalks its prey at a distance of 20 to 100 m, surprising its victim with its great speed and striking it down with its front paws.

African elephant
(*Loxodonta africana*; pages 2–3, 18, 178–85, 188–92, 195–98, 201–11, 250)
Family: Elephants, Elephantidae
Order: Proboscideans, Proboscidea
Class: Mammals, Mammalia
Habitat: Steppes and savannahs
Mode of life: The largest land mammal in the world, measuring 4 m at the shoulder and weighing up to 7 tons. As vegetarians, they have to process enormous quantities of grass with their molars each day. Elephants are gregarious animals with a complex social organization: the basic unit is a family group consisting of several cows and their young. The herd is led by an experienced female. Individual members of the group form close ties; injured or sick animals are supported and cared for by their fellows. They were formerly at home all over the African continent, but now most elephants live in reserves.

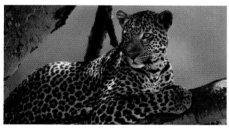

Leopard
(*Panthera pardus*; pages 269–71)
Family: Felids, Felidae
Order: Carnivores, Carnivora
Class: Mammals, Mammalia
Habitat: Savannahs, semi-deserts, forests
Mode of life: Highly adaptable, survives in an enormous variety of habitats. Is seen as a loner, but also lives in pairs. The colour of its coat means that it is well camouflaged, and so it is active both night and day, and rests only at the hottest times of the day. It is known to drag its prey up a tree to keep out of reach of lions and hyenas.

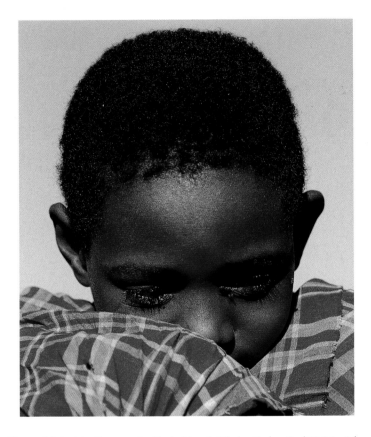

First published in Germany by Frederking & Thaler Verlag GmbH, Munich
Infanteriestr. 19, Haus 2, D – 80797 Munich
www.frederking-thaler.de

Second edition

Copyright © 2003 Frederking & Thaler Verlag GmbH, Munich
Original title: *Mein Traum von Afrika*

Photographs © Carlo Mari, Legnano, 2003
Concept: Carlo Mari, Legnano
Text copyright © Carlo Mari, Legnano, and Claus-Peter Lieckfeld in collaboration with
Hannelore Leck-Frommknecht, ethnologist, Munich, 2003
Translation © Michael Robinson, London, 2003
Quotation by Kuki Gallmann, *The Night of the Lions*, Viking, London, 1999

The authors have asserted their moral rights to be identified as the authors of the book.

Editors: Martin Meister, GEO Hamburg, and Michele Schons, Munich
Design and layout: Carlo Mari with Petra Dorkenwald, Munich
Cartography: Margit Symmangk, Munich
Production: Verlagsservice Rau, Munich
Originated by NovaConcept Kirchner GmbH, Berlin
Printed and bound in Italy by Printer Trento S.r.l., Trento

ISBN 3-89405-626-6

A CIP catalogue record for this title is available from the British Library